Volume 14

DIRECTORY OF
WORLD CINEMA
BRITAIN

Edited by Emma Bell and Neil Mitchell

intellect Bristol, UK / Chicago, USA

First Published in the UK in 2012 by Intellect, The Mill, Parnall Road, Fishponds, Bristol, BS16 3JG, UK

First published in the USA in 2012 by Intellect, The University of Chicago Press, 1427 E. 60th Street, Chicago, IL 60637, USA

A catalogue record for this book is available from the British Library.

Publisher: May Yao
Publishing Manager: Melanie Marshall

Cover photo: Fish Tank 2009, BBC Films/The Kobal Collection

Cover Design: Holly Rose
Copy Editor: Heather Owen
Typesetting: Mac Style, Beverley, E. Yorkshire

Directory of World Cinema ISSN 2040-7971
Directory of World Cinema eISSN 2040-798X

Directory of World Cinema: Britain ISBN 978-1-84150-557-2
Directory of World Cinema: Britain eISBN 978-1-84150-607-4

Printed and bound by Cambrian Printers, Aberystwyth, Wales.

DIRECTORY OF
WORLD CINEMA
BRITAIN

This Directory would not have been possible without the efforts and generosity of the contributors, and the support and assistance of Intellect's staff, particularly May Yao and Melanie Marshall. In addition, Emma Bell would like to thank her friends and colleagues Frances Tempest, Fi Roxburgh, Frank Gray, Ewan Kirkland, Louise Fitzgerald and Jedge Pilbrow for their advice and support. Neil Mitchell would like to thank Alan Hodge, John Berra and Gabriel Solomons for welcome advice, information and support on this and other projects, as well as his family and friends for their unwavering encouragement.

Emma Bell and Neil Mitchell

INTRODUCTION

Film-making in Britain has a long and illustrious history dating back to the nineteenth century when pioneers in the embryonic technology, art and industry of motion picture production, such as photographer Eadweard Muybridge – one of the 'fathers of cinema' – and film-makers Robert Paul and George Albert Smith, lay the foundations for Britain's renowned cinema industry.

After over 100 years of film-making, anyone compiling an overview of a national cinema is tasked with identifying a coherent definition of the 'national' that can be sustained throughout shifting social, historical, cultural, industrial and political contexts. Films placed under the banner of 'British cinema' can be differentiated from those of, say, Hollywood, France or Japan, yet do not all neatly fit into one definition of the national in terms of conditions of production, modes of exhibition, genre, style or content. While this is as true of Britain as it is of many national cinemas, it is the consistent diversity of British cinema that makes it so interesting to study.

Accordingly, this Directory comprises one way of organizing British cinema, which acknowledges that there are other ways of doing so. The films and film-makers here appear in loose categories – history, industry, identity and genre – that are explored on their own terms. Trying to maintain the boundaries of those categories, however, beneficially reveals how much they interlink and affect each other. In other words, this is an attempt to capture the substance and diversity of British cinema, rather than to disaggregate it.

The Directory's historicization of British cinema starts with the nineteenth-century Pioneers, particularly the Brighton school, and 'On Location' then explores the role that Brighton and Hove have (actually) played in British cinema's creative imagination. The industrial base of British film-making is mapped throughout, but there are special sections on the silent era, British studios, women in the industry and the arthouse sector. Individual essays discuss specific practitioners – David Lean, Michael Powell and Emeric

Pressburger and Shane Meadows – whose work, in very different ways, has made an important contribution to British cinema culture.

Most of the essays and reviews discuss the social relevance of British cinema and its relationship to national identities. Britain, of course, comprises distinct regions – England, Wales, Scotland and Northern Ireland – that are increasingly involved in an ongoing process of political and cultural devolution. While British cinema is notoriously Anglocentric, it is not beneficial to assume that the majority of its films are 'English'. Britain's simultaneous unity and divisions need to be acknowledged, and the impact of devolution on the film industry explored. While many of the films throughout the Directory are Scottish in origin or substance, the independence of the Scottish industry is explored in detail in a specific chapter. Given that many surveys of British cinema neglect the modest but important film cultures of Wales and Northern Ireland, there are sections on film-making in, and representations of, those regions.

One might suggest that British cinema represents and reflects 'Britishness', yet 'Britishness' is a loaded term that invites one to think of what might make a national culture unique to the exclusion of whatever does not 'fit' that model. Any definition of Britishness has to include its endemic divisions and syntheses of regions, social classes, ethnicities and the English North/South divide. It must also acknowledge that national identities shift over time according to political, social and economic conditions, and that the ongoing process of economic and cultural globalization destabilizes ideas of the 'national'. While many authors here examine cultural shifts in, and diversification of, national identity, an in-depth discussion on multiculturalism explores some of the ways in which British cinema reflects experiences of ethnicity, race, post-colonialism, immigration and cultural hybridity in Britain.

The remaining essays and reviews are organized by genre – melodrama, crime, comedy, horror, science fiction, art and documentary – that identify types of film in which British cinema has shown particular strength and explore the ways in which British film-makers have interpreted and developed genres. While identifying national film 'types' is problematic, the Directory distinguishes more characteristically 'British' genres – social realism and the heritage film – describing their origins, forms and functions.

This Directory's first review, *The King's Speech*, its cover film *Fish Tank*, and its Award of the Year film, *Harry Potter*, highlight issues raised above. *The King's Speech* is a quality heritage biopic that offers an intimate portrait of a British monarch at a pivotal moment in British history; its manner is patriotic, sentimentally Anglocentric and uncritical of the seemingly intractable British class system. *The King's Speech* was drawn from British source material, created by a British-American screenwriter, realized by a British director, and employed a British and Commonwealth cast and crew. It has been phenomenally successful across the globe, winning many important international awards. *Fish Tank* is an exploration of class and gender in the British social realist tradition, depicting a young girl struggling to find her place in a bleak urban landscape. It was written and directed by a British woman, uses regional actors and creative professionals, is mostly British funded and did reasonably well at the the the arthouse and independent box office. *Harry Potter* is a superlative blockbuster franchise of fantasy films telling the story of a lowly orphan liberated from dreary suburban England into an epic, magical realm. It is adapted from children's books by British author JK Rowling, employed a predominantly British crew and reproduces archetypical British landscapes, landmarks and mythologies, yet is American owned and funded. Though they draw on different genres, cultural references and histories, were created in different industrial conditions and represent radically different images of Britishness, *The King's Speech*, *Fish Tank* and *Harry Potter* are apposite examples of contemporary British cinema.

Britain's substantial volume of classic and innovative films made the final selection of topics and titles in the Directory extremely difficult, yet the final list was chosen because,

together, they reflect something of British cinema's richness and complexity. Our contributors thoughtfully talk about many other British films and film-makers that we hope the reader will find interesting and enjoyable.

Finally, in this Directory, the credit 'Production Designer' is used to signify the person who designed the overall look of a given film. In early productions, however, that person was often credited as 'Art Director'. As the responsibilities of an Art Director have changed significantly over time, that credit no longer always signifies the person responsible for the film's overall look. While the credit may sometimes differ in related publications or websites such as imdb.com, to ensure consistency, it was appropriate to use Production Designer throughout.

Emma Bell

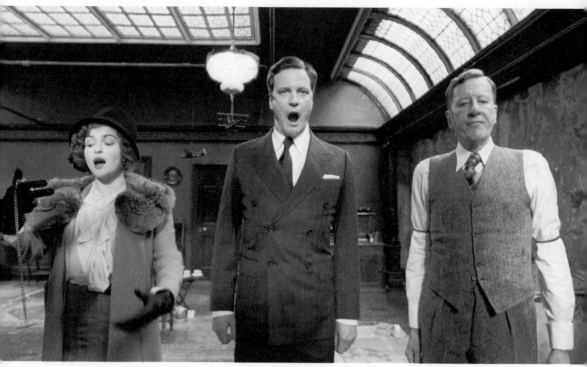

The King's Speech, See-Saw Films/The Kobal Collection.

FILM OF THE YEAR
THE KING'S SPEECH

The King's Speech

Studio/Distributor:

Seesaw
Bedlam/Momentum

Director:

Tom Hooper

Producers:

Ian Canning
Gareth Unwind
Emile Sherman

Screenwriter:

David Seidler

Cinematographer:

Danny Cohen

Production Designer:

Eve Stewart

Composer:

Alexandre Desplat

Editor:

Tariq Anwar

Duration:

118 minutes

Genre:

Heritage

Cast:

Helena Bonham Carter
Colin Firth
Derek Jacobi
Geoffrey Rush

Year:

2010

Synopsis

Prince Albert, the second son of King George V, must give a speech at the closing of the 1925 Empire Exhibition, held at a packed Wembley Stadium. His stammer causes him to fail pitiably. Initially acting under the alias 'Mrs Johnson', his wife engages the services of Lionel Logue, an unorthodox Australian speech therapist who specializes in curing stammers. Logue and Prince Albert begin a complex and tempestuous working relationship, and Logue proves invaluable in helping Albert overcome his anxieties.

George V dies and Albert's older brother becomes King Edward VIII, beginning the abdication crisis that unexpectedly brings Albert's ascension to the throne. The stress on Albert, now King George VI, increases as he is forced to speak at his coronation and, again, upon the outbreak of WWII. The morale of his subjects depends upon him delivering a crucial nine-minute speech, broadcast live on radio, to the entire Empire.

Critique

An Oscar-laden triumph for the recently dissolved UK Film Council (UKFC), *The King's Speech* is another of the well-acted, high-end dramas decorated with impeccable period detail of the type that has become a feature of British film-making since the 1980s. *The King's Speech* generally avoids the over-seriousness that hampers other heritage films, though, through its strong comic sensibility, there are several good gags and numerous Pygmalionesque scenes of speech therapy.

A film like this will always be judged on the performances of its leads and, by that measure, *The King's Speech* is superb. Both Colin Firth as 'Bertie' (Prince Albert, later King George VI) and Geoffrey Rush as Lionel Logue give admirable depth to characters that could quickly become cliché-ridden. Bertie could slide into a mess of ticks and tantrums; Firth moulds him into a believable and fragile man whose suffering and self-doubt are unique, but easy to identify with. Logue could dissolve into an absurdly hammy antipodean version of Henry Higgins; Rush ensures he has both strength and fragility. If their interactions occasionally suffer from thoughts that only in a film could an eccentric commoner persuade a staid king to dance, sing and swear his way through speeches, these are dispelled by the conviction with which the sequences in question are acted, and the memory that this is based upon a true story.

The casting is clever. Michael Gambon, with his stage actor's voice and gravitas, makes the part of George V seem far larger than it is, and makes Bertie's tales of growing up fearing his father believable. The choice of Guy Pearce, an Australian, to play a king of England feels, at first, an odd one but it enhances the presentation of King Edward VIII as an international playboy irreconcilably different from his overtly English brother. Helena Bonham Carter, as Queen Elizabeth, has both the haughtiness to play a woman whose snobbishness borders on bigotry and the gentleness to make her charming.

The film falters when it strays into unrestrained solemnity. By the time of the King's address to the Empire, most of the most of the jokes have stopped and one has the impression that the fate of the free world depends upon Bertie's ability to give a single speech without stammering. Early on, the film emphasizes the enormousness of the impact Bertie's speech impediment has upon him, the Royal Family and its inner circle; late in the film the audience are asked to believe the issue seems equally enormous to all the members of a nation that has just declared war on the Nazis. Even so, director Tom Hooper merits great praise for constructing an extended scene of a man standing in a small room talking into a microphone as engaging and emotional as the climactic moments of 'rise of the underdog' films with which *The King's Speech* shares its structure. Such assuredness pervades the production.

Scott Jordan Harris

AWARD OF THE YEAR
HARRY POTTER

The British Academy of Film and Television Arts (BAFTA) is an independent body that supports the moving image arts and industry in Britain. The Academy holds an annual award ceremony that celebrates excellence and achievements in the film industry, and presents awards in categories such as Best Film, Best Director and Best Costume Designer.

In 2011, the Academy garlanded the *Harry Potter* series with the 'Outstanding British Contribution to Cinema' award. The series comprises eight films adapted from children's novels by JK Rowling: *Harry Potter and the Philosopher's Stone* (2001), *Chamber of Secrets* (2002), *Prisoner of Azkaban* (2004), *Goblet of Fire* (2005), *Order of the Phoenix* (2007), *Half-Blood Prince* (2009) and *The Deathly Hallows Part I* (2010) and *Part II* (2011). Throughout the films, the young orphan Harry Potter (Daniel Radcliffe) discovers he has magical talents when he is liberated from his normal 'Muggle' (non-magical) home and summoned to Hogwarts School of Witchcraft and Wizardry. At Hogwarts, Harry meets Ron Weasley (Rupert Grint) and Hermione Grainger (Emma Watson), who become his best friends, and his mentor, Professor Dumbledore (Richard Harris/Michael Gambon). Harry soon learns that he is fated to battle his nemesis, the evil Lord Voldemort (Ralph Fiennes), who killed his parents. Harry, Ron and Hermione must quest for magical objects, escape labyrinths, and defeat a bestiary of monsters to find all of the pieces of Voldemort's soul and destroy them before he gains enough power to take over the magical world.

While there are disagreements about what constitutes a 'British' film, *Harry Potter* signified a major shift in those debates; as a 2009 UK Film Council report states: 'different legal and fiscal definitions [of British film] have been used since the 1930s, for the purposes of quota fulfilment, and tax relief and subsidy eligibility, but the debate has, if

anything, become more intense in the era of the globally successful *Harry Potter* adaptations' (UK Film Council, 2009:12). *Harry Potter* not only demonstrates excellence in British film-making, but also exemplifies the contemporary social, industrial and economic conditions within which British cinema operates.

Beginning in 2001, the *Harry Potter* series took over a decade to complete and employed over 2000 people. It is owned by Warner Bros and American funded, directed by both British and American directors, (Chris Columbus, Mike Newall, David Yates), and much of the profits are reaped abroad. Yet the films are adapted from British source material, used British settings, myths and characters, were produced by Englishman David Heyman and, at author JK Rowling's request, principally employed British talent. The films were set in Britain, having been shot in Leavesden Studios in Hertfordshire and locations including Alnwick Castle, Oxford University and King's Cross Station. *Harry Potter* showcased a wealth of British acting talent including Richard Harris, Michael Gambon, John Hurt, Maggie Smith and Ralph Fiennes, as well as making international stars of Daniel Radcliffe, Emma Watson and Rupert Grint. The creative excellence of those working on the *Harry Potter* films has earned countless nominations and awards from film institutions and festivals across the globe. To date, *Harry Potter* is the most profitable film franchise and has generated a phenomenal fan culture and a multi-billion-dollar industry of tie-in products, merchandise and even a theme park.

Harry Potter draws on recognisable and exportable aspects of Britishness to construct the sense of place and culture of its two worlds. The dreary world of the 'Muggles' is the unreconstructed Middle England suburbia of 'Little Whinging' and metropolitan landmarks, whereas the magical world is a Dickensian England of cobbled streets with cluttered old shops, boarding schools, creepy little villages, Arthurian enchantment, ancient folklore, quaint villages, wild forests and ageless castles. The two worlds, then, form a touristic brochure of iconic British spaces: King's Cross Station, London Zoo, London buses, thatched cottages, etc. These locations are nostalgic, picturesque and whimsical ideals of antiquated and middle-class Britishness for home and international audiences alike. Indeed, in an attempt to boost trade, the British Tourist Authority produced a 'Potter Map of Britain' that entices visitors to visit locations, including central London, Alnwick Castle, Oxford University, Durham Cathedral, as well as the Glenfinnan Viaduct and Glencoe in Scotland.

Set in the magical mirror of an upper-class boarding school, *Harry Potter* is also a very British narrative fantasy of class mobility. Harry's near-Dickensian twist of fate takes him from his lowly and lonely status in the world of 'Muggles' to significance, empowerment, friendship and material privilege at Hogwarts. The infrastructure of the magical world parodies British state bureaucracy, finance and class, such as the intractable, and corrupt Ministry of Magic, the oppressive and humourless goblin-run Gringott's Bank and the system of class privilege that distinguishes even magical families, from the aristocratic self-interested Malfoys to the lowly, loveable Weasleys.

It is, then, problematic to define the *Harry Potter* films as straightforwardly 'British' and they are generally seen as British-American co-productions. International audiences do not always perceive them as British due to 'the scale and production values' which are more often associated with American film-making (UK Film Council, 2009: 64). As such, *Harry Potter* may exemplify 'one of Britain's new cinematic identities which seems to oscillate between UK and US cultures' (ibid: 66).

Emma Bell

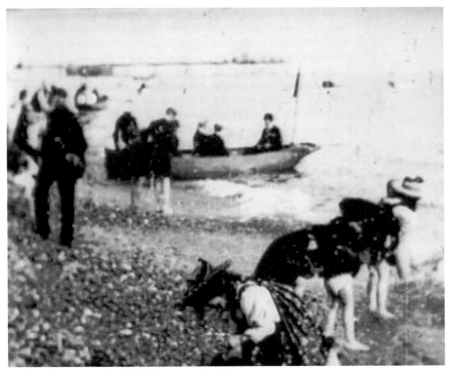

Scene on Brighton Beach, 1896/7, 35mm print held by the BFI.

THE PIONEERS

In the nineteenth century, inventors across Europe and America experimented with photographic motion picture technologies, producing sequential images that could be animated in a variety of ways. For example, in 1889, British patent number 10,131, entitled 'Improved Apparatus for Taking Photographs in Rapid Series', was granted to William Friese-Greene. For the time, it appeared to be an astonishing machine as it was one of the first patents for a cinematographic camera. Unfortunately, the device was too slow – some say only 5 frames a second – which meant that the successful illusion of movement from projected image to image was never achieved. While Friese-Greene was not the inventor of cinema, his accomplishment was to be an active contributor to the evolution of the concept of cinema in the late 1880s and early 1890s.

The ambition to create moving pictures was realized technically and commercially in the 1890s in the United States by the Edison Company of West Orange, New Jersey. While the beginnings of what one might consider 'cinema-proper' is usually credited to the Lumière Brothers' 1895 Cinématographe show in Paris, where they projected films to a paying audience, the first real 'films' to be commercially exhibited in the UK were American in origin, produced using a Kinetograph and designed for use in the Kinetoscope. Largely the invention of the engineer William Kennedy Laurie Dickson at the Edison Laboratory, the Kinetoscope was a film viewer driven by an electric motor that enabled a single user to view a single 40-foot length of 35mm celluloid nitrate film with a duration of 25–30 seconds. (The 35mm gauge was established by Dickson and is still the dominant film gauge).

The first Kinetoscope parlour opened in London at 70 Oxford Street on 17 October 1894. *The Times* newspaper described the parlour as having ten machines and named five of the films on display: *Blacksmith's Shop, Carmencita, Annabelle Serpentine Dance, Wrestling Scene* and *Cock Fight*. The preparation for the filming had ranged from the very simple, such as the *Annabelle* dance film where the solo dancer performed to camera in the undecorated and naturally-lit interior of the black tar paper studio, to the more elaborate *Blacksmith's Shop. The Times* newspaper described the latter as: 'One scene represents a blacksmith's shop in full operation, with three men hammering iron on an anvil, and who stop in their work to take a drink. Each drinks in turn and passes the pot of beer to the other. The smoke from the forge is seen to rise most perfectly' ('The Kinetoscope', *The Times*, 18 October 1894: 4). These representations of working lives and popular culture provided a very distinctive portrait of American life: here was a very masculine world-view that was interested in the physicality of modern life. The Edison Company conceived of the films as products for national and international consumption and as perfect vehicles for displaying the new medium's potential.

Edison had only patented the Kinetograph (the film camera) as he was confident that no one would be able to produce films without the use of his film camera. However, Edison underestimated the ingenuity of the young London-based electrical engineer, Robert Paul (1869–1943). From April 1895, advertisements in the English Mechanic heralded a real and significant challenge to the Edison attempt to monopolize Kinetoscope film production.

In the 5 April 1895 issue of the *English Mechanic* journal, Paul placed this advertisement: 'Kinetoscopes and Films. New Topical Subjects daily. Large stock. List free. Paul, 44 Hatton Garden, London' (*English Mechanic* 61:1567, 5 April 1895: vi). Paul was not only announcing the availability of his version of the Edison Kinetoscope but also that he had succeeded in producing his own films. It is more than likely that this was the first announcement of the first British-made 35 mm films produced on the film camera devised by Paul and Birt Acres. A fortnight later, Paul's advertisement named the subject of one of his Kinetoscope films: *Boat Race*, 1895. This was the Oxford and Cambridge Boat Race of 30 March 1895 and was probably the first time that the name of a British film had been published (*English Mechanic* 61:1569, 19 April 1895: vi).

Paul's advertisements in the *English Mechanic* announced effectively the beginning

of the British film industry. Paul had succeeded in making his own version of the Kineto-scope and then created, with Acres, a 35mm film camera. Some of the Paul/Acres' films were similar in style and content to the Edison/Dickson studio films produced at the Black Maria, such as works like *Carpenter's Shop* and *Boxing Kangaroo*. However, what distinguished these first British films were the use of locations and the recording of two significant national events – the *Boat Race* film and another film of the Derby horse race. These new films possessed a very particular sense of national identity and culture.

1896 marked the first year of film projection in Britain, and Paul led this initiative. In that year, his work was screened in theatres in over thirty British towns and cities. Freed from the single person film viewer, Paul's work demonstrated the new medium's magi-cal control over space and time. It may well have personified, for some, the excitement of modern life, the promise of the next century and the summit of British technology and imagination. Paul's new, illustrious status was confirmed by *The Strand Magazine*, an illustrated monthly, which devoted an article to the making of Paul's *Derby* film in its edition of August 1896. This feature, with its seventeen-frame illustrations from the film, stated, 'the great race, as depicted by Mr. Paul's animatographe, is a veritable marvel of modern photography and mechanism' ('The Prince's Derby – Shown by Lightning Pho-tography', *The Strand Magazine* 12, August 1896:140).

The publication of Paul's advertisement for the creation of the new company to be known as 'Paul's Animatographe, Limited,' was dramatic evidence of Paul's business confidence. The advertisement, which in fact was the abridged prospectus, was over 1000 words in length and began with the astonishing declaration that, from March 1896 to March 1897, his business had 'yielded a Nett Profit of £12,838 15s. 4d., on a capital of about £1000, or 1,200 per cent' (*The Era* 24 April 1897: 8; *The Economist* 24 April 1897: iii).

Cecil Hepworth, who would start his own film production company in 1899, used his column in the *Amateur Photographer* in early 1897 to criticize film. He believed it to be a medium without a future. However, he reversed his position as a result of Paul's prospec-tus. 'More than once I have aired the opinion in this column that animated photography is getting played out. That I was utterly and hopelessly wrong in so soliloquizing is now proved – or near proved.' Animated photography, as Paul's prospectus asserted, was 'one of the greatest attractions the world of amusement has ever had and it is enjoy-ing a phenomenal success.' It was a medium with 'great possibilities', and this was the moment 'to develop the resources of the invention, and to extend its present lucrative field of operation' (Hepworth 1897: 374).

In less than one year, the 27-year-old Paul had become known as a distinguished inventor and a representative of the modernity that was an integral part of contemporary Britain. His evolving talents as an engineer, film-maker, distributor and exhibitor com-bined to bring his films to the nation. Paul's success was the result of his exploitation of an innovative medium through the sale of his projector and the exhibition of his pleas-ing and essentially optimistic films. Throughout his career, Paul avoided all contentious subject matter; the world, as viewed by his camera, appeared as one of charm, respect, industry, order and excitement.

To the first generation of British film-makers, including Hove residents GA Smith and James Williamson, Paul, in 1896, had demonstrated the viability of film as a cultural and commercial form and, in doing so, he created a new British industry. Across Britain, the endeavours of other pioneers, including Cecil Hepworth and William Haggar, urged on the exciting new medium. Film production companies, including British Mutoscope, Biograph, Mitchell and Kenyon, and Gaumont, soon followed as the first purpose built film studies began to appear.

Frank Gray

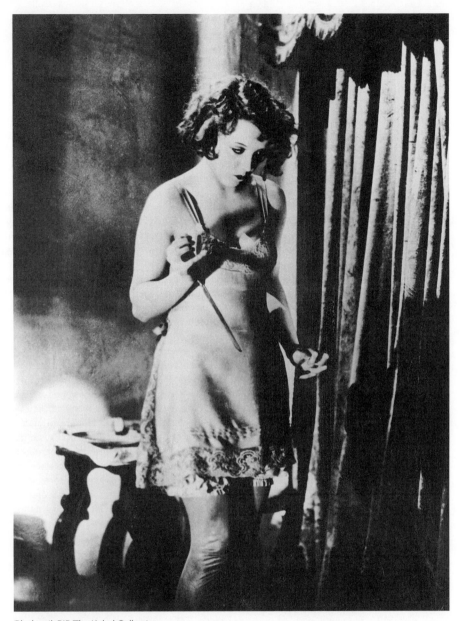

Blackmail, BIP/The Kobal Collection.

BRITISH SILENT CINEMA

For many years, much of the silent era remained one of the deepest valleys of the submerged 'lost continent' of British cinema. At one end of this period, pioneers such as Robert Paul and Cecil Hepworth were celebrated for their formal development of the new medium. At the other end, emerging directors of the mid-to-late 1920s, such as Anthony Asquith and Alfred Hitchcock, were seen to have recaptured something of this early spirit of invention. The intervening years were largely viewed as a cinematic Dark Age, when Britain's contribution to the developing art and business of film-making fell far behind that of Hollywood, Scandinavia, France and Germany. It is often claimed that silent British cinema is studio-bound, overly reliant on literary and theatrical sources, lacking in dynamism and creativity, and 'un-cinematic' in style. However, recent work has contested these views by re-evaluating many of the films, personalities and economics of this period. This revisionism has been facilitated by the wider availability of material through digital formats and screenings at festivals like the British Silent Film Festival. The careers of directors including Maurice Elvey, Henry Edwards, Adrian Brunel and Graham Cutts, screenwriters such as Eliot Stannard, Alma Reville and Lydia Hayward, to say nothing of actors like Betty Balfour, Ivor Novello, Mabel Poulton, Guy Newall and Ivy Duke, have been opened up for (re)discovery. Likewise, the vibrant cinema culture of the period, from the development of film fan magazines during the 1910s to the influential Film Society (established in 1925), has become more widely appreciated.

Between the early 1900s and the coming of synchronized sound in the late 1920s, film production and exhibition underwent momentous changes. Studios were set up and from the early 1910s purpose-built cinemas began to appear. Film running times grew longer and by the end of this period the feature film had become the dominant form. Regulation was increased with, for example, the creation of the British Board of Film Censors in 1912, and the implementation of the Cinematograph Films Act (or 'Quota Act') in 1927, which attempted to confront the growing dominance of Hollywood by stipulating that a percentage of all films shown in cinemas should be British.

WWI had a dramatic effect on the nascent industry: many studios temporarily closed down, London lost its position as the centre of world film import and export, and Hollywood began to consolidate the production and distribution systems that would assure its future place as a market leader. The war also shaped subject matter, and an array of films exploring the conflict appeared both during and immediately after the war. To give but two examples: *The Battle of the Somme* (1916) was a landmark documentary propaganda film (albeit with some staged elements) that packed in wartime audiences, while the fictional feature, *Blighty* (1927), made a decade later, portrays the breaking down of class barriers occasioned by the war.

One positive outcome of war was that the shortage of men opened up workplace opportunities for women. Women had been involved in film-making from the very beginning, establishing themselves not only as actors but also scenarists, camerawomen and even directors in the case of performer-director Ethyle Batley. From the mid-1910s women made increasingly significant contributions to cinema, and this was consolidated by a growing recognition that women were the largest demographic of cinemagoers. As critic Iris Barry wrote in 1926, the 'one thing never to be lost sight of in considering the cinema is that it exists for the purpose of pleasing women. Three out of every four of all cinema audiences are women' (Barry 1926: 5926). This awareness was reflected in the increasing number of female-centred narratives in which women had varying degrees of agency as performers, producers, and authors of scenarios or source material. The silent British 'woman's film' can be traced from *The Exploits of Three-Fingered Kate* (1909–1912) to *Greek Meets Greek* (1922) – one of several films produced by actor Violet Hopson in which she plays an independent and capable business woman – through to the tragic romance, *The Constant Nymph*, which was one of the biggest British films of 1928.

Despite the rise of the feature film, cinemas continued to screen mixed programmes, which included shorts, newsreels, educational films and topicals. Early crime and adventure series such as *Lieutenant Daring* (1911–1914) and *Ultus* (1915–17) remained popular with audiences and producers and gave way to later series such as *The Adventures of Sherlock Holmes* (1921–23) and *The Mystery of Dr Fu-Manchu* (1923–4). With its roots in the music hall, comedy was another popular genre for shorts. Hepworth's *Tilly* films (1910–1915) featured Alma Taylor and Chrissie White as anarchic schoolgirls, while the *Pimple* series parodied topical events and films. Science and non-fiction films were also staples of production and exhibition. Films such as Percy Smith's time-lapse *Birth of a Flower* (1910) enthralled and educated audiences, while newsreels and 'cinemagazines' formed a key part of cinema programmes during the 1910s and 1920s (and for many decades beyond).

British fiction films of this period often drew heavily on indigenous theatre and literature and, to a lesser extent, music hall and illustration. Unsurprisingly, Shakespeare was frequently filmed. Percy Stow made an imaginative pocket version of *The Tempest* in 1908, while *Henry VIII* and *Richard III* (both 1911), and a more extensive *Hamlet* (1913), proudly featured the cream of British stage talent. More contemporary plays were also adapted. Oscar Wilde's *Lady Windermere's Fan* and Pinero's *The Second Mrs Tanqueray* were both filmed in 1916, for example, while Noël Coward's *The Vortex* and *Easy Virtue* were adapted in 1927.

Dickens proved popular, too, with short tableaux from the pioneer period giving way to longer adaptations as the 1910s progressed. Hepworth and Thomas Bently, for instance, made a feature-length version of *David Copperfield* in 1913. Scenarist Eliot Stannard's *Dombey and Son* (1917) demonstrated that film-makers were not necessarily overly reverent towards their sources when he controversially put Dickens' characters into contemporary dress. Producers also attempted to cash in on best-selling novels such as historical swashbucklers by Rafael Sabatini, crime thrillers by Edgar Wallace, and romances by Ethel M Dell and Marie Corelli. Producers often worked closely with authors and publishers to create film versions of popular novels, and in return, reinvigorate sales of books, often re-packaged as film tie-in editions.

British producers were mindful of overseas, primarily American, competition. As part of a bid to create a distinctly British cinema, they often showcased the beauties of the British landscape or exploited iconic landmarks and locations. Pioneer Cecil Hepworth's later films had a strong pastoral sensibility, with titles such as *Tansy* (1921) and *Comin' Thro' the Rye* (1923) featuring extensive, and lovingly-shot, rural locations. The production of fiction films set in the British past was another important strategy (although Hollywood and other national cinemas covered similar territory). Subjects ranged from 'real' stories such as Boudicca's revolt against the Romans (*Boadicea*, 1926) and the life of Queen Victoria (*Sixty Years a Queen*, 1913) to fictional costume romps such as *The Elusive Pimpernel* (1920). This early deployment of literature, history and landscape has been viewed by some as indicative of the long lineage of British 'heritage' cinema (Higson 1995: 26–27).

Silent British cinema was also cosmopolitan, adapting and incorporating aspects of new styles and techniques such as German Expressionism and Soviet Montage. The 1910s and 1920s saw fruitful interaction between Britain, Hollywood and Europe. For instance, Alfred Hitchcock and Adrian Brunel worked in German studios, while Anthony Asquith spent some time in Hollywood observing directors such as Chaplin and Lubitsch before returning to work in British studios. Americans and Europeans also came to work in Britain. American-trained directors such as George Fitzmaurice and Harold Shaw came to Britain, followed by European émigrés such as directors Arthur Robison and EA Dupont, production designer Alfred Junge, and cinematographer Werner Brandes.

American stars such as Florence Turner, Mae Marsh, and Anna May Wong all made films in Britain and the presence of an American star was one way to expand the

audience for British films and increase their popularity in foreign markets. This strategy was adopted by producers such as Michael Balcon, who brought American Betty Compson to England to star in *Woman to Woman* (1923), and Herbert Wilcox, whose *Nell Gwyn* with Dorothy Gish found success in both Britain and America. Europeans also appeared in British films, although the coming of sound created problems for foreign actors such as Lya de Putti, Maria Corda (wife of the Hungarian producer Alexander Korda) and Anny Ondra, the star of Hitchcock's *Blackmail* (1929).

The conversion to sound was not instantaneous. Some commentators felt that 'talkies' were a passing fad, or that silent features would continue to be made and shown alongside sound ones. It was also expensive and time-consuming for studios and cinemas to equip themselves with sound technology. Numerous films were released in both silent and sound versions during this transitional period and many smaller and provincial cinemas continued to show only silent films into the 1930s.

Nathalie Morris

Tilly in a Boarding House

Studio/Distributor:
Hepworth Manufacturing
Company

Director:
Hay Plumb

Producer:
Cecil Hepworth

Duration:
525ft

Genre:
Comedy

Cast:
Alma Taylor
Chrissie White

Year:
1911

Synopsis

Tilly and her sister Sally are staying in a boarding house with a strict female chaperone. They play doubles tennis with two young men but soon get bored, so the men give Tilly and Sally piggybacks around the tennis court, much to the shock of their chaperone who promptly locks them in their bedroom. Tilly and Sally escape by dressing up in boys' clothes and climbing out of their window. They sneak into their chaperone's room, jump up and down on her bed before tying her up in her own bed sheets and hitting her with pillows. They attack a policeman in the hallway and are chased through the boarding house before escaping onto the roof. After managing to lose their pursuers, they run back to their room and change back into female attire just in time to pose as the epitome of innocence when their chaperone comes to check on them.

Critique

Joyous anarchy reigns in this tale of schoolgirl high jinks, one of around twenty *Tilly the Tomboy* films made between 1910 and 1915 in which Tilly and her sister Sally wreak havoc in the midst of polite society. The *Tilly* films revel in their outrageous antics, which range from commandeering a horse-drawn fire engine and hosing down the general populace in *Tilly and the Fire Engines* (Lewin Fitzhamon, 1910) to terrorizing a sick old woman by bouncing on her bed (while she is still in it) in *Tilly the Tomboy Visits the Poor* (Lewin Fitzhamon, 1910) to disturbing the night's sleep of a whole guest house, as in *Tilly in a Boarding House*.

Alma Taylor and Chrissie White both give the impression of entirely relishing their roles in the *Tilly* films and their slapstick performances are full of energy, exuberance and irreverence. Many early films were 'chases', in which narrative, comedy and anticipation is generated by pranks, mischief and rebellion, and the Tilly films follow this well-established pattern. While it is the prim chaperone that bears the brunt of their unleashed energy, other authority figures are targets for violence, with a hapless policeman receiving similar treatment before the obligatory chase commences.

Cross-dressing is a staple of comedy – especially British comedy – and the *Tilly the Tomboy* films are no exception to this rule. Although the girls are rarely decorous, dressing up as boys gives them freedom to shrug off the Edwardian constraints of their gender. In *Boarding House*, Tilly and Sally's male costumes not only facilitate their escape but also give them licence to run riot without fear of retribution – no-one suspects that the two boys who made such mischief are really those two angelic looking girls. Like other transgressive female heroes of the time, such as the expert thief, *Three-Fingered Kate* (Ivy Martinek), Tilly and Sally frequently avoid punishment by presenting an innocently-feminine front when their angry victims come calling. In *Tilly Visits the Poor*, for example, after stealing a laundry van and provoking a fight in a bakery, the girls return to the scene of their first crime (the abuse of poor Mrs Smith) and are discovered reading

and tending to the bed-ridden old woman. Thinking they have made a mistake, the pursuing villagers apologetically withdraw from the sickroom.

The teenage stars of the *Tilly* films, Alma Taylor and Chrissie White, both went on to be successful adult stars of the silent period. Taylor worked almost exclusively with producer/director Cecil Hepworth until his final feature film, *The House of Marney*, in 1926. Her stately performances in pastoral dramas such as *Tansy* (1921) and *Comin' Thro the Rye* (1923) belie her anarchic beginnings as *Tilly the Tomboy*.

Nathalie Morris

East is East

Studio/Distributor:

Turner Film Company
Drama Exclusive

Director:

Henry Edwards

Producer:

Henry Edwards

Screenwriter:

Henry Edwards

Cinematographer:

Tom White

Duration:

4895ft

Genre:

Comedy
Drama

Cast:

Henry Edwards
Edith Evans
Ruth Mackay
Florence Turner

Year:

1917

Synopsis

East End girl Victoria Vickers is courted by East End boy Bert, but is happy for them to remain friends. When Victoria is unexpectedly left a large sum of money by a rich uncle she is sent to live with Mrs Carrington, who attempts to teach her the ways of society. Victoria struggles to fit in with the upper classes so Mrs Carrington takes her to the Continent. With money given to him by Victoria, Bert establishes a successful chain of fish and chip shops. Two years pass and Victoria returns to England. She misses Bert and her old life but is bound by the terms of her uncle's will, which stipulate she must remain in society or forsake her fortune. Victoria is faced with a dilemma when Mrs Carrington's no-good son, Arthur, proposes marriage.

Critique

East meets west (London) in this tale of class-crossed lovers. American star Florence Turner provides music hall-style comedy and pathos in the role of Victoria, the Cockney girl who inherits a fortune on the condition that she moves west and learns to become a lady. British actor Henry Edwards stars as Bert, the stoic, loyal and slightly bumbling East End boy who tries to better himself for her sake.

The film was produced by Turner's own company, Turner Films, and was adapted and directed by Edwards, who would become one of the most talented and popular British film-makers and performers of the 1910s and 1920s. Edwards had played Gabriel Oak opposite Turner's Bathsheba in *Far From the Madding Crowd* (Laurence Trimble, 1915) before the actor-producer gave him his first chance to direct with *A Welsh Singer* (1915), in which she plays a shepherdess who becomes an opera star.

Although *East is East* was only Edwards' second film as director, he displays a remarkable ease and confidence in his handling of the story. The two leads are imaginatively and effectively introduced through close-ups of their worn-out shoes, while Bert's first proposal to Victoria is made over a fish and chip supper, foreshadowing the means by which he hopes to win her affections. As he later reads about a 'deluge of dogfish' in a newspaper, Bert's plan to establish

his own business is articulated with wry humour as he crosses out the word 'dog' and thoughtfully ponders the remaining 'fish'. Cut to a year later and Bert has his own prosperous fish and chip shop with his name above the door and delivery bicycles propped up outside. Conveying the passage of time, and Bert's increasing prosperity, the following year the bicycles have given way to two large vans and a sign proclaims 'branches everywhere'. Bert even has his own condiment, rather unappetizingly named 'Grummet's Gargle'.

As the story nears its climax, the parallel narrative threads – Victoria's increasing dissatisfaction with her West End lifestyle, Bert's efforts to socially improve himself, and rich boy Arthur's increasing debt problems and subsequent proposal to Victoria – are skilfully cut together. When Victoria accepts Arthur, Bert decides to sell up and leave London. The engagement is short-lived and, having renounced her fiancé and her fortune, the 'Hopfield Heiress' (as Victoria is described in the press) instinctively returns to the place where she and Bert were once poor and happy: a cottage in the Kentish countryside. As Christine Gledhill has noted, the rose-covered homestead that Bert retires to is typical of the nostalgic, rural retreat that would emerge as a fantasy of post-war English society (Gledhill 2003). Beautifully shot on location, this pastoral idyll contrasts with the stuffy drawing rooms of the West End and the shabby streets of the East, and provides a suitably neutral and idyllic space for the two protagonists to finally come together.

Nathalie Morris

Blackmail

Studio/Distributor:

British International Pictures

Director:

Alfred Hitchcock

Producer:

John Maxwell

Screenwriters:

Charles Bennett
Alfred Hitchcock
Garnet Weston

Cinematographer:

Jack Cox

Production Designer:

C Arnold

Editor:

Emile de Ruelle

Synopsis

Alice goes out with her policeman boyfriend Frank. They quarrel and Frank leaves, but Alice stays to keep a prior assignation with Crewe, an artist. Crewe invites Alice back to his flat and asks her to pose for him before attempting to rape her. In self-defence, she kills him and leaves the flat, observed by Tracy, a crook. The next day, Frank is called in to investigate the crime. He recognizes one of Alice's gloves, surreptitiously pockets it and goes to confront her. As the couple are talking, Tracy arrives and attempts to blackmail the couple. He soon falls under suspicion himself, however, and when the police turn up he panics and runs away, instigating a desperate chase through London, culminating on the roof of the British Museum.

Critique

Even without the distinction of being Alfred Hitchcock's final silent as well as his first sound picture, *Blackmail* is a key film both in the director's oeuvre and in the history of British cinema. It contains many elements which can now be seen as quintessentially 'Hitchcockian': a blonde protagonist; a man pursued by the police for a crime he did not commit; a chase culminating at a well-known landmark; and a cameo appearance from the director himself (as a harassed commuter

Duration:

82 minutes (sound version)/6740ft (silent version)

Genre:

Thriller

Cast:

Donald Calthrop
John Longden
Anny Ondra
Cyril Ritchard

Year:

1929

on the London Underground). Although *Blackmail* was Hitchcock's tenth film, it was only the second – following *The Lodger*, 1926 – that he made in the genre with which he would become synonymous: the crime thriller.

Like a number of feature films made during the transition to sound, *Blackmail* was released in both silent and 'talkie' versions. The former clearly demonstrates Hitchcock's full mastery of the technique of the silent film, but the latter version points the way to the future. Unlike many films released in sound and silent form, which generally used the new technology to add a synchronized score, sound effects and one or two (generally stilted) dialogue scenes, the talkie version of *Blackmail* demonstrates the expressive potential of sound on film. In *Blackmail's* celebrated 'knife' sequence, Alice (Anny Ondra) is tormented by a gossipy neighbour's discussion of the murder that Alice committed in self defence. The neighbour's speech is presented subjectively, from Alice's perspective, with the repetition of the word 'knife' emphasized and distorted on the soundtrack. The scene reaches its climax as Alice's father asks her to cut him a slice of bread and the guilt-ridden protagonist involuntarily reacts to the final and loudest repetition of the word 'knife' by losing her grip on the bread-knife and jerkily throwing it up into the air.

The decision to make sound and silent versions of the film presented Hitchcock with one particular challenge: the heavy accent of his Czech leading lady, Anny Ondra. Post-production dubbing was not technically possible, so Hitchcock decided to have Ondra mime her lines while English actor Joan Barry stood just off camera and spoke them out loud. This solution works surprisingly well, although, as a number of critics have pointed out, Barry's plummy tones do not really fit the character of a London shop girl.

Many contemporary commentators resented and resisted the coming of sound, feeling that silent film had reached an artistic peak. Paul Rotha (1930), for instance, believed that silent cinema would prevail and predicted that within a few months the sound version of *Blackmail* would be largely forgotten. This, of course, did not happen. While Anny Ondra's English-speaking film career ended with sound, *Blackmail* propelled Hitchcock out of the silent era and on to a long and celebrated career in talking pictures.

Nathalie Morris

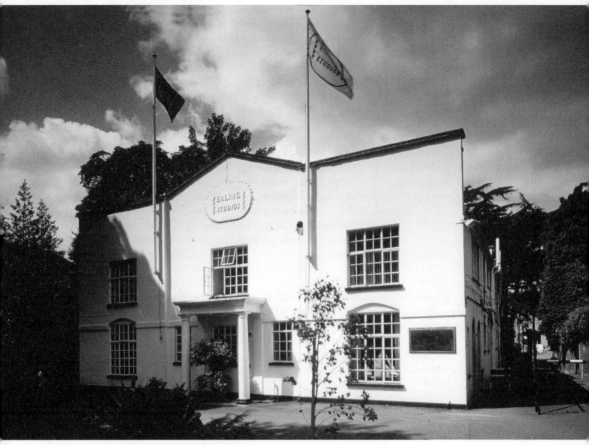

Ealing Studios, The Kobal Collection.

INDUSTRIAL SPOTLIGHT
BRITISH FILM STUDIOS

The first film studio in Britain was established in 1897, when George Albert Smith, one of the Brighton and Hove pioneers, established a 'film factory' for developing and printing films at The Pump House in St Anne's Well Pleasure Gardens, Hove. The following year, a new studio for making and processing films was founded in the same park. 1902 saw the first purpose-built film 'studio' and film processing unit established there by James Williamson's Kinematograph Company, and by 1914 there were glass studios along the nearby seafront. The beginnings of the main industrial base of a British film industry, though, were already centred around London, including Highbury and Teddington Studios and, from 1902, Ealing Studios – making the latter 'the oldest continuously working studio in the world' (www.ealingstudios.co.uk).

As a production base, the 'studio system' developed in line with contemporary industrial models with similar strategies for the marketing, distribution and consumption of their products. By the 1920s the majority of the most significant and powerful studios were in Hollywood and successful British entrepreneurs followed that model; the 1927 Cinematograph Films Act, introduced to protect the British industry, encouraged domestic production. Several studios emerged as production centres during the era – Wembley Studios following the 1925 Empire Exhibition; British National Pictures (BNP) at Elstree in 1926; British Lion at Beaconsfield in 1927; Ealing and Shepperton in 1931; and Pinewood and Denham in 1936. Gaumont-British studios had been operating in Shepherd's Bush since 1914 and from 1927 became associated by their shared Head of Production, Michael Balcon, with Gainsborough Studios based in Islington.

Three main figures associated with that moment in British cinema are Alexander Korda, J Arthur Rank and Michael Balcon. Their studios were concentrated into relatively small areas and the most successful attempted to ensure their own distribution and exhibition channels, like major US studios. As the industry grew in economic and cultural significance so did production specialization, including the emergence of hierarchies between the producer, director and stars, the establishment of teams of actors, writers, art designers, set builders, costume designers, lighting experts and cinematographers, as well as people to cater for their needs. Film workers were contracted, with a Head of Production overseeing the whole studio, and, from 1933, they were increasingly unionized. In line with mass production models, economies of scale could be incorporated into the industrial base of studio productions, which functioned during this period like film factories employing scientific management methods.

The BNP and Rank Organization were the closest that the British film industry got to the vertical integration model developed by the Hollywood majors. In addition to building Pinewood Studios, Rank invested in General Film Distributors and began integrating the production, distribution and exhibition aspects of industrialized studio production by also purchasing Gaumont-British (which was involved in production and exhibition) and shares in the Odeon exhibition circuit. Rank was assured US distribution through its links with Universal Studios. BNP became Associated British Picture Corporation (ABPC) after making a deal with Warner Bros. to distribute and exhibit films in its American cinemas. Yet during the mid-to-late 1930s a number of film companies collapsed. Rank took over Korda's London Film's Denham Studios in 1939, for example – only three years after it was built – and then the Elstree Studios.

As in Hollywood, the 1930s and 1940s were the high point of British studios as production bases, and certain studios became associated with particular styles of filmmaking, cultural concerns, production values, stars and genres. Rank, for example, made 'quality' pictures, Gainsborough became known for a series of costume melodramas between 1942 and 1946, Hammer (at the Bray Studios) was associated almost entirely with horror by the 1950s, and Ealing produced social realist and gently British 'Ealing Comedies'. Rank also established a 'charm school' of stars at their Highbury Studios, exploiting the marketing tool of stars as major cinema attractions. Contracted talent – especially when British studios paid a premium for Hollywood stars – could ensure a following through the vast critical and fan media associated with film-going.

For a while, some British film-makers like Michael Balcon saw Europe as a natural ally against Hollywood dominance. They looked to UFA studios in Germany, as well as various other European studios, for co-production work – in the pre-synchronized sound era 'foreign' language was not an issue and multilingual productions were proposed after the introduction of sound. Interesting developments also took place in the public film sector, through the Empire Marketing Board and General Post Office production units working in a Blackheath studio. Though not strictly aligned with the traditional studio system, they are worth mentioning as alternatives to the classic Hollywood system. Also, they were crucial in attracting European emigrants from 1933 onwards, and for developing and maintaining a vibrant British film culture and industry during the 1940s. Independent producers including The Archers (Powell and Pressburger), Cineguild (David Lean, Ronald Neame and Anthony Havelock-Allan) and Individual Pictures (Launder and Gilliat) – all of whom were included in the Independent Producers Ltd – were also able to find a place in the studio system. 'The independents were financed by the studio but autonomous with their choice of subject, technicians, and actors' (Powell 1986: 645) through the Rank Organization, though not without the tensions associated with the primacy of one on the aesthetic qualities of films and on the other on the economic imperatives of the studio.

One aspect of British studio history that should not be ignored is the use that has been made of them as 'outposts' to the American film industry – Teddington Studios were acquired by Warner Brothers in 1931, for example, and British International Pictures bought British National Studios at Elstree. Even Balcon – who would go on to develop the identity of Ealing Films as 'projecting Britain and the British character' – briefly worked for the British arm of American company MGM between 1936 and 1937.

Following the decline in cinema attendance and the rise of television throughout the 1950s, many British studios have been used for television production. For instance, in 1958, new commercial broadcasters bought both the Elstree and the Teddington Studios; the BBC bought Ealing in 1959 and Elstree (renamed EMI-Elstree in 1970) in 1984. By the beginning of the 1960s American studios started to invest heavily in British films again (Walker 1974).

Surviving British studios are those that expanded into other areas of production – Teddington, with Shepperton, has been part of the Pinewood Studios Group since 1985 and both are still in operation, producing films, TV productions and commercials. Ealing Studios is also still in operation but is no longer associated with a particular cultural product except when its historical identity is evoked for marketing purposes. This was the case with the successful 1988 comedy *A Fish Called Wanda*, even though it was registered as an American film and made at Twickenham Studios. The film was promoted as an 'Ealing Comedy' to capitalize on the studio's historic identity but also, perhaps, because it was directed by Charles Crichton, who had directed the classic 1951 Ealing Comedy, *The Lavender Hill Mob*.

Some British studios, like Pinewood, built up a reputation early on for technical expertise as much as for the cultural and marketing attributes of an identifiable style or set of concerns. This enabled Pinewood, for example, to be chosen for a variety of films including the James Bond franchise as well as iconically 'American' films from *Superman* (Richard Donner, 1977) to the more recent *The Bourne Ultimatum* (Paul Greengrass, 2007). And Warner Bros. bought Leavesden Studios in Hertfordshire where the *Harry Potter* franchise was in constant production for over a decade.

Studios are no longer the dominant trade marks for film products that they were between 1930 and 1950; media interest and marketing takes the director, star or franchise as the focus so that it is hardly common knowledge where a film is made. Yet, as the industrial base of moving image production studios is still as important as ever, studios continue to provide the facilities for a range of products; those who gained and have maintained a reputation for technical innovation and excellence have survived.

Nannette Aldred

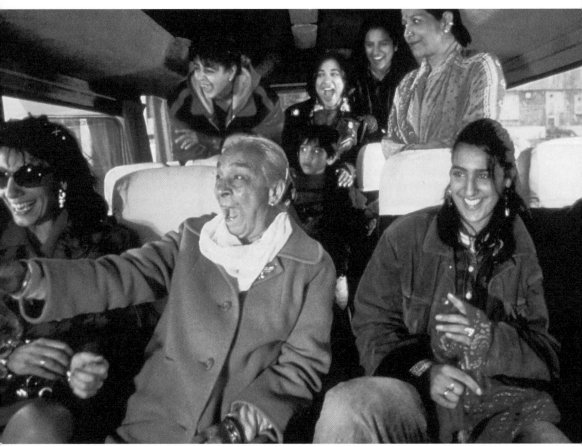

Bhaji on the Beach, UMBI Films/Channel 4/The Kobal Collection.

INDUSTRIAL SPOTLIGHT
WOMEN IN BRITISH CINEMA

It is perhaps ironic that the period of greatest opportunity for women within the film industry in Britain, as well as elsewhere in the world, seems to have been nearest to the restrictions and prohibitions of nineteenth-century femininity. In its earliest days, prior to its achievement of a state of cultural fixity, film was up for grabs for a myriad of pioneers, many of them female. Women worked in a range of positions in the fledgling industry, from scenario writer or cutter to exhibitor or publicist – a wealth of female involvement in Britain's early cinema that is only just beginning to be uncovered by research projects such as Women and Silent British Cinema.

Two of the most notable examples of early female eminence are the actor Violet Hopson, who set up her own production company at the end of the 1910s, and Dinah Shurey, whose patriotic militaristic films of the 1920s confounded expectations of what a women director might specialize in (Gledhill 2007). Another outstanding female professional of the British pre-sound cinema was Alma Reville, already an experienced editor and assistant director when she met her future husband, Alfred Hitchcock, who initially held a rather lowlier position in the film-making hierarchy (Morris 2008). Indeed, Reville's subsequent shift from independent autonomous worker to vital, if frequently un-credited, contributor to the auteur structure 'Hitchcock' gives the audience pause to think about how many other women might have played a pivotal behind-the-scenes role in the film business, invisibly guiding, suggesting, supporting, and persuading: occupying the traditional compensatory female role of 'the power behind the throne' rather than acknowledged powerbrokers. For instance, Sue Harper notes how secretaries 'have at all times been the grease which oiled the studio machine, yet there is very little surviving evidence about their labour and its complexities' since their importance was assumed 'so minimal that few people thought to document them'; ditto the work of continuity 'girls' (Harper 2000: 4).

Hence, it is vital when considering women's film work not only to look for the small group of exceptional female auteurs who break through but also to appreciate that they represent only the tip of an iceberg of women's contribution to film, the greater majority of which remains submerged and hard to measure. Even a screenwriter as prominent as Ruth Prawer Jhabvala, who worked on *Heat and Dust* (1983), *A Room with a View* (1985), *Howards End* (1992) and *The Remains of the Day* (1993), has seen her significant contribution to those films subsumed by their labelling as 'Merchant Ivory' films, named for their male producer and director, Ismail Merchant and James Ivory.

Women's marital and familial relationships with men have sometimes been a helping hand rather than a hindrance in gaining film work in an otherwise hostile environment. The producer Betty Box began her long and highly-successful career working for her brother Sydney Box in the 1940s; Sydney's wife Muriel Box was able to carve out a stronger position for herself within the industry by association with him, making the move from screenwriter – co-author of the enormously successful melodrama *The Seventh Veil* (1945) – to director, one of only a handful of women to attain such a position at that time. Women perhaps did slightly better in documentary than in fiction, with Kay Mander, Jill Craigie, Margaret Thomson, Ruby Grierson (sister of John), Mary Field and others doing distinguished work in this area. Outside of direction, signs of female creative agency might be glimpsed in more covert forms in wartime and post-war British films. Female costume designers used the medium of clothes to communicate character, from Elizabeth Haffenden's flamboyantly feminine gowns for Gainsborough's costume dramas in the 1940s to Julie Harris' perfect evocation of the deracinated, desperate girl-about-town in *Darling* (1965). Editor Anne Coates nudged director David Lean towards more innovative forms of cutting, influenced by the French New Wave, for *Lawrence of Arabia* (1962) (Brownlow 1997: 471). Writer Diana Morgan and producer Aida Young made their mark in two very different but both overwhelmingly-male studio environments, Ealing and Hammer – although it is worth noting that Young turned to production because her first attempt at direction had been met by cruel mockery from male technicians on the set and, hence, 'she turned to producing, in the hope that it would be less humiliating' (Harper 2000: 191).

If the sexual liberation of the 1960s did not result in a glorious opening up of the industry to female creativity, feminist film-makers did their best to rectify this in the 1970s, often working within collectives to make films whose style and content were avowedly political. They recognized the importance of women's access to the means of production and, as Sally Potter was later to remark of her feminist tour-de-force *The Gold Diggers* (1983), 'it would have been ironic to make a film with this subject matter and then accept a completely conventional male-dominated crew. So, along the lines of women can be welders, women can also be gaffers, riggers, camerapersons and carpenters and so on' (Cook 2005: 142). Even given the spadework carried out in the 1970s and 1980s, much remains to be done to open opportunities for, and raise the profiles of, women in the British cinema. That said, it is heartening to see women such as Natasha Braier, Sue Rowe and Eve Stewart flourishing in traditionally-male strongholds such as cinematography, visual effects and production design in recent British films such as *Somers Town* (2008), *The Hitchhiker's Guide to the Galaxy* (2005) and *Vera Drake* (2004).

Pleasingly, Sally Potter's relative scarcity value as a British woman director has declined somewhat in recent years, as she has been joined by the likes of Andrea Arnold, Antonia Bird, Gurinder Chadha, Sandra Goldbacher, Beeban Kidron, Sharon Maguire and Lynne Ramsay, to name just a few from the swelling ranks of contemporary female film-makers. Two women associated with other fields, art and acting, directed striking feature debuts in 2009; Sam Taylor-Wood with *Nowhere Boy* and Samantha Morton with *The Unloved*. Women working together as director/producer teams have also enjoyed considerable recent mainstream success, from the Amanda Posey-produced, Lone Scherfig-directed female coming-of-age drama, *An Education* (2009), to the knockout success of *Mamma Mia! The Movie* (2008) – the most financially successful film at the British box-office until its record was toppled by *Avatar*, with a DVD copy owned by an estimated one in four British households. Conceived and created by an all-female British team of writer Catherine Johnson, producer Judy Craymer and director Phyllida Lloyd, this vibrant singalong musical with a largely female following echoes Iris Barry's assertion back in 1926 that the 'one thing never to be lost sight of in considering the cinema is that it exists for the purpose of pleasing women' (Barry 1926: 59). Perhaps a new way of achieving that goal is to have stories for women told by women; one might observe that it is rare to find a film like *Mamma Mia!* in which a lone mother in her forties is neither pilloried nor punished for her past promiscuity but celebrated as a hero and permitted to occupy dramatic space equal to her ingénue daughter.

Women do not automatically or exclusively tell women's stories, of course – as with British directors from flag-waving Dinah Shurey to Susannah White, whose first big US assignment was the very masculine HBO Iraq war drama *Generation Kill* (2008). But whether they work on the girliest of chick flicks or the grittiest of guy films, women's gradually-increasing presence in the film industry means that the long-standing gender imbalance of that world is at least beginning to change. Nonetheless, the website for Bird's Eye View, the annual film festival celebrating women's cinema, cites the sobering statistic that at present only six per cent of directors and twelve per cent of screenwriters worldwide are women (www.birds-eye-view.co.uk). An interview with Melinda McDougall, co-director of the documentary *Erasing David* (2009), gives a strong sense of the hurdles women must still leap over in order to maintain a career:

> I think women do have to fight a lot harder in an industry that can be tough, (and recent) figures showing 5000 women left the industry in the last three years come as no surprise. By the time most women have built up years of experience as freelance directors, designers and producers they find themselves faced with the challenges of biology and unpaid maternity leave. Until TV and film companies provide adequate childcare (including on location) for talented female professionals, the female drain away from the industry will continue at a rapid pace. (McDougall in interview, Schmuel 2010)

Melanie Williams

The Seventh Veil

Studio/Distributor:

Ortus
Theatrecraft/General Film
Distributors

Director:

Compton Bennett

Producer:

Sydney Box

Screenwriters:

Muriel Box
Sydney Box

Cinematographer:

Reginald H Wyer

Production Designer:

James A Carter

Composer:

Ben Frankel

Editor:

Gordon Hales

Duration:

94 minutes

Genre:

Melodrama

Cast:

Hugh McDermott
James Mason
Herbert Lom
Ann Todd

Year:

1945

Synopsis

After a young woman, Francesca, attempts suicide, a psychiatrist is brought in to help her. Through her flashback confession under hypnosis, Francesca reveals that as an orphaned adolescent she was sent to live with her cousin Nicholas, who nurtured her talent for music but was often stern and cruel. Nicholas forbids Francesca to marry a fellow music student, training her instead to become an internationally-successful concert pianist. Her career soars while her neurosis increases. Seeking escape through marriage to an artist commissioned to paint her portrait, romance is again thwarted by Nicholas, who jealously attacks Francesca's hands with his walking cane. Realizing that this is the trauma that Francesca must overcome in order to recover, the psychiatrist uses music to help her work through her trauma and fulfil her romantic destiny.

Critique

James Mason's reputation for being British cinema's favourite handsome brute, first heralded by his appearance as dastardly Lord Rohan in Gainsborough's *The Man in Grey* (Leslie Arliss, 1943), was consolidated by his role as the sadistic guardian Nicholas in *The Seventh Veil* (1945). In both films he wields a weapon against a woman, beating Margaret Lockwood to death with a riding crop in the former and smashing a walking stick onto Ann Todd's vulnerable outstretched hands in the latter. It is disturbing that such instances of aestheticized masculine violence against women were popular with audiences. *The Seventh Veil* proved such a hit that even 60 years later it made an appearance in the top ten of the British Film Institute (BFI) list of the 100 most successful films at the British box-office, as well as making a significant profit in America, where it also earned an Academy Award for best screenplay. One of the film's key attractions is undoubtedly its evocative use of classical music, akin to another film of the same year, *Brief Encounter* (David Lean, 1945) and, interestingly, both featuring the talents of celebrated female pianist Eileen Joyce.

Although Mason's performance as the cruel-yet-vulnerable hero made hearts flutter, the film also created another star: Ann Todd, who plays Francesca. Todd's glacial poise earned her the nickname 'le petit Garbo' in France, capitalizing on her similarity to one of Hollywood's most distinguished actors. Unsurprisingly, given his preference for cool blonde beauty, Alfred Hitchcock was keen to work with Todd and this ambition was realized in *The Paradine Case* (1947). Todd's role in *The Seventh Veil* is a demanding one, encompassing an age range from adolescent schoolgirl to mature woman, ensuring that she keeps the spectator's sympathy even though she remains enigmatic, and frequently in a trance-like state, throughout the film. Unlocking the deepest secrets of Francesca's psyche through hypnosis and psychoanalysis provides the narrative impetus, and the film's title: the psychoanalyst Doctor Larson (Herbert Lom) characterizes the human mind as Salome, 'hidden from the world by seven veils – veils of reserve, shyness, fear. With friends, the average person will drop one

veil, then another, maybe three or four. With a lover, she will take off five, maybe six. But never the seventh veil. You see, the human mind likes to cover its nakedness.' Once her seventh veil has been stripped away, Francesca can be emancipated from the trauma of her past and can begin her life anew, as Larson suggests: 'Her mind is clear, and the clouds have been swept away. She is no longer afraid.' However, this vision of a new life is firmly entrenched in the idea of picking the right male suitor, and questions remain as to whether her final choice is really indicative of a liberated future. Several critics have intuited Muriel Box's feminist critique at work in the film, in which a woman ends up learning to love her male oppressor.

Melanie Williams

Bhaji on the Beach

Studio/Distributor:
Umbi
Channel 4/Film4 International

Director:
Gurinder Chadha

Producer:
Nadine Marsh-Edwards

Screenwriters:
Gurinder Chadha
Meera Syal

Cinematographer:
John Kenway

Production Designer:
Helen Raynor

Composer:
John Altman
Craig Preuss

Editor:
Oral Ottley

Duration:
101 minutes

Genre:
Drama

Cast:
Lalita Ahmed
Sarita Khajuria

Synopsis

The diverse members of a Birmingham Asian Women's Centre go on a daytrip to Blackpool. Several of the women harbour secrets that are revealed over the course of the day, provoking conflict within the group. One of the party, Ginder, is pursued by her husband and other male relatives who angrily disapprove of her desire for independence. Frustrated middle-aged housewife Asha meets Blackpool resident Ambrose, who shows her the sights of his home town. The other women and girls on the trip enjoy the myriad attractions of the traditional British resort whilst learning more about each other throughout an eventful day.

Critique

The working class seaside resort of Blackpool, that 'great roaring spangled beast' according to JB Priestly, has provided a vivid setting for many British films, from the Gracie Fields' extravaganza *Sing As We Go* (Basil Dean, 1934) to the meditation on comedy *Funny Bones* (Peter Chelsom, 1994). Blackpool provides material for generational and culture clash comedy, as a diverse group of Asian women enjoy Blackpool's pleasures, from the innocent enjoyment of paddling in the sea and donkey rides to the rather more risqué delights of boob-shaped Blackpool rock and male strippers. However, the town's colourful flamboyance also acts as a reminder that Britain is far from uniformly monochromatic and that sometimes, perhaps, the cultural distance between Blackpool and Bollywood is not so far.

Throughout the film, cultural hybridity is emphasized via small touches such as character's adding masala spice to a bag of chips or the witty Punjabi cover version of Cliff Richard's 'Summer Holiday' that accompanies the minibus drive along the motorway. In its yoking of Ealingesque ensemble playing and Bollywood fantasy, the film speaks of intermingling British and Indian cinema traditions. Any attempts to adhere to a traditional identity prove impossible and ultimately undesirable, as when Asha (Lalita Ahmed) is mocked by Mumbai sophisticate Rekha (Souad Faress) for trying to stick to the ideals of

Zohra Segal
Kim Vithana

Year:

1993

the home country when that society has modernized beyond recognition. Perhaps the most eloquent expression of the film's hopes for multiculturalism come from the romance of Hashida (Sarita Khajuria) and Oliver (Mo Sesay), who look like they might be able to overcome the entrenched prejudices of their respective backgrounds, and whose embrace is blessed by the magical touch of the famous Blackpool illuminations that suddenly beginning to twinkle over their heads.

Despite its comedic touches, *Bhaji on the Beach* retains a keen awareness of the racism that is 'always around the corner' according to director Gurinder Chadha, with a nasty stand-off between the women's group and a group of thuggish men at a service station. Chadha and co-writer Meera Syal also provide a nuanced portrayal of an abusive marriage, refusing to present Ranjit (Jimmi Harkishin) as an outright villain by showing his vulnerabilities whilst never pulling their punches about his brutality towards Ginder (Kim Vithana) and their son. In this sub-plot, along with that of downtrodden Asha who finally revolts against 'duty, honour, sacrifice', saying 'What about me? I wasn't meant for this!' *Bhaji on the Beach* triumphantly lives up to Chadha's aim (for non-Asian viewers, at least) to 'draw you in and make you care for my characters, and feel for them, and make you see that they are not 'other' any more'. Almost a decade elapsed between Bhaji and Chadha's next British feature, the highly successful *Bend It Like Beckham* (2002) but Chadha remains a pioneer of the new wave of British Asian cinema along with Hanif Kureishi, Ayub Khan-Din and Udayan Prasad, while providing her own valuable and often humorous perspective on female identity.

Melanie Williams

Fish Tank

Studio/Distributor:

BBC
UKFC
Kasander
Limelight/Artificial Eye

Director:

Andrea Arnold

Producers:

Kees Kasander
Nick Laws

Screenwriter:

Andrea Arnold

Cinematographer:

Robbie Ryan

Synopsis

Fifteen-year-old Mia lives in a high-rise flat in Essex with her mother and her younger sister. She is a rebellious loner whose relationship with her mother is mutually antagonistic and verbally abusive. Mia has a secret passion for dancing, which she hopes will be her ticket out of her grim everyday life, and she determinedly practices her routines in an abandoned flat. When her mother's charismatic and good looking new boyfriend Connor encourages and praises her dancing, Mia is drawn closer to him, happy that someone is taking an interest in her. But Connor may not be entirely motivated by a paternal concern and his interest in her may even be predatory.

Critique

Writer-director Andrea Arnold is distinctive in contemporary British film culture in her use of social realist aesthetics to focus on the lives of girls and women in working-class communities. While her settings have ranged from her native Dartford in the Oscar-winning short film *Wasp* (2003) to Glasgow for the surveillance drama *Red Road* (2006) and finally to the high-rise estates of Essex for *Fish Tank*, all three films

Production Designer:
Helen Scott

Editor:
Nicolas Chaudeurge

Duration:
117 minutes

Genre:
Drama
Social Realism

Cast:
Michael Fassbender
Rebecca Griffiths
Katie Jarvis
Kierston Wareing

Year:
2009

are connected through their focus on female experience. Although the most obvious points of contextualization for Arnold's films are contemporary works such as Shane Meadows's *Somers Town* (2008) or Ken Loach's *Sweet Sixteen* (2002), there are noticeable links with older British cinema traditions. For instance, *Fish Tank*'s study of an awkward teenager's sexual awakening and her antagonistic relationship with her sexually-provocative mother echoes the mother/daughter dynamic in the British New Wave milestone *A Taste of Honey* (Tony Richardson, 1961).

Akin to the casting methods used by Loach and Meadows, Arnold wanted a non-professional actor for the central role in *Fish Tank*, someone who would not merely play the character of combative teenager Mia but understand her intimately through her own life experience. When Katie Jarvis was spotted arguing with her boyfriend at Tilbury railway station, she was hastily signed up to play Mia. Jarvis exceeds all expectations of a complete newcomer to acting, giving a riveting performance that oscillates between sullen anger and heart-breaking vulnerability. Ambiguity is the keynote of Michael Fassbend-er's performance as Mia's mum's amiably sexy Irish boyfriend Connor, initially behaving towards Mia in ways that could be simultaneously interpreted as warmly avuncular or sexually loaded. As in her previous films, Arnold evokes her heroine's sexual desire through an aesthetic of a female gaze: examples include the close-up of Danny Dyer's mouth from Nathalie Press's lustful perspective in *Wasp*, the heroine's tracking of her future lover via CCTV in *Red Road*, and in *Fish Tank* via Mia's use of the video camera to record and play back a bare-chested Connor as he dresses, as well as her covert voyeuristic observations of her mother and Connor's lovemaking. Arnold also communicates sexual attraction in more sensual terms with slow-motion close-ups of Mia enjoying the physical closeness of a piggy-back ride, or breathing in Connor's freshly-spritzed aftershave when he bends over her.

Fish Tank refuses gushing sentimentality. Although we empathize with her, Mia is also capable of cruelty, foregrounded in one stomach-churning sequence where we fear she may commit a terrible act of revenge. Lest we assume that *Fish Tank* is directly autobiographical, given Andrea Arnold's own Thames Estuary upbringing and her early career as a dancer, the director provides an important corrective: 'Those things have never directly happened to me. My mind goes places, I have an imagination.'

Melanie Williams

Sapphire, ITV Global/The Kobal Collection.

CULTURAL CROSSOVER
MULTICULTURALISM IN BRITISH CINEMA

'Multiculturalism' is a loaded term that, basically, describes a culture that comprises many cultures. Britain can be described as a 'multicultural society' in that it includes people of many races, ethnic backgrounds, cultures and religions who are, nevertheless, all British. To define 'British Cinema', it is imperative to take into account the fact that British society comprises not just white Christians, and that British culture has come to incorporate the tastes and influences of all the 'other' British people.

For many people in Britain 'multiculturalism' has become problematic because the term has become weighted by discussions around immigration and how such cultures should be integrated into 'British' culture and society. For the right wing within Britain, a multicultural society is one in which immigrants should subsume their own cultural identities in favour of 'British' social behaviours. This might involve, for example, speaking only in English, and religions other than Christianity not having a significant cultural voice – in short, by not being publically 'other'. In contrast, for the left wing of British politics, Britain is a nation in which cultural differences are embraced and immigrant cultures can sit in parallel to British culture without being denigrated. This might involve all children learning about religious festivals such as Diwali as well as Passover and Christmas, Sikh policemen wearing turbans and the law being sensitive to non-Christian religions, including the place of Sharia law for Islamic communities. In this version of multicultural Britain, being publicly 'other' is a marker of progress in the 'post-colonial' society that followed the collapse of the British Empire and British colonies in the twentieth century.

One reason why multiculturalism is difficult to talk about is because some people frame it as a social experiment. As far back as 1975, when Horace Ové made the first British feature film by a black director, *Pressure*, 'a critique of British multiculturalism and institutionalised race relations' was being proposed (Pines 1997: 212). However, films made in the 1970s and 1980s by black film-makers' collectives, such as John Akomfrah's *Handsworth Songs*, made in 1986 with the Black Audio Film Collective, have been described as 'a cinema of duty' (Bailey 1992, in Malik 1996) which is partly 'social issue [driven] in content' and 'documentary-realist in style' (Malik 1996: 203). And in many British films it is 'political multiculturalism' (ibid.) which has been addressed and treated both as an ideal and as unobtainable. For example, Roy Ward Baker's 1961 film *Flame in the Streets* shows a union worker trying to gain rights for the West Indian workers in a factory.

Tensions between the left- and right-wing political views of multiculturalism have meant that, by and large, a mid-line has been maintained since the 1980s to the extent that multiculturalism in Britain can be boiled down to two things: education about other cultures from primary school age; and the right to worship and live according to one's culture. These are, fundamentally, legal interpretations of multiculturalism embedded in the race and religious anti-discrimination laws brought in since the mid-1970s. Yet they have also permitted diversity of, and familiarization with, all of the 'others' in British society. British television, for example, represents immigrant cultures on a regular basis in both factual and fictional programming without it being a cause for significant comment. A good example of this is 2009/2010 Channel 4 reality TV series *The Family* which featured the day-to-day lives of a British-Asian family without drawing much attention to the family's ethnicity or culture.

However, in British cinema, the representation of immigrant cultures is less consistent – it is typically framed in terms of difference and is often controversial. British pop music is clearly multicultural in that music from typically non-white genres – such as ska, hip-hop and R&B – can be recognizably and multiculturally 'British'. As Karen Alexander notes, echoing the concerns framed briefly by Malik (1996), this cultural 'fusion' 'is missing from our cinema screens [and yet] flourishes in our clubs and our radio stations'. So 'it seems ironic that the complexities of black British culture can be encapsulated in a love song or a dance track but fail to find articulation in one of the most modern of forms, cinema' (Alexander 2000: 113).

In 2010, two films which encapsulated British cinema's problematic engagement with the multicultural other were released in quick succession: *The Infidel* (Josh Appignanesi), a comedy written by Jewish comedian David Baddiel about an Islamic man who finds out he was born Jewish, and *Four Lions* (Chris Morris), in which four British-Pakistani failed suicide bombers attempt to infiltrate the London Marathon. Morris' film is a parodic text from a writer/director who consciously aims to create debate through addressing such taboo topics as religious fundamentalism in Britain.

There are exceptions – albeit few of them – to the rules which Alexander and Malik identify in films which have been critically well-received. Three important examples are *Baby Mother* (Julien Henriques, 1998), *Kidulthood* (Menhaj Huda, 2006) and *Adulthood* (Noel Clarke, 2008) – the latter two appear to be influenced by earlier films about Afro-Caribbean and African British youth cultures, such as Isaac Julien's 1991 film, *Young Soul Rebels*.

Nevertheless, the critique that Alexander made in 2000 does still have salience, as British non-white actors seem to find more work outside Britain – for example Idris Elba, who returned to British screens in *Luther* (BBC, 2010) only after success in the cult US crime drama *The Wire* (HBO, 2002–2008) and Archie Panjabi, who stars as an investigator in *The Good Wife* (CBS-Scott Free Productions, 2009–). What is notable about these roles is that, particularly for Panjabi, her role in *The Good Wife* is very different from the British-Asian female stereotypes most frequently seen on British television and in British film, where women are shown to be restricted, domestically focused and often poorly educated. These stereotypes are even sometimes exacerbated by texts created within the British-Asian community, such as the BBC sitcom *The Kumars at No. 42* (2001–2006).

'Post-national' is a term that describes the fragmentation of national identity – of a single, homogeneous culture sharing common ideals. For Higson (2000) and Leggott (2008), amongst others, the 'post-national' is strongly connected to political devolution from 1997 onwards. In British cinema, a key marker of the 'post-national' is the presence of 'cultural hybridity' in films made within Britain. 'Hybridity' (in this sense) refers to the ways in which subject matter, aesthetics, performance, style and sometimes international co-production arrangements, combine aspects from at least two origins to create a distinctive text. So a 'culturally hybrid' text is cross-cultural and inherently defuses ideas of a coherent national identity. Higson argued in 2000 that multiculturalism is evident in British cinema from the 1940s onwards (Higson 2000: 44), but it is the extent to which, and how, multiculturalism has been engaged with by British films that shapes the curve towards the hybridity of the post-national cinema – the national having been often erroneously framed in terms of a 'cinema of consensus'.

Hybridity is a reflection of the impact of both colonialism and postcolonialism on British society and creativity, and of the growth of a potentially multicultural British society. For postcolonialist analyses, such as those by Malik (1996) and myself (Claydon, 2008, 2009), hybridity in British cinema has been apparent since the 1970s. In the late twentieth century, adaptations of work by British-Asian writer Hanif Kureishi, such as *My Beautiful Laundrette* and *Sammy and Rosie Get Laid* (Stephen Frears, 1985 and 1987) and *The Buddha of Suburbia* (BBC, 1993), drew attention to young British-Asian experience in the context of British popular culture in the 1970s and 1980s, paving the way for films such as *Bhaji on the Beach* (Gurinda Chadha, 1992), *My Son the Fanatic* (Udayan Prasad, 1997), *East is East* (Damien O'Donnell, 1999) and *Bend It Like Beckham* (Gurinder Chadha, 2002). Drawing upon Gurinder Chadha's own observations, Malik commented that that it is 'the "pull" between British and Asian identities and between British and Indian cinema aesthetics that generates the pleasures of hybridization in the cinematic form' (Malik 1996: 212). But this statement holds just as true for combinations of other identities and cinemas. A much-commented-upon example of hybridity is Baz Lurhman's *Moulin Rouge* (2001), which creates a hybrid of musical genres in unexpected contexts

and combinations, from classical Hollywood musical, Bollywood romance to popular music – for example, a tango version of The Police song 'Roxanne'.

In British cinema this cross-cultural component can recently be seen in Chadha's 2010 film *It's a Wonderful Afterlife,* which, like her British/India co-production *Bride and Prejudice* (2004) re-invents a classically English text – Jane Austen's novel *Pride and Prejudice* – not just by updating it but by combining Bollywood aesthetics and performance styles with British themes and Hollywood schmaltz. Many critics felt that *Bride and Prejudice* failed by trying to do too much and, in the process, lost its coherence. Nevertheless, cross-cultural films do have an audience, particularly in those who do not problematize 'multicultural Britain' as a concept but, rather, present it as simply a reality of contemporary Britishness.

To understand multiculturalism in British cinema, it is important to really think about cinema as a cultural artefact: something that is evidence of society. Despite the concerns outlined above, it is clear that the 'other' in British society is represented to a much greater extent today than it ever has been. Even if true hybridity is a long way off in British cinema, equality of representation is gradually coming closer in contemporary, multicultural Britain. Yet, in the media, there remains a constant commentary about the lack of presence of the 'other' in British film and television. This *is* beginning to change but, for the moment, multiculturalism in British cinema is still far too concerned about the differences between people and cultures in Britain rather than the similarities: only when these things collapse into each other will true hybridity exist.

E Anna Claydon

The Drum

Studio/Distributor:

London Film/United Artists

Director:

Zoltan Korda

Producer:

Alexander Korda

Screenwriters:

Lajos Biró
Hugh Gray
Patrick Kirwan
Arthur Wimperis

Cinematographer:

Georges Périnal

Production Designer:

Vincent Korda

Composers:

John Greenwood
Miklos Rosza

Editor:

Henry Cornelius

Duration:

104 minutes

Genre:

Drama

Cast:

Valerie Hobson
Roger Livesey
Raymond Massey
Sabu

Year:

1938

Synopsis

In the Peshawar region of pre-independence India, the fictional Prince Ghul leads a rebellion against the Raj. Ghul plots against his brother the Khan and his young nephew, Prince Azim, as traitors to India for helping the English. After murdering the Khan, and the escape of Azim and his master-at-arms Wafardar, Ghul disingenuously invites the British, lead by Captain Carruthers and his new wife, to return to his city, Tokot, which is home of the Sacred Drum of Tokot. Once there, he plans to challenge the belief that the English are fearless. Azim, now in Peshawar, hears of Ghul's scheming and comes out of hiding to try and warn the British governor via his drummer-boy friend Bill, but this attempt fails. Azim returns to Tokot to help his friends, despite it not being in his ultimate interest, arriving in time for a great feast that Prince Ghul has organized for the British troops.

Critique

In the build up to WWII, the Korda Brothers' London Films was the prestige studio in Britain and trained much British talent towards higher ambitions or their own careers. *The Drum* fits into this era of great productivity and aspiration but it also sits right at the point when London Film's financiers were becoming concerned about the Hollywood-scale budgets that were favoured. Much of *The Drum* was made in India, and has an authenticity that shines from the long vistas. Yet it would only be another year before cuts and entrenchment would be watchwords at London Films; *The Four Feathers* (Zoltan Korda, 1939) made extensive use of stock footage and British locations whenever possible – hence the 'tribute' parody *Carry on up the Khyber* (Gerald Thomas, 1968) being made in North Wales.

The Drum is notable for three reasons: Raymond Massey's ghoulish performance as Prince Ghul, Sabu as Ghul's plucky and arrogant nephew Prince Azim, and the casting of Mohammed Khan as Prince Khan – the heroic parallel to Roger Livesey's Captain Carruthers. Actors, of course, must work with the material they are given and as instructed by directors. Sadly, the audience sees little of Khan but his performance feels naturalistic and less mannered than the stylized stereotypes being played out by the rest of Korda's cast. In contrast, Raymond Massey was 'blacked-up' for his heavy-handed portrayal of Ghul, and his distinctive voice overlaid with another accent.

Ghul signals his villainy by associating himself with the Ottoman Empire in WWI, creating continuity with the 'gathering storm' of WWII. Sabu's teenage prince is caught in a cultural bind in which he, like his father, is caught between India without the Raj (what Ghul fights for) and India within the Raj (what Captain Carruthers represents, as he tries to temper Azim's arrogance). Azim is an interesting if problematic character but he is ultimately a narrative mechanism by which to personify the colonial other as a child and the British empire as parent – especially given his father's considerable age and Carruthers as a surrogate father.

A viewer watching this film can find the narrative problematic, given that postcolonialism leads to a questioning of Ghul's representation as

villain because he aims to prevent the growth of the Raj. In a limited way, the film does attempt to address this near its conclusion when Azim's master-at-arms, Wafardar, attempts to persuade him to leave 'the English' to their fate because that will serve Azim better. The dilemma is resolved by reducing the decision to one that is fundamentally about friendship: Carruthers and his wife are Azim's friends and the moral thing to do is to save them. It is important to remember that this film was made ten years before India achieved Independence and before Partition. *The Drum*'s setting in the Peshawar district makes the militarism of the Raj all the more salient – it invokes a call for peace, but it is a British-run peace.

E Anna Claydon

Sapphire

Studio/Distributor:

Artna
Rank Organisation/J Arthur Rank

Director:

Basil Dearden

Producer:

Michael Relph

Screenwriter:

Janet Green

Cinematographer:

Harry Waxman

Production Designer:

Carmen Dillon

Composer:

Philip Green

Editor:

John D Guthridge

Duration:

92 minutes

Genre:

Drama

Cast:

Michael Craig
Paul Massie
Bernard Miles

Synopsis

One cold winter morning a young woman called Sapphire is found dead on Hampstead Heath. Her scarlet underskirts and racy stockings prompt the police to think there is more to the case than the body in question. It emerges that Sapphire was having a relationship with a student, and she was pregnant. Most importantly, she was mixed race and had hidden that fact from many of her new friends. As the police investigation tries to track Sapphire's life and relationships, it reveals a woman deeply uncomfortable with being classified as 'coloured' and increasingly passing as white, to the extent that many people she knew are astonished or outraged when they learn of her origins. The police initially suspect Sapphire's white boyfriend David but, gradually, suspicion shifts from character to character as the police, travelling through the mostly racially-divided landscape of 1950s' London, uncover just how complicated Sapphire's short life really was.

Critique

When *Sapphire* was released in 1959, it was part of a cycle of contemporary British films by Basil Dearden and Michael Relph that became known as 'social problem' films. These were not 'kitchen-sink' dramas – the phrase later used to describe the predominantly working-class domestic dramas of the British New Wave. The social problem genre was important in helping to shape a language of post-war issues-driven films. *Sapphire* is a straightforward police-procedural structure but one that lends itself well to the social problem genre. Social problem narratives follow a set format: discover a problem, investigate it, identify failings in the ways in which society handles the problem, resolve the drama but not the problem on a wider scale. This structure can be seen in films as wide-ranging as *The Blue Lamp* (Basil Dearden, 1949) through to *Kes* (Ken Loach, 1969), and examples can still be found in contemporary realist films such as *Kidulthood* (Menhaj Huda, 2006).

Throughout the 1950s, the British government encouraged the immigration of people from the Commonwealth into Britain to per-

Yvonne Mitchell
Nigel Patrick

Year:
1959

form key jobs, albeit quite lowly ones, such as nurses and bus conductors. During this period the generation of mixed-race children born to British women and black American GIs began to reach adulthood and it is partly this age-group that Dearden's film seeks to represent. The questions which *Sapphire* seeks to answer are 'Who is Sapphire?' and 'Why does she want to pass as white?' In trying to respond to these questions, the film succeeds in representing the complexities of being mixed-race across cultures when being mixed-race is negative in both of those cultures. What is also interesting in this film is that while Sapphire is the victim, and signalling how Dearden would later treat his characters in the homosexuality-as-issue drama *Victim* (Basil Dearden, 1961), she does not emerge from the narrative as innocent. Her own response to her mixed-race identity is as much debated as the responses of others, particularly in her discovery that she could 'pass' for white and then drop her non-white friends.

Importantly, although Dearden shows the audience the worst of immigrants, such as the gangster thugs lead by Horace Big Cigar (Robert Adams), he also carefully parallels this with the worst of white society in, amongst others, the teddy boy gangs – another 'social problem' of the era. Furthermore, Dearden shows black characters such as Sapphire's brother, a doctor, and her barrister ex-boyfriend, who are as successful, if not more so, than white characters such as the police superintendent and inspector. And shows that students of all backgrounds are significantly less prejudiced than others. *Sapphire* has dated immensely, as attitudes to race have rightly changed, but many of the issues it raises are still pertinent. *Sapphire* confronts and challenges racial stereotypes both about the black communities from white people and about white communities from those labelled 'other'. Ultimately, *Sapphire* still has an important message about immigration, racism and multiculturalism.

E Anna Claydon

My Son the Fanatic

Studio/Distributor:

Arts Council of England
BBC
Canal+
Image International
UGCDA
Zephyr/Feature Film

Director:

Udayan Prasad

Synopsis

Taxi driver Parvez works the nightshift, portering prostitutes and their clients around the run-down streets of a Yorkshire town. He balances his own liberalism against the growing religious and political fanaticism of his frustrated son Farid. Parvez is distanced from his conservative wife and cannot understand his son; Farid gradually becomes more judgemental about his father's life and conspires with his mother. Parvez confides in his sex-worker friend Bettina as he transports her between meetings with her client, German businessman Mr Schitz. As Farid becomes increasingly fanatical, his father becomes more liberal, playing Louis Armstrong and drinking whiskey in his basement as a rebellion against the serious young men and their imported Maulvi (religious instructor) who increasingly fill the house. Parvez's friendship with Bettina deepens, and he has to make a choice between his family, his friends and his own happiness.

Producers:

Chris Curling
George Faber
Anita Overland

Screenwriter:

Hanif Kureishi

Cinematographer:

Alan Almond

Production Designers:

Colin Blaymires
Sara Kane

Composer:

Stephen Warbeck

Editor:

David Gamble

Duration:

88 minutes

Genre:

Drama

Cast:

Rachel Griffiths
Akbar Kurtha
Om Puri
Stellan Skarsgård

Year:

1997

Critique

When *My Son the Fanatic* was released, it caught a moment in British multiculturalism that would have been impossible just a few short years later in the wake of 9/11. This is because, whilst the film is set in the kind of northern town synonymous with stories about British-Asian converts to religious fundamentalism, it deals with the frustrations of a father and his son about existing both within and outside British culture. It approaches the subject with a sensitivity that emphasizes the dilemma of many British-Asian people: what does it mean to be British and Othered by British society? This is an area that many films and television dramas about British-South-Asian identities have approached before and since, for example *My Beautiful Laundrette* (Stephen Frears, 1985), *Bhaji on the Beach* (Gurinder Chadha, 1992), *East is East* (Damien O'Donnell, 1999) and *Britz* (Peter Kominsky, 2007).

My Son the Fanatic does not profess to answer these questions and problematizes the answers given by the characters about finding a place in British society, making most of them 'other' in some way. Consequently, the film can be read as expressing the idea that we are all strangers. All the characters are fundamentally strangers, with the exception of Parvez (Om Puri) and Bettina (Rachel Griffiths). They become the only real bond in the film as they share personal concerns, leading to Bettina telling Parvez her real name. They share physical intimacy when Bettina kisses Parvez, saying it is a long time 'since I kissed a man' and thus, despite her prostitution, the kiss is genuine and very personal.

Strangeness pervades the narrative and the characters' interactions, but it is especially apparent in the relationships between Parvez, his wife Minoo (Gopi Desai) and their son, Farid (Akbar Kurtha). Minoo is in sympathy with her son and is critical of Parvez playing jazz and drinking whiskey. Their split lives are highly indicative of the estrangement between husband and wife, with Parvez working at night and Minoo carrying out her 'duties' during the day. Yet great affection is initially shown between father and son, and Parvez is clearly proud of Farid. However, Farid's tension appears to be initiated by Parvez's pride being tied into Farid's engagement to the white daughter of a senior policeman, an engagement that is broken off by the conclusion of the film's opening credits. The audience learns that Farid ended the relationship because of his antagonism towards his future in-laws and their bigotry – the audience is just as aware of the white family's snobbery as they are of Parvez's nervous gushing.

My Son the Fanatic articulates a concern about fanaticism, which is genuine for many British-South-Asian parents. It is a concern that, in 1997, seemed less real that it does today, and which Kosminsky's *Britz* naturally elaborated upon to reflect the post-9/11 world. *My Son the Fanatic* stands as a rare example of a film about multiculturalism that fully interrogates the schism of identity felt by many on the periphery of the dominant culture and ideology.

E Anna Claydon

Quadrophenia, Curbishley-Baird/The Kobal Collection.

ON LOCATION
BRIGHTON AND HOVE

Brighton and Hove is integral to the history of British cinema both onscreen and off. Early film pioneers, including George Albert Smith, William Friese-Greene and James Williamson, established their trades there. Many early British films were shot in Brighton and Hove; initially, these were static one-shots and 'actualities' such as *On Brighton Beach* (Robert Paul, 1896), and *Bank Holiday at the Dyke* (James Williamson, 1899). By 1897, Smith had established a film production space in Hove, and Williamson soon set up his own local studio. Early film-makers worked at the purpose-built Hove Studio until it closed at the outset of WWI. These pioneers helped establish the city as a prominent space in which the fledgling British film industry could emerge. Between 1948 and 1966 local film-makers attempted, unsuccessfully, to establish the Brighton Film Studios as a leading British film production space. The studio's output was mostly limited to advertisements and B-movies, but did host the screen debuts of 'The Goon Show' stars, Peter Sellers, Harry Secombe and Spike Milligan in Tony Young's *Penny Points to Paradise* (1951).

Seaside resorts have a reputation for escape, pleasure, creativity and abandon and, since its establishment in the early part of the nineteenth century as a growing community drawn down from London by the Prince Regent's 'pleasure palace', Brighton fulfils many of those purposes. Brighton's iconic vistas of Regency and Georgian architecture, seafront attractions and narrow Laines are home to a diversity of locals, students, artists, a thriving LGBT community and plays host to the millions of holidaymakers who regularly visit. The city also has a shadowier reputation for danger, criminality and sexual transgression. Brighton's seafront landmarks, coastal vistas and surrounding countryside – the Royal Pavilion, the Palace Pier, the remains of the West Pier, the North and South Laines, Madeira Drive, the South Downs and nearby Beachy Head – have played host to a variety of narratives in film, theatre, literature and television that reflect its reputations. These distinctive spaces and faces appear in often-competing screen visions of the city. Notable films such as the Brechtian anti-war musical *Oh! What a Lovely War* (Richard Attenborough, 1969), crime drama *Mona Lisa* (Neil Jordan, 1986) and the subculture clash *Quadrophenia* (Franc Roddam, 1979) have been based fully or in part in the city. The novel, stage and screen versions of Graham Greene's 1937 noir classic *Brighton Rock*, *Carry on at Your Convenience* (Gerald Thomas, 1971) and Channel 4's adaptation of Julie Burchill's lesbian drama *Sugar Rush* (2004) have employed the literal and metaphorical landscape. Burchill's work is noteworthy for representing the prominent LGBT community, which has been underrepresented on the big screen.

Whilst the city proved an apposite location for comedy, subculture and rite-of-passage films and relationship dramas, crime dominates its onscreen representations. Brighton's 'criminal' persona was formed through a series of grisly real-life crimes that influenced a series of films. The crime films, in turn, exacerbated the city's darker mythology. A Victorian-era poisoning case provided the inspiration for Robert Hamer's melodramatic crime drama, *Pink String and Sealing Wax* (1945). This bizarre tale of a pious pharmacist and his family drawn into the criminal machinations of a drunken, adulterous tavernkeeper's wife drew on contemporary fears about the city. Poverty and privilege, puritanism and vice, and love against lust are sharply contrasted as the respectable family are sucked into the sleaze of the backstreet drinking dens of 'Soho-on-Sea'. The highest profile cases were two unrelated murders in 1934, where the dismembered bodies of two young women were discovered in trunks, leading to Brighton being nicknamed 'The Queen of Slaughtering Places' – a spin on another sobriquet, 'The Queen of Watering Places'. These murders inspired Val Guest's 1962 film *Jigsaw*, which, with its focus being the local police, relied less on iconography as on a street-level vision of the city.

The city's most infamous crime drama is undoubtedly John Boulting's *Brighton Rock* (1947), a classic tale of extortion and murder that contrasts the city's seaside pleasures with a teeming criminal underworld. Inspired by the region's 1930s' gangsters and

racketeers, Greene's novel cemented the city's reputation for darker excess. Richard Attenborough's chillingly and intensely blank portrayal of teen gangster Pinkie Brown is legendary, yet Sam Riley effectively revised the role for Rowan Joffe's 2010 remake. Joffe's *Brighton Rock* stayed as close as possible to Greene's original narrative, but set it amid the Mods and Rockers battles of the early 1960s, with obvious references to another iconic Brighton film, *Quadrophenia*.

The shadow of *Brighton Rock* hangs heavy over the city as well as over subsequent British crime films. Local film-maker Pete Walker paid homage to it during the climax of his 1969 thriller *The Big Switch* – a tale of violent criminals, prostitution and black-mail. The film's denouement on the Palace Pier ghost train ride is clearly indebted to the famous scene in Boulting's film when Pinkie murders Hale during a ghost train ride. Michael Tuchner's *Villain* (1971) and Neil Jordan's *Mona Lisa* (1986) used the West and Palace piers respectively for darkly dramatic purposes that subvert notions of the pier as a safe, family-orientated or romantic destination. And Michael Winner's *Dirty Weekend* (1993) uses it in a sequence on the Palace Pier wherein a woman turns to murder after suffering at the hands of a 'peeping tom'. Crime in the city is shown to permeate the whole region; the B-movie *Smokescreen* (Jim O'Connolly, 1964), the adaptation of Joe Orton's play *Loot* (Silvio Narizzano, 1971) and the gangster film *Down Terrace* (Ben Wheatley, 2010) variously use the surrounding countryside, residential areas and back-streets to portray a citywide criminal network.

In contrast to its darker reputation, Brighton is also notorious as a place for pleasure, play and lack of inhibition; comedy films play on the seaside's reputation for 'dirty week-ends', carnival excess and Bacchanalian revelry. *Penny Points to Paradise, Genevieve* (Henry Cornelius, 1953) and the Norman Wisdom vehicle *One Good Turn* (John Paddy Carstairs, 1955) all used the seaside resort's identity for comedy value, but it is the Carry On team that most successfully married narrative to visual and cultural mythology. *Carry on at Your Convenience* exploits the potential of seafront saucy postcards and kiss-me-quick hats. A daytrip for the disgruntled unionized workers of a lavatory-making firm provides an outlet for sexual innuendo and corny gags, played out against a backdrop of sunshine, candy floss and joyous holidaymakers. In its Brighton scenes, *Convenience* foregrounds how the absence of civilized and conventional behaviour both dismantles and re-affirms the 'normality' from which the revellers have escaped. This illusion of the city as Rabelaisian landscape can only exist temporarily as normality has to be resumed for it to have credence.

Franc Roddam and The Who's Mod-classic *Quadrophenia* is the foremost film deal-ing with youth subcultures, coming-of-age narratives and troubled relationships. Others, such as Lance Comfort's *Be My Guest* (1965), a kitsch tale of a married couple and their musician son placed Brighton as being central to the pop music culture and explosion in 'teenage' lifestyles that pre-occupied social and political discourse at the time. Here, the Royal Pavilion, Clock Tower, Theatre Royal and the Grand Hotel stand in opposition to the emerging new socio-cultural order as monuments to previous generations. *Be My Guest*, along with *Quadrophenia*, Don Sharp's *Linda* (1960) and John MacKenzie's *Made* (1972), all place in Brighton characters who challenge perceived ideas of the city whilst construct-ing new ones. Conflicted relationships often reach crisis point in the city before reaching resolution back in the 'real world'. *Me Without You*, the story of a deep but damaging friendship between two females, uses the pair's time at the University of Sussex where they both fall for the dubious charms of a visiting professor as the central, formative narra-tive. Student digs and dingy clubs offer an alternate but equally compelling vision of the city where the often fraught emotional journey from adolescence into adulthood is given added symbolic weight by the constantly shifting population and mythology.

Brighton's Royal Pavilion has acquired symbolic status in the onscreen representa-tion of troubled relationships due to its history as being the destination for secret trysts

between The Prince Regent, latterly King George IV, and his long-time companion Maria Fitzherbert. Echoes of their passionate, emotionally-fraught relationship have resonated in Alberto Cavalcanti's *The First Gentleman* (1948), the American musical *On a Clear Day You Can See Forever* (Vicente Minnelli, 1970) and perhaps most intriguingly in another Graham Greene adaptation, *The End of the Affair* (Neil Jordan, 2000). Estranged lovers Maurice (Ralph Fiennes) and the unhappily-married Sarah (Julianne Moore) are reunited on a day trip to the seaside. During an evening concert at the Royal Pavilion, Sarah's husband Henry (Stephen Rea) arrives to inform them that Sarah is dying of cancer, and any notions of them finding lasting love are extinguished. This sequence is absent from Greene's source material, thereby providing an ideal summation of the uses of the city in film. History, symbolism, metaphors, mythology, poetic licence and socio-cultural diversity have provided film-makers with ample material for narrative substance, and their films exemplify many of the broader themes addressed in British cinema.

Neil Mitchell

Brighton Rock

Studio/Distributor:

Charter
ABPC/Pathé

Director:

John Boulting

Producers:

Roy Boulting
Peter De Sarigny

Screenwriters:

Graham Greene
Terence Rattigan

Cinematographer:

Harry Waxman

Production Designer:

John Howell

Composer:

Hans May

Editor:

Peter Graham Scott

Duration:

92 minutes

Genre:

Crime

Cast:

Richard Attenborough
Hermione Baddeley
William Hartnell
Carol Marsh

Year:

1947

Synopsis

Fred Hale is in Brighton playing the part of 'Kolly Kibber', who the locals need to spot to win a newspaper competition. Recognizing Hale as the man who betrayed their former leader, the members of a gang, now led by teenage sociopath Pinkie Brown, take to the streets to find him. Hale is pursued through Brighton and murdered by Pinkie on a pier funfair ride. Ida Arnold, having earlier befriended the agitated Hale, rejects the verdict of death by natural causes and sets out to discover what happened. Pinkie becomes aware that a local waitress, Rose Brown, unwittingly possesses information that could undermine his alibi. Pinkie sets out to seduce her and buy her silence. With the net tightening, Pinkie tries everything to stop Ida uncovering the truth about the crime, to prevent Rose from talking and to stop the other gang members from turning on him to save themselves.

Critique:

The Boulting Brothers' adaptation of Graham Greene's novel *Brighton Rock* (1938) is an evocative crime thriller; hard hitting for its time and hugely influential, but not without controversies or flaws. Its combination of noir-ish elements, sharp dialogue, seedy characters and gang violence brought a fresh realism and intensity to the British crime genre. With a heavily film noir use of shadow and expressionistic camera angles, *Brighton* Rock retains its Britishness in its cast, location and representation of crime drawn from incidents specific to the city. Its vision of the town is one of rain and misery, with the locals living in fear of extortion gangs and their crimes. With talk of spivs, skirts and bogies and use of the racecourse, bars, slum dwellings and pier for most of the action, *Brighton Rock* has a firm sense of time and place. The pier murder and gang attack staged at the racecourse are as tense and thrilling as any seen before or since in British cinema. On release, the *Daily Mirror* newspaper denigrated the film for its supposed 'false, nasty, cheap sensationalism'. So concerned were the Brighton authorities about the threat Boulting's film would pose to the tourist trade that they insisted he insert a conciliatory prologue disclaimer reassuring audiences that Brighton's is a safe and entertaining seaside resort and the Brighton being portrayed had 'long since vanished'.

Greene and Rattigan's screenplay does lessen the impact of certain aspects of the novel's narrative: the 'romance' between Pinkie (Richard Attenborough) and Rose (Carol Marsh), which is integral to the plot, is problematic onscreen, their meetings too brief for her to be believably smitten with Pinkie, as well as Marsh being too well bred to be plausible as a poor working class girl. The religious elements of the novel are also diminished onscreen, with more emphasis placed on the mystery elements. It is a problem of adaptations in general that what can be allowed to develop over time on the page is necessarily condensed for the big screen. Brighton Rock is by no means the only film to suffer in this respect and the overall strength of the production far outweighs any minor flaws.

Attenborough's chilling portrayal of conflicted Catholic Pinkie Brown, a non-smoker or drinker who lives a life of petty crime, extortion and violence, remains the film's highlight. Pinkie's constant fiddling with a cat's cradle alludes to this religious strain – the cradle being symbolic of Catholic Rosary beads as well as signifying his internal anguish and gradual mental unravelling as the police close in on him. There is a mounting dramatic urgency as the film progresses; plot twists, double crossings and violent incidents come thick and fast as Pinkie begins to lose control of the situation and his sham marriage to Rose takes its toll on them both. *Brighton Rock* is still one of the finest British crime films and perhaps Britain's strongest noir offering.

Neil Mitchell

Oh! What a Lovely War

Studio/Distributor:

Accord/Paramount British

Director:

Richard Attenborough

Producers:

Richard Attenborough
Len Deighton

Screenwriters:

Charles Chilton
Len Deighton
Joan Littlewood

Cinematographer:

Gerry Turpin

Production Designer:

Donald M Ashton

Composer:

Alfred Ralston

Editor:

Kevin Connor

Duration:

144 minutes

Genre:

Musical/Stage Adaptation

Synopsis

On the eve of WWI, Europe's heads of state, aristocrats, military leaders and diplomats gather to discuss tensely complicated political affairs, familial rivalries and the rise of nationalism. During a group photograph the Archduke Ferdinand and the Duchess of Hohenberg are murdered, and this tragic event is the catalyst for war. On Brighton's West Pier, General Haig sells war-entrance tickets to the men and women destined for the battlefield, and to their families. A music-hall style recruitment drive swells the ranks of the army and Britain enters the war on a wave of optimism. The turbulent war years are portrayed in a series of sketches, vignettes, choreographed musical numbers and songs that focus on life in the trenches, the soldiers' families back in Britain, and the secluded, opulent lives of the ruling classes.

Critique

Richard Attenborough's directorial debut is an audacious version of Joan Littlewood's 1963 satirical anti-war stage musical of the same name. The successful stage production, performed by Littlewood's Theatre Workshop company, led to various radio versions before Attenborough's big-screen adaptation. The film's sprawling narrative, seen through the eyes of a multitude of characters from across the social classes, portrays the vast chasm in experience between those who organized the war and those who fought it for them. The narrative's striking contrast of Brechtian staging with documented accounts of military mis-management and the devastation of war is exemplified by the decision to locate the action in and around the pleasure town of Brighton. Brighton's old West Pier, once the epitome of Victorian seaside architecture, becomes the metaphorical, and tragically ironic, site of WWI.

Gerry Turpin's superb cinematography and Harry White's impressive production design lends the film a realist tone, evoking the fear and misery of trench warfare as well as the camaraderie between the troops – their shared songs and moments of silent contemplation are

Cast:
John Gielgud
John Mills
Laurence Olivier
Maurice Roeves

Year:
1969

poignant, tragic and respectfully portrayed. In contrast, the absurdly bombastic fantasy sequences on the Pier where the upper classes choreograph the war are detached and emotionless; the top brass are portrayed as ignorant buffoons distracted by bitter infighting and displaying wilful ignorance about the war's effects on the nation.

The film's stellar ensemble cast play a combination of real-life figures, such as Kaiser Wilhelm (Ralph Richardson) and Field Marshal Haig (John Mills) and fictional characters – primarily the archetypically-British Smith Family. The working-class Smith's are the film's emotional heart, with their experiences symbolizing the tragic circumstances that touched virtually all families during the conflict.

The Brechtian songs range from upbeat music hall tunes via mournful hymns with adapted lyrics to striking choruses that contrast sharply with the quieter, deeply reflective scenes that highlight the emotional ebbs and flows felt by the soldiers and their families throughout the campaign. Visual motifs appear throughout – primarily the poppy, symbolizing impending death, that is handed out to soldiers departing for the Western front. The cricket scoreboard – an emblem of Englishness and fair play – is used in satirical fashion to rack up the death toll during major battles. These Brechtian techniques, designed to alienate and 'make strange' the action, force the viewer into intellectual engagement with the subject matter.

Attenborough's anti-war film has a timeless resonance; being filmed in 1968, that contradictory year of student riots, peace and love and the height of the deeply unpopular Vietnam war, gave *Oh! What a Lovely War* an immediate and receptive audience on its release. Over forty years later it is striking how pertinent the film's themes remain, and still act as a sharp rebuke to military folly and casual disregard for loss of life. The impact and resonance of Attenborough's screen adaptation of Littlewood's original material deepens with repeated viewing, so encompassing is its breadth of scope and ambition.

Neil Mitchell

Quadrophenia

Studio/Distributor:
The Who Films
Polytel/Brent Walker

Director:
Franc Roddam

Producers:
Roy Baird
Bill Curbishley

Synopsis

Teenage Mod Jimmy lives at home with his family whilst working as a junior office clerk. Obsessed by the music and fashion of Mod culture, Jimmy spends his nights with friends roaming the streets and clubs of London. Jimmy is increasingly besotted both with Steph, a regular on the scene, and with the upcoming 'weekender' trip to Brighton with the rest of the Mods.

After a party, tensions with local rockers culminate in vicious beatings on both sides, and with the procurement of a large quantity of amphetamines Jimmy's anticipation of the approaching 'weekender' is further fuelled. In Brighton, Jimmy, increasingly reliant on pills, is at the front line of a pitched battle between the Mods, Rockers and the police. But once back in London, his life spirals out of control. Jimmy desperately tries to restore order by running back to his beloved Brighton, with potentially tragic consequences.

Screenwriters:

Dave Humphries
Franc Roddam
Martin Stellman

Cinematographer:

Brian Tufano

Production Designer:

Andrew Sanders

Composers:

Roger Daltry
John Entwistle
Pete Townshend

Editors:

Sean Barton
Mike Taylor

Duration:

117 minutes

Genre:

Drama

Cast:

Leslie Ash
Phil Daniels
Phil Davis
Mark Wingett

Year:

1979

Critique

Jimmy's coming-of-age journey is as painful as any committed to the screen. British cinema has a rich history of portraying teenage angst and rebellion, and the nation as a whole has a deep fascination for popular music and subcultures. Franc Roddam's directorial debut is a loose adaptation of The Who's 1973 'rock opera' of the same name, with their music forming the majority of the soundtrack. The 1970s saw a proliferation of rock operas both onscreen and off, with Ken Russell's 1975 adaptation of The Who's 1969 album *Tommy* and Alan Parker's 1982 film adaptation of Pink Floyd's 1979 album *The Wall*.

Jimmy's (Phil Daniels) struggle with his sense of identity dominates the film. The clearest visual sign of his conflicted personality is a skilful shot of his multiple reflections in the wing mirrors of his Lambretta. His deteriorating mental state is explored within the realm of a quasi-documentary/social realist shooting style that adds a grainy authenticity to operatic source material. Roddam's film keeps the framework of the original Who opera while constructing an historical re-creation of British social, political and cultural life in the early to mid-1960s. The Mod sub-culture, with its fascination for tailor-made suits, Italian Scooters and ska, soul, beat and R&B, reached its peak during the 1960s and stood as the antithesis of the Rockers, with their taste for leather, motorcycles and 1950s' rock 'n' roll. The ultimately baseless antipathy between the teenage gangs and society in general is highlighted in the uneasy friendship between Mod Jimmy and Rocker Kevin (Ray Winstone). Inter-generational and cross-generational divides are succinctly captured when Jimmy hears Kevin singing a 1950s' Gene Vincent number in the public baths; crossed words are exchanged before Jimmy retaliates by singing The Kinks' *You Really Got Me*. Realizing that they know each other from school, a friendly exchange occurs before everyone else present castigates them for their noise-making. When Kevin is later attacked by the Mods, Jimmy is torn between his gang loyalty and revulsion at seeing someone he knows suffer at their hands.

Quadrophenia's centrepiece is the bank holiday 'weekender', shot in *vérité* style to give a thrilling immediacy to the running battles between the gangs and the police. The historical basis for these scenes adds to their impact: on the Whitsun weekend of 1964 over a thousand teenagers were involved in rioting on Brighton beach, resulting in vandalism, hospitalizations, fines and prison sentences. Brighton also acts as the point in which Jimmy, rather than cementing his identity, loses himself. First seduced and then spurned by Steph (Leslie Ash), abandoned by family and friends, unemployed and consumed by bitterness and drug abuse, he unravels in spectacular fashion. Jimmy is one of the many 'Angry Young Man' figures in British culture and cinema, a stock character from the 1950s through to the present, and *Quadrophenia* has become a cult film and a cherished part of the mythology of Mod culture.

Neil Mitchell

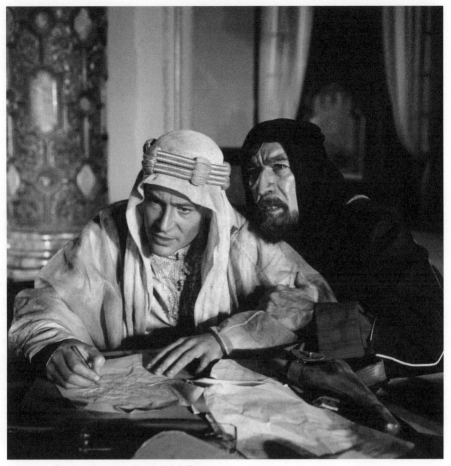

Lawrence of Arabia, Columbia/The Kobal Collection.

DIRECTORS
DAVID LEAN

Before becoming one of British cinema's most important directors, David Lean served a prestigious apprenticeship in the industry, cutting his teeth as a clapper boy followed by a period as an editor – a profession in which he quickly distinguished himself. By the age of 30, Lean was working under Anthony Asquith before assuming duties for Michael Powell. Arguably, Lean's glittering fourteen-film career, spanning almost forty years, saw him usurp his masters to become one of Britain's most celebrated and successful film-makers. That Lean's experience of working under such substantial figures can be regarded as an interesting aside rather than a formative arc of any summary of his work is testament to the way in which he marked out his own cinematic identity with his first feature, the wartime naval drama *In Which We Serve* (1942). That film's writer and star, Nöel Coward, looking for an accomplished technician, offered Lean the co-directorship and their subsequent collaborations – *This Happy Breed* (1944), *Brief Encounter* (1945) and *Blithe Spirit* (1945) – saw Lean assume sole directorial duty. While a far cry from the epic, exotic fare of *The Bridge on the River Kwai* (1957) and *Lawrence of Arabia* (1962), those early films established many of the tropes sustained throughout the director's oeuvre.

A commitment to adaptation and/or drawing from real events was a key concern for Lean. He believed that cinema is at its best when it explores the capacity to render engagingly that which exists in an already-established form, be it literary text or popular memory. This is not to suggest that Lean's stylistic repertoire was limited. Rather, he saw the tools at his disposal as supplementary elements, deployed to heighten his source material and achieve its cinematic potentials. For example, the opening sequence of *In Which We Serve*, wherein the camera surveys the building of a ship, is undoubtedly typical of the trend in wartime realism to evoke the documentary movement's aesthetic verisimilitude. Taken in the context, though, of the film's tightly-wrought structuring system– carefully orchestrated battle sequences, expressive contrasts between the idealized Britain of its characters' memories, the manifestation of the nation through the metaphor of the ship – Lean's rendering of the realist trend becomes distinguished.

Lean's subsequent film, *This Happy Breed*, with its portrait of an ordinary family London during the interwar years, could, at first glance, be similarly understood within the generic fashions and propagandistic demands of the period. Yet this adaptation of Coward's stage play again shows Lean's distinctive cinematic craft at work. This is best illustrated in the scene in which husband and wife, Frank and Ethel, are informed of their son and daughter-in-law's deaths in a car accident. Their daughter, Vi, goes out to the garden while the camera stays in the living room – where the vast majority of the film unfolds – gently panning across the empty space. This shot takes place over an uncomfortably-long 35 seconds, after which the shell-shocked parents re-enter the frame. While the viewer comprehends the once-bustling family room now bereft of its inhabitants, an incongruously jaunty song plays on the radio. This subtly-expressive treatment of space and sound was to find even greater resonance in Lean's final work with Coward, the early masterpiece, *Brief Encounter*. For example, the unhappily-adulterous Laura sits guiltily in the lounge with her husband, listening to crashingly-loud and melodramatic music on the radio. The music fills the mundane domestic space until she cannot bear it any longer and turns the radio down. The scene emphasizes Laura's discomfort – her heightened awareness of the tediousness of her marriage compared to the intensity of her brief encounter with her lover, Alec.

Despite the ending of Lean's productive partnership with Coward, Lean maintained his willingness to explore the potentials of cinematic adaptation in the Dickens adaptations *Oliver Twist* (1948) and *Great Expectations* (1946). Having ruthlessly but efficiently edited Dickens' novels, Lean was able to represent their narratives faithfully and progressively while realizing their inherent visual potentials. For example, Great Expectations contains distinctive moments of subjectivity and impressionism, such as when a young Pip is spoken to by a cow while on his way to meet Magwitch, alongside an atmospheric

treatment of Victorian London that visually evokes Dickens' own figurative approach to the City.

While Lean continued to work prolifically in Britain throughout the next decade, *The Passionate Friends* (1948), set partly in Switzerland, and *Summertime* (1955), set in Venice, indicated a willingness to move outside the spatial confines of his own country. Arguably, this desire to seek new cinematic canvases was to define his reputation, with *The Bridge on the River Kwai* (1957), *Lawrence of Arabia* (1962) and *Dr Zhivago* (1965) comprising a triumvirate of hugely-successful historical epics. However, the increased dimensions of Lean's work in these three films do little to suggest a parallel philosophical departure from his signature approach. For example, the vast desert landscapes of *Lawrence of Arabia* enabled Lean to expand his expressive register – hitherto mostly contained in domestic spaces. He made full use of the scope of the desert space to explore the boundaries of cinematic spectacle, achieving some of the most iconographic and conspicuously-authored long shots in cinema. Given that these historical epics can be seen to represent Lean's aesthetic maturation as a film-maker, not to mention his commercial and critical pinnacle, it should be noted that they coincided with a reunion with the cinematographer Freddie Young – with whom he had previously collaborated on Powell and Pressburger's *One of Our Aircraft is Missing* (1942).

If the move to foreign locations saw Lean further embrace his passion for the visual rendering of the literary and historic imaginary, it was no surprise that this temporal and spatial adventurism fell somewhat flat when he returned closer to home, to Ireland, to film *Ryan's Daughter* (1970). The failure of that film prefigured a 14-year hiatus, which was ended with his final work, *A Passage to India* (1984). It is interesting to note the circularity of this film. Just as he began by observing – and transcending – the generic codes of his period with the wartime realism of *In Which We Serve*, Lean finished with one of the definitive works of the British heritage revival cycle of the 1980s. This is a fitting narrative for a film-maker who was both a typically British director and an artist who always sought to move beyond the limitations of nationhood. Typically, at his death in 1991, he was again working on another adaptation – a version of Joseph Conrad's novel *Nostromo* that would surely have again seen him exploring the spectacular and the exotic.

David Forrest

Oliver Twist

Studio/Distributor:
Cineguild
Rank Organisation/General Film
Distributors

Director:
David Lean

Producer:
Ronald Neame

Screenwriters:
Stanley Haynes
David Lean

Cinematographer:
Guy Green

Production Designer:
John Bryan

Composer:
Arnold Bax

Editor:
Jack Harris

Duration:
116 minutes

Genre:
Melodrama
Heritage

Cast:
Alec Guinness
John Howard Davies
Robert Newton
Kay Walsh

Year:
1948

Synopsis

An unidentified woman dies after giving birth in a London poor-house. Nine years later, her child, who has been arbitrarily named Oliver Twist, is expelled from that poorhouse for asking for extra gruel. Oliver runs away to London where he falls in with a gang of young pickpockets overseen by the nefarious fence, Fagin, and the brutal thief, Bill Sikes. After being fairly tried for stealing, Oliver is taken in by the wealthy Mr Brownlow and lives luxuriously until Sikes and his partner, Nancy, kidnap him and return him to Fagin's lair. A remorseful Nancy arranges to meet Brownlow, who is searching for Oliver. Fagin's protégé, the Artful Dodger, follows Nancy and overhears her talking to Brownlow. She confesses, but shields Sikes. When Fagin convinces Sike's that Nancy has betrayed them, Sikes is driven into a murderous rage, which forces the police to conduct a dramatic manhunt.

Critique

As the film *Pygmalion* (Anthony Asquith, 1938) is to *My Fair Lady* (George Kukor, 1964), so *Oliver Twist* is to *Oliver!* (Carol Reed, 1968). In both cases, the latter is the flashier, bigger budget musical that attracted Oscars and dominates the popular memory, while the former is the more artful and remains the definitive cineamtic adaptation of its literary source to date.

Considered alongside Lean's previous Dickens adaptation, *Great Expectations (1946)*, *Oliver Twist* proves Lean's affinity for Dickens, his ability to translate, rather than simply film, the author's works for the screen. Like *Great Expectations*, *Oliver Twist* is concise, vivid and expertly paced. Scenes do not have their length dictated by their length in the novel but by the needs of the narrative. Contrast the long, suspenseful scene in which Oliver walks up to the poorhouse warden to ask for more gruel with the subsequent rapidly edited sequence that actually conveys far more information – the various authority figures learning of Oliver's request; their reactions to it; his expulsion from the poorhouse; the offer that five pounds will be given to any man who takes Oliver as an apprentice).

The lighting design of *Oliver Twist* is as expressive as the film noir classics with which it is contemporaneous, and is just as obviously indebted to German Expressionism. This visual richness allows Lean to avoid the torrent of words and pedantic plotting that can overburden other Dickens adaptations. He trusts his casting, his costumes and, above all, his cinematography to convey the depth and detail that, in the novel, is provided by words. The result is a film that can feel like a distillation of Dickens.

Oliver Twist's great failing is Alec Guinness' characterization of Fagin: a hideously shallow and grotesque presentation of a Jewish crook with a ludicrously over-large nose and obtuse accent. Dickens eventually softened the anti-Semitism of his original novel, making Fagin less of a stereotype, and Lean should have done the same. When transferred to the screen, Dickens' characters work best when

they are broadly drawn, but Lean and Guinness deliver an ill-fitted and absurd caricature.

The anti-Semitic portrayal of Fagin cannot, however, obscure the elegance and intelligence of the rest of the production. The years 1945–1948 brought four brilliant cinematic adaptations of canonical works of English literature: Lean directed *Oliver Twist* and *Great Expectations*, while Laurence Olivier delivered his classic *Henry V* and then the Oscar-winning version of *Hamlet*. Of these great classics of British cinema, *Oliver Twist* deserves to endure as long as any.

Scott Jordan Harris

Lawrence of Arabia

Studio/Distributor:
Columbia
Horizon/Columbia

Director:
David Lean

Producer:
Sam Spiegel

Screenwriter:
Robert Bolt

Cinematographer:
FA Young

Production Designer:
John Box

Composer:
Maurice Jarre

Editor:
Anne V Coates

Duration:
227 minutes

Genre:
Historical Drama

Cast:
Peter O' Toole
Omar Sharif
Anthony Quinn

Year:
1962

Synopsis

In 1916, Lieutenant TE Lawrence, a British Intelligence Officer at an outpost in Cairo, is sent on a mission to liaise with Arab leader, Prince Faisal, who is leading an unsuccessful revolt against the Ottoman Empire. Lawrence, familiar with the Bedouin people from his studies at Oxford, is asked by Colonel Brighton to help bring the Arabs under English command. Instead, Lawrence leads the Arabs on a seeming suicide mission across the treacherous Nefud desert to attack the Ottoman stronghold, Aqaba. The astonishingly successful attack helps unite warring tribesmen, and Harith leader Sherif Ali becomes one of the Lawrence's most trusted lieutenants. Lawrence becomes an international sensation, attracting an American reporter who needs a larger-than-life figure to convince Americans to enter WWI. But, as Lawrence and the Arab forces march on Damascus, his dream of forming a united Arab nation may be threatened by generations-old tribal conflicts.

Critique

Lawrence of Arabia, released in 1962, lives on in the popular imagination as a sweeping epic about one man battling against nature and overwhelming odds while on the adventure of a lifetime. What is easily forgotten is how intimate and idiosyncratic this David Lean picture actually is – particularly in its third act. The film is divided into two parts, the first showing TE Lawrence as adventurer and unlikely hero embracing his destiny and becoming a conquering warrior. Director David Lean fills the screen with vast desert landscapes as Maurice Jarre's enduring theme scores the hero's journey.

In the second half of the film, everything begins to unravel for the hero as his struggle turns inward and he battles his own demons. Lawrence's journey much more explicitly begins to mirror that of Christ, as he is receives stigmata-like injuries in battle, is held down on a plank in a crucifixion pose before being beaten by Turkish captors, and later rises from his crippling injuries to lead his followers to victory. Lawrence also believes he is a Christ-figure and that redemption is his to give. This belief in his own power begins to drive him mad and leaves him emotionally ruined after his torture by the Turks reminds

him of his weakness and humanity. As Lawrence later descends into bloodthirsty madness, Lean's camera focuses less on the landscape and more on the flawed man and the machinations of those who have been exploiting him. Many big screen epics have copied the blueprint of *Lawrence of Arabia*, following an Anglo outsider on his journey to integrate into and ultimately save a foreign culture. Films from *Dances with Wolves* to the science fiction fantasy *Avatar* have recycled this storyline, but they lack the deeply-flawed, possibly disturbed, protagonist at their centre.

FA Young's landscape photography is stunning, but it is Lawrence's emotional journey as portrayed by Peter O'Toole in his first major role that gives the film its lasting impact. O'Toole portrays Lawrence as both effete and dynamic. Through charisma and strength of will, Lawrence unites the Arab world behind him, and O'Toole portrays this convincingly while preserving a quirk-filled character riddled with neuroses and occasional crippled by doubt. Historians have strongly criticized the authenticity of O'Toole's portrayal of Lawrence, not to mention the film's exaggerated and decidedly colonial sense of history. But O'Toole's commitment to showing a flawed, delusional Lawrence gives some legitimacy to the film's exaggerations; *Lawrence of Arabia* is a tragic hero rewarded, but ultimately betrayed, by his destiny.

Randall Yelverton

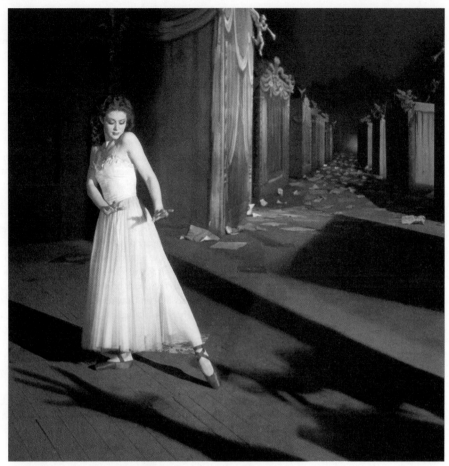

The Red Shoes, ITV Global/The Kobal Collection/George Cannon.

DIRECTORS
POWELL AND PRESSBURGER

The work of Michael Powell and Emeric Pressburger is as crucial to an appreciation and understanding of British cinema as the work of David Lean, early Alfred Hitchcock, Carol Reed or the output of Ealing Studios. Powell and Pressburger's several masterpieces are beautiful, in virtually all the ways in which films can be beautiful, as well as being broadly entertaining and intellectually invigorating.

Powell was a well-established, if un-revered, English director when he first worked with the Hungarian émigré writer Pressburger on *The Spy in Black* (1939). After this came two collaborations on which the pair worked more closely: *Contraband* in 1940 and the Oscar-winning *The 49th Parallel* in 1941. It was not until 1942 and *One of Our Aircraft Is Missing* that they shared the writer-director-producer credit, and used the production company name 'The Archers', which have come to characterize their partnership. In 1943 they made the acclaimed *The Life and Death of Colonel Blimp*, and established the aesthetic standards for which they are admired. After this came numerous collaborations until a brief separation in 1957 and a final separation 15 years later. But it is on *Blimp* and the five successive films – *A Canterbury Tale, I Know Where I'm Going!, A Matter of Life and Death, Black Narcissus* and *The Red Shoes* – that their reputation rests.

While Powell and Pressburger's impact on British – indeed, international – cinema is undeniable, it can be difficult to discuss their work in a way that deals in such plain facts. There are, perhaps, three chief reasons for this. The first is that Powell and Pressburger's films are somewhat unusual, so unlike the work of many film-makers who preceded and succeeded them (even those such as Martin Scorsese, on whom they exerted an often-acknowledged influence). Powell and Pressburger's collaborations were characterized by opposition to working methods or artistic ideals other than their own, such that their best films cannot easily be written of as belonging to a genre or movement, or judged by the respective standards that could be invoked if they did.

The second reason is that Powell and Pressburger made fantastical films that are especially unusual in the context of British cinema. As Mark Duguid stressed in 'Fantastic Life', an essay for the BFI: 'If 20th-century cinema is characterised as a battle between "realism" and fantasy, then Michael Powell and Emeric Pressburger, at least after 1943, allied themselves with the forces of fantasy. In this respect, they found themselves at odds with almost the entire British cinematic tradition' (Duguid 2006).

British cinema is accustomed to the realistic and the literal. Powell and Pressburger's films sit aside from that tradition, which can make them problematic to assimilate and discuss. Consider the centrepiece of The Archers' most ambitious film, *The Red Shoes*. It is a fourteen-minute fantasy ballet sequence, which mirrors the plot of the film, which does not, cannot, take place in reality. Is it a performance, freed from the constraints of the stage, as it is understood in the mind of the audience, or the dancer, or the director? Or is it a cinematic device to illustrate the film's plot? British film-makers are unaccustomed to posing such metaphysical questions; such an episode, which Patrick Colm Hogan might aptly term 'paradiegetic', would be as unremarkable in Indian cinema as it is remarkable in British. The ballet sequence leads to the third, and most powerful, reason why Powell and Pressburger's films can be difficult to process. As the well-known British film critic Barry Norman noted, when including *The Red Shoes* in his *100 Best Films of the Century*:

> There are those who regard *The Red Shoes* as the finest achievement of the Powell-Pressburger partnership. There are many more for whom it is the most perfect ballet film ever made and yet others who see it as the ideal backstage musical [but] what is beyond question is that this is a breathtakingly imaginative film, an attempt to fuse music, dance and drama with a brilliant command of film technique into something that comes as close as possible to total cinema. (Norman 1998)

Similarly, the electric eroticism that charges *Black Narcissus*; the undefined but manifest spirituality that powers *A Canterbury Tale*; the eerie, supernatural atmosphere in *I Know Where I'm Going!* are crucial to the narratives of those films, but almost impossible to pinpoint. It is difficult to say what part of the production they spring from, yet they are communicated to the audience by purely cinematic means. It is this that marks the films of Powell and Pressburger out from those of their contemporaries, and substantiates their impact on British, as well as international, cinema.

As a final note, though, it must be stressed that 'Powell and Pressburger' films are not solely the work of Michael Powell and Emeric Pressburger. While their method of film-making, and the joint credit they took for it, is a challenge to auteur theory, the designation 'a film by Powell and Pressburger' is insufficient. They had many regular collaborators, most obviously the standout cinematographer Jack Cardiff, whose artistic talents helped define the Powell and Pressburger aesthetic. Powell and Pressburger productions highlight the contradictory importance in film-making of a singular vision and a collaborative approach to realizing it. Theirs was a collaboration – between themselves and between them and the members of their crews – that, at its best, produced works 'as close as possible to total cinema'.

Scott Jordan Harris

The Red Shoes

Studio/Distributor:

The Archers
General Film Distributors

Directors:

Michael Powell
Emeric Pressburger

Producers:

Michael Powell
Emeric Pressburger
Independent Producers

Screenwriters:

Michael Powell
Emeric Pressburger

Cinematographer:

Jack Cardiff

Production Designer:

Hein Heckroth

Composer:

Brian Easdale

Editor:

Reginald Mills

Duration:

85 minutes

Genre:

Art
Melodrama

Cast:

Marius Goring
Robert Helpmann
Leonide Massine
Moira Shearer
Anton Walbrook

Year:

1948

Synopsis

Vicky Page, an aspiring ballerina, fulfils her ambition of joining the prestigious Ballet Lermontov, the company owned and run by Boris Lermontov. Loved and feared in equal measure, Lermontov has dedicated his life to ballet above all else and expects his collaborators to do the same. When his prima ballerina leaves him to get married, he begins to groom Vicky as her replacement, believing that she shares his passion. He commissions a new work for her, 'The Red Shoes', and it duly makes her a star. During rehearsals Vicky falls in love with the ballet's ambitious young composer, Julian Craster. When Lermontov fires Craster, Vicky elopes with him. When she is unable to adjust to Julian's demands that she give up dancing, Lermontov lures her back for another performance of 'The Red Shoes' with tragic consequences.

Critique

On paper, *The Red Shoes* is a rather conventional backstage melodrama, and the conceit of having a protagonist torn between love and devotion to art was already a well-worn cliché. This is perhaps surprising, given that several of Powell and Pressburger's previous efforts, such as *A Canterbury Tale* (1944) and *A Matter of Life and Death* (1946), featured highly original and eccentric narratives. However, the plot of *The Red Shoes* is the least interesting and important aspect of this ambitious and often experimental work, which must stand as one of the seminal works in British cinema history.

As much a work about film-making as it is about ballet, the onscreen collaborators that Lermontov relies upon parallel the offscreen talents that Powell and Pressburger assembled to join their production team, The Archers. This included the set designer and painter Hein Heckroth; cinematographer Jack Cardiff (who conspired to give the film the look of a Degas painting); composer Brian Easdale, who provided the music before the shooting began; and editor, Reggie Mills, who cut the film to the rhythms of the score. Additionally, Leonide Massine and Robert Helpmann choreographed the film and appeared as dancers. And, of course, the glorious Moira Shearer, making her debut as Vicky Page, alongside Archers' regular Anton Walbrook, who gave a bravura performance as Lermontov.

The centrepiece of the film is unquestionably the performance of *The Red Shoes* ballet itself. This justly-celebrated fourteen-minute sequence, which expressionistically depicts Vicky's inner thoughts as she dances, is almost a film-within-a-film. Despite Shearer's misgivings that she was given scarce opportunity to actually dance, the ballet is a technical tour de force that synthesizes choreography, music, literature, painting and photography into a cohesive, entirely cinematic whole. Powell insisted upon shooting to live playback of Easdale's score, thus Cardiff was able to operate the three-strip Technicolor camera without a blimp. Cardiff also employed a number of 'in camera' effects such as stop motion, superimposition and varied shooting speeds. For his part, Heckroth provided over one hundred

backdrops that often recall surrealist paintings. Finally, the images were cut together by Mills, who edited the sequence with the help of a metronome.

Powell and Pressburger later took the idea of the composed film even further in works such as their version of Offenbach's *The Tales of Hoffmann* (1951), *Oh…Rosalinda!!* (1955), an updating of Johan Strauss' *Der Fledermaus*, and Powell and Heckroth's superb adaptation of Bartok's *Bluebeard's Castle* (1964). None of these, however, managed to repeat the critical and commercial success of *The Red Shoes*.

The film's influence has been great: Vincente Minnelli's *An American in Paris* (1950) can be seen as Hollywood's attempt to emulate it; numerous directors, including Martin Scorsese, credit it with inspiring their vocation to cinema; and in Britain it has become a rallying point for film-makers such as Ken Russell, Derek Jarman and Sally Potter. For many, *The Red Shoes* represents the summit of Powell and Pressburger's work and is a superlative example of British art cinema.

Brian Hoyle

Black Narcissus

Studio/Distributor:

The Archers
General Film Distributors

Directors:

Michael Powell
Emeric Pressburger

Producers:

Michael Powell
Emeric Pressburger
Independent
George R Busby

Screenwriters:

Michael Powell
Emeric Pressburger

Cinematographer:

Jack Cardiff

Editor:

Reginald Mills

Production Designer:

Alfred Junge

Duration

100 minutes

Synopsis

A group of nuns led by Sister Clodagh, the new young Sister Superior, move into an old building high up in the Himalayan mountains that has been converted into a school and hospital for local Indian people. However, once there, several of them begin to show signs of the strain and pressure of living in such a remote location. Sister Ruth, for example, develops a passion for the English male supervisor, Mr Dean, whilst Sister Clodagh begins to dwell longingly on her life before joining the convent. As Sister Ruth's desire threatens to overwhelm her, she initiates a chain of events that could put an end to the nuns' work in the mountains.

Critique

Black Narcissus is one of the key films in the canon of British melodrama, and can be understood as an attempt to recapture and rework some of the defining tenets of the classic Gainsborough period melodramas that proliferated between 1943 and 1946. The film was Powell and Pressburger's ninth feature together, and functions as a companion piece to *I Know Where I'm Going* (1945), as both films involve strangers in a strange land. Both films, also, concern an ostensibly secure woman making a journey to a remote location, one that seems to exist outside of time and space, in a landscape rife with its own history, customs and myths. And both films trace the means whereby this place and its people exert a determining influence over the increasingly beleaguered protagonist.

As their first film made entirely away from the necessities of the war effort, Powell and Pressburger dived headfirst into lurid waters with *Black Narcissus*, giving free reign to hysteria, to excesses of emotion

Genre:

Melodrama

Cast:

Kathleen Byron
David Farrar
Deborah Kerr
Sabu

Year:

1947

and, concomitantly, of style. The studio-bound production of *Black Narcissus* reconfigures Mopu as a landscape of the mind, an interior realm, which triggers feelings and hitherto suppressed memories in two very different women. This is seen most overtly when Sister Clodagh (Deborah Kerr) reminiscences of her romantic life before the convent.

Alongside this, Jack Cardiff's Oscar-winning Technicolor cinematography contrasts an increasingly bold palette with soft light and colours reminiscent of the Dutch artist Johannes Vermeer. The opening image of the film depicts the Mother Superior before a window on frame left, illuminated with a shaft of light that washes through the composition in an echo of Vermeer's distinctive paintings such as *Woman Holding a Balance*. This in fact proves a prophetic title, as *Black Narcissus* is increasingly characterized by a tenuous holding in check of dichotomous elements. In addition to the contrast between the white skin of the Sisters and the dark skin of the locals, there is the juxtaposition between the natural odour of the Indians that is so unpleasant to Sister Ruth (Kathleen Byron) in particular, and the foetid aromas of the young general's exotic perfumes. Indeed, one scent lends the film its title, being symbolic in suggesting an artificial perfume covering up the underlying reality of what occurs naturally. This latter point is particularly significant in that it figures as a correlative of the central dichotomy between action and sublimation. The Sisters Clodagh and Ruth function as opposing sides of one personality: Ruth is an external manifestation of Clodagh's repressions and latent desires. In addition to their physical similarity, this figurative split is made succinctly clear in one single transition, from the final scene at the convent to the first with the nuns at Mopu. A tight close-up of Clodagh dissolves into a shot of Ruth striding through large doors and out onto a vertiginous precipice – this veritable throwing open of the doors underlines the sense of Ruth's release and liberation contrasted with Clodagh's figurative imprisonment, imprisoned entirely within herself.

Powell's long-held ideal of cinema, what he termed a 'composed film', really began with *Black Narcissus*. The film's key stylistic elements function in a perfect, synchronous concord of visual expression; *Black Narcissus* is a paradigmatic melodrama, and a key example of a distinctively British idiom.

Adam Bingham

This Is England, Film4/UK Film Council/The Kobal Collection/Rogers/Dean Rogers.

DIRECTORS
SHANE MEADOWS

'This ain't fucking London. This isn't even Nottingham, man. This is Sneinton.' These words – spoken by Shane Meadows himself in his first film *Smalltime* (1996) – humorously mark out the defiantly provincial terrain that has come to distinguish the director's work. Born in the Staffordshire market town of Uttoxeter, Meadows' social focus has from the outset largely remained within the confines of small working-class communities in the Midlands. Both socially and geographically, Meadows' favoured milieu is perhaps best described as the margins of the margins. The unassuming title sequence of *Shane's World* (2000) – a feature-length showcase of short films screened on Channel 4 – is a case in point. In one scene, Meadows rides a moped around unassuming suburban streets, gradually reaching the edges of a nameless town before trundling aimlessly down a small road and into the rural hinterlands. This, then, is Shane's world: the regional non-places, forgotten spaces and anonymously sprawling outreaches of contemporary Britain.

The director's frugal working method is grounded in a DIY ethos, which emphasizes improvisation, limited overheads and the importance of collaboration. Meadows has long surrounded himself with a trusted coterie of close friends and family who function as the nucleus of his creative team. Meadows' first wife Louise repeatedly worked as both actor and producer on his earlier films; more recently, Warp Films' Mark Herbert has joined Meadows' team on regular production duties. Childhood neighbour Paul Fraser is a regular screenwriter, while other Staffs-based friends such as Paddy Considine and musician Gavin Clarke are also long-term collaborators. Meadows' use of carefully-sourced non-professional performers has also provided him with a stable of young acting talent including Vicky McClure, Andrew Shim and the acclaimed Thomas Turgoose.

After several years spent making short films on borrowed video equipment, the director's first feature films lay down something of a blueprint based around Fraser and Meadows' experiences growing up in Uttoxeter. Both *TwentyFourSeven* (1997) and *A Room for Romeo Brass* (1999) combine serious social themes with naturalistic performances and colloquial humour. There is an authentically expressive vigour to the dialogue, and Meadows has retained an instinctive ear for the earthbound idiom of his characters. Both films also foreground a thematic preoccupation with male violence and fractious relationships between (real or symbolic) fathers and sons. Indeed, whether absent, inept or brutal, the problematic nature of fatherhood remains arguably the dominant ideological trope in his oeuvre. Despite the somewhat problematic marginalization of female characters in Meadows' worldview, the director is far from an unapologetic masculinist. Plagued by dysfunction and violent tendencies, masculinity in his films is invariably unsettled and often psychopathic. Veering incoherently between paternal gravitas, dope-fuelled homoeroticism, violent rage and childlike tears, Combo's (Stephen Graham) behaviour in *This is England* (2006) exemplifies the troubled state of contemporary British masculinity in Meadows' output.

Although *TwentyFourSeven* and *Romeo Brass* struggled at the box-office, they both showcased Meadows' distinctive talent. His third feature, *Once Upon a Time in the Midlands* (2002), had a substantial budget and high-profile stars including Robert Carlyle, Kathy Burke and Rhys Ifans, but with greater commercial backing came greater restrictions. Denied final cut and with a busy cast unwilling to commit to Meadows' lengthy improvisational workshops, the film's production was a frustrating and largely unhappy experience. A critical and commercial failure, *Once Upon a Time…* is, if not exactly the 'crock of shit' the director has claimed it to be, then certainly Meadows-lite. Yet while the film is undeniably whimsical, it typifies Meadows' conflation of social realism with free-wheeling humour and scatological absurdism. Heavily foregrounded in the promotional trailer, the image of Ricky Tomlinson gloriously enthroned on the lavatory is practically a signature shot. Elsewhere, a gleeful cameo by comedians Vic Reeves and Bob Mortimer underscores the film's generic status as a surreal suburban soap opera.

Meadows' defiant follow-up to the disappointment of *Once Upon a Time...* was the low-budget *Dead Man's Shoes* (2004), a striking and rapidly-shot exercise in British rural Gothic. The director's growing reputation amongst both critics and audiences was consolidated by the subsequent success of *This is England*, a 1980s-set coming-of-age drama about (amongst many other things) a group of young skinheads infiltrated by a far-right political ideologue. Although violent and disturbing, the charm and genuine richness of Meadows' work is most often found in the textural minutiae of both these films. These are worlds where pints of milky tea are supped from beer mugs and inept gangsters nod enthusiastically to pounding hip-hop whilst incongruously crammed into a tiny Citroen. A burgeoning relationship between teenagers in *This is England* is tender, awkwardly lustful and hilarious in equal measure. For aficionados, a culturally precise parting shot delivered to a beleaguered shopkeeper – 'Oh, and you're a mong!' – is amongst the most celebrated moments in Meadows' work.

Meadows' first film set outside the Midlands, *Somers Town* (2008), offered an optimistic riposte to the questions raised about racism and xenophobia in *This is England*. A typically 'Meadowsian' tale of two young men entering the perilous and emotionally fraught world of adulthood, *Somers Town* presents immigration and transnational flows as colourful solutions to the monochrome social problems and personal limitations of contemporary Britain. With a wistful magical-realist flourish, hard-working Polish migrants and beautiful French waitresses provide emotional and familial succour for Meadows' dislocated adolescent waifs. Like *Somers Town*, *Le Donk and Scor-Zay-Zee* (2009) offered a lightening of mood and a move away from the violence and more troublesome themes of Meadows' previous work. Based around the exploits of a character developed in short films, *Le Donk...* is an enjoyably daft faux-rockumentary featuring Considine as the eponymous 'Donk', a former roadie-turned-manager of a (real-life) white Nottingham rapper. Largely improvised and shot in just five days, *Le Donk...* is as bizarre, funny and insular as an in-joke between two men who have known each other since their teens ought to be. Seemingly throwaway, the film nevertheless carries a characteristically bittersweet edge. Donk is as delusional as any of Meadows' more unhinged male characters, but the attentive use of a gentle acoustic score carefully registers the sadness underlying his clownish, would-be rock 'n' roll persona. As in so many of Meadows' features the utopian 'happy ending' of *Le Donk...* seems curiously unreal and more akin to wish-fulfilment fantasy writ large. This may be indicative of Meadows' covert cynicism, his naïve sentimentality, or further evidence of the deep-rooted humanist sensibility underpinning his work. Given Meadows' creative restlessness, only time will tell.

Martin Fradley

Dead Man's Shoes

Studio/Distributor:

Warp Films
Big Arty Productions
Film4
Optimum Releasing

Director:

Shane Meadows

Producer:

Mark Herbert

Screenwriters:

Paddy Considine
Shane Meadows

Cinematographer:

Danny Cohen

Production Designer:

Adam Tomlinson

Composer:

Various Artists

Editors:

Celia Haining
Lucas Roche
Chris Wyatt

Duration:

90 minutes

Genre:

Crime

Cast:

Paddy Considine
Toby Kebbell
Gary Stretch
Stuart Wolfenden

Year:

2004

Synopsis

Richard is a disaffected soldier who returns to his hometown for one last mission: to track down the men who tormented Anthony, his younger brother with learning difficulties. One by one, Anthony's abusers – small time drug dealers, petty criminals and wannabe gangsters – fall prey to Richard as he seeks revenge. Paranoia and neurosis build to a final showdown set against the desolation of the rural Midlands landscape.

Critique

Arguably Meadows' most distinctive feature to date, the low-budget and largely improvised *Dead Man's Shoes* was conceived of as a personal riposte to the compromised production of *Once Upon a Time in the Midlands* (2002). Lurching between lairy humour, mournful visual poetry and genuinely disturbing moments of violence and psychological trauma, *Dead Man's Shoes* is a singular distillation of Meadows' under-appreciated talent for surreal social abstraction. While some critics found the rudimentary revenge plot overheated, *Dead Man's Shoes* is more productively understood as a neo-gothic psychodrama.

Shot in Derbyshire, Meadows' exacting sense of place has rarely felt more intuitive. Attentive to the brittle landscape's resonant spaces and overlooked textures, the film's stark imagery is as haunted as any of its guilt-ridden characters. As rural expanse encroaches upon the small town of Matlock, the sense of stasis and social decay is palpable. Meadows' social critique remains largely implicit in the world of *Dead Man's Shoes*. Its vision of life on the social and economic peripheries is almost hermetically sealed. Coupled with generic nods to the Western, the film's final image – a sweeping aerial shot of the Peak District ghost town – serves to underscore its unearthly conflation of metaphysical insularity, formal realism and mythic portent.

The richness of the film is found in the interaction between its characters. For example, a simultaneously grotesque and hilarious scene in which two low-grade drug dealers read aloud to each other from a dirty magazine acts as an appropriate litmus test for the viewer's susceptibility to the raw, earthy humour of life's minor players. In keeping with the film's moral relativism, dissolute rogues like Herbie (Stuart Wolfenden), Soz (Neil Bell), and ringleader Sonny (Gary Stretch) are increasingly sympathetic as their murderous antagonist wreaks his revenge. Elsewhere, Toby Kebbell is quietly impressive as Anthony, while Considine provides his unsmiling character with appropriately-focused yet unhinged menace. Broader political commentary is not entirely absent, however – one of the film's most uncanny images is that of Richard clad in a depersonalizing, military-issue gas mask. Violently disturbed, the mental health of this malevolent paratrooper is explicable in part by the trauma of his presumed service in the

Middle East. Richard's final acknowledgement – 'now I'm the monster' – underscores the film's thematic preoccupation with the violent return of the repressed.

If the troubling relationship between masculinity and violence remains a recurrent theme in Meadows' work, in *Dead Man's Shoes* it is augmented through shifting and disoriented psychological states – the sequence in which Richard ruthlessly spikes the gang's tea with powerful hallucinogens, for example, is rendered with unnerving accuracy. Expressionist touches are also to the fore, as in flashback sequences that are ambiguous in both origin and reliability. The viewer is never certain whether Anthony is a supernatural figure or one of Richard's unsound mental projections. The film's gothic ambience is underscored when a stoned Herbie tellingly describes Richard as 'like a ghost'. The film's dark tone is intensified by its diverse and tone-shifting soundtrack, helped, no doubt, by the fact that it was the first feature by Warp Films, aligned to Warp Records, who produced, and Chris Cunningham, responsible for music videos and documentaries such as *All Tomorrow's Parties* (2009). Warp also co-produced Meadows' modishly soundtracked *This is England* (2006) and produced the television spin-off series, *This is England '86* (2010). *Dead Man's Shoes* is unquestionably a mood piece, but it more than justifies Meadows' continued faith in his instinctive working methods.

Martin Fradley

This is England

Studio/Distributor:

Warp Films
Big Arty Productions
Film4/Optimum Releasing

Director:

Shane Meadows

Producers:

Mark Herbert
Louise Meadows

Screenwriter:

Shane Meadows

Cinematographer:

Danny Cohen

Production Designer:

Mark Leese

Synopsis

Summer, 1983. Twelve-year-old Shaun is lonely and grieving for his father who has been killed in the Falklands. When he meets a friendly local skinhead gang headed by Woody, Shaun is taken under their wing – he has his head shaved, gets a skinhead uniform, goes to parties and forms a relationship with an older Goth girl called Smell. All seems well until Combo – an intimidating, older skinhead with extreme political beliefs – is released from prison. Combo becomes a father figure to Shaun, but his return forces an abrupt split within the group, and Shaun's loyalties are torn.

Critique

With British military personnel occupying Iraq and Afghanistan and a resurgence of neo-fascist politics in Britain, *This is England*'s release in 2006 could hardly have been more timely, being a film about nationalism and the insidious promises of racist ideology set against the backdrop of a politically-divisive war. Meadows' resonant period piece takes an ambivalent but emotionally powerful look at the ideological and cultural schisms of the Thatcherite 1980s. *This is England* is an unsettling mixture of nostalgia and melancholy for an

Composer:

Various

Editor:

Chris Wyatt

Duration:

101 minutes

Genre:

Social Realism

Cast:

Stephen Graham
Vicky McClure
Andrew Shim
Thomas Turgoose

Year:

2006

era which functions as the social and political primal scene of contemporary Britain; appropriately, a strong sense of irresolution marks out the film's interrogation of the cyclical relationship between socio-economic disenfranchisement and political extremism. The contradictions of the period are showcased in an impressionistic opening montage. Bleak footage from the Falklands war and images of miners in violent clashes with riot police sit uneasily alongside snapshots of Duran Duran, Knight Rider and skinhead subculture. This discord sets the tone for the film, measuring as it does the rise of neo-liberal consensus against the fraught political conflict of the period. 'In 1983', Meadows wrote, 'people still cared about society as a whole but now they'll keep their mouth shut as long as they've got the house, the job and the car they want' (Meadows 2007) Ultimately, *This is England* returns to one of Meadows' favourite themes: the demise of social idealism.

Although widely interpreted as the director's first candidly political film, *This is England* is rarely didactic. The film opens with Shaun (Thomas Turgoose) symbolically 'waking up' to Thatcher's aggressive dogma broadcast on the radio, but the narrative itself is largely structured around two contrasting skinhead gangs. The steady decline of the Left in the 1980s is mapped across the semiotic guerrilla warfare of subcultural practice – the skinheads articulate class solidarity through DIY expressive forms such as graffiti and the skinhead uniform of workers clothes – donkey jackets, braces, denims, Dr Marten's boots, etc. *This is England* challenges the principle that skinhead culture is straightforwardly nationalist by showing the degradation of a progressive subculture rooted in Mod, Ska and two-tone harmonies to a thuggish extremism soundtracked by livid post-punk discord. In contrast to the grim isolationism of skinhead Combo (Stephen Graham) and the National Front supporters, the film celebrates the inclusive and pro-social skinhead collective headed by Woody (Joe Gilgun). Woody's gang, for example, inhabits democratic and municipal spaces: suburban streets, subway tunnels and swimming baths, whereas Combo's gang lurks in the shadows of grotty pubs and remote nationalist rallies. An expedition to vandalize disused council homes is the most joyous sequence in the film as Woody and the gang's gleeful rejection of dominant social and political values is undercut by the unselfconscious poignancy of their actions.

From the prominent 'Skrewdriver' graffiti to the multicultural sounds of Toots and the Maytals on the soundtrack, *This is England* insistently foregrounds the political battleground of 1980s' popular and sub-cultures. The final scene is scored by a suitably downbeat cover of 'Please Please Please Let Me Get What I Want' by The Smiths, whose lead singer Morrissey embodies many of the film's key themes. Himself a second-generation Irish immigrant, Morrissey's flirtations with right-wing imagery, political sideswipes at Thatcherism, dubious comments on race and immigration, ambivalent celebration of 'Englishness', and repeated questioning of traditional

forms of masculinity, make him a significantly incoherent figure who echoes the film's political and emotional contradictions. As Shaun silently stands on the shoreline at the very edge of England, gazing back at the audience, Turgoose's doleful eyes are both plaintive and accusatory.

Martin Fradley

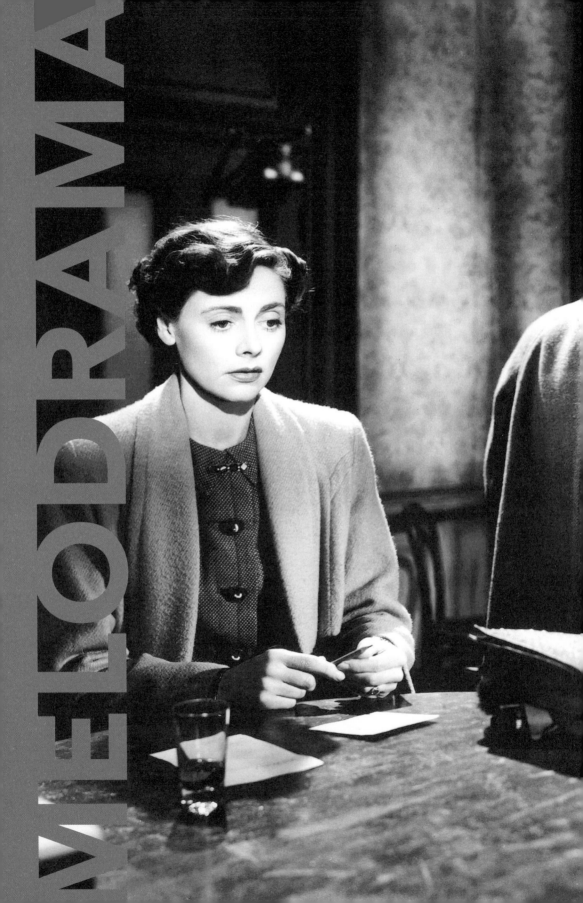

In the early decades of the British film industry, melodrama was a far from prevalent genre. In the 1920s and 1930s, there were significant attempts at producing romantic films – *Comin' Thro' the Rye* (Cecil Hepworth, 1924), for instance, or *Underground* (Anthony Asquith, 1928) – that sought to capture an essential Britishness, usually by exploiting distinctively British landscapes. Beyond this, it was films made at Gainsborough studios in the 1940s that first offered a characteristically British form of pure melodrama as distinct from romantic drama. At a time when cinema in Britain was beginning to enjoy international acclaim for its quasi-documentary dramas, Gainsborough popularized a form of lurid period melodrama that attracted audience popularity and critical derision in equal measure. Beginning with *The Man in Grey* (Leslie Arliss, 1943) and encompassing *Fanny by Gaslight* (Anthony Asquith, 1944), *Madonna of the Seven Moons* (Arthur Crabtree, 1944), *The Wicked Lady* (Leslie Arliss, 1945), *Caravan* (Arthur Crabtree, 1946) and *Jassy* (Bernard Knowles, 1947), Gainsborough's 'bodice-rippers' openly flaunted their excesses and blatant class and sexual conflicts in reminiscence of an archaic age of stage melodrama.

Ideas about sexuality in melodrama are typically tied up with social class. From *Brief Encounter* (David Lean, 1945) and *Madonna of the Seven Moons*, through the new wave films *Room at the Top* (Jack Clayton, 1958), *Saturday Night and Sunday Morning* (Karel Reisz, 1960) and *Alfie* (Lewis Gilbert, 1966), and on to *The Virgin and the Gypsy* (Christopher Miles, 1970), *The Go-Between* (Joseph Losey, 1971) and the social realist melodrama *Letter to Brezhnev* (Chris Bernard, 1985), open and voracious sexuality has tended to be equated with the working classes or with foreigners, and this has been factored into discussions of typical British mores and respectable middle-class reserve. However, as Robin Wood has noted: 'bourgeois sexual repression [finds its] inverse reflections in the myths of working class squalor and sexuality' (Wood 1986: 74). In the Gainsborough films in particular one finds such a dichotomy given full, excessive reign. Not, as may be imagined, to reinforce such stereotypes but, rather, to subtly question or challenge their veracity. This is true not simply of *Fanny by Gaslight*, in which the repository of (monstrous) sexuality is an aristocrat, but in *The Man in Grey* and *The Wicked Lady*, wherein upper-class masculinity is susceptible to, indeed falters markedly before, the intrusion of overt sexual allure. And despite the containment and restored order inherent in these films' conclusions, the very force of both the disturbance and the disavowal infers that overt sensuality is not a preserve of the proletariat: that, ultimately, such a class-based thematic represses as much as it reveals.

The films that followed immediately in Gainsborough's wake displayed that studio's influence in that they worked precise variations on its central melodramatic motifs and methodology – its triangular central relationships, florid visual style and intense, convoluted character psychology. *Black Narcissus* (Powell and Pressburger, 1947), *Saraband for Dead Lovers* (Basil Dearden, 1948), *Blanche Fury* (Marc Allégret, 1947), *The Red Shoes* (Powell and Pressburger, 1948) and *Gone to Earth* (Powell and Pressburger, 1950) all figure in this group,

Left: *Brief Encounter*, ITV Global/The Kobal Collection.

with the Archers films in particular offering perhaps the most overtly melodramatic British works ever made. Always stylistically audacious, expressionistic in *mise-en-scène*, and set in an enclosed, insular milieu in which pressure is directed inward and action becomes circumscribed as connotative of psychological malaise, each of the above films is built around fractured female subjectivity, around subtly modulated studies of women torn between opposing, dichotomous states of being: whether desire and repression in *Black Narcissus*, work and marriage in *The Red Shoes* or respectable middle-class married life and animalistic passion in *Gone to Earth*. The spectre of female death at the end of all three films attests to a fundamental tension and incompatibility within patriarchal society and culture, which the films variously represent, connote or thematize. It is a tension that relates to female desire, agency and autonomy, a thematic of excess (in the sense of an overreaching of perceived boundaries) that is mirrored in the films' *mise-en-scène* and that, like this style, cannot be recuperated into the dominant order.

Throughout the 1950s, excluding isolated and unsuccessful examples of the genre such as *The Gypsy and the Gentleman* (Joseph Losey, 1958), melodrama did not figure prominently in British cinema. It resurfaced only at the end of the decade with a new wave of young directors. The work of Lindsay Anderson, Tony Richardson and Karel Reisz has been conceptualized along numerous lines, specifically as a golden age of social realist cinema and a significant step toward a viable British art cinema. One term that does not typically figure in this discourse is melodrama, but it can be seen to figure predominantly in the movement, principally in their psychological and psychoanalytical scenarios, enacting as they do specifically Oedipal narratives of personal frustration and failure within a familial context.

As Geoffrey Nowell-Smith has noted, impaired masculinity is frequently central to melodrama: 'Patriarchal right is of central importance [but] he or she can only live out the impairment [that is] imposed by the law' (Nowell-Smith, 1987: 71–72). Joe Lampton in *Room at the Top* is exemplary of this paradigm. His trajectory concerns an overt wish to ascend to the symbolic law of the father, Mr Brown, whose phallic smoke stacks dominate the landscape of Warnsley where the film takes place. However, his successful fulfilment of this desire entails a figurative castration in accepting the containment of marriage to Brown's sexually-staid daughter, and an attendant entrapment within domesticity as an inheritor of the bourgeois familial line.

This is a denouement common to many new wave films. Arthur Seaton in *Saturday Night and Sunday Morning* does not desire the same class mobility as Joe Lampton, but his implicitly oedipal revolt against his father in immediate sensory gratification has the same result in containment within impending marriage and domesticity, and a curtailing of his overt sexuality. Although seemingly diametrically opposed on the surface, there is in fact a marked commonality and contrast with the Gainsborough melodramas here insofar as sex is ostensibly regarded as something to be suppressed within the institution of marriage and the family, with the prospective wives of Lampton and Seaton generally of a higher-class and both less forthcoming in their sexual availability.

A decidedly contrastive but nonetheless significant and prophetic film appeared at the end of the 1960s. In the wake of the new wave in Britain, *Women in Love* (Ken Russell, 1969) returned colourful excess to its melodramatic study of class, sexuality and gender and, in so doing, it pointed toward a new direction in the genre with literary adaptations drawn from the classic English canon. Adapted from the novel by DH Lawrence, Russell's film is directly concerned with questions of gender, desire and relationships. Through its four protagonists it traces a veritably diagrammatic map of ideas about love, marriage and sexual liberation, and of exactly how social mores can impact on individual subjectivity.

The following year, another Lawrence adaptation, *The Virgin and the Gypsy*, appeared, and that film further stands as paradigmatic of the pictures of repression, class and

sexuality inherent in the British melodrama. Indeed, with its story of a disaffected vicar's daughter and her dalliance with numerous outcasts in polite society (including a sexually-voracious gypsy and an unmarried bohemian couple living in sin) this picture could almost be an updated Gainsborough drama. It is, unlike *Women in Love*, a largely restrained and sober film, but one that culminates in a scene that exemplifies perfectly the mode of displaced, sublimated expression that characterizes melodrama in its most salient form. A huge cascade of water from a broken dam floods the vicar's middle-class home, in the process killing the stern elderly matriarch against whom the protagonist had rebelled and wrecking the building completely. It is an image redolent of the wave of desire released in the protagonist by her encounters with the gypsy, a wave that directly threatens the repressive environment of the religious middle-class home and literally washes away what are for her its restrictive mores (following the incident, she simply leaves the house and drives away with the bohemian couple). It is perhaps the key image of a key genre in the British canon: a canon that, as Tom Ryall points out, should be used as a popular idiom in constructions of British identity (Ryall 1997: 33–34).

Adam Bingham

Fanny by Gaslight

Studio/Distributor:

Gainsborough
General Film Distributors

Director:

Anthony Asquith

Screenwriter:

Doreen Montgomery

Producer:

Edward Black

Cinematographer:

Arthur Crabtree

Production Designer:

John Bryan

Composer:

Cedric Mallabey

Editor:

RE Dearing

Duration:

100 minutes

Genre:

Melodrama

Cast:

Phyllis Calvert
Stewart Granger
James Mason
Wilfrid Lawson

Year:

1944

Synopsis

As a young girl, Fanny Hopwood has no notion that her father runs a bordello. Even on returning from boarding school years later she remains ignorant of this family secret until a fight with an arrogant patron results in the patriarch's death. The fact that he ran a bordello becomes public knowledge, and Fanny is compelled to move away to the country home of a businessman, Clive Seymour, whom she learns is her real father. Fanny bonds with Seymour, but thereafter her relationship with his politician friend causes a scandal, leaving her precarious happiness hanging in the balance.

Critique

In 1943, *The Man in Grey* (Leslie Arliss) made an indelible mark on British cinema. The film was the inaugural example of what became a distinctively British form of melodrama that acquired the colloquial label 'the bodice-ripper'. *Fanny by Gaslight* represented a move to capitalize on this significant success, even reuniting three of *The Man in Grey's* four major stars (Margaret Lockwood being the missing party), and casting them in ostensibly comparable roles of the antagonistic aristocrat Lord Manderstoke (James Mason), the home-bound Fanny (Phyllis Calvert) and her romantic partner Harry Somerford (Stewart Granger).

Issues of class and sex figure strongly in *Fanny by Gaslight*, perhaps more markedly than in any other Gainsborough melodrama. Overt sexuality in this film generally leads to despair: beginning with the seedy bordello symbolically located directly beneath the comfortable Victorian family home, and then personified by Lord Manderstoke and the purely sexual fascination he excites in several women. *Fanny by Gaslight* also presents Manderstoke as an external manifestation of unconscious rampant appetites – the figurative dark side to both of Fanny's fathers and to her prospective husband. Fanny only turns to Manderstoke following the death of her fathers, thus inferring a familial, oedipal trajectory to her actions throughout the latter part of the narrative.

What further distinguishes Asquith's film from its generic peers at Gainsborough is its narrative methods. Instead of a straightforward linear story, *Fanny by Gaslight* progresses through a series of more or less compact sequences that play out almost like miniature soap operas. But the narrative is not overtly fragmented or discontinuous, rather, it is structured around a series of largely self-contained events and character arcs, in which Fanny encounters (and largely appears to overcome) a number of obstacles placed in her path. This method of plot construction underlines the protagonist's compartmentalized lives and identities (she is variously known as Fanny Hopwood, Fanny Whooper, even 'just Whooper') as she is shunted from one environment, one life, to another. Given that Fanny often remains passive, acted upon, this narrative form implicitly questions the various and variant forces that shape identity and self-hood, especially for women. Such a thematic concern is especially prevalent in the

film's final moments, which broadly prefigure Douglas Sirk's later Hollywood masterpiece *All that Heaven Allows* (1955). Following a threat to Fanny's partner's life – a partner she had previously been persuaded to give up – the narrative captures perfectly a sense of the personal and fateful circumstances that have an effect on female agency in such oppressive social conditions.

While it might seem reactionary to position femininity merely as the arbiter of domestic values, home and family, one of melodrama's chief functions has typically been to expose ideological contradictions. In *Fanny by Gaslight* the necessity of eliminating Lord Manderstoke's rampant sexuality underlines the notion that romantic and domestic stability depends on suppression and repression (for Freud, of course, they were necessary for subjectivity). Moreover, the very force of this disavowal, especially following Somerford's acquiescence to Manderstoke's behaviour in fighting a duel, suggests an irrational fear of what Manderstoke represents. This fear, perhaps, is that the force of sexuality cannot be neatly assuaged and disassociated from because it lies within as much as without. In this respect at least, *Fanny by Gaslight* is exemplary of the genre, and is a particularly fascinating test case for British melodrama as contrasted with its development in Hollywood in the ensuing decades.

Adam Bingham

Brief Encounter

Studio/Distributor:
Cineguild/Eagle-Lion

Director:
David Lean

Screenwriters:
Noël Coward
Anthony Havelock-Allan
David Lean

Producer:
Noël Coward

Cinematographer:
Robert Krasker

Production Designer:
LP Williams

Editor:
Jack Harris

Duration:
86 minutes

Synopsis

In a train station café, Laura and Alec are restrainedly heartbroken over what appears to be their final moments together before Alec leaves the country. On returning home, Laura sits desolately with her husband Fred and imagines confessing to him the story of her time with Alec. She met Alec at the same railway station café some weeks earlier and, over the course of meeting one another every Thursday, their mutual attraction grew into true and deep love. Alec and Laura became terrified of their adulterous feelings, however, and spent their brief encounters together in longing, distress and uncertainty.

Critique

Brief Encounter is based on *Still Life*, Noël Coward's 1936 one act play – part of a portmanteau piece entitled *Tonight 8:30* which is amongst the prolific playwright's most personal and popular works. The film adaptation has similarly become a standard, not only in the repertoire of British screen melodrama but in British national cinema in general, remaining as it does an ambivalent touchstone for, and a bold paradigm of, a defining era in its history and development.

This ambivalence characterizes the film's reputation and critical stature rather than its artistry. Once heralded as a key example of

Genre:

Melodrama

Cast:

Joyce Carey
Stanley Holloway
Trevor Howard
Celia Johnson

Year:

1945

screen verisimilitude, and continually championed by scholars such as Richard Dyer, it has at the same time been vilified for its stereotypical Britishness, its portrait of middle-class reserve and repression. Indeed, by the time of the British New Wave a little over a decade later, it was already implicitly positioned as a paragon of the kind of cinema that Tony Richardson, Lindsay Anderson et al. were vehemently reacting against. As such, it was countered and opposed in works like *Look Back in Anger* (Tony Richardson, 1959) and especially *Saturday Night and Sunday Morning* (Karel Reisz, 1960), whose openly sensual depiction of a housewife's adultery stresses physicality over emotion, the easy satiation of the flesh without any attendant feelings of guilt or remorse.

Beside this, Lean fascinatingly problematizes the generic identity of *Brief Encounter*. Its status as overt melodrama resides in Laura's entrapment in her middle-class home, and within the attendant patriarchal constructions of femininity that are placed upon her (wife and mother rather than woman). And though the film's style may have been perceived as naturalistic, in keeping with the dominant idiom of the time, this is in fact misleading. A number of the (largely happy) scenes in the town are filmed naturalistically, but these are explicitly contrasted with an equal assemblage of stylized moments at the railway, in which cinematographer Robert Krasker (*The Third Man*, Carol Reed, 1949) employs an expressionistic noir register of high contrast/low key lighting and sharp, canted compositions to suggest Laura's (Celia Johnson) interior turmoil and instability, her world thrown out of kilter.

The flashback structure of the narrative may also be taken as prototypical film noir, especially of the confessional mode that characterizes such canonical works as *Double Indemnity* (Billy Wilder, 1944) and *Out of the Past* (Jacques Tourneur, 1947). The personal recollections of these works' protagonists serve as an index of their attempts to wrest a measure of mastery and personal agency from a situation (usually related to an illicit affair) that has spiralled out of control. It is as though their appropriation of the function of storyteller can restore to them distance and empowerment; and Laura's trajectory in *Brief Encounter* is clearly comparable, her interior dialogue all the more fascinating for remaining just that, a story that cannot be told.

Brief Encounter should be venerated for offering the first significant post-war vision: a film in which the world beyond the purely personal remains distant. It is about interiority and psychological malaise, with the contrastive modes of melodrama and film noir appropriated as symbolic of subjective states, of a romance that throws a character's world out of kilter. Such film literacy adds another layer to the narrative; and arises from Laura's regular cinema-going, which informs her (deliberately) clichéd imagining of a European holiday with Alec (Trevor Howard). This intertextuality of vision makes *Brief Encounter* a film ahead of, rather than exemplary of, its time, and far from the clichéd picture of Britishness it has been taken to be.

Adam Bingham

Great Expectations

Studio/Distributor:
Cineguild/General Film
Distributors

Director:
David Lean

Producer:
Ronald Neame

Screenwriters:
Anthony Havelock-Allan
David Lean
Cecil McGivern
Ronald Neame
Kay Walsh, from Charles
Dickens' novel

Cinematographer:
Guy Green

Art Director:
John Bryan

Composer:
Walter Goehr

Editor:
Jack Harris

Duration:
118 minutes

Genre:
Melodrama
Heritage

Cast:
Valerie Hobson
Martita Hunt
John Mills
Jean Simmons
Anthony Wager

Year:
1946

Synopsis

Pip, an impoverished orphan, encounters an escaped convict one night in a churchyard. The convict threatens to kill Pip if he does not bring him food and a file to release his chains. When Pip returns home he is beaten and berated by his sister, who sees the boy as a burden. Despite his fear, Pip returns to the convict only to find he has been recaptured. Pip is invited to the mansion of eccentric spinster Miss Havisham, where he becomes entranced by Estella, her ward, and falls in love with her despite her coldness towards him. When Pip turns 14 he leaves the mansion for an apprenticeship as a blacksmith. Several years pass when Pip is visited by Jaggers, Miss Havisham's lawyer, who informs him that a mysterious benefactor has provided the means for him to become a rich gentleman, one with great expectations.

Critique

Great Expectations was the first of David Lean's Dickens adaptations, closely followed by *Oliver Twist* (1948). To condense the narrative for the screen, Lean omitted some characters and plot-lines, but this ultimately resulted in a respected and revered adaptation that has become a much-loved classic. Guy Green, whose impressive cinematography contributed to other Lean productions, such as *In Which We Serve* (1942) and *This Happy Breed* (1944), deservedly won an Oscar for his work on *Great Expectations*. Green's skill is most evident in the opening churchyard scene between Pip (Anthony Wager) and the convict Magwitch (Finlay Currie) – the camera pan over the cold, desolate marshes and bleak churchyard maintains an intensity and suspense comparable to techniques of German Expressionist film-making.

Like many Dickens' stories, *Great Expectations* follows Pip from childhood to adulthood, and the younger actors in Lean's film give convincing portrayals. Anthony Wager as the young Pip plays the part with such sincerity that the appearance of John Mills as the adult Pip seems somewhat disjointed – Mills, at the age of 38, was also rather too old to play the character. Similarly, 17-year-old Jean Simmons, in her first film role, gave such a convincing portrayal of the cold and distant young Estella that Valeria Hobson's performance as the older Estella appears to be that of a different character.

Martita Hunt, as the eccentric spinster Miss Havisham, had played the part in stage adaptation and very effectively transferred her role to the screen. The famous scene in Havisham's sprawling, decrepit mansion where she shows the young Pip her decayed wedding cake, and tells of how time has stood still since her fiancé abandoned her, is chillingly melancholic. Many reviewers compare Hunt's Havisham to Billy Wilder's 1950 classic *Sunset Boulevard* in which the main character, Joe Gillis, even refers to Havisham.

Great Expectations has magnificent performances from the supporting cast. Alec Guinness, as Herbert Pocket, is an amiable comic

foil to Mills' Pip, and Francis L Sullivan as Mr Jaggers is the quintessential pompous oaf, a recurring figure in Dickens' work. Finlay Currie playing Abel Magwitch gives a performance of depth, with his imposing voice and presence running from sinister to heartfelt.

Lean's film drew on the substance of Dickens' novel that, in its themes of fate, regret and guilt, is clearly about class divide in Victorian Britain. Lean's film had great significance at the time of its release, just after the end of WWII, in speaking to the sense of uncertainty, financial hardship, loss, grief and hope that pervaded Britain in the mid 1940s. As in much English literature, and Lean's classic melodrama *Brief Encounter* (1945), there is a sense of romantic fatalism about *Great Expectations* in that the famous British reserve prevents characters from finding their 'happily ever after.'

Michael King

The Pumpkin Eater

Studio/Distributor:
Romulus Films
Columbia

Director:
Jack Clayton

Producer:
James Woolf

Screenwriter:
Harold Pinter

Cinematographer:
Oswald Morris

Production Designer:
Edward Marshall

Editor:
James Clark

Composer:
Georges Delerue

Duration:
118 minutes

Cast:
Anne Bancroft
Peter Finch
James Mason

Synopsis

Jo Armitage, a mother of seven children from two marriages, divorces her second husband, Giles, after meeting his friend, Jake. Jo and Jake quickly marry, although their relationship is strained. Jake is a successful screenwriter and provides for his large family, but he has extramarital affairs. He also sends the children sent away to boarding school, undermining Jo's stability and leaving her an unhappy, directionless housewife. After an unplanned child of their own is born, and an incident with a mentally-unbalanced woman, Jo seeks psychiatric help. She declines to travel with Jake when he goes to Morocco on business, and agrees to have herself sterilized, preventing any further children. Jack's obnoxious friend Conway informs her that Jake has been carrying on an affair with his wife, Beth. The resulting fight between Jo and Jake leads her running back to Giles. But when Jake's father dies, Jo resumes contact with him, risking another nervous breakdown.

Critique

In recent decades it has become a routine fascination within British cinema to deconstruct the middle classes – to turn over pleasant-looking stones and then poke at whatever is beneath with sticks sharp enough to draw blood. This tendency reached a peak early on with *The Pumpkin Eater*. Anne Bancroft stands proudly but not happily at the forefront of a gathering of some of Britain's finest talents – her co-stars Peter Finch and James Mason, the director Jack Clayton, and the single greatest destroyer of middle-class illusions, the playwright and screenwriter Harold Pinter. Bancroft's award-nominated performance is a tour de force of subtlety and economy. Jo is burdened with poor taste in men, poor impulse-control to match, and a growing legion of sons and daughters. Bancroft depicts Jo's decline into confusion, depression, desperation, and

Genre:

Drama

Year:

1964

something akin to madness, and becoming a singularity of pain: a star collapsing in on herself.

It is in that vein that *The Pumpkin Eater* rejects traditional forms of sentiment. Clayton's direction has the sharp, almost visceral look and feel of a French New Wave film that is almost divorced from British traditions. Cinematographer Oswald Morris uses the black and white photography to make the characters' unhappiness all the

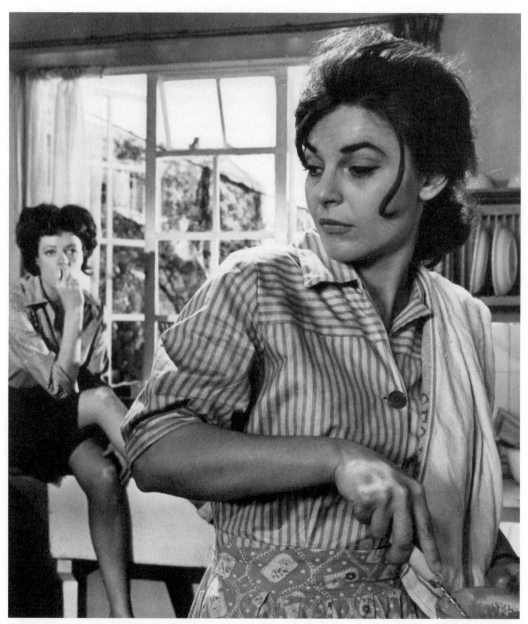

The Pumpkin Eater, Columbia/The Kobal Collection.

more stark, their eyes struggling to find sparks of life, their futures barren. Underpinning it all is the seething black heart of Harold Pinter's script – an efficient adaptation of Penelope Mortimer's semi-autobiographical novel. Pinter never troubles himself with why these characters might be so beastly, or whether or not they might live happily ever after. Tellingly, in a story about a woman with so many children, the kids themselves are not given much screen time beyond acting as plot devices or particularly noisy set decoration. They are not needed. The adults are more than childish enough on their own, and their petty games of power and control guarantee their unhappiness.

In one particularly mesmerizing scene at a beauty parlour, Jo and another woman strike up a conversation. What could be normal chatter quickly dissolves into menace and madness, with the woman's face threatening to crack as she hisses thuggish threats and informs Jo that her nails are capable of ripping open human flesh. That the middle classes are an unhappy lot under the skin is beyond cliché, but *The Pumpkin Eater* asks: are these people unhappy or sociopathic? Does one breed the other? Is it ultimately anyone's fault but their own? In the world of *The Pumpkin Eater*, the answers are never perfectly clear. It is the asking that is important – the ripping open of flesh to let confusion, insecurity and cruelty spill out. Along with the likes of *This Sporting Life* (Lyndsay Anderson, 1963), this film is almost the start of a new British film tradition, which endures to this day in everyone from Mike Leigh to Andrea Arnold. Anne Bancroft is effortlessly glamorous, yes. But as Jo, her pain and problems are not the stuff of Hollywood, but of life in modern Britain.

Patrick Tobin

Darling

Studio/Distributor:
Appia
Vic Films/Anglo-Amalgamated
Film Distributors

Director:
John Schlesinger

Producer:
Joseph Janni

Screenwriter:
Frederic Raphael

Cinematographer:
Ken Higgins

Synopsis

In voice-over narration, model and 'It Girl' Diana Scott tells her tale to a magazine journalist, sugar-coating the truth shown on film. Her story begins in earnest when she starts an affair with broadcaster and intellectual Robert, the pair of them leaving their spouses and setting up home in the West End. Diana, reluctant to remarry, soon gets entangled with advertising executive Miles who helps her get into acting. Robert dislikes Diana's new 'smart-set' friends; she is easily bored and, after an abortion he handles badly, they drift apart. Miles pushes their fling a step too far by taking Diana to an orgy in Paris. Long suspicious, Robert uncovers the affair and leaves. Diana holidays in the Mediterranean with new gay best friend Malcolm. Despite her professional success, she feels something is missing and reaches a spiritual crisis, finally accepting a marriage proposal from an Italian prince. Realizing her mistake, she attempts to rectify it.

Production Designer:
Ray Simm

Composer:
John Dankworth

Editor:
James Clark

Duration:
128 minutes

Genre:
Melodrama

Cast:
Dirk Bogarde
Julie Christie
Laurence Harvey

Year:
1965

Critique

Darling begins with a poster of starving African children being papered over by the face of a fashion model, Diana Scott (Julie Christie), and ends with the same model condemned to life as an Italian princess – and the viewer feeling sorry for her. Contemporary critics accused the film's authors, John Schlesinger and screenwriter Frederic Raphael, of lacking a clear attitude toward their material – 'stylistic dissonance', according to Kenneth Tynan (Tynan 1965: 24) – a point they largely conceded once the Oscars had been handed out. *Darling* succeeds in portraying a world in which a fixed outside perspective is difficult to obtain; and it, too, is part of that world. Could it be otherwise? If Diana's rise through Swinging London is built on the betrayal of personal bonds, the crux of Raphael's satire is that her fall results from her hunger for permanence.

A panorama of Britain during the post-war Long Boom in the style of *La Dolce Vita* (Federico Fellini, 1960), *Darling* comprises a series of vignettes of elites old, new, and hybridized, from the Surrey suburbs whence Diana came, through Mayfair galleries and television studios, to Fellini country itself. Outside Rome on a commercial shoot at a Renaissance palazzo owned by her husband-to-be, Diana thinks she has found that elusive 'sense of eternity'. (It is a compound joke: early on, her first husband is seen learning Italian, to her bored disdain.) Raphael's highly-polished dialogue, particularly from the mouth of ad-man Miles (Laurence Harvey), is in itself an indictment of the society that produced it, and of the general tone of artificiality – Raphael himself called the film a superficial take on superficiality. Yet it makes Christie's revelatory naturalness all the more affecting by contrast.

Diana's voiceover narration, presented as an interview given to a popular magazine journalist, is used intermittently to euphemize the action on screen, as when she calls her fellow attendees at a Parisian orgy 'emotionally inquisitive', and Schlesinger's *mise-en-scène* at its best does something similar. The most effective instance of an under-used tactic comes in the first shots of Miles' Antonionian apartment block *moderne*, the camera tracking in sympathy with its clean lines before coming to a halt on two posters of an oil refinery. A time capsule of modish decor, the apartment block also suggests the world of industrial production – as seen in Schlesinger's earlier films – that underpins Diana and Miles' synthetic bubble of conspicuous consumption.

Again hinting at another world, Schlesinger cast one of his Oxford tutors, Hugo Dyson, as Walter Southgate, a Leavis-esque opponent of everything else the film represents. Lionized by mass media intellectual Robert (Dirk Bogarde), on his death Southgate is mourned, again suggesting Schlesinger's *A Kind of Loving* (1962), as the last of the 'regional tradition of English literature' – and so a source of the 'permanent values' Robert's life otherwise lacks. It is one of the film's richer ironies that it is on television, and by the metropolitan cognoscenti he despises, that Southgate is so honoured, and his tradition sustained.

Henry K Miller

The Go-Between

Studio/Distributor:
Columbia/MGM-EMI

Director:
Joseph Losey

Screenwriter:
Harold Pinter

Producers:
John Heyman
Norman Priggen
Robert Velaise

Cinematographer:
Gerry Fisher

Production Designer:
Carmen Dillon

Composer:
Michael Legrand

Editor:
Reginald Beck

Duration:
113 minutes

Genre:
Melodrama

Cast:
Alan Bates
Julie Christie
Edward Fox
Dominic Guard

Year:
1971

Synopsis

In Brandham, a large country house, a young boy named Leo is spending the summer with his friend's family. Over the course of a very hot July, Leo becomes particularly fond of Marian, his friend's older sister. And after making the acquaintance of a local farmer, Ted Burgess, Leo begins to courier private letters back and forth between Ted and Marian. On learning the nature of their secret correspondences, Leo's feelings begin to change. But as Marian's wedding to a local Viscount approaches, the estranged couple have even greater need of his help.

Critique

The Go-Between, adapted from LP Hartley's semi-autobiographical 1953 novel, takes its place in the British melodramatic canon in a number of ways. For example, it is an exploration of class and social stratification. It is also a companion piece to *Brief Encounter* (David Lean, 1945) in that both employ an alinear structure to tell the story of an intense love affair, and map out their illicit unions through a naive consciousness.

The Go-Between was Harold Pinter's third and final collaboration with the blacklisted ex-pat American director Joseph Losey after *The Servant* (1963) and *Accident* (1967). The job of adapting the novel was not only one of condensing the narrative but of reconfiguring it. Hartley's novel is an exploration of class and social stratification, of obsession, oppression and repression. It is a self-reflexive literary text, narrated in the first person, and concerned with the power of language to embellish and augment, create or subvert, 'reality' – hence the fervent letter-writing, the florid names and descriptions that define the insular world of schoolboys, etc. In what is arguably his sparsest screenplay, Pinter stripped away much of this literary theme so that the adaptation emphasizes the immediate, sensory realm endemic to cinema. For most of the narrative there are only snatches of a voice-over (just single lines such as the novel's opening refrain), and a sporadic, brief intercutting of scenes featuring the aged Leo back at Brandham to establish a past tense. Unlike *Brief Encounter* or Hartley's novel, the structure is built around flashforwards rather than flashbacks, with its precise location in time rendered ambiguous.

Indeed, time in *The Go-Between* is fluid, bleeding back and forth between eras and memories, creating tension between seeing and re-seeing, immediacy and distance. This is a correlative of the typical melodramatic conflict between the surface and what lies beneath, between expression and repression. It is here that the class thematic emerges most overtly. Losey and Pinter had already worked through several coruscating studies of class divide in Britain, and in *The Go-Between* they also explore the psychological import that is another defining feature of melodrama. The film can be thought of in terms of the id and superego made manifest, less in the personas of the central characters than in the contrast

between the repressive upper-class strictures and the open sexuality of the workers – more than one character talks of Ted Burgess' (Alan Bates) voracious appetites in this respect.

The Go-Between won the Palme d'Or at the 1971 Cannes Film Festival, ahead of that year's favourite, *Death in Venice* (Luchino Visconti, 1970). It is in many ways a summation of Losey and Pinter's collaboration, taking the inter-personal class conflict and corrosive power play of *The Servant* and the languid, dreamlike and subjective atmosphere of *Accident* and making a film that is more comfortable in its assumed genre. It is also less self-conscious in its construction of a British art film modelled after the Italian, specifically Antonioni. Given its treatment of fallible memory and the past's construction by the present, *The Go-Between* clearly stands in place of the adaptation of Marcel Proust's 1913 novel *À la recherche du temps perdu* that the writer and director wanted to make together, and for which an unrealised script was written.

Adam Bingham

Miss Julie

Studio/Distributor:
United Artists
Optimum Releasing

Director:
Mike Figgis

Screenwriter:
Helen Cooper

Producers:
Mike Figgis
Harriet Cruickshank

Cinematographer:
Benoît Delhomme

Production Designer:
Michael Howells

Composer:
Mike Figgis

Editor:
Matthew Wood

Duration:
97 minutes

Genre:
Melodrama

Synopsis

During Midsummer's Night at a manor house in northern Sweden in 1894, the Count's daughter, Miss Julie, has joined her servants in dancing. She berates the footman, Jean, who is engaged to a cook named Christine, for not dancing again with her. Miss Julie deigns to spend the night talking in the kitchen with Jean whilst Christine is sleeping, discussing their lives of poverty and privilege, and their dreams. However, following an incident wherein they hide from the other servants, Jean and Julie have sex, and thereafter begin to argue ferociously over their feelings and actions, and plans are made for the pair to flee the estate.

Critique

August Strindberg's 1888 play *Fröken Julie* cast a significant shadow over the artistic landscape of the twentieth century, not only in the dramatist's native Sweden but also in a number of different countries and across several mediums. Given its pervasive class-based thematic, Britain unsurprisingly figured prominently among those countries. Strindberg's play influenced British playwrights including John Osborne and Alan Ayckbourn, and Patrick Marber and Zinnie Harris have updated the play and transposed the action to Britain.

Mike Figgis' 1999 adaptation of *Miss Julie* is a faithful, claustrophobic chamber drama that retains the focus of Strindberg's (almost) single set. However, it is not mere filmed theatre, as was John Glenister and Robin Phillips' 1972 production featuring Helen Mirren and Donal McCann. Figgis freely intersperses the modes and paradigms of both stage and screen, not only employing the tenets of each but also subtly using them to particular effect. The

Miss Julie, Red Mullet Prod/The Kobal Collection/Mike Figgis.

Cast:

Saffron Burrows
Tam Dean Burn
Maria Doyle Kennedy
Peter Mullan

Year:

1999

setting of the kitchen is an overtly-theatrical space, with marked entrances and exits that rupture the action and relationships. Either separately, as in the opening act when Miss Julie (Saffron Burrows) storms in to confront Jean (Peter Mullan), or together, as in the central scene when the drunken servants pour into the kitchen, Jean and Miss Julie are continually interrupted *in medias res*. The invasion of their space is a potent symbol of the breaking of barriers and boundaries that lies at the heart of the narrative.

Figgis, though, opens out the film visually. He employs a contrasting variety of wide- and narrow-angle lenses, long shots and claustrophobic close-ups, static and hand-held mobile takes to connote the clash of two mutually-exclusive lives. Moreover, he visually denotes the importance of the animalistic sex scene between Miss Julie and Jean, as well as its violent power struggle, by abruptly changing the aspect ratio and employing a split screen to show both protagonists at one and the same time, together but visually wrenched apart, close in flesh but not in spirit.

The implied confinement of the film's setting entraps the protagonists as completely as the cage around Miss Julie's beloved pet bird. It is an enclosed world that, despite all the flagrant talk of escape and of social mobility, of flight and of movement, remains entrenched in archaic strictures of class and sex that have been internalized by both Julie and Jean.

Figgis bucks the trend of his peers and refuses to transpose the material; the film, like the play, is very specific about its time and place – Midsummer's Eve, Northern Sweden, 1894. The midsummer's eve setting is an important facet of Swedish life, as seen in films like *Sommarnattens leende/Smiles of a Summer Night* (Ingmar Bergman, 1955). In *Miss Julie* it becomes redolent of an actual, albeit temporary, transformative process. It is a privileged night when boundaries between master and servant are overturned and normalcy is obliterated to allow a cathartic outpouring of jubilant, overzealous feelings.

Familial, sexual, gender and class-based struggles occupy the central battleground of the melodrama genre. Few texts so comprehensively encompass them all, and few adaptations match Figgis' ambition and intelligence in understanding and reflecting their significance.

Adam Bingham

The British crime film is frequently ignored by the scholarly community, although certainly not by the cinema-going public. In their edited collection on the British crime film (perhaps the only comprehensive collection of its kind), Steve Chibnall and Robert Murphy describe the genre's reputation as 'lost in a limbo between half-baked realism and lukewarm melodrama' (Chibnall and Murphy 1999: 2). Relegating the British crime film to critical purgatory persists, despite recent British film-makers such as Guy Ritchie working successfully in the genre.

Some of this unwillingness to engage with the British crime film may be due to the nebulous nature of the term 'crime genre' itself. As Raymond Durgnat has pointed out, the crime genre is difficult to define and to locate – after all, many films feature crimes of one kind or another, from Stoll Picture Productions' 1920s' Sherlock Holmes adaptations to *Trainspotting* (Danny Boyle, 1996). It is important to note that no genre category is stable, least of all crime, and that many sub-genres and cycles can be grouped under the category of crime – from the 'spiv', or black market racketeer, cycle of the 1940s such as *Waterloo Road* (Sidney Gilliat, 1944) to classic heist films like *The Italian Job* (Peter Collinson, 1969), to the postmodern gangster film typified by Guy Ritchie's *Lock, Stock and Two Smoking Barrels* (Guy Ritchie, 1998).

One might ask, then, what makes a crime film 'British', and there is, of course, no definitive answer. Durgnat suggests the British 'style' of violence may be more subtle than the direct Hollywood approach (Durgnat 2009: 251), and there is also a tendency to regard Alfred Hitchcock's films as characteristic of the British crime genre. Yet the shifting contexts of British life, the influence of British literary and theatrical traditions, and the history of the British film industry undoubtedly affect British crime films. Taking into account both the films and their contexts, there are, perhaps, two effective litmus tests by which to gauge the 'Britishness' of a crime film: its complex entanglement with Hollywood crime films, and its negation of particularly British forms of masculinity.

Raymond Chandler, the hardboiled writer and critic often considered the 'high priest' of the crime genre, was scathing in his criticism of British crime traditions exactly for their 'Britishness'. His call for realism involved taking crime out of the – presumably unrealistic – settings of British drawing rooms of 'Cheesecake Manor' and putting it back on the (American) streets where it belongs (Chandler 1979:9). His influential essay 'The Simple Art of Murder' is an indictment against the upper-class, cerebral, refined, and 'feminine' crime stories he associated with 'Britishness'. Chandler describes iconic British crime authors such as Agatha Christie, and characters such as Sherlock Holmes, as out of touch with the people. Chandler makes the basic and pervasive assumption that the American hardboiled crime genre, a profound influence on film noir, is in direct opposition to British 'lady-like' conventions of writers such as Dorothy Sayers, whose readers 'like their murders scented with magnolia blossoms and do not care to be reminded that murder is an act of infinite cruelty' (Chandler 1979:13). There is something absurd about this pervasive opposition between

Left: *The Third Man*, London Films/The Kobal Collection.

macabre British ladies consuming murder stories and the hard American men living them.

Yet British crime films have always been at home on the 'mean streets'. What could be a more formative crucible of criminal manhood than the London that Andrew Spicer describes: 'the mythologized metropolitan demimonde of Soho, the "square mile of vice", or the East End...[London is] a city at once sharply contemporary, and also Gothic, deriving from Dickens, and Thomson's "city of dreadful night"' (Spicer 2001:126). Despite common opinions to the contrary, comparing British with American models of crime is over simplistic. British crime films have always been produced amid fears of American cultural imperialism, and under the watchful eyes of the censors – from the inception of the British Board of Film Censors (BBFC) in 1913 to the 'video nasties' debates of the 1980s. Michael Powell's 1960 film *Peeping Tom* sparked a firestorm of outrage for its brutal sexualized murder, and its insistence on making the audience complicit in its voyeurism.

One main concern has been with the potentially corroding influence of Hollywood violence on British society. Yet the British crime genre most clearly distinguishes itself from its Hollywood counterparts in its representations of criminality and of heroism. While the man on the right side of Her Majesty's law – Sherlock Holmes or PC Dixon in Basil Dearden's *The Blue Lamp*, 1949 – embodies ideals of gentlemanly stoicism; more compelling, and perhaps more resonant, are their adversaries and dark doubles: the cosh boys, the wide boys, the delinquents, cat burglars, spivs, hoodies, psychopaths and mockney gangsters. British criminal masculinity can be powerful, often erotically charged. The so-called crisis in masculinity which men in crime films face is often read as symptomatic of wider social problems, for example the juvenile delinquent is often read as created by the lack of father figures in the wake of WWII.

Spicer and others have identified several archetypes of masculinity that provide a cornerstone of the British crime genre. Typical, although not necessarily canonical, British crime films *Peeping Tom* (Michael Powell, 1960), *The Italian Job* (Peter Collinson, 1969) and Sherlock Holmes adaptations are excellent representatives of many of these types. Fascination with criminal masculinity can be imagined on a sliding scale of pathology: from the irascible and loveable two-bit thief to the serial killer. In *Peeping Tom*, Mark Lewis is just such a serial killer, a disturbed and disturbing psychopath driven to desire/murder by his biologist father's cruel and invasive experiments. Like Norman Bates in Hitchcock's *Psycho* (released the same year), Mark is a formative character in the mythology of the serial killer – an archetype of white criminal masculinity that has come to dominate the crime genre. He is shown as shy and polite but unable to fight his murderous drives – confusing his sexual desire with his violent impulses, he is driven to film women as he kills them.

On a less sinister note, Michael Caine's Charlie Croker has all the well-dressed bravado of the spiv, and embodies a good measure of the globe-trotting spy-hero's charisma. Croker is also the satirical, comic double of another of Caine's criminal roles, Jack in the darker film *Get Carter*. Caine has played some of British (and Hollywood) cinema's best known, loved and reviled characters – from bit roles in the BBC's *Dixon of Dock Green* (1955–1976) to the protagonist in *Alfie* (Lewis Gilbert, 1966). Caine's embodiment of a working-class London masculinity is self-consciously highlighted in *The Italian Job*; Charlie Croker draws our attention to the fact that criminal masculinity is a seductive performance at the heart of the genre.

Finally, as perhaps the most well-known British character of the crime genre, Sherlock Holmes' many incarnations incorporate several British archetypes: from Basil Rathbone's memorable performance opposite a bumbling Dr Watson, to Jeremy Brett's intense gentleman investigator on ITV, to Michael Caine's parody of Sherlock Holmes in *Without a Clue* (Thom Eberhardt, 1988), to American actor Robert Downy Jr's reinvention of Holmes

as bare-knuckle boxer and damaged genius. Holmes, one of the very first forensic investigators, has sustained such longevity because he couples cerebral, upper-class gentility with action and adventure.

The British crime film registers the fears and fantasies of the nation that produces and watches it. Because of the high stakes of the genre (murder, violence, the letter of the law), and because of its consistent popularity with British audiences, the crime genre provides a barometer for analysing the shifting dynamics of British culture.

Lindsay Steenberg

The Adventures of Sherlock Holmes (Series)

Studio/Distributor:
Stoll Picture Productions

Director:
Maurice Elvey

Screenwriter:
William J Elliott

Cinematographer:
Germain Burger

Production Designer:
Walter Murton

Duration:
15 episodes (between 1800ft to 2610ft each)

Genre:
Crime

Cast:
Arthur Bell
Madame d'Esterre
Eille Norwood
Hubert Willis

Year:
1921

Synopsis

Consulting detective Sherlock Holmes solves a number of different crimes, assisted (and occasionally hindered) by his faithful friend Dr Watson and Inspector Lestrade of Scotland Yard. Holmes and his companions investigate mysteries such as the case of the stolen beryl coronet, the murder of the Honourable Ronald Adair, the secret of the man with a twisted lip, and the case of Mary Sutherland's disappearing bridegroom, Hosmer Angel. Drawing upon his incredible powers of observation and his extensive skills of disguise, Holmes is largely successful. He is bested just once, when he meets his match in the enchanting actor Irene Adair, former mistress of the King of Bohemia.

Critique

With *The Adventures of Sherlock Holmes*, director Maurice Elvey and screenwriter William J Elliott found the ideal format for the cinematic presentation of Sir Arthur Conan Doyle's famous detective stories. Each episode of the 15-part series tells a compact, self-contained story, with cases selected from across Conan Doyle's oeuvre to tell a varied range of stories and offer a range of cinematic pleasures.

Eille Norwood was one of the first British actors to portray the legendary detective onscreen. Norwood took the part very seriously, even shaving his hair to create the distinctive high forehead portrayed by Holmes' most famous illustrator, Sidney Paget. As a trained stage actor, Norwood also created his own make-up for the numerous disguises that Holmes adopts during the course of the series. These include a doddering parson, a decrepit opium addict and a shabby tramp. Conan Doyle himself spoke approvingly of Norwood, finding his performance glamorous and compelling.

The series is notable for the way in which its episodes are structured. Earlier screen adaptations of Conan Doyle's tales often linearized their narratives, presenting events in chronological order with Holmes only appearing at the very end. *The Adventures of Sherlock Holmes*, on the other hand, generally preserves the narrative structure and detection plotting of the original stories. Restrictive narration and subjective flashbacks are frequently used to shape the telling of the story, and numerous cinematic devices are deployed to convey visually the processes of detection. In *The Beryl Coronet*, for example, Holmes investigates the attempted theft of a precious diadem. As he examines the scene of the crime and 'reads' a complex set of footprints, superimposition of images is used to show his thought processes, revealing the particular sequence of actions that created the prints.

Throughout the series, director Maurice Elvey made good use of a varied array of locations that were deployed as just one of the series' many selling points. Several key scenes of the episode *A Scandal in Bohemia* were filmed inside a West End theatre to

give the story's milieu a convincing sense of authenticity, while in *The Man With the Twisted Lip* the titular mendicant plies his trade in the heart of London's Piccadilly. Although Conan Doyle largely approved of the series, his one gripe was the fact that it was set in a contemporary 1920s, rather than the Victorian setting of his stories. This was perhaps largely for reasons of economy on the part of the producers, period films being more expensive to make. In fact, it was not until 1939 that Sherlock Holmes films returned the detective to his Victorian roots.

The Adventures of Sherlock Holmes was extremely successful for its production company, Stoll, and the studio went on to make a further two series of Holmes films (*The Further* and *Last Adventures*) as well as two accompanying feature films, *The Hound of the Baskervilles* (Maurice Elvey, 1921) and *The Sign of Four* (Maurice Elvey, 1923). This was quite an undertaking for a British studio at the time and it is notable that it was not until the 1980s' Granada Television series, starring Jeremy Brett as Holmes, that another company attempted to put the vast majority of Conan Doyle's famous detective stories onto the screen.

Nathalie Morris

The 39 Steps

Studio/Distributor:
Gaumont British
Gaumont British Distributors

Director:
Alfred Hitchcock

Producers:
Michael Balcon
Ivor Monragu

Screenwriters:
Charles Bennett
Ian Hay

Cinematographer:
Bernard Knowles

Production Designers:
O Wendorff
Albert Jullion

Composer:
Hubert Bath
Jack Beaver
Charles Williams

Synopsis

The 39 Steps follows Canadian Richard Hannay as he resourcefully reacts to mysterious situations beyond his control. On the run from false murder charges, Hannay journeys to Scotland and back trying to clear his name and escape from the labyrinth of international espionage into which he has been drawn. On the way he meets Pamela who, like Hannay, is swept up in the perilous drama. Unable to trust the authorities, Hannay and Pamela must evade capture and protect an important national secret. Using clever disguises, they strive to untangle the crimes, coincidences and conspiracies that have ensnared them.

Critique

The 39 Steps arguably represents the apex of auteur director Alfred Hitchcock's British work. Its economical combination of several different genres (from the screwball comedy to the spy thriller) mingles seamlessly in this story of an innocent man on the run. It is also a film on which many of Hitchcock's key collaborators worked, among them his wife Alma Reville, screenwriter Charles Bennett and author John Buchan, whose novel is the (loose) basis for the film, and who Hitchcock described as strongly influential.

The film opens with Hannay (Robert Donat) picking up a mysterious woman at a dance hall. In an odd but delightful sequence, sliding between camaraderie, suspicion and sexual tension, Hannay makes the woman a stiff drink and some pan-fried haddock. Later that night, the woman's murder catapults Hannay into action,

The 39 Steps, ITV Global/The Kobal Collection.

Editor:

DN Twist

Duration:

86 minutes

Genre:

Crime

Cast:

Madeleine Carroll
Robert Donat
Lucie Manheim
Godfrey Tearle

Year:

1935

setting into motion the fast-paced and taut plotting for which Hitchcock is known.

The 39 Steps contains many other Hitchcockian elements: a well dressed blonde (albeit not as icy as the ones that were to follow); a cameo appearance by the director himself (in the crowd outside of the music hall in of the film's early scenes); and the use of a McGuffin (the object/person which starts the plot but which in itself is unimportant – i.e. the ambiguous Air Force secrets in *The 39 Steps*). Hitchcock spends less time on themes of voyeurism and psychoanalysis than in his later films, such as *Rear Window* (1954), *Marnie* (1964) and *Psycho* (1960). This is mostly due to the inclusion of a healthy dose of screwball comedy. Midway through the film, Hannay finds himself handcuffed to the unimpressed Pamela (Madeleine Carroll). In a triumph of humour (and a visual style now associated with Hitchcock) Pamela eats a sandwich and takes off

her stockings while handcuffed to the attentive Hannay.

Along with his plotting and visual style, Hitchcock is infamous for the treatment of his female characters (and, it is has been reported, his actors). According to cinephile legend, Hitchcock once glibly responded to the question of how to make interesting films: 'torture the women!' Certainly, the women in *The 39 Steps* face their share. The entire adventure depends on Annabella Smith's (Lucie Mannheim) brutal stabbing. The Scottish crofter's wife Margaret is left to offscreen domestic abuse when she helps Hannay escape the police. Even the protagonist Pamela finds herself chased and kidnapped by spies, and unwillingly embraced by a (supposed) murderer. As in other Hitchcock films such as *The Birds* (1963) and *Notorious* (1946), these women's pain and peril drive the plot and form the central spectacles of the film.

Although reliant on some outmoded stereotypes (a Scotland peopled by dour Calvinists, for example) the film is a significant part of the Hitchcock canon and an enduringly successful example of the British crime film.

Lindsay Steenberg

The Third Man

Studio/Distributor:
London Film
British Lion

Director:
Carol Reed

Screenwriter:
Graham Greene

Producers:
Alexander Korda
Carol Reed
David O Selznick

Cinematographer:
Robert Krasker

Composer:
Anton Karas

Editor:
Oswald Hafenrichter

Cast:
Joseph Cotton
Trevor Howard
Alida Valli
Orson Welles

Synopsis

Pulp novelist Holly Martins arrives in post-war Vienna, a city divided into sectors amongst the victorious allies, only to discover that Harry Lime – the ex-school friend who invited him there – has died in mysterious circumstances. Martins attends Lime's funeral and meets Major Callow, a British who had been chasing Lime. Martins becomes suspicious about how his friend died and tracks down Lime's acquaintances and enemies as well as Anna, Lime's girl-friend, who he starts to fall in love with. Martins discovers that Lime was embroiled in a shady world of smuggling, racketeering and black-market dealings and may not even be dead after all. Martins and law enforcers led by Major Callow search the dark Vienna streets, down into the underworld network of sewers, to find what really happened to Harry Lime.

Critique

Consistently appearing in lists of the top British films of all time, *The Third Man* has retained its lofty position not only for its technical brilliance but also for the complex moral questions that lay at the heart of the film. Much of this is due to the script by Graham Greene, who had a rare literary talent for compelling and intellectually rich crime stories. Greene's background as a film reviewer meant he understood the nuances and powers of the cinema; he was enthusiastic about bringing his work to the screen, scripting other adaptations including *Brighton Rock* (John Boulting, 1947) and *The Fallen Idol* (Carol Reed, 1948) that also became classics of British cinema. Whilst Harry Lime's famously profound 'cuckoo

Duration:
104 minutes

Genre:
Thriller

Year:
1949

clock' speech was the work of Orson Welles, it is Greene's tightly-plotted narrative and ability to create compelling characters that work in shades of grey that helps the film endure.

It is also easy to forget that Welles has comparatively little screen time in the film: much of the success of the film is due to Joseph Cotton, who, as Holly Martins, manages to create a protagonist who is largely ineffectual and yet redeems himself through his sense of morality. It is a remarkably selfless performance from an American actor whose work has often been overshadowed by that of Welles. Of course, Welles is at the height of his powers here, managing to be both effortlessly charming and completely repellent. Alida Valli as Anna and Trevor Howard as Major Callow add even more gravitas to the narrative with beautifully judged performances.

Carol Reed's direction of *The Third Man* cemented his reputation as one of the best British directors of the era. The film's classic look owes much to Robert Kaskar's stunning cinematography, shot in wonderfully modernist film noir style and deeply indebted to German Expressionism. From the long, looming shadows of the celebrated sewer scene to the infamous shot that 'reveals' Lime from the shadows, this is a work created with meticulous care and attention during each frame. Anton Karas' famously infectious and incongruous zither music also adds to the film's unique atmosphere.

The Third Man has endured for so long because it is a unique film noir thriller and a complex and political morality play. It is an examination of different cultures and ideologies struggling to reconfigure at the end of WWII that is resolutely controlled and beautifully crafted. A triumph of direction, performance and script, *The Third Man* is deserving of the praise it still achieves as a true classic of cinema more than 60 years since it was released.

Laurence Boyce

The Blue Lamp

Studio/Distributor:
Ealing Studios
General Film Distributors

Director:
Basil Dearden

Producers:
Michael Balcon
Michael Relph

Synopsis

The Blue Lamp follows rookie policeman Andy Mitchell as he is inducted into the hallowed brotherhood of the Paddington Green police station. He is mentored by the father figure, veteran PC George Dixon, and even moves in with Dixon and his wife. Paralleling Andy's story is that of Diana Lewis, a working-class girl who has fallen in with a gang of juvenile delinquents. As Diana's life gets increasingly more frightening, Andy's life gets much cosier. Both narrative strands collide midway through the film when George is shot. No longer are we following Andy's idyllic introduction into the police community but its systematic hunt for Diana's boyfriend, Tom Riley.

Screenwriters:
TEB Clarke
Alexander Mackendrick
Jan Read
Ted Willis

Cinematographer:
Gordon Dines

Production Designer:
Jim Morahan

Editor:
Peter Tanner

Duration:
84 minutes

Genre:
Crime

Cast:
Dirk Bogarde
Peggy Evans
James Hanley
Jack Warner

Year:
1949

Critique

The Blue Lamp is a striking cinematic example of the police procedural – that is, a crime story which gives its audience insider information about how the mechanisms of law and order function. The film, however, does more than just this. In Charles Barr's words, it has had 'an enormous impact and inaugurates new cycles [of] drama which embodied Ealing's adjustment to the post-war world' (Barr 1977: 82). Its two-part narrative structure, its realist aesthetic, its post-war context and its morals all rotate around the gaping hole that WWII had torn in the social fabric of London. This plays out most visibly in the film's representation of the juvenile delinquent. These hoodies in fedoras, which were a considerable contemporary social concern, haunt the pool halls, cinemas and seedy cafes of post-war London and we are warned of their threat in the film's opening voice-over.

This dangerous underworld collides with the idyllic world of Paddington Green when Dixon (Jack Warner) is shot half way through the film. In the moment when a grieving Andy (Jimmy Hanley) returns to the Dixon home to tell Mrs Dixon (Gladys Henson) the sad news, the film changes gears. Mitchell reassures her: 'We'll get him. Whoever did it.' In the spirit of British stoicism, Mrs Dixon replies: 'I expect you will.' It is on this intimate sequence that the film's dual structure hinges. When the plot picks up once more, it has changed in tone, pace and even genre. Signifiers of the Ealing comedy, the British New Wave of social realism and the social problem film are augmented by those of the procedural, the 'couple on the run' sub-genre and even the film noir.

After the widow is reassured and demonstrates her ability to 'keep calm and carry on', Andy and the Paddington force go through the procedures of criminal investigation – tracking down leads and evidence (a raincoat, a revolver) gathering suspects in a line-up, interviewing a series of witnesses and finally chasing down the guilty man. The film showcases the speed and efficiency of the police force; their systems of communication are visualized and dramatized in montages that are commonplace in the police genre today. The film's climax sees Riley (Dirk Bogarde) being chased through a busy greyhound racetrack. In a heavy-handed but nonetheless poignant fantasy of post-war consensus, the professional criminals there use their considerable influence to cooperate with the police and apprehend Riley. In a visually-stunning sequence, which would not have been out of place in a sophisticated noir such as The Third Man (Carol Reed, 1949), or indeed, a postmodern homage such as Reservoir Dogs (Quentin Tarantino, 1992), Riley is cornered by two groups of slow moving men in trench coats emerging, in unified formation, from the shadows. The film closes with a shot mirroring its opening – a close up on the eponymous blue lamp of the police station. Order, community, and consensus have been restored, albeit at the cost of a good man like George Dixon.

The sadness haunting the happy ending of The Blue Lamp vanished when the film was turned into a television series for the

BBC, also starring Jack Warner. Although praised for its realism in showing the daily, working-class side of police work, critics have condemned it for lacking the bite of the film. *Dixon of Dock Green* (various, 1955–1976), like its American counterpart, *Dragnet* (various, 1951–1959), has been influential to the police/crime genre and also to the ways in which a post-war society (either in the UK or the US) imagines rebuilding productive masculinity and an orderly community in the midst of a rising consumer culture. Both *The Blue Lamp* and its television spin-off demonstrate the lasting impact that the British film industry, and studios such as Ealing, has had on the crime genre and on the lasting mythology of the decent, hardworking bobby on the beat.

Lindsay Steenberg

Peeping Tom

Studio/Distributor:
Michael Powell (Theatre)
Anglo-Amalgamated Film
Distributors

Director:
Michael Powell

Producers:
Albert Fennell
Michael Powell

Screenwriter:
Leo Marks

Cinematographer:
Otto Heller

Production Designer:
Arthur Lawson

Composer:
Brian Easdale

Editor:
Noreen Ackland

Duration:
101 minutes

Genre:
Crime

Synopsis

Peeping Tom charts several days in the secret life of serial killer and film-camera focus-puller Mark Lewis as he attempts to complete his 'documentary', a chilling assemblage of footage of the women he has killed. Mark's killings seem to be accelerating due to his burgeoning, yet chaste, romance with 21-year-old children's book author, Helen. Mark's modus operandi is to kill women with a knife concealed in the tripod of a custom-designed camera, which is mounted with a mirror to show the women their own terrified faces as they die. Mark is frustrated because his film does not yet capture the true terror of death, and he is frightened that he will be unable to stop himself from filming and killing Helen, who reminds him of his mother. Mark's homicidal acts are paralleled by his haunting exploration, through the medium of film, into his tortured and unhappy childhood as the subject of his father's cruel experiments on the nature of fear.

Critique

Despite, or perhaps because of, the outrage the film caused at its release, it has been rehabilitated by film scholars, and interpreted as uniquely able to reveal audiences' complicity in the apparatus of the crime film, and of film more generally. Yet, as Adam Lowenstein points out, few take into account its particularly British social and industrial context (Lowenstein 2000: 221–32). *Peeping Tom*, after all, is a British film made by one of Britain's foremost directors, Michael Powell. In fact, many contemporary reviews expressed outrage that Powell, who had directed the beloved ballet melodrama *The Red Shoes*, would sully his hands with so violent and disturbing a picture.

In addition, few scholars give the film enough credit for establishing many of the key psycho-pathological conventions that are central to the mythology of the postmodern serial killer. In its exploration of a disturbed and complex psychological state

Cast:
Maxine Audley
Carl Boehm
Anna Massey
Moira Shearer

Year:
1960

Peeping Tom lends itself to interpretation via psychoanalytic ideas. Mark (Carl Boehm), the eponymous Peeping Tom, suffers from pathological voyeurism or 'scoptophilia', as a psychiatrist explains in a surreal sequence that implicates the audience who are willing (and paying) observers of Mark's brutal sexualized crimes. The causes of Mark's voyeurism and his drive to kill trace back to his scientist father's documentation of his cruel experiments on Mark as a child. Several sequences show this footage in which, significantly, Mark's father is played by director Michael Powell and the young Mark is played by Powell's son. In these self-conscious instances the film insists on asking questions about complicity and ethics in film-making.

Released in the same year, *Peeping Tom* is often compared to Alfred Hitchcock's *Psycho* (1960) and regarded as its forgotten double. Whereas the psychiatrist at the close of the latter film ultimately explains Norman Bates' monstrous psychology, one receives no such resolution in *Peeping Tom*. Mark Lewis is a tragic figure that inspires not only revulsion, but also pity. He is a much more resonant and disturbing version of the serial killer.

Mediated British crime culture and crime cinema have played an important role in inventing and shaping the onscreen serial killer. British media, after all, produced what is widely considered to be the first serial killer, Jack the Ripper, who is the progenitor of characters like Norman Bates and Mark Lewis. Indeed, Englishness is often considered a feature of the 'refined' serial killer, as for example in the figure of Hannibal Lector as played by Anthony Hopkins in *Silence of the Lambs* (Jonathan Demme, 1991).

Peeping Tom's story of compulsion and sexualized violence has had profound influence on popular culture and on film scholarship. Mark Lewis' horrifying story at once disgusts and fascinates spectators, and can make them feel the guilt and voyeurism that so many other crime and horror films merely capitalize on.

Lindsay Steenberg

Victim

Studio/Distributor:
Allied/J Arthur Rank

Director:
Basil Dearden

Producer:
Michael Relph

Screenwriters:
Janet Green
John McCormick

Synopsis

Melville Farr, a closeted gay barrister with a thriving legal practice, is gliding confidently towards being a Queen's Counsel when he starts to be persistently contacted by a young working-class man, Jack Barrett. Barrett has been embezzling money from his employer and goes on the run, taking with him a mysterious scrapbook. When Barrett is captured and questioned by the police, he remains reticent but his hastily-discarded scrapbook is retrieved and reveals his involvement with Farr. Homosexuality is illegal, and investigating detectives suspect that Barrett is being blackmailed because of his sexuality. Rather than destroy Farr's reputation, Barrett commits suicide. Realizing that Barrett was actually trying to warn him, Farr seeks out other gay men being blackmailed and makes it his mission to pursue the blackmailers. Being exposed as

Victim, ITV Global/The Kobal Collection.

Cinematographer:
Otto Heller

Production Designer:
Alex Vetchinsky

Composer:
Philip Green

Editor:
John D Guthridge

Duration:
96 minutes

Genre:
Crime

Cast:
Dirk Bogarde
Peter McEnery
Derren Nesbitt

gay would put Farr's marriage in jeopardy and ruin his career, but he is determined not to be a 'victim'.

Critique

A crime thriller that can make a claim to influencing somewhat more relaxed attitudes and laws towards homosexuals, *Victim* was among several films from the Rank Organisation that sought to tackle a raw social issue, as with race relations in *Sapphire* (Basil Dearden, 1959). At the time of the film's release, homosexuality was an imprisonable offence and extorting funds from gay men was a lucrative business for predatory blackmailers. Controversial upon its release (it was banned in America), this BAFTA-nominated film wrings tension and paranoia out of the criminalized and stigmatized status of homosexuality.

Otto Heller's black-and-white photography captures the cool whites and velvety blacks of London, a city of opportunities and possibilities that could swing between the satisfaction about getting away with it or the perils of getting caught. The first 30 minutes of *Victim* visually reinforces this climate; characters are

Anthony Nicholls
Sylvia Syms

Year:
1961

introduced in varying states of distress, desperation and hostility as they are pursued not only by police but also by the unseen menace of the blackmailers. The dramatic lighting and camera angles enhance the tension and suspense of the unfolding narrative.

Green and McCormick's screenplay includes enough sub-plots and surprises that, even for contemporary viewers, cloud any certainty over how the affair will conclude. Even more surprising is the inclusion of an intense confrontation between Farr (Dirk Bogarde) and his caring wife Laura (Sylvia Syms) that does not flinch from showing the far-reaching consequences of Farr's decisions. There is no doubt about the suspicion, paranoia and isolation caused by the criminalization of homosexuality.

Taking on the role of the determined and tormented barrister was especially daring as, living with his business manager, Dirk Bogarde was himself subjected to intrusive speculation about his sexuality. But Dearden's film marked a turning point in Bogarde's career, as this controversial role swiftly carried him from matinée idol to an actor of depth. His performance is assured and he was fortunate to be a part of an expert cast, particularly Peter McEnery as Barrett, who convey all the desperation, mistrust and self-loathing of being trapped in a no-win situation because of one's sexual preference.

Victim masterfully uses the laws against homosexual behaviour as the basis for creating a compelling whodunit thriller. By today's standards, some may find it melodramatic and didactic, as some of the characters seem to be preaching – such as in the scene involving a barber jailed previously for his sexual orientation. But this has to be forgiven, as the film was a first attempt at sympathetically showing homosexuals and their plight. This film took genuine risks by tackling a real problem and casting light on all the 'victims' enslaved at that time by a useless and inequitable law.

Deirdre Devers

The Italian Job

Studio/Distributor:
Oakhurst/Paramount British

Director:
Peter Collinson

Producers:
Stanley Baker
Michael Deeley
Bob Porter

Screenwriter:
Troy Kennedy Martin

Synopsis

Cockney parolee Charlie Croker plots to steal four million dollars from the Turin bank. He assembles a ragbag team of computer and explosives experts, henchmen, drivers, and financial backers. Charlie's team then outline their plans and then practise their driving, bomb-making and general capering skills. The team travels to Turin to execute their plans against the backdrop of the world cup.

Critique

The Italian Job is a camp celebration of the small time British crook, and of Britishness in general, being a parodic tribute to the British crime or caper genre, and to the popular culture of 'swinging' 60s' Britain. Noël Coward appears as the gentlemanly crime boss Mr Bridger, whose financial support for the bank heist

Cinematographer:
Douglas Slocombe
Production Designer:
Disley Jones

Composer:
Quincy Jones

Editor:
John Trumper

Duration:
99 minutes

Genre:
Crime

Cast:
Maggie Blye
Michael Caine
Noël Coward

Year:
1969

is secured while in the prison toilets. Bridger articulates ironically-mannered Englishness when he reprimands Charlie Croker (Michael Caine) for interrupting him with the patriotic line: 'There are some things which, to an Englishman, are sacred.' Other memorable moments of Anglophilia include an extended chase scene in Mini-Cooper cars, and comedian Benny Hill's performance as Professor Peach, a computer expert with a penchant for full-figured women.

The Italian Job is perhaps most (in)famous for its closing scene – a literal cliff-hanger ending. With the Mafia at their heels, the gang's bus is precariously balanced on the edge of a cliff – Croker and his gang huddled on one side of the bus and the gold, topped by a Union Jack, piled at the other. No one can move towards the gold without sending the bus hurtling over the cliff and the gang cannot escape to safety without sacrificing the gold. There is no resolution, only Croker's enticing line: 'Hang on a minute, lads, I've got a great idea...'

Theories abound about the fate of Croker's team and the gold. In 2008, to mark the 40th anniversary of the film's release, the Royal Society of Chemistry even announced a competition to solve the problem, with the prize being a holiday in Turin. Entries had to be scientifically sound and assume a 30-minute deadline before the bus falls. According to BBC news, the winner, John Godwin, spent 'a good long day with a calculator' to provide his answer. Some might say that the cliff-hanger ending was merely a gimmick to leave the way open for a sequel, but if we obey the laws of the crime genre in addition to the laws of physics, a solution might be found that involves the fetishized grappling hook that Croker introduced to the audience at the film's opening. Ultimately, the film is so compelling because there is no definitive solution, and this only adds to its cult appeal.

It is telling that the 2003 US remake did not include a closing mystery, ending instead with a celebratory montage of each member of Croker's team enjoying the consumer goods that they had earlier fantasized about – Handsome Rob (Jason Statham) enjoying his Aston Martin car, Lyle (Seth Green) enjoying speakers so loud that they literally blow women's clothes off, and Croker (Mark Wahlberg) enjoying the hard-won love and respect of glamorous safe-cracker, Stella Bridger (Charlize Theron). Although certainly equipped with its own appeal, it is hard not to read the American re-make as an extended advertisement for the re-launch of the Mini-Cooper.

Although rarely considered in crime genre scholarship, its glossy aesthetic, exotic locales, fast pace and knowing send-ups have secured it a place of honour in the history of Britain's popular cinema. Eminently quotable, even those who have not seen the film may know the scene when Croker chastises his hapless explosive team with the line: 'You're only supposed to blow the bloody doors off!'

Lindsay Steenberg

Get Carter, MGM/The Kobal Collection.

Get Carter

Studio/Distributor:
MGM British
MGM-EMI

Director:
Mike Hodges

Writer:
Mike Hodges

Producers:
Michael Caine (uncredited)
Michael Klinger

Cinematographer:
Wolfgang Suschitzky

Production Designers:
Assheton Gorton
Roger King

Synopsis

London-based gangster Jack Carter returns to his hometown of Newcastle to mourn his recently-deceased brother Frank. Carter is told that his brother died in a drink-driving accident, but he harbours suspicions that Frank was murdered. Carter begins poking around in the wrong places, arousing the anger of mob boss Cyril Kinnear, among others. After a violent encounter with some thugs, Carter is told that arcade owner Cliff Brumby was involved in his brother's death. Carter quickly realizes that he is being sent on a wild goose chase. Carter himself is also on the run from his boss in London who has sent men to pressure him into returning. While eluding them, and continuing to hunt his brother's killer, Carter is given a pornographic film. On watching it, he discovers that Frank's daughter – his niece – is in the film. Enraged, Carter goes on the warpath, intent on hunting down everyone involved.

Critique

Get Carter may well be Britain's most complete and brutal response to the mythical culture of film Westerns. It is now-legendary writer-director Mike Hodges' debut, adapted from a

Composer:
Roy Budd

Editor:
John Trumper

Duration:
107 minutes

Genre:
Crime

Cast:
Michael Caine
Britt Ekland
Ian Hendry
John Osborne

Year:
1971

similarly bleak pulp novel by Ted Lewis. The protagonist Jack Carter (Michael Caine), weary beyond his years, is both vigilante and outlaw, taking both vengeance and justice into his own hands. The main difference, of course, is that there is no endless frontier or Technicolor sunset for him to ride off into – just a cold beach in Newcastle, caught between coal slag and an unfriendly ocean, while listless grey skies hang above. Even though his world is dressed in the most stylish fashions of 1972 and set to a jazzy, haunting score, it is a northern urban dystopia of dingy underground bars, seedy backroom pornography studios, industrial wastelands and brutalist post-war architecture.

Carter is no hero, either. In the course of tracking down his brother's killer, Carter immerses himself in the seedy, grimy culture of the Newcastle underworld. Sleaze oozes throughout *Get Carter* – even playwright John Osborne's mannered performance as crime boss Kinnear is thoroughly suffused with nihilism and casual criminality that hangs heavily in the grimy air around him. A host of sneering thugs and femmes fatales – most notably Britt Ekland – populate a joyless and harsh world. Despite it being full of sex, money and drugs, no one in Carter's world is satisfied and everyone knows there is only one way out. Even Carter shows no intention of ever 'going straight' like so many crime-film anti-heroes do, instead throwing himself with increasing fury into his quest for vengeance.

Caine's performance as Carter set the mould for generations of London hard men in film – violent men who possess a sick and twisted sense of honour about themselves even when they are abusing women and murdering their enemies. Caine's icy righteousness and bloodless charm is perhaps the film's best trick in that it only partly obscures how jaded Carter is, how seemingly undisturbed by the demons surrounding him and within him. Carter's sense of injustice seems driven not by morality but by a powerful sense of reputation and family loyalty – as, for example, in the scene in which Carter puts on a grainy pornographic film and sees his niece being sexually exploited; as the whirring of the projector overwhelms the soundtrack his smug expression of selfish pleasure dissolves in muted horror.

Carter is completely at home in Newcastle's run-down working-class pubs and crumbling housing estates. As his frenzy builds to a fever pitch, it is easy to forget that he is a prodigal on the run, fatefully compelled back to his homeland on unfinished business. In this world, Carter can try to avenge misdeeds committed against himself and his people, but there is no ultimate victory. If there is a moral to *Get Carter*, it is that the world will always be wicked.

Patrick Tobin

The Long Good Friday

Studio/Distributor:
British Lion
Paramount British

Director:
John Mackenzie

Writer:
Barrie Keeffe

Producer:
Barry Hanson

Cinematographer:
Phil Meheux

Production Designer:
Vic Symonds

Composer:
Francis Monkman

Editor:
Mike Taylor

Duration:
109 minutes

Genre:
Crime
Thriller

Cast:
Eddie Constantine
Bob Hoskins
Bryan Marshall
Helen Mirren

Year:
1979

Synopsis

Harold Shand, the most powerful criminal figure in London, is trying to get out of crime and into the more lucrative world of property development. In collaboration with the American Mafia, he intends to develop waterfront land into a future Olympic Games site. Before the deal can be signed, attacks are made on Shand, including a car-bombing and the murder of one of his lieutenants. As Shand's girlfriend Victoria and crooked Councillor Harris try to keep the Mafia from washing their hands of the property deal, Shand and his lieutenants, including the fearsome 'Razors' and Jeff, travel to London, interrogating anyone they can find. After a brutal inquest, Shand discovers that he has been targeted by the IRA, whose resources and ruthlessness outstrip his own. He must find out why they are involved before they catch up with him.

Critique

The Long Good Friday takes the framework of a grim and gritty London gangster film and expands it into a multinational political thriller. In the late 1970s the formation of the EEC, soon to become the European Union, brought about previously-unparalleled economic integration between European countries. Property development became a major trade for the prosperous, and every stage, down to the smallest detail, was dangerously political. Harold Shand (Bob Hoskins) is the linchpin of London's criminal underworld but he wants to go straight because of ambition and materialism. Harold wants power, wealth and influence over more than just the nattily-dressed crooks and victims he controls. In one of Shand's best lines, he proclaims 'I'm not a politician – I'm a businessman!' He struggles to move from the underworld to the world of business and politics, and to find out where, and if, boundaries lie between the two.

By reaching out beyond London, not only does Shand invite prosperity – through the money of the Mafia – but chaos and violence, through his escalating rivalry with the IRA. It is not a game he can win, but he is too proud and stupid to realize it. Shand's inevitable downfall is not down to the police – there is no power of law here. Instead, he falls prey to the toxic fusion of politics, business and crime that contaminated the property-development boom in Thatcher's Britain. The astonishingly-rapid crumbling of Shand's empire is hastened by how quickly he is ready to rip away his 'legitimate' facade and revert to savage, merciless thuggery. This grim forecast – that no matter how savvy you are, no matter how strong you are, no matter how scary you are, there is always something out there more powerful – is the message at the centre of most British crime thrillers, but the political implications in *The Long Good Friday* are particularly bleak.

Hoskins' turn as Shand overwhelms the film – his ferocity overpowers the rest of the film to stunning effect, transcending the dated fashions and synth-and-sax score. Even noir veteran Eddie Constantine, as American Mafia emissary Charlie, and Helen Mirren, delivering an inimitable touch of class as Harold's girlfriend,

struggle to keep up with Hoskins. Shand is a crook trying to maintain a veneer of respectability in the corrupt world of politics and business. When the intimidating, serious-minded Constantine dares talk back to him, Hoskins' quivering attempt to stay calm is gripping. It is a career-best performance, right up to the last moments, in which the audience are finally invited to sympathize with the fearsome tyrant – Hoskins says more with a silent expression than some actors manage in a lifetime.

Patrick Tobin

Mona Lisa

Studio/Distributor:
Handmade Films/Palace Pictures

Director:
Neil Jordan

Producers:
Stephen Wooley
Patrick Cassavetti

Screenwriters:
Neil Jordan
David Leland

Production Designer:
Jamie Leonard

Cinematographer:
Roger Pratt

Composer:
Michael Kamen

Editor:
Lesley Walker

Duration:
104 minutes

Genre:
Crime

Cast:
Bob Hoskins
Cathy Tyson
Michael Caine
Robbie Coltrane

Year:
1986

Synopsis

Returning home after seven years in prison to an ex-wife who does not want to see him and a teenage daughter he barely knows, small-time loser George gets work as a chauffeur for a sex worker of African-Caribbean descent called Simone. The job is thrown his way by shady gangster Mortwell, the man George went to prison for. George drives Simone between jobs and despite their all-too-apparent differences they build an unlikely friendship. As he slowly fall in love with Simone, she uses him to hunt the mean streets of London and Brighton to find her friend, Cathy, who she suspects has been abducted and sexually abused by a violent pimp called Anderson. Mortwell wants George to find out what Simone is doing with her wealthy clients and, as he digs deeper, the answers he uncovers puts both his, Simone and Cathy's lives at risk.

Critique

Perhaps it is strange that it took an Irish poet and novelist with a yen for modern fairytales to make one of the standout London crime thrillers of the past 20 years. After the mixed reception of the fantastical *The Company of Wolves* (1984) director Neil Jordan turned to more assured and grittier territory for this noir thriller. Set among the neon-soaked streets of London, his city is filled with pimps, call girls, low-level hard men and dirty old geezers. No one is what they seem and everyone is after something from someone else. The audience discovers this world through the eyes of George, played by Bob Hoskins, mixing the menace and violence of Harold Shand in *The Long Good Friday* (John Mackenzie, 1979) and the naïvety and innocence of Arthur in the TV series *Pennies from Heaven* (Piers Haggard, 1978) to devastating effect. Michael Caine is on hand as the Machiavellian villain, expertly giving Mortwell a chilling, reptilian menace, while Cathy Tyson brings both a steely edge and warmth vital to the key role of the damaged Simone, seducing George with a damsel-in-distress story that offers both the hope of love.

As an outsider, it is clear Jordan is not impressed by the geezers and hard men of old London town and would rather expose the

squalid realities of the sex trade – the drug dependency, the violence and the lies. Nor is he enamoured with how noirs usually play out. He would rather use thriller conventions to examine misplaced and mismatched emotions that leave his characters scooped out and devastated. With a keen eye and mordant wit he strips away the layers of these violent men, baring the rotten, fetid, money-obsessed souls bit by bit, until you are in no doubt about the human cost of prostitution.

The film constantly unnerves, shifting from barely-concealed hellish fantasy to all-too-real violent brutality, sometimes in the same scene. Just as you have settled, savage violence brings you back to the grim reality. While the thriller conventions motor the story forward, Jordan merrily toys with the genre tropes – Simone may be the working girl, but it is George who has the heart of gold. George and his pal Thomas (Robbie Coltrane) also make for a charming double act, undercutting the wider grimness with dry banter. Their ongoing chats about detective stories also serve to echo the main action, but Jordan never sacrifices the heart of the story for these flourishes and quirks. The meta-detective story that George and Thomas throw back and forth is never overplayed or heavy-handed. The confidence of this seemingly-simple tale is staggering. It is at times playful, touching and surreal – George sends a white rabbit at the start of the film as a message to Mortwell but the audience are never privy to what that message might be or mean.

But it is the clash of romanticism and the brutality of lost love that really makes the film soar. Nat King Cole's smooth, syrupy vocal offset the grit and the neon with a 1950s' sentimentality that constantly lulls the viewer into hoping that things might just turn out alright. But Jordan knows life is just not like that.

Adam Richmond

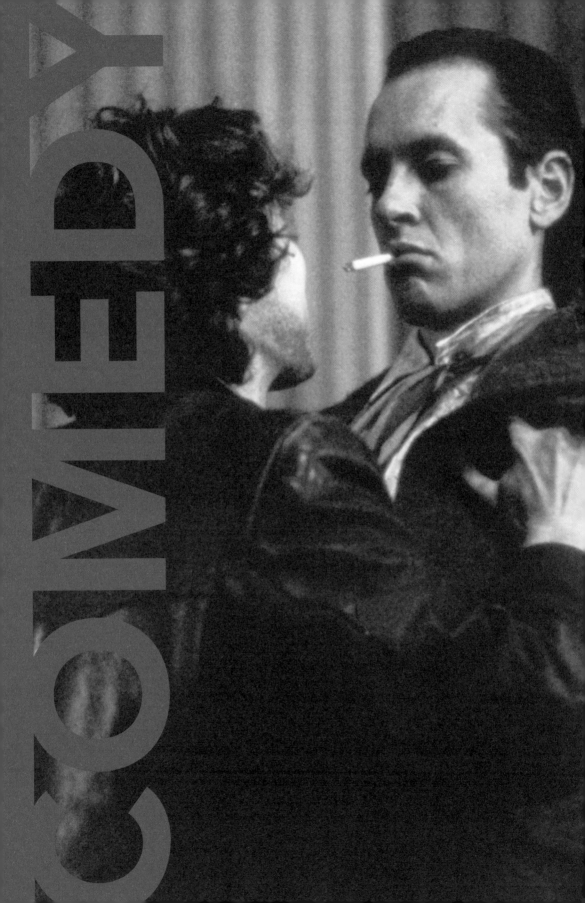

Comedy is a significant, universal and enduring genre and British cinema has produced an extensive array of comedians, comic narratives and comic modes. While some examples, most notably the Ealing comedies, have become emblematic of British culture, defining distinctly national forms of comedy can be problematic, as Geoff King and Andy Medhurst have shown (King 2002 and Medhurst 2007). However, the disruptive potential of comedy, whether in the refined style of Ealing classics or the carnivalesque release of the *Carry On* films, seems especially powerful in a culture like Britain's that seems to cleave to hierarchy, decorum and order. Hence the delight in the ways in which the lascivious George Formby, Alistair Sim's coy Miss Fritton, or the misanthropic Withnail challenge British norms of class, gender and propriety.

British comedy is reliable at the box-office: low-budget work can reap good domestic profits, and some high-concept vehicles, such as *Bean* (Mel Smith, 1997) can be internationally successful. Most British comedy is performer-led, showcasing established comedians and comic groups. While the influence of theatrical styles on British film comedy can be traced, for example, in Oscar Wilde adaptations, music hall, variety, radio and television have provided the main sources for film comedy performers and characters, from Gracie Fields to Simon Pegg. A century of British comics, from Charlie Chaplin to Sacha Baron Cohen, have also become Hollywood stars.

Early cinema embraced comedy with chases, transformations and what Tom Gunning (1995) has called 'mischief gags' – all key elements of British and international films. As artisanal output declined, individual performers and characters emerged more strongly. Fred Evans, for example, became a star in the WWI era, just as his childhood friend Chaplin emerged in America. Evans' popular Pimple character featured in onscreen escapades that often parodied popular films and genres, as in *Pimple's Battle of Waterloo* (Fred and Joe Evans, 1913) which burlesques the historical epic. Similarly, Betty Balfour, a leading comedy star of the 1920s, played the character of Squibs, a Cockney flower seller, in a series of films that mixed comedy and sentiment.

1930s' comedy was dominated by two stars, George Formby and Gracie Fields, who represented notions of northern authenticity and cheer during the Depression era. Originally music hall performers, their films showcased their musical and comic skills equally. Formby moved between childlike innocence and the knowing innuendo of his songs, such as 'With My Little Stick of Blackpool Rock'. While Fields shared Formby's lovelorn quality, her persona was conciliatory and reassuring, as when she saves her cotton mill from closure in *Sing As We Go* (Basil Dean, 1934). Other popular performers of the period with music hall roots included Will Hay and Arthur Lucan, creator of Old Mother Riley. A more sophisticated, concert party ethos was represented in the work of Cicely Courtneidge, often partnered by her husband Jack Hulbert.

Ealing Comedy, which has become a touchstone for British film, emerged in the mid-1940s and continued to produce films for a decade. A commemorative plaque placed at the entrance of Ealing Studios on its closure in 1958 reads, 'Here during a quarter of a

century many films were made projecting Britain and the British character.' Ealing comedies celebrated eccentric forms of rebellion or collective action, as in the gold bullion robbery masterminded by a timid bank clerk in *The Lavender Hill Mob* (Charles Crichton, 1951), or the Scottish islanders' appropriation of shipwrecked alcohol in *Whisky Galore!* (Alexander Mackendrick, 1949). Responding to the anxieties of the post-war austerity era, Ealing films like *Passport to Pimlico* (Henry Cornelius, 1949) emphasized the value of community against the state, while others offered much darker views of society: in *The Ladykillers* (Alexander Mackendrick, 1955), for example, the group is monstrously venal. Alongside Ealing, the Boulting Brothers provided a rather jaundiced perspective on post-war society. Their series of satirical comedies began with *Private's Progress* (John Boutling, 1956) and peaked with the cynical study of labour relations, *I'm All Right Jack* (John Boulting, 1959).

The 1950s, once considered a stagnant era for British cinema, now seems rich in comic talent. The comedian Norman Wisdom rose to stardom with *Trouble in Store* (John Paddy Carstairs, 1953), which introduced his inadvertently destructive 'Gump' character. There are parallels with Formby, but Wisdom employs greater pathos: he is more innocent than gormless and his songs, such as 'Don't Laugh At Me 'Cos I'm a Fool', are plaintive rather than lewd. In 1954, *The Belles of St Trinian's* (Frank Launder) initiated the highly successful and classically British *St Trinian's* series. Set in a disorderly girls' boarding school, Alistair Sim's drag performance as the headmistress, Miss Fritton, is only one disruptive element in films that suggest the anarchic power of femininity.

The supremacy of the Rank Organisation during the period encouraged the growth of the middle-class comedy. *Genevieve* (Henry Cornelius, 1953) mixed tradition and modernity in the romantic comedy story of two couples competing in the London to Brighton vintage car rally, with the chic and authoritative Kay Kendall emerging as a major comic talent in a period when most female characters were demure helpmeets (Geraghty, 2000:160–66). And the series of *Doctor* films starring Dirk Bogarde, such as *Doctor in the House* (Ralph Thomas, 1954), emphasizes bumptious middle-class life rather than the body humour of the hospital *Carry On* films.

The *Carry On* films were a dominant presence in the 1960s, producing 29 films between 1958 and 1978. With their emphasis on sexual innuendo and bodily functions, these cheaply-made, hugely popular films exemplify the best and worst of the British low comedy tradition. The early films, *Carry on Sergeant* (1958), *Teacher* (1959), *Nurse* (1959) and *Cruising* (1962), directed by Thomas and written by Norman Hudis, echo a post-war, sub-Ealing ethos of consensus, with a ramshackle group learning how to become responsible professionals. Talbot Rothwell's scripts, from 1963 onwards, specialized in more riotous genre parodies including *Cleo* (1964), *Spying* (1964) and *Screaming* (1966). But the final films in the early 1970s made an uncertain return to contemporary settings.

Carry On is a world of workshy, henpecked men, shrewish wives, gormless and lusty youths and predatory women, where class and gender boundaries are loosely maintained. The appeal of the films lies partly in their ragged air. Parodic plots provide a familiar base and loosely-structured narrative on which to pin gags, slapstick and innuendo. A repertory of performers in standardized roles was also crucial to the films' success. The comfortingly familiar *Carry On* team, led by comedian Sid James, made household names of Hattie Jacques, Bernard Bresslaw, Jim Dale, Joan Sims and Barbara Windsor. Kenneth Williams was a leading radio star when he joined *Carry On*, appearing in the cleverly camp series *Round the Horne*, and his involvement spans the entire output. Initially cast as a supercilious intellectual, Williams developed a conspiratorially camp persona that, alongside the fey Charles Hawtrey, contributed to *Carry On's* strong queer dynamic.

As British society changed and became more liberal, the films tried – with varying degrees of success – to engage with contemporary issues such as trades union strikes (*at Your Convenience*, 1971) and even feminism (*Girls*, 1973). *Camping* (1969), in which characters try to visit a nudist camp, was the most successful attempt to engage with

permissiveness, but the *Carry On*s began to seem tame and tired. Their populist bawdy was substituted in the following decade by soft-core sex comedies, most famously the *Confessions* series such as *Confessions of a Window Cleaner* (Val Guest, 1974) starring Robin Askwith.

After a 1960s boom – facilitated by heavy investment from Hollywood – the British film industry declined in the 1970s. Nonetheless, film adaptations of television sitcoms such as *On the Buses* (Harry Booth, 1971) and *Steptoe and Son* (Cliff Owen, 1972) were successful. This 'pre-sold' material, aimed at a family audience, was produced cheaply enough to return a profit from the domestic market. The Monty Python team made a feature-length version of their television sketch show in the early 1970s and went on to the audacious satires *Monty Python and the Holy Grail* (Terry Gilliam and Terry Jones, 1975), *Monty Python's Life of Brian* (Terry Jones, 1979) and *Monty Python's Meaning of Life* (Terry Jones, 1983).

From the early 1980s onwards, the emergence of production companies such as Goldcrest, along with increased funding possibilities from television, notably Channel 4, helped to revitalize British cinema. A distinctive talent in this period was the Scotsman Bill Forsyth, who, in films including *Gregory's Girl* (1980) and *Local Hero* (1983), evolved a gentle, dry, observational comedy style. Forsyth drew on Ealing tropes but created his own distinct idiom, and his erratic career since has been a great loss to British cinema. 1980s alternative comedians including French and Saunders, Rik Mayall and Adrian Edmondson, made surprisingly little impact on film, although their *Comic Strip Presents…* series for Channel 4 contained memorable film parodies. The era's most enduring comedy is Bruce Robinson's *Withnail and I* (1986). Set at the fag-end end of the 1960s, Robinson's cult film depicts the nostalgic chaos of two unemployed actors living in poverty in Camden, surviving on drugs and alcohol after the 'hippy dream' has turned into a nightmare. From the perspective of the conservative and repressive 1980s, *Withnail and I* has an elegiac sense of period; avoiding the clichés of Swinging London, it depicts urban squalor and decay with a decrepit class system.

In the 1990s, Richard Curtis, as a writer and then director, defined a new style of highly exportable middle-class British comedy beginning with *Four Weddings and a Funeral* (Mike Newell, 1994). Curtis' favoured leading man, Hugh Grant, contributed hugely to their success with his image of the diffident English gentleman. Curtis' comic proficiency is undeniable (evidenced by his earlier television work on the *Blackadder* series), but much of his films have a self-satisfied formularity. More spirited British comedy came in animated form with Nick Park's hugely-successful, inventive and eccentric *Wallace and Gromit* films. Park's films, which draw wittily on northern comic traditions, adroitly parody genres, as in the noir-ish *The Wrong Trousers* (1993), and were successfully extended to feature-length in *The Curse of The Were-Rabbit* (Steve Box and Nick Park, 2005).

So far, British film comedy in the twenty-first century has seen weak vehicles for television performers, such as the much-derided *Sex Lives of the Potato Men* (Andy Humphries, 2004) with Johnny Vegas, Mackenzie Crook and Mark Gattis. Tellingly, the biggest comic star of the period, Ricky Gervais, chose to work in Hollywood. However, three significant figures have successfully transferred to film: Edgar Wright, Simon Pegg and Sacha Baron Cohen. In *Shaun of the Dead* (2004) and *Hot Fuzz* (2007), writer-director Wright and writer-performer Pegg developed an affectionate form of genre parody which mocks both Hollywood hyperbole and British understatement. Baron Cohen achieved great success with *Ali G Indahouse* (Mike Mylod, 2002), in which his suburban hip-hop character is elected to Parliament, and *Borat: Cultural Learnings of America for Make Benefit Glorious Nation of Kazakhstan* (Larry Charles, 2006), the mockumentary satire in which a wide-eyed Kazakh journalist tours America. Baron Cohen's talent for interaction with unsuspecting victims is often uncomfortable and controversial. Like many British comedy traditions, it exploits the genre's disruptive potential to challenge assumptions about class, race, gender and cultural values.

Adrian Garvey

Women's Rights

Studio/Distributor:
Bamforth and Company
Riley Brothers

Duration:
1 minute 14 seconds

Genre:
Comedy

Year:
1899

Synopsis

In late Victorian England, in a woodland clearing, two women gossiping by a fence fail to notice a man and boy, who surreptitiously nail their skirts to the fence and run away. The distraught women struggle to free themselves until, finally, the fencepost breaks away.

Critique

Long thought, for obvious reasons, to be called *Ladies Skirts Nailed to a Fence*, this film has now been identified as an early mockery of the movement for women's rights. Women's campaigns for freedom had been growing in the latter half of the nineteenth century, coalescing around the suffragette campaign. *Women's Rights* was produced in 1899 by the Yorkshire-based Bamforth and Company Films, a manufacturer of lantern slides who had recently moved into film production and would become one of the major forces in British production during the Early Cinema period. In the same year they produced an ardent variant of the popular and provocative 'Kiss in the Tunnel' films.

Women's Rights is characteristic of the playful nature of Early Cinema. Though formally more complex, it most obviously echoes the Lumière Brothers' historic 1895 comedy *L'Arroseur Arrosé*, in which a boy tricks a gardener into spraying himself with his own hose. Cinema in this early period was a novelty form of popular entertainment often associated with fairgrounds and sideshows, and many examples light-heartedly explore film's narrative and formal boundaries.

Women's Rights has an anarchic, anti-authoritarian tone typical of the period: the humiliated women are figures of respectability while their tormentors wear cloth caps and aprons. The extremely broad performance style of the women, as they excessively brandish their umbrellas, has the dimensions of pantomime. The chase, a standard trope of the time, is referenced here in the extended view of the women's flailing attempts to free themselves. There is also a suggestion of 'liveness' in one performer's look to the camera for guidance as the fencepost breaks away; the ending seems a little haphazard and perhaps this was not the intended conclusion for the sequence. The three-shot sequence marks a sophistication in editing for the period, when static camera single shots were common, but the decision to move the action rather than the camera to reveal the intruders' mischief disrupts spatial continuity. This inconsistency typifies the haphazard advance of early cinema language.

Women's Rights ably demonstrates the enduring, problematic and very British tradition of drag, as exemplified by Alastair Sim as Millicent Fritton in the St Trinian's films or Alec Guinness as various D'Ascoyne ladies in the Wildean social satire *Kind Hearts and Coronets*. In the 1890s, cross-dressed male performers such as those playing the women in *Women's Rights* had license for physical behaviour that was denied to many female actors. However,

the 'feminist' title of the film suggests a sarcastically misogynist message: such women, it is implied, are unfeminine, mannish in their assertiveness. Simultaneously, the 'women' are shown aggressively gossiping, one of the most castigated forms of behaviour associated with femininity. While drag's disruptive, performative aspects can potentially challenge gender norms, here it reinforces prejudices against women and mocks women's autonomy. Perhaps because of its aesthetic and thematic crudity, the film remains undeniably funny, a testament to the wit and social responsiveness of early cinema, and a forerunner of the British film comedy tradition.

Adrian Garvey

Kind Hearts and Coronets

Studio/Distributor:
Ealing Studios/General Film Distributors

Director:
Robert Hamer

Producer:
Michael Balcon

Screenwriters:
John Dighton
Robert Hamer

Cinematographer:
Douglas Slocombe

Production Designer:
William Kellner

Composer:
Ernest Irving

Editor:
Peter Tanner

Duration:
106 minutes

Genre:
Comedy

Cast:
Joan Greenwood
Alec Guinness

Synopsis

In Edwardian England, on the eve of his execution for murder, the Duke of Chalfont writes his memoirs in his cell. His story is told in flashback: he was raised in poverty as Louis Mazzini, after his mother was disowned by Chalfont's D'Ascoyne family for marrying beneath her. On her death, Louis vows vengeance on the D'Ascoyne family and sets out to claim the title himself. His childhood friend Sibella rejects his marriage proposal because of his lowly status as an assistant in a draper's shop, but they continue an affair after her marriage to the dull but rich Lionel. After ingeniously murdering a succession of D'Ascoynes, Louis claims the Dukedom and takes Edith, the widow of one of his victims, as his Duchess. But Louis' plans go astray when a jealous Sibella frames him for Lionel's murder.

Critique

Kind Hearts and Coronets is part of the darker Ealing comedy tradition, associated especially with Robert Hamer and Alexander Mackendrick. It is the studio's only period comedy and exemplifies a high comedy style, which is surprisingly rare in British cinema. The film's mannered style, embodied in Dennis Price's Louis Mazzini character, makes a thrilling game out of an assault on aristocratic tradition as Louis murders his way to a dukedom.

While another Ealing comedy of 1949, *Passport to Pimlico* (Henry Cornelius), offers a fantasy retreat to wartime community spirit, *Kind Hearts and Coronets* looks to the Edwardian era as a class-ridden time of stifling restraint and hypocrisy. While the film's satirical take on social position can be related to the dawn of the post-war meritocratic age, Louis himself is no radical. Louis is avenging his mother's banishment from the family, but is also motivated by an absolute faith in privilege and revels in his brief tenure as Duke.

The protean Alec Guinness was the definitive Ealing protagonist, most frequently appearing as an everyman figure. Here he plays an array of aristocratic D'Ascoynes, male and female, who

Valerie Hobson
Dennis Price

Year:
1949

are generally dull or monstrous – a grotesque gallery of deserving targets for Louis to inventively despatch. Guinness' virtuoso performance has perhaps overshadowed the achievement of Dennis Price as Louis, whose contempt for his betters is perfectly judged and whose dry, disdainful voiceover sets the film's sardonic tone: 'It is so difficult' he grumbles 'to make a neat job of killing people with whom one is not on friendly terms.' In its day, the film's sexual content was considered as provocative as its casual treatment of murder, especially in the unambiguous treatment of Louis and Sibella's passionate extra-marital affair. While Ealing tended to be very male-centred, Hamer's films do contain complex female characters such as the seductive and calculating Sibella.

Kind Hearts and Coronets presents a world obsessed with propriety and appearance; its comedy arises from the beautifully sustained tension between exquisite manners and murderous acts. The film's ludic tone is maintained by its unresolved ending: as Louis is released from jail to find both Sibella and Edith awaiting him, he suddenly remembers his incriminating memoirs In class-riven Britain this dramatic irony was part of the film's significance, but American censors demanded a revised, moralizing conclusion, with Louis brought to justice. While adaptations of Wilde tend to be constrained by their classic status, Hamer's film perfectly conveys the Wildean spirit of social satire and barbed wit.

Adrian Garvey

Genevieve

Studio/Distributor:
Rank Organisation
Sirius/General Film Distributors

Director:
Henry Cornelius

Producer:
Earl St John

Screenwriter:
William Ross

Cinematographer:
Christopher Challis

Production Designer:
Michael Stringer

Composer:
Larry Adler

Editor:
Clive Donner

Synopsis

Two antique car enthusiasts, Alan McKim and Ambrose Claverhouse, participate in the annual London to Brighton Rally at which racing is absolutely forbidden. Alan drives the eponymous Genevieve, a 1904 Darracq, and Ambrose drives a Spyker from the same year. Alan is accompanied by Wendy, his wife, and Ambrose by Rosalind, his new girlfriend, and an enormous, bothersome dog. At a party in Brighton, Rosalind becomes drunk and, climbing onstage, provides more entertainment than the band. During escalating arguments between Alan and Ambrose about the comparative merits of their cars and about Ambrose's former relationship with Wendy, they decide to race one another on the return run from Brighton to London, with Alan's beloved Genevieve at stake. A hectic race ensues, in which Alan and Ambrose play increasingly underhanded tricks on each other in efforts to gain an advantage and get back first to London Bridge, the designated finishing line.

Critique

Genevieve is a film that is aware of its quaintness: the idea of a race between two cars that, even in the 1950s, must have looked ancient and absurdly slow, emphasizes that from the outset. Although the film was, at the time of release, set in contemporary

Duration:

86 minutes

Genre:

Comedy

Cast:

John Gregson
Kay Kendall
Kenneth Moore
Dinah Sheridan

Year:

1953

Britain, it focuses so intently on old fashioned objects and pastimes, and takes place in distinctly un-modern settings as tradiional pubs and country lanes, that it has a somewhat timeless quality and has not aged in the same way it would have been had it been set 50 years earlier.

Even the characters are self-consciously quaint: Kenneth Moore's Ambrose amuses himself immensely when he tells a doubting Rosalind (Kay Kendall): 'My dear old girl, when that car gets started, you will be intoxicated by the exuberance of your own velocity!' It is a glorious line emblematic of the film's parochial appeal. It is indicative of the film's delight in pre-war sensibilities that one of the drivers apparently decides to abandon the race because an old man is talking to him and it would be impolite, un-British, to drive off. It is a sign of how well these sensibilities are integrated into the production that this seems a valid deciding factor in a race that has occupied so much of the characters' attention.

The interplay between the four main characters is crucial to the comedy but, whilst the performances from Moore, Shore and Kendall are all superb and well suited to the film, the underrated John Gregson overshadows them. His role as Ambrose McKim plays up his physical resemblance to James Stewart and marks him as an English equivalent. Open-faced and honest, yet driven and quietly intense, Gregson brings to Ambrose a believability and wholesome charm. It is not just Gregson who does perhaps his best work here: *Genevieve* is as well-directed by Henry Cornelius' as his classic Ealing comedy *Passport to Pimlico* (1949), Kay Kendall give a superbly kooky performance as Rosalind, and Larry Adler's Oscar-nominated harmonica music score is lively and joyous, its evocative strains being as integral to the film as the quaint old motor cars.

Scott Jordan Harris

The Belles of St Trinian's

Studio/Distributor:

London Films/British Lion

Director:

Frank Launder

Producers:

Sidney Gilliat
Frank Launder

Screenwriters:

Sidney Gilliat
Frank Launder

Synopsis

St Trinian's is the very worst school in Britain and its female staff and pupils are totally uncontrollable. It is the beginning of term and St Trinian's is in crisis – the headmistress, Millicent Fritton, has frittered away the school fees on gambling and gin, and an undercover policewoman, posing as 'Miss Crawley' the gym mistress, is gathering evidence of illegal scams in order to close down the school. In desperation, Fritton takes a bribe to readmit her brother Clarence's hell-raising daughter, Arabella. Fortune seems to smile when a rich Indian princess, whose father owns the prize-winning stallion 'Arab Boy', also joins the school. Fearing being sent to 'proper' schools, the staff and fourth form, aided by 'Flash Harry' the spiv, stake all their ill-gotten gains on Arab Boy to win the gold cup. But Clarence, a crooked bookmaker, will be bankrupted if Arab Boy wins, so Arabella leads the sixth form in a plot to steal the horse. 'Creepy' Crawley's investigations threaten all their schemes and the future of St Trinian's hangs precariously in the balance.

The Belles of St Trinian's, London Films/British Lion/The Kobal Collection.

Ronald Searle (original drawings)
Val Valentine

Cinematographer:
Stanley Pavey

Production Designer:
Joseph Bato

Composer:
Malcolm Arnold

Editor:
Thelma Conell

Duration:
91 minutes

Genre:
Comedy

Cast:
George Cole
Hermione Baddeley
Joyce Grenfell
Alastair Sim

Year:
1954

Critique

The Belles of St Trinian's is the first in a series of films by British comedy-writing duo Gilliat and Launder, followed by Blue Murder at St Trinian's (1957), Pure Hell of St Trinian's (1960) and The Great St Trinian's Train Robbery (1966). They are adaptations of a cartoon series by Ronald Searle, whose scratchy sketches of gruesome gals and terrible teachers delighted readers in the post-war era. St Trinian's showcased contemporary British comedy talent including Joyce Grenfell as the reluctant detective Miss Crawley, George Cole as the endearingly geezer-ish 'Flash Harry', Hermione Baddeley, Dora Bryan, Beryl Reid and Joan Sims as scandalous schoolmistresses, Terry Thomas, Sid James and Frankie Howerd as male dupes and, of course, Alistair Sim, dragging up magnificently as the coyly ruthless Millicent Fritton and swapping genders to play her brother Clarence.

St Trinian's gleefully exploded conventional post-war representations of class and gender. They are boarding school narratives, that classically British genre in which, from Tom Brown's School Days in 1857 to the contemporary Harry Potter series, children are dispatched from the family home to fend for themselves in an often abrasive institution. While the boarding school, a cradle of the British class system, is an elitist educational establishment for fee-paying middle and upper classes, St Trinian's plays on the post-war decline of the British upper class as much as its decadent and ungovernable reputation. These posh girls are far from rich or refined: they run money-making scams, collude with spivs, bookies and smugglers, terrorize local villagers and generally behave far worse than their working-class counterparts.

While the films are anarchic girl comedies in the tradition of the silent-era Tilly the Tomboy series, St Trinian's girls are the most outrageous girls in British cinema. The younger pupils cause incessant havoc with casual arson, gambling, explosives, illegal distilling and plotting new ways to ambush incautious staff; the sixth formers have graduated to blackmail, espionage and robbery. The mistresses, too, have committed unspeakable and 'unladylike' crimes, from burglary to extortion and possibly even murder. Indeed, 'St Trinian's' has become shorthand for anarchic female insubordination.

A forgettable revival, The Wildcats of St Trinian's (Frank Launder, 1980), traded entirely on sexual exploitation, as do more recent revivals (Oliver Parker and Barnaby Thompson, 2007/2009), which are little more that anglicized American high school comedies. The original St Trinian's used sexuality to manipulate men and ridicule upper class debutante culture, but these remakes collude with moral panics about 'bad girls' and disturbing sex fantasies about 'naughty schoolgirls' and 'strict mistresses'.

St Trinian's provided generations of young women with images of joyous female anarchy, of girls made less of 'sugar and spice' than 'sneezing powder and gin'. The moral of the films is 'never trust little girls – especially the posh ones'.

Emma Bell

Carry On Screaming

Studio/Distributor:
Peter Rogers Productions/
Anglo-Amalgamated

Director:
Gerald Thomas

Producer:
Peter Rogers

Screenwriter:
Talbot Rothwell

Cinematographer:
Alan Hume

Production Designer:
Bert Davey

Composer:
Eric Rogers

Editor:
Rod Keys

Duration:
97 minutes

Genre:
Comedy

Cast:
Harry H Corbett
Jim Dale
Fenella Fielding
Kenneth Williams

Year:
1966

Synopsis

In Edwardian England, Inspector Bung and his assistant Slobotham are investigating the abduction of Doris, which may be linked to the disappearance of several other young women. While searching the crime scene in the woods, the policemen visit the house of mysterious scientist Doctor Watt and his sister Valeria. Unsuspected by the police, the Watts are using a revived prehistoric figure, Oddbod, to kidnap women, who are then 'vitrified' and sold as a shop mannequins. As he continues the investigation, Valaria seduces Bung and uses a magic potion to temporarily turn him into a werewolf. Slobotham, dragged-up as a woman as bait, is abducted, along with Bung's suspicious wife Emily, who has been following him. After spending a terrifying night at Watt's house, during which an unsuccessful attempt is made on his life, Bung determines to solve the mystery.

Critique

A knowing genre parody, which productively unites elements of *Carry On* and Hammer, *Carry On Screaming* reflects a long tradition of comedy-horror hybrids, spanning *The Ghost Train* (Walter Forde, 1931) to *Lesbian Vampire Killers* (Phil Claydon, 2009). *Screaming* adroitly adopts the Hammer *mise-en-scène* with its fog bound night-time exteriors, upholstered country manor and pulsing basement laboratory. The plot, also, randomly references key horror texts including *Frankenstein, The Mummy, Jekyll and Hyde* and, in Valaria and Doctor Watt's appearance at least, suggestions of *Dracula*. The basic plot device, abducted young women 'vitrified' by a mad scientist and sold as mannequins, draws heavily on *House of Wax* (André De Toth, 1953.)

While the combination of these genres might seem surprising, there are correlations: both open up repressed and taboo subjects that are mediated through emotions of laughter and/or fear. *Carry On* and Hammer also shared parallel economic fortunes between the 1950s and 1970s, arguably for similar reasons. Both touched on transgressive material during periods of rapid social and cultural change, and both were eventually stranded – by the decline of the national film industry, but also by cultural liberalization that rendered their shocking elements ineffective.

Critically dismissed in their day, the *Carry On* films' cultural significance is now more widely acknowledged and their amiable crudity now encourages a nostalgic affection. Strongly cast, fluently combining generic parody with standard ribaldry, *Screaming* shows the series at its height.

Adrian Garvey

Carry On Screaming, Ethiro Prods/The Kobal Collection.

Withnail and I

Studio/Distributor:
Handmade Films
Handmade Films

Director:
Bruce Robinson

Producer:
Paul Heller

Screenwriter:
Bruce Robinson

Cinematographer:
Peter Hannan

Production Designer:
Michael Pickwoad

Composers:
David Dundas
Rick Wentworth

Editor:
Alan Strachan

Duration:
107 minutes

Genre:
Comedy

Cast:
Ralph Brown
Richard E Grant
Richard Griffiths
Paul McGann

Year:
1986

Synopsis

Two out-of-work actors, Withnail, an aristocratic, temperamental heavy drinker and drug-user, and the more placidly middle-class Marwood, share a squalid flat in late 1960s' Camden, London. Withnail rails against the world, covers himself in Deep Heat in attempt to keep warm and resorts to drinking lighter fuel in his desperation for alcohol. After being visited by drug dealer Danny, failing to pay their rent again and being threatened in a local pub, Marwood suggests a holiday and they visit Withnail's flamboyant Uncle Monty to secure a trip to his cottage near Penrith. They flee London in an alcohol-induced craze, only to find the remote cottage cold and inhospitable and the locals threatening; they are terrified by an intruder in the night, have to kill their own dinner, cause havoc in a Penrith tearoom and Monty tries aggressively to seduce Marwood. On learning that Marwood has an audition, they flee back to London.

Critique

Withnail (Richard E Grant) and Marwood/I (Paul McGann) have become cult comedy figures and much of the film's humour stems from Withnail's bilious, misanthropic invective. Bruce Robinson's screenplay revels in a theatrical use of language, which is heightened by Richard E Grant's suitably over-scaled performance. Costumed and styled like a shabby Edwardian rake, Withnail's monstrous sense of entitlement fuels his disgust at his surroundings and disbelief at his inability to find work. The more reactive Marwood acts as both foil and audience identification figure within this shabbily-bohemian world at the end of the decadent 1960s.

Withnail and I presents an almost exclusively masculine environment. The few women glimpsed are grotesques, such as the head-scarfed housewife biting into a fried egg sandwich in a café, or hostile authority figures, as in Miss Blennerhassett (Irene Sutcliffe) in the genteel Penrith tearoom. While the central male relationship has an almost romantic intensity, emphasized by the emotionally-charged farewell sequence, homoerotic anxiety is displaced onto the predatory figure of Uncle Monty (Richard Griffiths). Griffiths' vivid portrayal of this avaricious, aristocratic eccentric is a triumph of comic excess, but the homophobic nature of the characterization is undeniable, and in line with some other reactionary elements of the film, which castigates anything beyond its narrow setting.

Withnail and I was Bruce Robinson's directorial debut and, perhaps because of this, includes some awkwardly-staged scenes, such as an encounter with a randy bull. Withnail was financed by Handmade Films – the production company formed to make Monty Python's Life of Brian (Terry Jones, 1979) and which became a significant force in British cinema during the 1980s. Withnail and I attracted little critical attention on its original release and performed poorly at the box office, but developed a strong cult following on video during the 1990s and is now considered a

classic. It is especially popular among student audiences, drawn to the hedonistic, alternative world it celebrates, with Danny (Ralph Brown), the gnomic drug dealer and creator of the infamous Camberwell Carrot, a particular favourite. The florid eloquence of Robinson's screenplay is eminently quotable; from Monty's sentimental 'As a youth I used to weep in butcher's shops' to Withnail's indignant 'We want the finest wines available to humanity! We want them here and we want them now!'

The film self-consciously marks the morning-after mood of the end of a definitive social era; in Danny's words, 'They're selling hippie wigs in Woolworths, man. The greatest decade in the history of mankind is over.' As a semi-autobiographical account of Robinson's own experiences, it is, despite the comedy, imbued with a melancholy nostalgia for an era of freedom, decadence and chaos.

Adrian Garvey

Four Weddings and a Funeral

Studio/Distributor:
PolyGram
Channel 4
Working Title
Channel 4

Director:
Mike Newell

Producer:
Duncan Kenworthy

Cinematographer:
Michael Coulter

Production Designer:
Maggie Gray

Composer:
Richard Rodney Bennett

Editor:
Jon Gregory

Duration:
117 minutes

Genre:
Comedy/Drama

Synopsis

Charles is constantly invited to weddings, although he cannot ever see himself as a willing groom. That is, until he meets an American guest named Carrie at the film's first wedding and falls instantly in love. As Carrie returns to America, they both feel something of a missed opportunity. Three months later Charles again encounters Carrie at a wedding, although this time she is engaged to another man. After meeting a host of ex-girlfriends, and the death of a close friend, Charles is forced to re-think his own stance on marriage and commitment, fearing he has let the perfect woman pass him by. As Carrie's marriage looms, Charles becomes her close friend but resolves to win her over indefinitely.

Critique

Although British television-comedy writer Richard Curtis had already penned a film comedy prior to 1994's *Four Weddings and a Funeral*, in the form of *The Tall Guy* (Mel Smith, 1989), it was with this second film that he established his own screen-writing credentials. Directed by Mike Newell, *Four Weddings* also established the lucrative crossover potential for a British domestic comedy overseas, particularly in America where the film was a surprise hit. Not only did it enable Curtis to make a career out of similar romantic comedies, such as *Notting Hill* (Roger Michell, 1999), *Bridget Jones's Diary* (Sharon Maguire, 2001) and *Love Actually* (Richard Curtis, 2003), it also led to similar British films – often featuring American stars – aimed at international audiences, such as *Sliding Doors* (Peter Howitt, 1998).

However, it should not be considered surprising that *Four Weddings* proved such a saleable commodity overseas. Although its setting is contemporary, the film's depiction of Britishness is consistent with that of British cinema's most internationally-popular

Cast:

Hugh Grant
John Hannah
Andie MacDowell
Kristin Scott Thomas

Year:

1994

genre: the heritage drama. Charles (Hugh Grant) and his group of friends are, for the most part, foppish public school graduates, with one of their number among the richest men in England. Every occasion they are invited to (except the funeral) takes place in the most sumptuous of country homes and attended by members of the aristocracy.

Almost all of the film's humour relates either to British attitudes towards sex (in one scene Charles is trapped in a cupboard and forced to listen to some excruciatingly embarrassing love making), or to social and class observational comedy (Charles is consistently seated next to people he would rather avoid, including a dotty, hard-of-hearing old relatives and a series of ex-girlfriends). However, these potentially-awkward scenes avoid *schadenfreude*, with laughs being light-hearted and palatable, derived from the 'wacky' wedding guests. Much of *Four Weddings* is an affectionate send-up of Britishness in the form of upper-class affectation, custom and speech, but it has a celebratory manner. Hugh Grant portrays all the stuffiness and strained emotion of the archetypal Englishman with amiable perfection in a role that firmly established his screen persona as a loveable fop.

Unlike some of Curtis' later work – which could just as easily be set in America – *Four Weddings* feels evocative of certain specifically-British sensibilities. Perhaps credit can go to Mike Newell for many of the film's more nuanced moments, though he frequently stoops to cliché at other points – particularly the many countryside establishing shots, which resemble the kitsch art on biscuit tins. *Four Weddings* also boasts likeable supporting performances from Simon Callow, James Fleet and John Hannah which, along with the occasional gentle laugh and the good-natured spirit of the piece, make it an endearing film, in spite of what could be seen as its overbearing tweeness.

Robert Beames

Brassed Off

Studio/Distributor:

Channel 4
Miramax
Prominent Features/Channel 4

Director:

Mark Herman

Producers:

Steve Abbot
Olivia Stewart

Synopsis

In the Yorkshire mining town of Grimley, the colliery band, led by Danny, struggles to find motivation to continue playing after their profitable pit is designated for closure. Gloria, who works for the pit managers, arrives back home in Grimley and tries to join the all-male band and rekindle her relationship with pit-worker and band-member Andy. As the band progresses through the heats of a national competition, miners stage angry protests and the devastating impact of the pit closure becomes apparent. For Danny, the competition becomes a matter of pride and of defiance, but Gloria's relationship to the pit management leaves the band vulnerable.

Brassed Off, Miramax/Film Four/The Kobal Collection/Sophie Baker.

Screenwriter:
Mark Herman

Cinematographer:
Andy Collins

Production Designer:
Don Taylor

Composer:
Trevor Jones

Editor:
Michael Ellis

Duration:
107 minutes

Genre:
Comedy/Social Realism

Cast:
Tara Fitzgerald
Ewan McGregor
Pete Postlethwaite
Stephen Tompkinson

Year:
1996

Critique

Brassed Off is typical of a number of socially-conscious mid-nineties British films, such as *The Full Monty* (Peter Cattaneo, 1997), that construct a tragi-comedy from a cultural context shaped by industrial decline and male unemployment. Born in Yorkshire, writer and director Mark Herman knew only too well the devastating impact of de-industrialization on northern working-class communities. *Brassed Off* is a renunciation of Thatcherism and an indictment of the impact of economic reform on industrial working-class communities. It eulogizes the emotional lives and social communities of men that were forged in the industrialized workplace; the characters of family man Phil (Stephen Tompkinson) and band leader Danny (Pete Postlethwaite) offer a poignant critique of Thatcherism's impoverishment of working-class communities and the effacement of working-class culture. *Brassed Off* emerged in 1996 at the outset of the wave of British cultural invigoration known as 'Cool Britannia', just prior to election of New Labour. It is also, then, infused with proto-Blairite optimism and a sentimental 'feel good' factor that appears at odds with its claims to serious political commentary.

Its more light-hearted romance plot balances the film's sometimes heavy-handed political critique. When Gloria (Tara Fitzgerald) arrives back in Grimley it is clear through her clothing, accent and mannerisms that she no longer truly belongs in the community and her employment by the pit managers leads to her being ostracized.

The film positions Gloria as the naïve but well-meaning middle-class outsider whose formalized education and corporate knowledge is inferior to the miner's experience at the literal coal face of industrial relations. Gloria's rehabilitation begins when she realizes that her managers have misled her; her loyalty to the miners allows her to become a viable love interest for Andy (Ewan McGregor).

For McGregor, Brassed Off came on the back of Trainspotting (Danny Boyle, 1996) and cemented his position at the forefront of a new generation of British talent. A departure from Renton's knowing nihilism, Andy is more typical of the masculinity-in-crisis narratives that were a staple of nineties' British cinema. McGregor imbues Andy with a nervous charm and disarming sincerity, realizing the character's deep-seated resignation with emotional candour. If Phil is the character through which the film explores the consequences of de-industrialization on men with children, then Andy articulates the effects of industrial decline on a younger generation.

Herman uses the climatic scenes of the film to return to his central political point when Danny delivers an impassioned speech about how years of Conservatism led to the men in the band 'losing the will to live, to breathe', none of them having 'an ounce of hope left'. As with the strip scene at the end of The Full Monty, Brassed Off cannot offer any resolution to the problems it presents and relies on a poignant 'feel good' suspension of reality through collective celebration. Aboard an open-top bus, the band take to the streets of London and reprise the hymn 'Land Of Hope And Glory' in an era where no hope remains. The crowd cheers on regardless.

Sarah Godfrey

East Is East

Studio/Distributor:
Film4
BBC
Assassin/Channel 4
View Askew

Director:
Damien O'Donnell

Producer:
Leslee Udwin

Screenwriter:
Ayub Khan-Din

Cinematographer:
Brian Tufano

Synopsis

It is 1971 and George Khan, a Pakistani immigrant, runs a chip shop in Salford with his English wife Ella and their seven children. When his eldest son refuses to go through with an arranged marriage and runs away, George demands that his family lives by strict Pakistani traditions. With the exception of the slightly pious Maneer, the children are more interested in embracing British culture than their Pakistani roots. When they discover that George has arranged for two of them to be married, tensions come to a head. George tries to assert his role as the head of the household whilst Ella and the children resist.

Critique

East is East is an adaptation of Ayub Kahn-Din's hit play of the same name, which focuses upon identity, multiculturalism and British-Asian experience during the 1970s. The film followed on from earlier British Asian works including The Buddha of Suburbia

Production Designer:

Tom Conroy

Composer:

Deborah Mollison

Editor:

Michael Parker

Cast:

Linda Bassett

Jimi Mistry

Archi Panjabi

Om Puri

Jordan Routledge

Duration:

96 minutes

Genre:

Comedy

Year:

1999

(BBC, 1993) and *Bhaji on the Beach* (Gurinda Chadha, 1992), but it is also a product of the 'Cool Britannia' New Labour era when films such as *Trainspotting* (Danny Boyle, 1996), *The Full Monty* (Peter Cattaneo, 1997) and *Brassed Off* (Mark Herman, 1996) showed that British cinema and stories about Britain could be both political and popular. There is a certain irony that Damien O'Donnell and Ayub Kahn-Din's adaptation was released just as the notion of 'Cool Britannia' was slowly fading from British culture. Despite the fact that the party was starting to finish, the film is still suffused with an air of celebration in its portrayal of multicultural Britain.

Certainly, much of the racism of 1970s' Britain is presented as a mere annoyance and the preserve of buffoons and fools, as Enoch Powell – and those who support him – become figures of ridicule. Any threat they could prove is downplayed and diffused by farce (such as a football through one of their windows) and there seems to be an element of comic revenge at play here. What better way to defuse your victimizers than to make fun of them and their ignorance? Indeed, there is only one moment, when a sign from Bradford has been altered to read 'Bradistan', when the more insidious side to British society is alluded to.

The biggest threat comes from within the family, with George heavy-handedly imposing his Pakistan values on his mixed-race children. But deep down there are notions of masculinity and empowerment at play: Ella (Linda Basset) is a confident and outspoken woman who is prepared to stand up to her husband, whilst their children seem almost mocking in their ways of defiance (such as gorging on forbidden pork sausages and bacon whilst George is out of the house). Like *My Beautiful Laundrette* and *The Buddha of Suburbia*, *East is East* also has a vaguely queer agenda, with Nazem, George's eldest son, running away from the arranged marriage as much because of his sexuality as his cultural identity. George's aggressive desire to force his family to comply is presented as a scared man attempting to reassert control as much as proudly attempting to maintain religious and traditional values.

With the emotional conflict at the heart of the film, it relies on strong acting to pull it all together, and Puri, Mistry and Basset are wonderfully believable in their parts. Alongside the intense familial drama, O'Donnell creates scenes of sharp northern wit and broad comedy, such as a cheesy 1970s' disco, a sweet Bollywood dance sequence, a 'little and large' duo of lusty white girls, a lewd art project and a large dog humping everyone (echoing a similar scene in *The Buddha of Suburbia*).

Despite its sometimes uneven nature, *East Is East* remains an endearingly popular and celebratory example of British cinema. It even led to a (less successful) sequel, *West Is West* (Andy De Emmony, 2010), in which George makes one last attempt to 'sort out' Sajid, his youngest son, and the Khan family, by returning to Pakistan.

Laurence Boyce

Shaun of the Dead

Studio/Distributor:

Universal
Studio Canal
Working Title/United
International Pictures

Director:

Edgar Wright

Producer:

Nira Park

Screenwriters:

Simon Pegg
Edgar Wright

Cinematographer:

David M Dunlap

Production Designer:

Marcus Rowland

Composer:

Daniel Mudford
Peter Woodhead

Editor:

Chris Dickens

Duration:

99 minutes

Genre:

Comedy/Horror

Cast:

Kate Ashfield
Simon Pegg
Nick Frost

Year:

2004

Synopsis

Shaun has a dull retail job in North London. While his girlfriend is unhappy about all the time they spend in their local pub, The Winchester, his flatmate Pete complains about the behaviour of Shaun's slobbish friend Ed. When Liz dumps Shaun, he and Ed enjoy a raucous, drunken night. They are oblivious to a developing zombie outbreak until the next morning, when they are menaced by the undead in their back garden. Escaping from Pete, who has become a zombie, they pick up Shaun's mother Liz and her friends, but have to abandon Shaun's infected stepfather Philip. After several close encounters with the undead masses they reach The Winchester, only to find it surrounded by zombies. Eventually, barricaded inside, they prepare to fight for their lives.

Critique

Shaun of the Dead, billed as a 'A Romantic Comedy, With Zombies', was part of the early twenty-first century new wave of British horror films, which included *28 Days Later* (Danny Boyle, 2002) and *Dog Soldiers* (Neil Marshall, 2002). The film shares the 'fanboy slacker' spirit of the Channel 4 television sitcom *Spaced*, also directed by Edgar Wright, and written by and starring Simon Pegg and Jessica Stevenson (who has a cameo role here).

The film achieves a strong sense of place, its North London suburban locale providing a suitably mundane setting for Shaun's humdrum life and the slowly-developing spectacle of the zombie menace. The opening scenes suggest that Shaun is sleepwalking through his own life – his robotic morning visit to the corner store is replayed for comic effort when he fails to notice how the world has changed overnight, as he misses the bloody handprints on the shop's fridge door. This uncanny quality is central to the zombie genre and provides much of the film's humour. In their first encounter with a zombie – a dishevelled girl found staggering about the back garden – Shaun and Ed assume she is drunk, and, then, that she is making sexual advances. This laddish humour is followed by a knowingly-geeky address to the audience when, on discovering that records make good missiles, they begin to bicker over the merits of Shaun's vinyl collection. But the sequence becomes increasingly graphic and gory, representing a shift in the film's tone from comedy to horror.

Shaun of the Dead is in many ways a 'buddy movie', with the relationship between Shaun (Pegg) and Ed (Nick Frost) at its core. Although Shaun's ostensible quest is to protect his girlfriend Lizzie, the film is more concerned with male friendship. Indeed, the standard narrative trajectory of maturing is rejected: rather than Shaun accepting the need to grow up and join the adult world, Lizzie is incorporated into his homosocial environment of pubs, computer games and puerile jokes. While the romantic storyline is quite superficially handled, there is a surprising Freudian intensity to Shaun's relationship with his mother. His fantasy of executing his

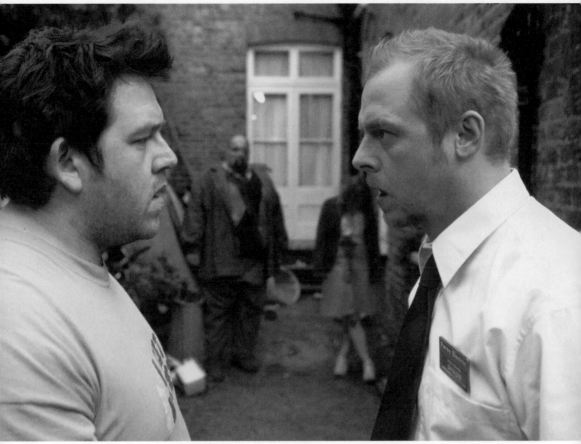

Shaun of the Dead, Big Talk/WT 2/The Kobal Collection/Oliver Upton.

infected stepfather is replayed with relish, and there is a disruptive emotional depth to the scene where he has to kill his mother after she has been bitten.

Wright's signature visual style, established in *Spaced*, employs a comic hyperbole, playing on a deliberate disjunction between the emphatic swish pans and strident chords of action cinema and his own prosaic settings and characters. Similarly Pegg's nerdishness and Frost's crass blokish persona work to create an inclusive rapport with the audience, which helps the film to negotiate generic boundaries and shifts in tone. Wright's playful and allusive approach to genre continued in his next film, *Hot Fuzz* (2007), the second in a planned trilogy. Also starring Pegg and Frost, this combined elements of British horror, notably *The Wicker Man* (Robin Hardy, 1973), with tropes of the Bruckheimer buddy movie.

Adrian Garvey

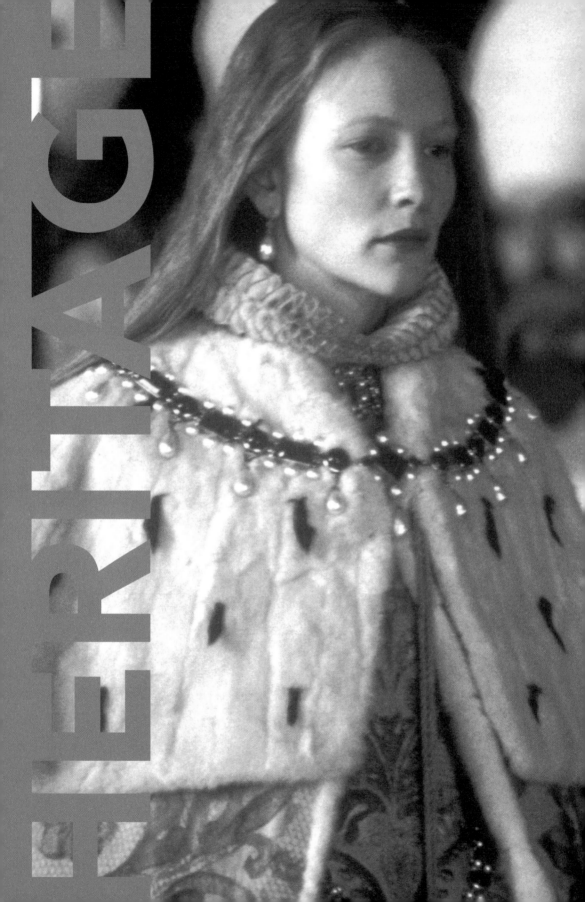

The heritage film stands out as perhaps the quintessential British film genre. The term emerged in the early 1990s to refer to a distinctive trend of popular period dramas and television serials that recreate the historical and literary past. Literary adaptations such as *A Room with a View* (James Ivory, 1986) as well as the sports biopic *Chariots of Fire* (Hugh Hudson, 1981) are often cited as the start of a cycle that became immensely popular with audiences both at home and abroad, contributing to the renaissance of British cinema in the 1980s. Yet as 'heritage films' (as they were re-named by film historian Andrew Higson) they have been the object of ongoing debates that connect the films' iconography of Englishness with a commercialized heritage culture polemically associated with the Thatcher years (1979–1991). Within and beyond this context, the term 'heritage film' is used to designate films where the emphasis on period reconstruction as a vehicle for literary adaptations, biopics, melodramas or comedies of manners invites an appreciative eye for all things of the past (Dyer 2002: 206). Such appreciation has been regarded as a symptom of reductive nostalgia and a bland middlebrow film culture. However, beyond these negative connotations, British heritage film has proved a versatile and resilient film genre sensitively attuned to the changing times industrially, aesthetically and ideologically.

Stretching all the way back to the silent era, the undying popularity of the romantic costume film and the classic adaptation, such as *Henry V* (Laurence Olivier, 1944) or *Great Expectations* (David Lean, 1946), provide the historical foundations for the modern heritage film. In the 1980s, however, period film became almost exclusively associated with quality drama. In particular, Indian producer Ismail Merchant and American director James Ivory – the core team behind Merchant Ivory Productions – alongside their frequent collaborator screenwriter Ruth Prawer Jhabvala – perfected a cycle of adaptations that travelled from the British Raj (*Heat and Dust*, 1983) to Edwardian England (*Maurice*, 1987; *Howards End*, 1992) to Italy (*A Room with a View*; *The Golden Bowl*, 2000). Graced with impeccable literary (EM Forster, Henry James) and acting credentials, Merchant Ivory's heritage films are small in scale and intimate in focus but often visually spectacular, offering a melancholic iconography of Englishness. The absence of direct political commentary and of a marked auteurist aesthetic (the opulent *mise-en-scène* of heritage objects and sites feels sometimes static) made Merchant Ivory the target of derogative criticism. This has tended to shadow the films' sharp focus on melodramatic narratives of social conflict, often focused on individuals (Margaret Schlegel and Leonard Bast in *Howards End*; Charlotte Stant in *The Golden Bowl*) whose aspirations are crushed by rigid class barriers. With their adaptation of Kazuo Ishiguro's novel *The Remains of the Day* (1993) Merchant Ivory demonstrated that their picture-perfect heritage films could deal critically and poignantly with themes such as sexual repression and class betrayal. Their restrained heritage films can thus be linked to other, more valued British dramas by expatriate directors such as Joseph Losey (*The Go-Between*, 1970), Stanley Kubrick (*Barry Lyndon*, 1975) or Robert Altman (*Gosford Park*, 2001); they have also set an often unacknowledged template for period melodramas that continue to

exploit the iconography of gentrified British past, if only to look into its darker recesses, as in Stephen Poliakoff's *Glorious 39* (2009).

In the early 1990s, however, the British heritage film and especially the classic literary adaptation were viewed as part of a new heritage culture associated with shameless commercialism and the promotion of conservative values that arose during the Thatcher era. As early as June 1991, upon the release of Charles Sturridge's EM Forster adaptation *Where Angels Fear to Tread*, Cairns Craig in *Sight and Sound* called the period film a 'theme park of the past' aimed at international audiences. He noted that the genre was 'in danger of turning into a parody of itself' and that 'maybe [it] was viable only in the decade we have just left' (Craig 1991: 10). Also sensitivized to the cultural and political climate, Tana Wollen showed concern that these 'nostalgic screen fictions' – as she called them – traded on visual authenticity while co-opting collective memory to suit a conservative political agenda (Wollen 1991). The heritage film's typical focus on the iconography of white upper-middle class and aristocratic privilege insidiously made the 'Britishness' of the films indistinguishable from a particularly limited understanding of Southern Englishness. For its critics, what is at stake is no less than the success of an idea of nation reduced to a narrow section of class, national and racial identities.

Retrospectively, the chronological links of the heritage film with Thatcherism seem overstated but they did make the heritage film prosper as a fixed category within the British cinema canon, and one that made the connections between text and context almost self-evident. However, the emphasis on Englishness and nostalgia was just one possible way of examining – and consuming – the heritage film. For feminist critics, the genre has clear progressive potential. Thus Claire Monk pointed out that the gay anti-romance *Maurice* or the arch irony in *A Room with a View* subverted the films' realist settings by foregrounding marginalized pleasures and subjectivities. Moreover, foreign creative talent as well as co-production arrangements means that an international version of the heritage film has existed all along, which are also open to experimentation. Sally Potter's *Orlando* (1992) and Jane Campion's *The Piano* (1993) were especially celebrated for their self-conscious (postmodern) use of costume and period setting in order to foreground subversive gender identities, whereas other genre films proposed adventurous explorations into sexuality and society: *Carrington* (Christopher Hampton, 1995); *The Wings of a Dove* (Ian Softley, 1997). Whether these films were indicative of a new 'post-heritage' phase, as Monk put it, it became clear that the 1990s' heritage film allowed room for shifting established boundaries of taste and representation.

The beginning of the New Labour era (1997–2010) and its initial thrust of social and economic optimism seemed to effect a change on the ways in which British films reflected on the relation between the present and the past. Ideologically, *Elizabeth* (Shekhar Kapur, 1998) was another celebration of the British imperial past, yet it showed that a more vigorous, genre-driven and hybrid heritage film was possible. Period films expanded formally and narratively, while, as Monk notes, the most conservative aspects of heritage iconography (the limited social scope; the touristic use of heritage settings) paradoxically seemed to move to films with contemporary settings, such as *Four Weddings and a Funeral* (Mike Newell, 1994), *Notting Hill* (Roger Michell, 1999) and *Bridget Jones's Diary* (Sharon Maguire, 2001). The dialectic between heritage continuity and historical change was further refined in *The Queen* (Stephen Frears, 2006), possibly the British heritage film that best encapsulates the presence of the past in the contemporary popular imagination.

The former emphasis on issues of nation has moved on to the industrial relationships between British cinema and Hollywood. In his 2003 book *English Heritage, English Cinema*, Higson notes that the move from 'cottage industry' product to crossover film (an art film with the potential to crossover to multiplex exhibition and revenue) has attracted Hollywood studio backing and ensured the continuing visibility of the British heritage film as an international phenomenon. *Shakespeare in Love* (John Madden, 1998), for

example, was developed through Miramax, and *Pride and Prejudice* (Joe Wright, 2005) had Focus Features and Universal behind it. These films function as both rom-coms and prestige heritage films, with the signs of British literary culture (William Shakespeare and Jane Austen) enhancing the films' 'brand' value in the international marketplace.

With global Hollywood being increasingly de-centred and the decline of independent production companies such as Goldcrest and Merchant Ivory, the politics of the heritage genre have become more difficult to locate. The heritage film can both mimic Hollywood formulas (as in the belated sequel, *Elizabeth: The Golden Age,* Shekhar Kapur, 2007) and heavily depends on multi-national sources of funding. It also continues to offer an effective springboard for British stars and a relatively safe haven for young directors. Following Helena Bonham Carter and Colin Firth, Keira Knightley was catapulted to heritage stardom by *Pride and Prejudice* (2005) and *Atonement* (2006), both directed by Joe Wright, and *The Duchess* (2007), by Saul Dibb. The fate of the heritage film as an independent British production may, however, have its days numbered. The rocky financing of *Tristram Shandy: A Cock and Bull Story* (Michael Winterbottom, 2005) is ironically mirrored in the film itself through the travails of a film crew attempting to put together a film adaptation of the Laurence Sterne novel. With its recognizable heritage lineage and atypical tongue-in-cheek reflection on the genre, *A Cock and Bull Story* stands out as perhaps the most imaginative and fitting summary of the possibilities and constraints offered by the heritage film as a typically British genre.

Belén Vidal

Henry V

Studio/Distributor:
Two Cities/Eagle-Lion

Director:
Laurence Olivier

Producer:
Laurence Olivier

Playwright:
William Shakespeare (original play)
Dallas Bower
Alan Dent
Laurence Olivier (all uncredited)

Cinematographer:
Robert Krasker

Production Designer:
Paul Sheriff

Composer:
William Walton

Editor:
Reginald Beck

Duration:
137 minutes

Genre:
Heritage/Stage Adaptation

Cast:
Leslie Banks
Robert Newton
Laurence Olivier
Harcourt Williams

Year:
1944

Synopsis

An Elizabethan staging of Shakespeare's *Henry V*, at the original Globe Theatre, transforms into a fully cinematic imagining of the play. Young King Henry has matured from the callow, carousing Prince Hal and is now a steady and admirable monarch. He has also abandoned the companions of his youth, most obviously the ailing Sir John Falstaff. After the Archbishop of Canterbury explains that Henry has an apparently valid claim to the French crown and, after being insulted by the French Dauphin's reaction, Henry invades France. The invasion proceeds well but, with his army afflicted by fatigue and illness, Henry decides to withdraw. Another insult from the French inspires him to lead his troops in the famous Battle of Agincourt, at which they are massively overmatched.

Critique

A splendid cinematic adaptation of Shakespeare, *Henry V* is a film that serves several purposes. It was made to boost the morale of the British public after half a decade of WWII and subsequently is, at times, pure propaganda. Beyond that it serves to educate the audience about the business of staging and appreciating Shakespearean plays as the playwright intended.

Starting and ending the film by showing it to be a performance of *Henry V* at the original Globe Theatre is inspired. Hecklers, backstage chaos and groundlings who desert the show as soon as it starts to rain succinctly capture the environment in which Shakespeare's plays might first have been performed, and for which they were written. For example, in the Elizabethan theatre, male actors played all parts, thus there is an ingenious match dissolve in the film when the action returns to the Globe – Princess Katharine, played throughout the film by female actor Renee Asherson, is suddenly played by a boy.

Henry V is an apposite Shakespeare play with which to use this film-within-a-play device: the chorus famously implores the audience to overlook the limitations of 'this wooden O' (the Globe theatre) and 'Think when we speak of horses, that you see them.' As such, the play almost explicitly calls out to be staged in an arena as visually unlimited as film and, fittingly, the common imposition of a 'slice of life' sensibility on the filming of Shakespeare is avoided here. Indeed, the knowledge that the audience is watching actors playing actors playing roles is a suitably Shakespearean experience and adds to the film's depth and resonance. It also allows its distinctive art design, often reliant upon painted two-dimensional backgrounds, to appear not fake, but fitting.

As a complete presentation of the play the film is, however, flawed in that it omits the most controversial of Henry's lines. There is no intimation, for example, of the darker edge of his speech to the governor of Harfleur, when the English King promises that, without an immediate surrender, the 'foul hand' of his soldiers will 'defile the locks of your shrill-shrieking daughters' and leave 'your

naked infants spitted upon pikes'. The complexities of character these lines reveal are crucial to the play, but inconsistent with the film's propagandist purposes.

Whatever the film's other aims, one of its most important purposes is to showcase, and to preserve, the talents of Laurence Olivier, capturing a great British actor performing the work of the greatest British writer of any age. As such, it is an invaluable cultural artefact. In addition, its conception as a piece of WWII propaganda makes it a social document. Yet, fascinatingly, it raises British morale by denigrating the French, Britain's allies of the time. The author Alexander Solzhenitsyn wrote that 'literature becomes the living memory of a nation'. Sometimes, so does film. In its genuine historical and cultural significance, Olivier's *Henry V* certainly has this status.

Scott Jordan Harris

Chariots of Fire

Studio/Distributor:
Enigma
Allied
Goldcrest/20th Century Fox

Director:
Hugh Hudson

Producer:
David Puttnam

Screenwriter:
Colin Welland

Cinematographer:
David Watkin

Production Designer:
Jonathan Amberson

Composer:
Vangelis Papathanassiou

Editor:
Terry Rawlings

Duration:
124 minutes

Genre:
Heritage

Synopsis

Chariots of Fire is the true story of a group of British sprinters at the 1924 Paris Olympics, told through the letters sent home by a Cambridge student, Aubrey Montague. Englishman Harold Abrahams and Scotsman Eric Liddell face deeply personal obstacles between them and the Olympic gold medal. Abrahams must confront anti-Semitism and judgements made because he uses a professional coach. Liddell, a devout missionary, must persuade his sister that he can best serve God by running as fast as possible and winning the medal. However, when the first heat of the 100m is set for a Sunday, Liddell has a difficult choice to make.

Critique

It is a mistake to dismiss *Chariots of Fire* as just a 'sports film', or to pigeon-hole it in the same category as the heritage films of, say, Merchant Ivory. The film is not an adaptation of a Forster, Dickens or Austen novel, but is an original screenplay based on a true story. This hint of realism serves to ameliorate the languid pleasures of heritage films such as *A Room with a View* (James Ivory, 1985) and provides something more irregular and nuanced.

Chariots of Fire must have exasperated sections of the British film community when it was released and subsequently won four Oscars and a BAFTA. Its storyline is decidedly populist; its main characters are upper-class products of public schools; its female characters are mere ciphers; and, despite some social-realist credentials on the part of its script-writer, Colin Welland, many of its themes seem to echo the individualistic and entrepreneur-led ethos of the new Thatcherite regime. The competitive nature of the Olympic Games narrative endorses patriotic fervour, and the rivalry between Liddell and Abrahams echoed that of British runners Steve Ovett and Sebastian Coe in the 1980 Moscow Olympics.

Chariots of Fire, 20th Century Fox/Allied Stars/Enigma/The Kobal Collection.

Cast:

Ian Charleson
Ben Cross
Nicholas Farrell
Nigel Havers

Year:

1981

The film also deploys symbols of British patriotism and prestige – the Union Jack flag, the hymn 'Jerusalem' (from which the film takes its name), the works of Gilbert and Sullivan, etc. – that had been subverted by the previous generation of British film-makers. Equally, the use of the Scottish Highlands as the savage opposite to the civilized Cambridge college quad seemingly erases differing political and cultural identities across Britain's internal borders.

Yet the British iconography daubed over the film is gently subverted, as in Lindsay Anderson's casting as Master of Caius, and the acknowledgement of pervading anti-Semitism within the period splendour. Despite the pre-eminence of the Abrahams story, the Liddell story prevails, shifting the narrative about acceptance into the British elite into a story about compromise and honour, as a bullying establishment makes way for Liddell's rapturous inspiration. Ian Charleson is said to have re-written the famously evangelical track-side speech to make it more believable, and his luminescent performance as Liddell manages to redeem the script from clichéd Scottish reel.

Another factor that makes *Chariots of Fire* so memorable is the soundtrack. The decision to use Vangelis Papathanassiou's

startlingly contemporary (for 1981) electronic soundtrack over the period façade accentuates the difference between this and other heritage films. The contemporary style of the soundtrack lends the film an action-based momentum that marks its out from more speech-laden or voluptuously-visual heritage films. And, with its use of replays and slow motion, the film's visual style subtly borrows from the look of contemporary sports television. Hudson's frame often resembles that of the BBC's *Grandstand* sports programme circa 1981, but populated with 'amateur' athletes played by well-known actors. It is this stylistic distinctiveness that manages to engage and make the story emotionally relevant for a wide audience.

At the time of the film's release, many people in the British film industry sought the same levels of public funding that was enjoyed in France. But the success of *Chariots of Fire* promised to usher in a new era of populist, commercial, Hollywood-facing film-making in Britain, summed up by Welland's line in his Oscar acceptance speech, 'the British are coming!'

Dafydd Sills-Jones

Howards End

Studio/Distributor:
Merchant Ivory/Mayfair
Entertainment
Director James Ivory

Producer:
Ismail Merchant

Screenwriter:
Ruth Prawer Jhabvala

Cinematographer:
Tony Pierce-Roberts

Production Designer:
Luciana Arrighi

Composer:
Richard Robbins

Editor:
Andrew Marcus

Duration:
142 minutes

Genre:
Heritage

Synopsis

In Edwardian London, the liberal and independent Margaret Schlegel strikes up a friendship with Mrs Wilcox, the wife of a wealthy industrialist, after Margaret's sister, Helen, has a fleeting affair with Mrs Wilcox's youngest son at Howards End, the family country retreat. When Mrs Wilcox dies and unexpectedly leaves Howards End to Margaret, the Wilcoxes destroy the evidence of the bequest. Widower Henry Wilcox proposes to Margaret, much to the dismay of his eldest son and daughter, who see Margaret as a social climber. Helen resents Henry, considering him responsible for the precarious situation of Leonard Bast, an impoverished but socially-striving clerk whom the sisters had befriended. When revelations entangle Leonard and his wife Jacky more deeply with the Schlegels and Wilcoxes, Margaret confronts Henry with his class prejudices. The characters' fates dramatically converge at Howards End, with tragic consequences.

Critique

Epitomizing the English 'phase' of Merchant Ivory's cosmopolitan output, *Howards End* was the most commercially and critically successful of a series of tasteful literary adaptations throughout the 1980s and 1990s. Novelist EM Forster became central to the heritage canon with no less than five of his works adapted for the screen, including *A Room with a View* (1985) and *Maurice* (1987), both directed by James Ivory. In a fragmented industry heavily dependant on overseas box-office, *Howards End* became associated with a new quality British cinema with the potential for

Cast:
Helena Bonham Carter
Anthony Hopkins
Vanessa Redgrave
Emma Thompson

Year:
1992

international crossover success. After high-profile exposure at the 1992 Cannes Film Festival and three Oscar Awards (including Best Actress to Emma Thompson) the film secured worldwide distribution and became a modest hit in America.

Andrew Higson (2003) noted that *Howards End* could be considered 'a pictorial signifier of everything that the heritage industry represented', namely the commodification of the English historical past and the embracing of conservative values during the Thatcher years. For critics like Higson and John Hill (1999), *Howards End* shows a tension between its liberal critique of class barriers and the spectacular aesthetics of period reconstruction. Lavishly photographed in widescreen and with a rich *mise-en-scène*, the look of the film is suffused with a gentle nostalgia for Edwardian upper-class lifestyles. Pre-WWI England is a society in flux, but the country retreat that draws the emancipated yet deracinated Schlegels is visualized as a rural haven. Placid long shots and languid camera movements – such as the memorably slow tracking shots that follow Mrs Wilcox (Vanessa Redgrave) in the tone-setting opening scene – provide a sense of stability and reassurance.

Higson also pointed out the multiplicity of discourses surrounding the film. It could be regarded as bound to museum aesthetics, with the camera levelling admiringly at the material splendour of property and objects, encouraging a touristic gaze. However, *Howards End* can equally be read as an ambiguous class melodrama with nuanced performances, in which the family house evokes class dispossession and inheritance disputes. The Wilcoxes' standing as a rising financial class in pursuit of the accumulation of property (a theme all too resonant at the peak of the Thatcherite period) is a counterpoint to the focus on emotions attached to the loss of a home – or the lack of one – that join the 'New Woman' Margaret Schlegel (Emma Thompson) and the almost Victorian Mrs Wilcox. Howards End, the idealized family home, also becomes the setting for an act of absurd violence that reveals a social order closing ranks against class interlopers.

The film's themes emerge from its *mise-en-scène* as well as from the display of property that make its concerns seem resolutely bourgeois. Yet, to evoke François Truffaut's famous phrase with regard to the context of post-war French cinema, *Howards End* encapsulates that 'certain tendency' of quality adaptations. It sank so deeply into the consciousness of British cinema to create a distinctive aesthetic and even motivate affectionate parody, as in *Love and Death on Long Island* (Richard Kwietniowski, 1997) and *Stiff Upper Lips* (Gary Sinyor, 1998).

Belén Vidal

Orlando

Studio/Distributor:
Adventure Pictures/Sony
Pictures Classics

Director:
Sally Potter

Producer:
Christopher Sheppard

Screenwriter:
Sally Potter

Cinematographer:
Aleksei Rodionov

Production Designers:
Ben van Os, Jan Roelfs

Composer:
David Motion/Sally Potter

Editor:
Hervé Schneid

Duration:
93 minutes

Genre:
Heritage/Art

Cast:
Lothaire Bluteau
Quentin Crisp
Tilda Swinton
Billy Zane

Year:
1992

Synopsis

Orlando unfolds over five hundred years of British history through the eyes of a character who changes sex, from man to woman, mid-way through his/her journey. As a young lord, Orlando pledges to obey the command given by Elizabeth I in 1600: 'Do not fade, do not wither, do not grow old.' He experiences romantic disappointment and is thrown into the midst of colonial wars. In 1700, Orlando wakes up as a woman, only to find the ownership of the estate bestowed to 'him' by Elizabeth I endangered by 'her' new feminine condition. In 1850 Orlando is abandoned by her adventurer lover, but bears a daughter who rides into London with her in the 1990s. Her journey concludes under the same oak tree where it began five centuries earlier, with an optimistic nod towards the future.

Critique

Based on Virginia Woolf's modernist novel and *roman-à-clef* about Vita Sackville-West (*Orlando: A Biography*, 1928), Sally Potter's first mainstream fiction feature draws on the conventions of heritage film as well as on Potter's own experimental film practice in previous works such as *Thriller* (1979) and *The Gold Diggers* (1983). *Orlando*, alongside *The Piano* (Jane Campion, 1993), best represents the turn to an anti-classicist, formally adventurous and politically progressive heritage film in the 1990s – a trend sometimes called post-heritage or anti-heritage (Voigts-Virchow 2004). In *Orlando*, the orderly landscapes of heritage film are transformed into a gender-bender hall of mirrors.

Orlando is divided into a series of historical chapters, each one preceded by an inter-title. They form a sequence that follows Orlando's life journey, both as male and as female, from '1600 Death' to 'Birth' (undated, but located in the 1990s), passing through '1610 Love', '1650 Poetry', '1700 Politics', '1750 Society' and '1850 Sex'. By rigorously fragmenting space and time into a series of self-enclosed episodes, *Orlando* unfolds as a multi-faceted portrait of its central character.

The celebration of fluid, androgynous identity in Woolf's novel is grounded in the film by a riveting yet appropriately deadpan performance by Tilda Swinton, former collaborator of queer avant-garde film-maker Derek Jarman, as the eponymous hero/heroine. Orlando journeys on through (her)story without history apparently affecting his/her character or appearance and becomes a sounding board for culturally-determined conceptions of masculinity and femininity. As a man, he is cornered into waging colonial wars; as a woman, she is forced into submission and threatened with dispossession. The narrative is devoid of conventional progression and instead 'time-jumps'. Sometimes it even violates the rules of visual continuity that constitute the mainstay of the classicist narrative mode in the heritage film – nowhere is this more apparent than in Orlando's transition from Victorian lady to pregnant WWI refugee.

This aesthetic of interruptions is reinforced by Orlando's sometimes puzzled, sometimes ironic look to camera. This self-reflexive 'look' is the film's main rhetorical strategy, allowing the story to build on narrative echoes and repetitions that represent the character's accumulated experience.

Orlando's trans-historical look posits, as Pidduck (2004) points out, a clearly feminist mode of address. Whereas in the novel Orlando has a son that allows her to hold onto her estate, in the film Orlando bears a daughter and, most crucially (as Potter herself has noted), she lets go of the house. In the last section of the film Orlando steps into her former property (now a tourist heritage attraction) and stands in front of her five-century-old portrait with a smile of recognition and amusement. The gentle, playful humour as well as the poignancy of its feminist statement accounts for *Orlando*'s lasting popularity and its imaginative reworking of heritage film codes. A utopian film at heart, *Orlando* constitutes a poignant meditation on the need to face history while letting go of the past.

Belén Vidal

Elizabeth

Studio/Distributor:
Polygram
Working Title/Universal Pictures

Director:
Shekhar Kapur

Producers:
Tim Bevan
Eric Fellner
Alison Owen

Screenwriter:
Michael Hirst

Cinematographer:
Remi Adefarasin

Production Designer:
John Myhre

Composer:
David Hirschfelder

Editor:
Jill Bilcock

Cast:

Synopsis

Upon the death of Mary I, her half-sister Elizabeth – daughter of Henry VIII and Anne Boleyn – ascends to the throne. Elizabeth's position initially seems untenable, with the Catholic Church unable to acknowledge a Protestant monarch and allies of France determined to attack England. She is urged to consider a suitor – including the future King of France – to consolidate her claim to the throne. Elizabeth instead embarks on an affair with her childhood sweetheart Lord Dudley, a liaison that is no secret to the royal court, but she discovers that Dudley is married and prepares to cut him out of her life. When it emerges that many of her supposedly loyal courtiers are involved in a plot to betray and depose her, Elizabeth enlists the aid of the ruthless Francis Walsingham to flush out the traitors and conspirators. As her enemies begin to fall, war with France looms. Elizabeth must complete her transformation from shy country girl to 'The Virgin Queen' of history who will lead the Armada naval battles and forsake all others for her beloved England.

Critique

With its setting in a well-known moment in British history and an impressive cast – from Blanchett to the likes of Sir John Gielgud and Sir Richard Attenborough – *Elizabeth* initially seems a fairly typical British costume drama. Whilst the film does showcase gorgeous set pieces and sumptuous costume designs, director Shekhar Kapur and screenwriter Michael Hirts crafted a film that revels in dense political intrigue and character intimacy, even

Cate Blanchett
Christopher Eccleston
Joseph Fiennes
Geoffrey Rush

Duration:
124 minutes

Genre:
Heritage/Biography

Year:
1998

though it takes quite a few liberties with historical accuracy. The slow transformation of Elizabeth (Cate Blanchett) from the demure pawn of political games to the powerful head of state is fascinating to behold. The machinations and divisions within her royal court have a counterpoint to Elizabeth's internal struggle between her duty to herself and to her state. Much is made of her gender (though the film avoids crass and easy gender politics) with all the supposed (in the minds of the royal court) 'female failings' pointing to why she cannot be allowed to rule England.

The price of power and devotion to her country is that Elizabeth has to transcend any notion of being free to follow her own desires – she is told at one point that 'Her Majesty's body and person are no longer her own property. They belong to the state.' But the film also hints that the ruling power was also a divine one (as in regal doctrine). Moments such as Elizabeth receiving the news that Mary is dead and taking possession of the royal ring are imbued with an almost mythic significance with the screen flashing to white; the climax of the film sees Elizabeth draw upon a statue of the Virgin Mary as inspiration for subjugating her personal needs for the greater good of England. Yet this notion of divinity is set apart from ideas of organized religion – Elizabeth is shown to be confused by the question of religion, placating Catholics and Protestants out of necessity rather than religious faith or dogma.

There are sly moments of humour as Elizabeth practises a speech that she will give to a room full of unfriendly Bishops, and one cannot help thinking of modern politicians doing the same. Elizabeth I, The Virgin Queen, has become a legendary historical figure but, the film suggests, all legends have a fallible and very real person behind them.

Laurence Boyce

Pride and Prejudice

Studio/Distributor:
Universal
Working Title /Studio Canal

Director:
Joe Wright

Producers:
Tim Bevan
Eric Fellner
Paul Webster

Synopsis

Twenty-year-old Elizabeth Bennet is intelligent, witty and independently minded. She is also in need of a husband. When her father passes away, Longbourn, the Bennet estate, will not be left to her and her four sisters, but instead will pass to her father's unctuous cousin Mr Collins, a clergyman, who hopes to take Elizabeth's hand in marriage. Elizabeth, meanwhile, has become interested in Mr Wickham, a charming military officer, while her soft-spoken sister Jane has caught the eye of Mr Bingley, a wealthy young man vacationing near Longbourn.

Mr Bingley is accompanied by his friend, the taciturn rich landowner Mr Darcy, whom Lizzie finds prideful and exceedingly unpleasant. As Mr Bingley courts her sister, Elizabeth keeps running into the stuffy Mr Darcy at social functions. She warms to him on realizing that he matches her in wit and intensity of opinion. Yet startling revelations threaten the future of Longbourn, the good

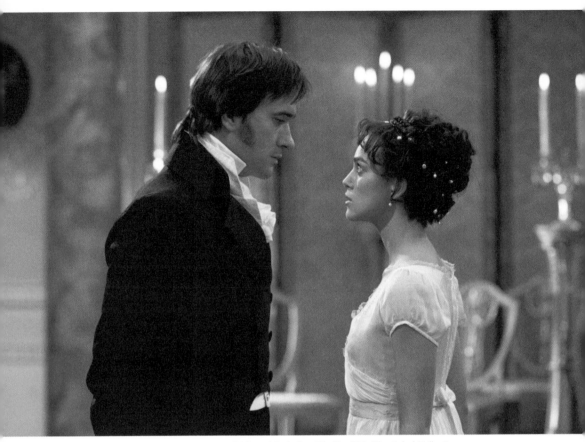

Pride and Prejudice, Working Title/The Kobal Collection.

Screenwriter:
Deborah Moggach, based on Jane Austen.

Cinematographer:
Roman Osin

Production Designer:
Sarah Greenwood

Composer:
Dario Marianelli

Editor:
Chris Dickens

Duration:
129 minutes

Genre:
Heritage

name of the Bennet's and the burgeoning affection between Elizabeth and Mr Darcy.

Critique

Pride and Prejudice is an Austen-inspired film that rises above the staid conventions of so many previous adaptations of the author's work. The characters in director Joe Wright's film sweat in their overcrowded ballrooms, behave raucously at times, and share their picture perfect estates with unruly livestock. Austen adaptations have often been dry affairs, with conversation and costuming taking centre stage at the expense of the vitality and romance of the author's works. This 2005 version of the classic novel features less of Austen's text, but it also offers an earthier and richly sensual take on the story. It reinvigorates the text, as did the similarly lush *Sense and Sensibility* (1995) from director Ang Lee, and reminds modern viewers why Austen's works continue to captivate readers and audiences. The cast is uniformly excellent with Brenda Blethyn and Donald Sutherland standing out in particular as the seemingly

Cast:
Brenda Blethyn
Keira Knightley
Matthew Macfadyen
Donald Sutherland

Year:
2005

mismatched Mr and Mrs Bennet.

Director Joe Wright (*Atonement*, 2007) brings a dynamic visual style to *Pride and Prejudice* with a restless camera that recalls the work of American virtuoso Brian De Palma. A central scene where the Bennet's attend a ball at the vacation home of Mr Bingley (Simon Woods) is a visual treat as the camera swoops and glides through the spacious estate in one-seemingly unbroken take. The scene is not simply technically impressive, however, as it also conveys the rapidly changing fates of the Bennet sisters as they simultaneously humiliate themselves at different locations through-out the home and endanger their romantic futures.

A key to the film's success is its commitment to showing the evolution of Elizabeth (Keira Knightley) from giggling girl to wiser and more reserved woman. In doing so, this film remains truer to the text. In the excellent 1996 BBC version, a favourite of Austen fans, Elizabeth is a woman of substantial bearing and character throughout, making Mr. Darcy's initial rejection of her seem capri-cious and cruel. The Elizabeth in this version must mature, as must Mr Darcy (Matthew Macfadyen), making their path from rivals to devoted spouses seem more organic and less like a necessity of the script. Both Knightley and Macfadyen convincingly convey their characters' paths to maturity as well as imbue them with significant passion.

By creating a lush, visually-compelling narrative, this adaptation loses some of the dry and cutting dialogue for which Austen is known, but delivers a fiercely romantic take on the classic story that has delighted, and continues to delight, generations of readers and viewers.

Randall Yelverton

A Cock and Bull Story

Studio/Distributor:
BBC Films/Redbus

Director:
Michael Winterbottom

Producer:
Andrew Eaton

Screenwriter:
Frank Cottrell Boyce

Synopsis

A Cock and Bull Story starts behind the scenes, with Steve Coogan and Rob Brydon playing versions of themselves as a bickering duo of comedians about to embark in the shooting of a film adapta-tion of Laurence Sterne's novel, *The Life and Opinions of Tristram Shandy*. Coogan kick-starts the film 'proper' by narrating a series of humorous vignettes about the main character's conception and birth. Mid-way through a sequence in which Tristram's mother goes into labour, the film turns its attention to the crew shooting the film-within-the-film. The film-making process is beset by production difficulties and the discontent of investors after the daily screenings of rushes. In the meantime, Coogan's rivalry with Brydon escalates and his personal life is complicated by his fleeting affair with a cinephile production assistant and the arrival on set of his partner and child.

Critique

Cinematographer:

Marcel Zyskind

Production Designer:

John Paul Kelly

Composer:

Edward Nogria

Editor:

Peter Christelis

Duration:

90 minutes

Genre:

Heritage

Cast:

Rob Brydon
Steve Coogan
Naomi Harris

Year:

2005

A whimsical film on the adaptation of the allegedly unfilmable novel by Laurence Sterne, *A Cock and Bull Story* constitutes a witty, meta-cinematic send-up of the conventions of the heritage film, as well as a humorous reflection on the impossibility of faithfully adapting a work of classic literature.

The film falls within an illustrious tradition of films about film-making. As in Truffaut's *Day for Night* (1973), the film director (played by a self-effacing Jeremy Northam with more than a passing likeness to Winterbottom himself) remains an observer of the unruly behaviour of his cast. The film, like its narrator, does not tell its story 'straight' but gets lost in constant digressions, not least those provoked by the burden of expectations placed by fans of the novel and meddling experts on set. While played up for comedy, these interferences reveal very real pressures on the film-making process, mirroring the actual difficulties encountered by Winterbottom and his long-standing producer Andrew Eaton. The film's pledged £6.5 million budget was slashed to less than half that figure shortly before the film went into production. Things were then kept afloat by Eaton's cash-flowing the day-to-day shooting expenses through his company Revolution Films until a new financing deal was secured. Put in this context, the easiness with which the fictional production team in *A Cock and Bull Story* is able to fly in star Gillian Anderson to play Widow Wadman seems almost like an act of ironic wishful thinking that alludes to the endemic relationship between independent financing in Britain and the American market.

A Cock and Bull Story feeds on Coogan and Brydon's established television personas, as well as on Winterbottom and Coogan's previous collaboration in *24 Hour Party People* (2002). Rather than deploying comedy to parody the heritage genre, the film inflects familiar heritage iconography with a relish for language and performance, a trait shared by both the literary adaptation as well as television comedy. In the opening credit sequence Tristram (Steve Coogan) launches into the telling of his life as a stand-up comedy routine against the imposing visual backdrop of the heritage estate of Heydon Hall in Norfolk, accompanied by Michael Nyman's musical score from Peter Greenaway's *The Draughtsman's Contract* (1982). This playful mixture of references continues with the comic yet erudite detours into eighteenth-century obstetrics and military history, as well as film-literate jokes ('a womb with a view'). The English garden, romantic trope par excellence in the heritage film, is played for laughs in a scene in which Uncle Toby (Rob Brydon) courts Widow Wadman whilst she shows rather more interest in his physical 'fitness for marriage'.

Romance may be a bit of a red herring but the film ultimately exhibits a moving affection for its flawed, talkative (anti-)hero caught between his fantasy film life and the very real demands of parenting, a theme that underpins other Winterbottom films such as *Wonderland* (1999) or *Genova* (2008). The meandering structure and parodic tone of the literary original become a pretext to shake off the quaintness of the genre, but also to propose a reflection on film-making as a hazardous team effort, a process every bit

as chaotic and yet ultimately life-affirming as the protracted birth sequence the film keeps returning to.

Belén Vidal

The Queen

Studio/Distributor:
Granada/Pathé

Director:
Stephen Frears

Producers:
Andy Harries
Christine Langan
Tracey Seaward

Screenwriter:
Peter Morgan

Cinematographer:
Affonso Beato

Production Designer:
Alan MacDonald

Composer:
Alexandre Desplat

Editor:
Lucia Zucchetti

Duration:
103 minutes

Genre:
Heritage/Biography

Cast:
James Cromwell
Helen McCrory
Helen Mirren
Michael Sheen

Year:
2006

Synopsis

In August 1997 the death of Diana, Princess of Wales, in a car crash in Paris throws Britain into turmoil. The Royal family and the newly-elected Prime Minister Tony Blair react to the unprecedented outpouring of public sentiment in very different ways. The Queen refuses to come down to London from Balmoral, Scotland, and to treat the death of the Princess as a matter of state. Blair sees his popularity rise as his staff steer public and media reactions to the tragedy and promote his seemingly-compassionate public image. Blair pleads with the Queen to respond to growing and hostile criticism of her inflexible attitude, whereas her son Charles, Diana's ex-husband, manoeuvres to distance himself from his mother's standpoint. Sticking to the principles of tradition, protocol, sobriety and restraint, the Queen feels increasingly isolated and criticized. Her attitude starts shift as she tries to rethink her position and understand why Diana's funeral means so much to British people.

Critique

The Queen is Stephen Frears' second collaboration with screenwriter Peter Morgan, following on from their television drama The Deal (Channel 4, 2003), which uncovers the roots of Blairite ideology and the rise of New Labour. Michael Sheen also played Tony Blair in The Deal and adeptly reprised his performance in The Queen. Like The Deal, The Queen was originally conceived of for television, yet it was given feature film status when French studio Pathé agreed to finance the project.

The Queen renovates the heritage film to reflect on the recent past and continues a successful cycle of monarchy films that includes Mrs Brown (John Madden, 1997) and Elizabeth (Shekhar Kapur, 1998). The Queen updates the theme of conflict between the monarchy's private and 'public' personas through focus on a contemporary monarch's unease with the effects of privacy meltdown and media over-exposure. Yet it also reinstalls some of the genre's most conservative traits. For example, when a nervous Blair (Michael Sheen) steps into Buckingham Palace for his first audience with the Queen (Helen Mirren), he is instructed on protocol in a way that provides a vicarious, touristic experience of tradition and deference for the contemporary, and especially international, audience.

Morgan's script is a balanced mixture of topicality and distance, taking on the events of 1997 as a symbolic turning point in the nation's recent past. The opening shots of the film, with news footage of New Labour's historic victory in the May 1997 general elec-

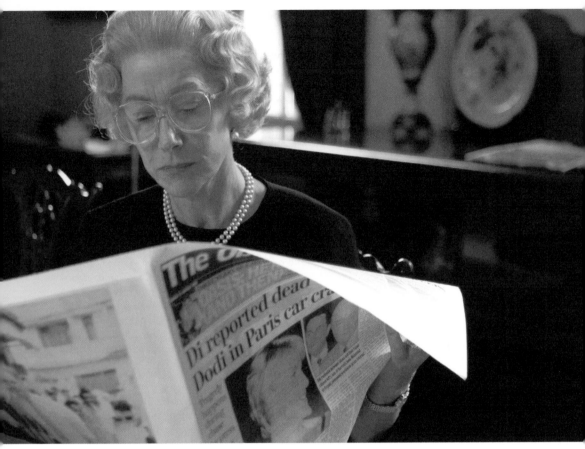

The Queen, Pathe/The Kobal Collection/Laurie Sparham.

tions, herald the moment of 'Cool Britannia' (Britishness as brand for youth, creativity and economic power). This prompted *The Times'* reviewer James Christopher (2006) to note that *The Queen* shows a 'sweet nostalgia for the golden age of Labour landslides'. However, Morgan's script carefully reframes this particular historical moment through the 24/7 flow of images that shape public knowledge. As Queen Elizabeth II distractedly watches television reports on the outcome of the elections while posing for an official portrait, a tension emerges between two forms of power, but also two different regimes of historical representation.

The Queen's perception of events unfolds as an intensely private drama, which is externalized in a clichéd epiphanic moment in the Scottish Highlands – a landscape often romanticized in British cinema as a place for escape and a source of self-knowledge for English characters (e.g. *Mrs Brown*). Mirren endows the Queen with psychological depth and agency in a film overwhelmingly sympathetic to the plight of the modern monarch. Yet Sheen's apparently more transparent performance as an idealistic Blair may

be, in fact, the real cipher of the film. His image, like Diana's (an uncanny televisual 'ghost'), is endlessly scrutinized by the various television sets that fill in the *mise-en-scène*.

The meetings between Blair and the Queen that bookend the narrative ironically highlight the permanence of monarchy versus the transience of elected representatives of power. Notwithstanding the film's (slightly reactionary) tone of disenchantment, *The Queen*'s fusion of heritage aesthetics and political drama is a prescient early assessment of the political moment just passed.

Belén Vidal

The origins of British horror cinema are found in early experiments in film, notably George Albert Smith's *Photographing a Ghost* (1898) and Walter R Booth's *The Haunted Curiosity Shop* (1901). Essentially experiments with multiple exposures and editing, these 'trick' films were not necessarily 'frightening' but they did provide British horror with foundational motifs – the ghost, cursed objects, the emergence of the past in the present, and the animation of the inanimate. Such 'trick' films continued during the WWI era, culminating in Britain's first feature-length horror, *The Wraith of the Tomb* (Sydney Northcote, 1915). While British horror production continued into the following decades, these films were dwarfed by US and German productions. Even so, the late 1920s and early 1930s saw the release of Alfred Hitchcock's first British film, *The Lodger: A Story of the London Fog* (1926); Boris Karloff's return to Britain to star in *The Ghoul* (1933) – the first British film to receive the BBFC's 'H' for 'Horrific' certificate; the founding of Hammer studios in 1934; and the emergence of perhaps the nation's first horror 'celebrity', Tod Slaughter, in films such as *Sweeny Todd: The Demon Barber of Fleet Street* and *The Face at the Window* (George King, 1936 and 1939).

Unsurprisingly, the advent of WWII bought a decrease in horror film production – although *The Halfway House* (Basil Dearden, 1944) is notable for its synthesis of propaganda with horror genre tropes. One month after the 'official' end of the war, Ealing released its only genuine horror film, *Dead of Night* (various, 1945). The film uses a portmanteau structure of five supernatural tales – a structure that influenced later British horror-film production, most notably those produced by Amicus Studios. In its focus on male protagonists who succumb to supernatural terrors in a contemporary post-war Britain, *Dead of Night* perhaps suggests a concern about the return to 'normal' civilian life for men who experienced combat during the war. In that sense, British horror can function not only as frightening entertainment but also as a means to address and confront contemporary social and personal anxieties.

The next significant stage in British horror is the emergence of Hammer Studios. Although founded in 1934, the studio did not achieve significant success until the original founder's sons, James Carreras and Anthony Hinds, purchased the film rights to the BBC's groundbreaking and popular science fiction serial, *The Quatermass Experiment* (1953). Hammer's film adaptation, *The Quatermass Xperiment* (Val Guest, 1955), was nationally and internationally profitable, and was quickly followed by *Quatermass II* (Val Guest, 1957) and a reworked version, X the Unknown (Leslie Norman, 1956). Looking for similar property, Carreras and Hinds decided to make an adaptation of Mary Shelley's 1818 gothic novel, *Frankenstein*. Mindful of James Whale's highly popular 1931 adaptation for Universal, Hammer's *The Curse of Frankenstein* (Terence Fisher, 1957) shifted narrative emphasis to Victor Frankenstein and gave a more complicated, Shelley-esque rendering of his Creation, the monster. The film was shot in colour, making it the first British colour horror film, and presented its more graphic elements in explicit detail. Although the film received considerable negative response from critics (most notably *The Sunday Times* and *The Tribune*), audiences flocked to see it.

In 1958 Carreras and Hinds followed *Frankenstein* with a reworked version of *Dracula*, again directed by Fisher. *Dracula* not only bought Hammer continued notoriety but also defined Britain's next horror icons, Peter Cushing and Christopher Lee. Hammer remained successful for the next fourteen years, even earning a Queen's Award for Industry, but by the late 1970s, audience interest in the studio's repetitive output began to dwindle. This was primarily because of increased horror film production in America and because Hammer's 'trademark' taboo scenes – violence, gore and nudity – become staples of both the horror genre and of mainstream cinema. In 1976, *To the Devil a Daughter* (Peter Sykes) marked the end of Hammer's reign over British horror.

Acknowledging the success Hammer had experienced, other UK directors and studios shifted their productions into the genre: Michael Powell directed the provocative *Peeping Tom* (1960) while Jack Clayton directed *The Innocents* (1961), Amicus began production on the aforementioned range of portmanteau films while Tigon released, amongst others, *Witchfinder General* (Michael Reeves, 1967) and *Blood on Satan's Claw* (Piers Haggard, 1970). Alongside this range of films emerged further instances of seminal British horror cinema – Robin Hardy's exquisite *The Wicker Man* (1972) and the emergence of genre directors Peter Walker and Norman J Warren. Exemplified by Walker and Warren's work, this era saw an increase in sexual content within horror films due to a certain sense of relaxation within the BBFC. Consequential horror films began to feature scenes of female nudity and increased violence upon women. While such imagery may have been solely for exploitational purposes, the emergence of the women's rights movement and the increased social visibility of feminism in the UK implies that one reading of the subtext of these films – such as *The House of Whipcord* (Peter Walker, 1973) – is a fear of female empowerment and so the narrative works to suppress female sexuality and the desire for equality by systematically reducing its female characters to a guilty party who are violently punished for their sexual and political expression.

While output in the 1970s would seem to indicate that British horror was thriving, it was, in reality, in steady decline. Hammer continued to set horror films in historic periods and attempted to regenerate the vampire genre through sexploitation (*The Vampire Lovers*, Roy Ward Baker, 1970) or hybridization with other genres (*The Legend of the 7 Golden Vampires*, Roy Ward Baker, 1974). US horror film production, however, was breaking new ground. Perhaps reacting to the country's political situation and the Vietnam War, US film-makers began directing low-budget and brutally violent horror films such as *The Last House on the Left* (Wes Craven, 1972) and *The Texas Chainsaw Massacre* (Tobe Hooper, 1974). In contrast to Hammer's period pieces, these films depicted the contemporary world as full of its own horrors, with men and women being stalked and then graphically raped and/or murdered. Faced with a steady withdrawal of national and international funding and the inability to compete with such shockingly graphic films, British horror retreated back into the shadows. While the following two decades were a rather barren period, a few British horror films and their directors made some significant impact, including Neil Jordan's *The Company of Wolves* (1984), Clive Barker's *Hellraiser* (1987), and Richard Stanley's *Hardware* and *Dust Devil* (1990, 1992).

As the new millennium loomed, British film-makers returned to the genre and embraced its heritage by making an asset of budgetary constraints. For the most part, they shunned the explicit imagery of horror's Golden Age and focused on the everyday, exposing – as those American films of the 1970s did – the dark and violent side of contemporary Britain. Films such as *The Last Horror Movie* (Julian Richards, 2003), *Eden Lake* (James Watkins, 2008) and *Mum and Dad* (Steven Sheil, 2008) tackled contemporary issues including serial killing, immigration and hoodie-wearing teenage mobs. In contrast, some films successfully merged comedy with horror – *Dog Soldiers* (Neil Marshall, 2002), *Severance* (Christopher Smith, 2006), *The Cottage* (Paul Andrew Williams, 2008) and, the most successful of them all, *Shaun of the Dead* (Edgar Wright, 2004).

Although brief and selective, this history of the British horror film intimates a clear schism that exists within its ongoing evolution: initiated by Hammer's success, British horror films were preoccupied with depicting graphic violence and gore within historically-grounded narratives; fear was generated by the spectacle of special effects and monstrous fabrications. To a certain extent, this trait has been maintained throughout the genre's development, but in recent works there is a marked shift in that horror is generated through the suspenseful construction of malevolence, and fears are located within everyday contemporary British society.

As a body of national work the British horror film constantly evolves by responding to the nation's anxieties, shifts within the genre globally and decreasing funding opportunities. Regardless of this, commonalities remain across the chronological range: the preoccupation with grounding terror in nationally recognizable spaces such as the city, the grand stately home, domestic streets and the rolling hills of the countryside. These quiet, bland and sometimes quaint spaces harbour all that is horrific, transforming them into spaces of terror in which anxieties can be violently played out – fears about invasion, terrorist assaults, pandemics, violent youth cultures, immigration and the neighbour as serial killer all make themselves manifest through horror cinema. In the face of such terrors, British horror tends to uphold a drawing together of the family, of overcoming difference and deficiency to work together to survive this grim representation of reality. Here, in dreadful but signifying moments of monstrosity, torture, violence and death, emerges a strong sense of social realism. This quality not only signifies a major shift away from the heritage-horror of Hammer films, but also signifies a much broader awareness within British film-making: British horror cinema is no longer concerned with gaudy, blood-red spectacle but with the very frightening possibilities already within our everyday lives.

James Rose

The Haunted Curiosity Shop

Studio/Distributor:
Paul's Animatograph Works

Director:
Walter R Booth

Producer:
Robert W Paul

Genre:
Horror/Trick Film

Year:
1901

Synopsis

The owner of a curiosity shop is subjected to a series of supernatural occurrences as various curios fly across the room and metamorphose into a variety of fantastical beings – a dancing skeleton, a mummy, three gnomes and a large vase that emits a spectral cloud of smoke.

Critique

The Haunted Curiosity Shop is something of a curiosity itself. Lasting just under two minutes, this early British film functions more as a spectacle than a short narrative, such that its genre status as horror is, potentially, questionable. The film was a collaborative effort between two pioneers of cinema, Robert W Paul and Walter R Booth. Paul was an electrical engineer who exhibited Kinetoscope films from 1894, and founded Paul's Animatograph Works in 1897. During thirteen years of production, Paul's studio produced 122 short films, a number of which were directed by the illusionist Walter R Booth. From 1899 to 1906, Paul and Booth would make increasingly complex 'Trick Films' – a genre of short films that relied on special effects to achieve their imagery. These skills were developed through shorts such as *Upside Down or The Human Flies* (1899) and *A Railway Collision* (1900), with each film increasing in complexity as Paul and Booth pushed the boundaries of film technology and stage magic performance.

By 1906 Booth established his own studio at his home in Isleworth, producing the first British animated film, *The Hand of the Artist*, while in 1910 Paul retired from the film business to pursue further technical innovations through his electrical engineering company. For their achievements during the brief period in which they worked together, Paul and Booth can be considered to be pioneers of British Cinema, with *The Haunted Curiosity Shop* demonstrating the range of their technical and innovative skill.

The Haunted Curiosity Shop has the appearance of a single continuous take recorded by a stationary camera. This lack of movement and apparently sustained continuity enhances the stage-like and performative nature of the narrative events – appearing more like a recording of a stage magic act than an actual narrative film – and compounds the film's sense of reality by making strange and supernatural occurrences seem all the more tangible. However, in terms of the film's actual production, it is a meticulously planned and constructed piece of work using a range of developing special effects processes, such as substitution and jump cuts. The most complex of these effects – particularly the moving skeleton – were achieved through double printing, while at its most simplistic – as with the three gnomes becoming one – the camera was simply stopped and the actors removed from the set. Because of this complex array of techniques, *The Haunted Curiosity Shop* functions as an elaborate and highly polished (for its time) showcase of Booth and Paul's growing skills as Trick Film-makers.

As to its value as a horror film, *The Haunted Curiosity Shop* features, albeit briefly, what became standard elements in early examples of the genre, namely the mummy, the skeleton and the floating skull. Because of the effects-driven nature of the film, the horrific value of these manifestations is somewhat subtracted, instead they appear more like comedic moments upon a stage. The shop keeper's response to the supernatural occurrences dampens any sense of fear in that his reactions fluctuate from shock to surprise to aggression and then, only at the end, to fear as the smoke rises up out of the vase.

James Rose

Dead of Night

Studio/Distributor:
Ealing/Eagle Lion

Directors:
Alberto Cavalcanti
Charles Crichton
Basil Dearden
Robert Hamer

Producer:
Michael Balcon

Screenwriters:
John Baines
Angus Macphail

Cinematographers:
Stan Pavey
Douglas Slocombe

Production Designer:
Michael Relph

Composer:
Georges Auric

Editor:
Charles Hasse

Duration:
104 minutes

Genre:
Horror

Synopsis

Architect Walter Craig is invited to spend the weekend at a country house. As he approaches the house he has a feeling of déjà vu, which is compounded when he enters the house. He recognizes all the other guests, claiming to have seen them before in a dream. Craig's claim interests one of the guests, the psychiatrist Dr Van Straaten, who questions him about his dream and Craig explains in detail events that are going to happen that evening. As Straaten and Craig talk, other guests interject with stories of their own, all of which are in some way connected to the supernatural through premonitions, ghosts, possessions and hauntings.

Critique

In 1919 Sigmund Freud published his seminal text *The Uncanny*. In this aesthetic and psychoanalytic study, Freud attempted to understand why certain occurrences induce fear. He wrote of the 'uncanny' sense of unfamiliar-familiarity provoked by automata, mannequins, ghosts, severed body parts, premonitions, repetition, déjà vu, live burial and death, as key instigators of the emotion of terror. For Freud, these frightening objects and phenomena are in some way unique to the individual in that they resonate with repressed anxieties, such as a past trauma, sexual incident, or a suppressed but evocative memory, which should dispel any fearful sense of the supernatural.

Released 26 years after the publication of Freud's text, *Dead of Night* can be interpreted as a visualization of those ideas. The film's Freudian subtext is compounded by the dream structure of the narrative, the stories verbalized as recollections and the presence of a psychiatrist. Dr Van Straaten (Frederick Valk) has a non-British accent and patiently listens to his host's stories only to immediately debunk them with psychoanalytic theory. He is adamant that Craig's (Mervyn Johns) recollected supernatural occurrences are nothing more than manifestations of suppressed desires, anxieties and fears. For Van Straaten, the narrative world is one where the supernatural can be explained through analysis and logic. In

Cast:

Mervyn Johns
Ralph Michael
Michael Redgrave
Googie Withers

Year:

1945

contrast, Craig and other guests express doubt at his conclusion and profess belief in their own corporeal experiences – which quickly isolates the psychiatrist. While the film is initially ambiguous as to which it favours, it soon exalts the supernatural as Craig descends into a series of nightmare scenes, all populated by the horrors the guests have spoken of.

An air of dreadful fate hangs over the film, indicating that all is moving inexorably and uncannily towards its horrifying end. Each story steadily increases the tension: a young girl's first naïve sexual contact is contrasted with the manifestation of a ghostly child; the complacent and sterile life of a recently-married couple is corrupted when the repressed husband is possessed by his alter-ego, a dominant masculine figure from the past; and, in the most disturbing story, it is uncertain if a ventriloquist is insane or if his dummy is alive and plotting to eliminate him. In each of the guest's stories, the horrific hinges upon the psychological. Each character walks a fine line between the unconscious and conscious realms. The entire film can be seen as an uncanny premonition that leaves Craig, helpless against fate, to act out those uncanny horrors again and again in the repetitive cycle of the nightmare.

James Rose

Dracula

Studio/Distributor:

Hammer /J Arthur Rank

Director:

Terence Fisher

Producer:

Anthony Hinds

Screenwriter:

Jimmy Sangster

Cinematographer:

Jack Asher

Production Designer:

Bernard Robinson

Composer:

James Bernard

Editors:

Bill Lenny, James Needs

Duration:

81 minutes

Synopsis

Jonathan Harker journeys to Count Dracula's castle in Transylvania under the pretence of assuming a position as his librarian. Dracula is a vampire and Harker is intent upon ending his reign of terror, but Dracula unleashes a bloody tide of vengeance upon Harker's family and friends back home in England. Harker's colleague Van Helsing arrives at the castle to find that Harker has joined the ranks of the undead and Dracula has fled. Dracula has hunted down Harker's fiancée Lucy, whose blood he is slowly draining. After recruiting Lucy to his demonic horde, Dracula turns his attention to her sister-in-law, Mina. Van Helsing joins forces with Mina's husband Arthur to destroy the vampire Lucy, and, upon discovering that Mina has also fallen prey to Dracula's influence, they set out to hunt him down.

Critique

The opening film in Hammer's *Dracula* series initially appears to be a traditional costume drama with lavish production design and sumptuous use of Technicolor. Christopher Lee's portrayal of Dracula as an elegant and charming British aristocrat redefined the Dracula for a generation of cinemagoers, providing a new incarnation of the Count alongside the iconic Bela Lugosi in Tod Browning's 1931 version for Universal. Alongside the English gentlemen Van Helsing (Peter Cushing) and Arthur (Michael Gough), Lee's casting places the Hammer film's tone resolutely in the British Home Counties.

Genre:

Horror

Cast:

Peter Cushing
Michael Gough
Christopher Lee
John Van Eyssen

Year:

1958

While the film's aristocratic pretensions and production values go some way to explaining its enduring popularity, that gloss disguises an uncanny undercurrent which marks out Terence Fisher's film as a true innovator in the horror genre. The apparently conservative version of one of cinema's most-told horror stories subverts its own conventions, advancing a series of inventions and reversals sufficient to surprise devotees of Bram Stoker's original 1897 novel. It is not just that Jimmy Sangster's script takes liberties with Stoker's plot – killing off Jonathan Harker (John Van Eyssen) near the start and marrying Mina (Melissa Stribling) to Arthur Holmwood – it diverges from audience expectations in other, more disturbing ways.

A few minutes in, Harker meets a young woman in Dracula's castle. She claims to be the Count's prisoner, begs his help but, as she embraces him, bares her terrible fangs. If one is sufficiently literate in vampire-lore to be unfazed by her blood-lust, one may find Harker's reaction unexpected: as he promises to help the girl and lays an avuncular hand upon her shoulder, he smiles a knowing smile. This Harker is hardly the innocent Victorian gentleman of Stoker's novel: he is a man on a mission, a fully-fledged vampire hunter. Harker's subsequent vampirization and (second) death at the hands of vampirologist Van Helsing further frustrates any usual expectations and this well-known story no longer seems familiar: anything might happen. This dramatic strategy is surely crucial to the film's suspense, and therefore to its success.

A most extraordinary moment comes with the revelation that Dracula has been hiding out in Holmwood's own house. The heroes are perplexed as to how the Count has been entering his victim's bedroom. Mina herself has given Dracula access to her cellar, where he has been resting in his coffin all day, awaiting their nightly tryst. The Englishman Holmwood's home has become Dracula's castle. In his 1919 essay 'The Uncanny', Sigmund Freud wrote of the way in which horror literature might reveal, within the homely and familiar (*heimlich*), the unfamiliar and uncanny (*unheimlich*). Hammer's *Dracula* commits an astonishingly uncanny transgression: he invades the husband's most intimate spaces and symbols of patriarchal power: his home and his wife. Dracula adds insult to injury because his ability to penetrate his victim's home comes by invitation only. In such ways, this classic British horror film is rather more radical than its hackneyed sequels might suggest. Over half a century on, it retains a freshness and a power to shock, a cinematic immortality appropriate to a tale of the undead.

Alec Charles

Don't Look Now

Studio/Distributor:

Casey
Eldorado/British Lion

Director:

Nicolas Roeg

Producer:

Peter Katz

Screenwriters:

Chris Bryant
Allan Scott
Daphne du Maurier (original
story)

Cinematographer:

Anthony B Richmond

Production Designer:

Giovanni Siccol

Composer:

Pino Donnagio

Editor:

Graeme Clifford

Duration:

110 minutes

Genre:

Horror/Thriller

Cast:

Julie Christie
Hilary Mason
Clelia Matania
Donald Sutherland

Year:

1973

Synopsis

After his young daughter Christine drowns in a lake, John Baxter and Laura, his wife, flee to Venice where he works to restore a decaying church. In Venice, Laura meets an elderly blind woman who claims to see the spirit of their dead child wearing the same red raincoat she died in. John is sceptical until he too begins to see a small red-hooded figure lurking in the streets of Venice. Is it the ghost of his daughter or is John losing his mind? The blind woman warns John that he faces certain death if he does not leave Venice, but he stays to find his daughter, even when Laura returns to England. John scours the streets and canals of Venice, haunted by guilt, grief, fear and that awful, red-hooded figure.

Critique

Nicolas Roeg's adaptation of Daphne du Maurier's haunting tale of grief is relentlessly suspenseful and unforgettably eerie. The opening sequence is a masterful montage of narrative and tone. As Laura (Julie Christie) and John (Donald Sutherland), are busy working in the house, Christine (Sharon Williams) wanders through the woods and gets too close to a pond. Laura is lost in a book, trying to search for answers to Christine's question about the curvature of the Earth, and Jack is studying slides of the church he will soon be restoring in Venice. Roeg cross-cuts between scenes of the couple working and scenes of Christine in a red-hooded jacket playing increasingly close to the pond: on one of his slides, John notices a red-hooded figure sitting in a church pew; he knocks a glass of water onto the slide, drowning the figure in water and destroying the picture; Christine falls into the water and drowns; John's sudden awareness of her peril seems clairvoyant. Whether or not Laura and John are guilty, by such dexterous editing, Roeg implicates them as participants in Christine's death.

Roeg makes his most devastating cut in the entire film at the point when John discovers Christine's body. Laura (Julie Christie) sees John holding his daughter's limp body and releases a piercing scream followed immediately by the sound and image of a screwdriver boring into a wall of a church. The scene instantaneously jumps to some time after the accident when John is hard at work restoring the church in Venice, giving orders to employees, consumed by his job without indication of grief. By cutting from tragedy to industry, Roeg robs audiences and, more significantly, John and Laura, of the catharsis of mourning. These are parents who have not adequately grieved, and the failure to do so could destroy John.

Don't Look Now gained notoriety for its disturbing climax as much as for an innovative and moving love scene montage wherein images of the Baxter's lovemaking are interspersed with post-coital scenes of the two getting dressed for a night out. As the spouses bare their bodies and grow more intimate, they simultaneously distance themselves as they cover their bodies in preparation for a

Don't Look Now, Casey Prods-Eldorado Films/The Kobal Collection.

dinner date. The love scene is frank without being exploitative, and is integral to a film that is highly attuned to the anxieties of parents who dread those moments when they cannot protect their children.

Much of Roeg's early work, such as *Performance* (1970), *Walkabout* (1970) and *Bad Timing* (1980), relies heavily on similar juxtapositions. Like *Don't Look Now*, these stories take place as much in the spaces between the images, in the unseen moments, and the inferences one might draw between the two. This, of course, is a core technique of film-making, but Roeg uses it without the addition of expository dialogue. His films, like those of David Lynch, can play like a nightmare remembered the morning after – a technique that works tremendously well for a psychological thriller like *Don't Look Now* that provokes mounting dread as John becomes lost in the labyrinthine alleys of Venice.

Randall Yelverton

The Wicker Man, British Lion/The Kobal Collection.

The Wicker Man

Studio/Distributor:
British Lion/British Lion

Director:
Robin Hardy

Producer:
Peter Snell

Synopsis

An officious and deeply religious Christian police sergeant, Neil Howie, receives an anonymous letter from Summerisle, a remote island off the coast of Scotland, informing him that a young girl named Rowan has gone missing. Flying to Summerisle to investigate, Howie shows a photograph of Rowan to the locals, but their responses are unforthcoming. Howie starts noticing the islanders' bizarre customs with growing consternation and his confusion is compounded by his sexual attraction to the beautiful Willow.

Screenwriter:

Anthony Schaffer

Cinematographer:

Harry Waxman

Production Designer:

Seamus Flannery

Composer:

Paul Giovanni

Editor:

Eric Boyd-Perkins

Duration:

88 minutes

Genre:

Horror

Cast:

Britt Ekland
Christopher Lee
Ingrid Pitt
Edward Woodward

Year:

1973

Eventually he meets Lord Summerisle, who explains that the islanders are all practising Pagans. Howie is scandalized and initially accuses the islanders of ritually murdering the girl. He attempts to leave the island to report his suspicions to the chief constable, but discovers that his plane has been sabotaged. Eventually deciding that Rowan is still alive, Howie desperately attempts to discover her whereabouts; but the islanders have further surprises in store.

Critique

Dubbed 'the Citizen Kane of horror movies' by the journal *Cinefantastique*, *The Wicker Man* is perhaps the pre-eminent British cult film of the 1970s. Veteran horror actor Christopher Lee, who plays Lord Summerisle, regards the film as the best he has been involved with and one of the greatest films made in Britain, while more cautious critics see the film as a hotchpotch whose 'fascinating ingredients', as an early *Financial Times* review put it, 'do not quite blend'. Indeed, despite some outstanding elements – Edward Woodward's fabulously frigid performance as the uptight Howie, Anthony Schaffer's sharp scriptwriting (particularly effective in the battle of wits between Howie and Lord Summerisle) and the haunting and lyrical invocations of pagan themes in Paul Giovanni's musical score – *The Wicker Man* is something of a curate's egg. It is difficult to locate the film within established generic conventions; the film's somewhat dissonant combination of the horror, thriller, comedy and even musical genres tends to confound narrative verisimilitude and interrupt the audience's suspension of disbelief, although the hybridity and unevenness of the film have inspired devotion among cult audiences.

Over the years, the film's mystique has been augmented by the many legends surrounding its chequered production history: tales of creative and personal tensions between novice director Robin Hardy and the film's cinematographer and screenwriter abound. But it is the highly eccentric formal elements of the text, such as Christopher Lee's camp performance as the louche yet debonair Lord Summerisle, the repeated use of a twang from a Celtic harp to mark moments of revelation, and Howie's many disturbing and uncanny discoveries on the island (a candle fashioned from a severed hand, a girl hiding in a wardrobe, a hare found in a coffin) that contribute most to its cult status. The rupturing effect of these playful and sometimes incongruous textual elements is consistent with the carnivalesque premise of a film that questions the hegemonic values of Christianity, sexual repressiveness and capitalist modernity – values frequently challenged in the countercultural climate of Britain in the early 1970s, particularly among 'hippies' and pagans.

Indeed, while the film's depiction of the islanders is sometimes less than sympathetic, *The Wicker Man* nonetheless offers one of British cinema's most elaborate portrayals of paganism, whose details Anthony Schaffer drew largely from JG Frazer's Victorian study of comparative religion, *The Golden Bough*. Unsurprisingly, pagans constitute a significant part of the film's cult audience, appreciating the film's critique of the policeman's blinkered and repressed worldview. Less progressive is the film's presentation of

Scotland as a culturally-peripheral repository of all that is weird and supernatural, a stereotype reproduced across a range of Scottish-set films, from *Whisky Galore!* (Alexander Mackendrick, 1949) to *Local Hero* (Bill Forsyth, 1983). Nevertheless, while lacking the sophistication and direct social relevance of the most celebrated British films of the early 1970s, such as Sam Peckinpah's *Straw Dogs* (1971) and Mike Hodge's *Get Carter* (1971), *The Wicker Man* is one of the most original and beguiling films of the period.

Stephen Harper

Hellraiser

Studio/Distributor:
Cinemarque
Film Futures/New World

Director:
Clive Barker

Producers:
Christopher Figg
David Saunders

Screenwriter:
Clive Barker

Cinematographer:
Robin Vidgeon

Production Designer:
Michael Buchanan

Composer:
Christopher Young

Editor:
Richard Marden

Duration:
94 minutes

Genre:
Horror

Cast:
Sean Chapman
Clare Higgins
Ashley Laurence
Andrew Robinson

Year:
1987

Synopsis

Having purchased an antique puzzle box in Morocco, Frank Cotton returns home to Britain where he sets about solving its riddle. By opening the box he releases a quartet of demonic entities, the Cenobites, who, in a perverse act of extreme pleasure, tear his body apart. As Frank's brother Larry and sister-in-law Julia move into the house, Larry accidentally cuts open his hand, the spilt blood from which partially resurrects Frank. The skinless Frank seeks out Julia and, by reminding her of their sexual liaisons prior to her marriage, convinces her to murder for his consumption. As Frank's power grows, so does Julia's beauty, arousing her stepdaughter Kirsty's suspicions. Kirsty's enquires lead her to Frank and to the puzzle box. Inadvertently opening it, she makes a bargain with the Cenobites, setting in motion a series of horrific murderous events.

Critique

Adapted from his own novella *The Hellbound Heart* (1986), Clive Barker's directorial debut is a seminal work in both British and International genre cinema. Predominately set in the Cotton family home, Barker deftly invigorates the Gothic trope of the Haunted Castle by making this home the site of unspoken emotions, gro-tesque rebirth, horrific murder and sexual desire, all set against the cold, dull reality of Thatcher's Britain: Larry (Andrew Robinson) and Julia's (Clare Higgins) failing marriage is confined to the home, the house itself seamlessly merging into the bland and mundane expanse of suburbia. Nothing happens here apart from the numb-ing routine of work, the daily chores of domesticity and sterile dinner parties. Nothing is said about the lost feelings of love that are solidifying into detachment and subsequently hate. Against this backdrop of simmering repression emerges a two-fold monstrous threat from the past, sexually unfettered and grotesquely beauti-fully, each offering sexual experiences beyond the reach of mortals, their ripe and vivid tones – fresh blood reds, shimmering leather black and the glint of cold metal – clashing with the decaying yellow tones that infuse the marital home and relationship.

As with all of Barker's fictions, the appearance of such monsters is one of dread but also one of a perverse liberation, for their

presence often forces characters into self-reflection, potentially resulting in powerful instances of self-awareness and possible renewal. Such a quality places narrative emphasis on Julia and her relationship with the resurrected Frank (Sean Chapman) and the way it turns her to murder when he offers the opportunity to escape her mundane existence. Julia's soliciting and murder of businessmen not only feeds Frank's return to human form but also acts out her fantasy of killing Larry, for each man she brutally murders mirrors his bumbling and emotionless state. These murders act as a cathartic release from her role as a bored and repressed housewife, investing her with a new-found sexuality and power over men, which enables her transformation into a beautiful murderess. This shift compounds the film's aesthetic concern with combining the violent with the beautiful: Frank's flayed flesh moist against his clean white shirt, blood soaking into a bed sheet like a Rorschach test, the grotesque symmetrical precision of the tortures inflicted upon the Cenobites – all embrace bodily corruption as an aesthetically ordered event and revel in its perverse beauty. The Cenobites' unique appearance intimates a preoccupation with the sadomasochistic but also duality – when Kirsty (Ashley Laurence) asks who they are, the Lead Cenobite cryptically intones 'Angels to some, demons to others', verbally declaring the dichotomy etched into their bodies.

Unsurprisingly for a narrative preoccupied with family conflict, the film ends with the destruction of that family and their home: Frank murders his brother and then Julia, quickly turning his sexual advances and murderous intentions upon his niece, only for her to trick him into one more deathly confrontation with the Cenobites. As Frank's body is torn to pieces, the house collapses into rubble, Kirsty barely escaping alive.

James Rose

28 Days Later

Studio/Distributor:
DNA/Fox Searchlight

Director:
Danny Boyle

Producer:
Andrew MacDonald

Screenwriter:
Alex Garland

Cinematographer:
Anthony Dod Mantle

Synopsis

Jim awakes from a coma in a London hospital to discover the city deserted. A highly-contagious, human-made virus that turns its victims into bloodthirsty creatures has ravaged the entire nation. Jim meets a trio of uninfected survivors and, urged on by a radio broadcast, they flee the metropolis in search of Major Henry West's outpost in the supposed safety of the countryside. However, West's sanctuary is not all it appears to be, and Jim soon realizes that the hordes of rabid, cannibalistic creatures have nothing on the savagery of the modern British army at play.

Critique

An opening montage of news footage unambiguously places *28 Days Later* in a present of urban conflict and ethnic unrest. The virus that devastates Britain is symbolic of the rage that

Production Designer:
Mark Tildesley

Composer:
John Murphy

Editor:
Chris Gill

Duration:
108 minutes

Genre:
Horror

Cast:
Christopher Eccleston
Brendan Gleeson
Naomie Harris
Cillian Murphy

Year:
2002

characterizes forms of contemporary existence and is a direct product of contemporary technologies. The film's naturalistic visual style, reinforced by its uses of digital video and held-hand camera work, fosters a documentary feel, which adds to its sense of immediacy. Like Francis Lawrence's adaptation of Richard Matheson's 1954 novel *I Am Legend* (2007), the BBC's 2009 remake of John Wyndham's 1951 novel *The Day of the Triffids* and the 2008 remake of the cult series *Survivors* (1975–1977), *28 Days Later* invokes apocalyptic fears that have lain dormant since the end of the Cold War – nightmares reborn of the events of 11 September 2001.

On 2 October 2001 Tony Blair declared that 'the kaleidoscope has been shaken. The pieces are in flux. Soon they will settle again. Before they do, let us re-order this world around us.' Danny Boyle's *28 Days Later* offers an immediate glimpse of how horribly wrong attempts at reconstruction might go. Its sequel, Juan Carlos Fresnadillo's *28 Weeks Later* (2007), more clearly announces itself as a critique of the 'War on Terror' in its effort to address the subject of military brutality, the failed reconstruction of an occupied zone and the consequent spread of rabid extremism and exportation of terror. Yet, released just over a year after 9/11, Boyle's original film also raises, and to some extent anticipates, urgent questions about the establishment of a new world order in the wake of an unimaginable catastrophe that the western world has brought upon itself.

Boyle's film presents a Britain in which the remnants of civiliza-

28 Days Later, DNA/Figment/Fox/The Kobal Collection/Peter Mountain.

tion resort to uncivilized methods of survival. The military officers still dress for dinner, but they starve and torture prisoners to extract information from them. It is not simply that the brutalization of society results from the catastrophe; it is also that the catastrophe has resulted from that long-term process of brutalization otherwise known as civilization. As Christopher Eccleston's Major Henry West observes: 'This is what I've seen in the four weeks since infection – people killing people. Which is pretty much what I saw in the four weeks before infection and the four weeks before that and before that as far back as I care to remember – people killing people. Which to my mind puts us in a state of normality right now.' The critical theorist Fredric Jameson suggested that apocalyptic science fiction conceals and yet provides a space for the performance of utopian desires. One may see this phenomenon at play in *The Day of the Triffids* or *Survivors*, but Boyle's grim vision depicts the last vestiges of the civil state – the British military – as torturers, rapists and vicious totalitarians who execute their own and relish the slaughter. There is very little scope for utopia here.

Alec Charles

SCI-FI

British science fiction film is marked out as a cinema of ideas by its indebtedness to intellectually- and artistically-rich literary and televisual influences such as the work of HG Wells, George Orwell, John Wyndham, PD James, Nigel Kneale, Terry Nation, Arthur C Clarke and Anthony Burgess. Wells himself wrote the screenplay for William Cameron Menzies' 1936 film production of *Things to Come*; other classics include adaptations of Wells' *The Time Machine* (George Pal, 1960), Wyndham's *The Midwich Cuckoos* (filmed as *The Village of the Damned*, Wolf Rilla, 1960), *The Day of the Triffids* (Steve Sekely, 1962), and PD James' *The Children of Men* (Alfonso Cuaron, 2006).

British television has also played a key role in the development of science fiction cinema in Britain. Nigel Kneale adapted Orwell's dystopian classic *Nineteen Eighty-Four* for television in 1954, and two years later Michael Anderson directed the first film version. Hammer Studios adapted Kneale's *Quatermass* television serials (1953–1959) into a trilogy of films released between 1955 and 1967 – the first of which made more money than any film Hammer had made up until then. In 1965, Hammer imitators Amicus Productions capitalized on the success of the BBC's *Doctor Who* series in the first of two feature-length encounters with Terry Nation's Daleks. More recently, the BBC co-produced Michael Winterbottom's *Code 46* (2003).

British science fiction cinema's exploitation of synergies between celluloid, print and broadcast media is epitomized by Stanley Kubrick's landmark film *2001: A Space Odyssey* (1968). *2001* was based on Arthur C Clarke's short story *The Sentinel,* originally written in 1948 for a BBC competition. Clarke and Kubrick then wrote a novel version, the composition of which paralleled the final film. Kubrick maintained this association with British science fiction literature when he filmed his adaptation of Anthony Burgess' cult dystopian novel *A Clockwork Orange* in 1971.

One might surmise that British science fiction cinema draws upon rich cultural and intellectual sources to compensate for low budgets and modest production values – British science fiction television had, after all, gained popularity despite cheap sets and poor effects, while literature never had to rely upon such fripperies. Despite working in a national film industry notoriously deficient in funding, science fiction film-makers demonstrate extraordinary visual creativity. Inventive – sometimes ground-breaking – production techniques, designs and styles distinguish the sumptuous visuals of *2001* and *Things to Come*, the experimentalism of Nicolas Roeg's *The Man Who Fell to Earth* (1976), the cyberpunk grime of Ridley Scott's *Alien* (1979), the gritty realism of Danny Boyle's *28 Days Later* (2002), and the neo-noir of Michael Winterbottom's *Code 46* (2003).

Bolstered by its openness to American investment and international talent (including Kubrick, François Truffaut, Ray Bradbury and HR Giger), British science fiction cinema can synthesize innovations in both ideas and their representation. This may be one reason why the Star Wars saga – that most Britishly-un-British of science fiction adventures – was made in Britain. In its melting pot of talent, medium and genre, British science fiction cinema finds its unique, imaginative vitality.

Alec Charles

The Quatermass Xperiment

Studio/Distributor:

Hammer
Exclusive

Director:

Val Guest

Producer:

Anthony Hinds

Screenwriters:

Val Guest
Richard Landau

Cinematographer:

WJ Harvey

Production Designer:

J Elder Wills

Composer:

James Bernard

Editor:

James Needs

Duration:

82 minutes

Genre:

Science Fiction

Cast:

Brian Donlevy
Margia Dean
Richard Wordsworth
Jack Warner

Year:

1955

Synopsis

Having lost radio contact for some time, the manned rocket ship Q1 crash-lands outside a Berkshire village. Professor Bernard Quatermass, the rocket's designer, supervises its opening, which reveals only one surviving crew member, Victor Carroon. When Quatermass takes the comatose astronaut to his laboratory to treat him, he discovers Carroon's body is undergoing physical changes. Through his investigation into the remains of the Q1 rocket and film footage taken inside the vessel during its fatal voyage, Quatermass concludes that an alien force penetrated the rocket, killing the crew and infecting Carroon. Carroon escapes and mutates into a monstrous being, forcing Quatermass to take drastic action.

Critique

Hammer Studio's origins lay primarily in low-budget thrillers and film adaptations of established British television and radio programmes. Although these films recouped their costs, the studio had yet to make a picture of significance or one that earned international recognition. In an effort to achieve this, studio executives James Carreras and Anthony Hinds purchased the film rights to the BBC's highly successful serial *The Quatermass Experiment* (Rudolph Cartier, 1953). Due to contractual obligations with the BBC, Nigel Kneale, who wrote the series, was unable to write the screenplay so Carreras employed experienced Hammer screenwriter Richard Landau. Carreras sought commercial success by employing American actor Brian Donlevy to play Quatermass to appeal to the American market. He also requested Landau condense the three-hour serial into a feature film and actively expand its graphic content to warrant the film being granted an 'X (Adults Only)' BBFC Certificate. *The Quatermass Xperiment* was indeed the first British film to be given an 'X' rating. To further capitalize on this accolade, Carreras requested the deliberate misspelling of the film's title. Both strategies worked, and the film generated a large national audience upon its initial release and then went on to repeat this success abroad, making *The Quatermass Xperiment* Hammer's first international success.

As a hybrid of science fiction and horror, the film has a preoccupation with invasion, with Landau's script demonstrating anxieties about the potential absorption of the human by the 'alien'. The opening scene of a rocket crashing in rural Britain and the subsequent mutation/absorption of Carroon (Victor Wordsworth) by an alien life force fed directly into contemporary anxieties. With the escalating space race, the development of the V2 bomb and the knowledge that Britain had developed and launched its first guided missiles, *Xperiment* suggested that, although the war was over, there were new enemies, as yet unseen, waiting to be encountered and intent on invasion. Potentially, the film suggests that Britain needed to place its faith in science, embodied in

the film in Donlevy's performance of Quatermass: confident and determined, Quatermass efficiently vanquishes the alien threat at Westminster Abbey. Prior to the film's release, the Abbey hosted the coronation of Queen Elizabeth II, making it a contemporary and positive symbol for post-war audiences. Although the mutated Carroon 'attacks' this building and partially 'consumes' it, Quatermass kills the creature in such a manner as to leave the building intact. The Abbey stands firm as a symbol of the country's future hopes, remaining impervious to the invader as science repels it. This scientific defence is reiterated when Quatermass marches back to his laboratory and launches another rocket, Q2, into the deeper reaches of space.

James Rose

Village of the Damned

Studio/Distributor:
MGM British
MGM

Director:
Wolf Rilla

Producer:
Ronald Kinnoch

Screenwriters:
George Barclay
Wolf Rilla
Stirling Silliphant

Cinematographer:
Geoffrey Faithfull

Production Designer:
Ivan King

Composer:
Ron Goodwin

Editor:
Gordon Hales

Duration:
77 minutes

Genre:
Science Fiction

Cast:

Synopsis

Inexplicably, the villagers of Midwich all collapse into a deep sleep. As the military cordons the area off and conducts tests to establish the cause of this collective narcolepsy, the community wakes up, seemingly unaffected by the strange occurrence. Months later, the local doctor discovers that all the women who are able to conceive are now pregnant. The women give birth within days of each other and their babies look disturbingly alike. As they rapidly age, the children demonstrate menacing telepathic abilities and the balance of power in the village soon starts to shift.

Critique

Faithfully adapted from John Wyndham's novel *The Midwich Cuckoos* (1957), *Village of the Damned* is a complex reworking of the 'invasion from within' theme that dominated much of 1950s' American science fiction cinema. With its ironic beginning, the film is firmly grounded in a nostalgic image of the quiet and sleepy English village: as the camera slowly pans across this quaint landscape, the villagers – seemingly dead – are shown slumped over park benches or barrows of vegetables, a farmer collapsed on his tractor, a shopkeeper sprawled across the counter, a bus crashed into a ditch. Taps are left running, an iron burns through a dress, a gramophone winds down; all making Midwich appear as if it has been subject to disaster that has extinguished all life but left the landscape intact. Initial dialogue, which suggests these 'deaths' may be the result of an undisclosed military exercise, evokes contemporary anxieties about chemical and biological warfare, nuclear-weapons testing and radiation poisoning. But it is slowly revealed that the village has been subject to an alien attack in which the women have been violated and impregnated. The invasion literally comes from within, as the women give birth to startlingly similar blonde and silvery-eyed children. This new hybrid species seeks to dominate the world through powerful mind

Michael Gwynn
George Sanders
Barbara Shelley
Martin Stephens

Year:
1960

control, and their appearance recalls frightening imagery of the Nazi Aryan 'master race'.

The children's assault on the village subtly begins when one child telepathically forces his mother to plunge her hand into boiling water in punishment for feeding them hot milk, and escalates as the children manipulate three men who threaten their survival into killing themselves. Through this telepathic control, the children take control of Midwich, enabling them to dominate the adults, dictating to their parents (and consequentially to the military) what should and should not be done.

At the heart of the story is Gordon Zellerby (George Sanders), a cultured science professor who represents the epitome of the educated, mannered English gentleman. Zellerby initially responds to the arrival of the children with an analytical distance, a quality which aligns him with Bernard Quatermass; both men consider their respective narrative threats as a potentially positive step forward for British scientific discovery and are criticized by the military for being blinded by intellect. While the children stimulate Zellerby's scientific mind, they threaten the men of Midwich: having had no part in their conception, the men are effectively castrated and placed at an emotional distance from their families. Gathering in the local pub, the men form a lynch mob to do what the 'authorities' will not do – kill the children. When their leader is forced to immolate himself, Zellerby finally recognizes the powerful threat the children represent, and engages them in a deadly battle of mind control.

James Rose

Brazil

Studio/Distributor:
Embassy International
20th Century Fox

Director:
Terry Gilliam

Producers:
Patrick Cassavetti
Arnon Milchan

Screenwriters:
Terry Gilliam
Charles McKeown
Tom Stoppard

Cinematographer:
Roger Pratt

Synopsis

Somewhere in the twentieth century, a fly falls onto a computer printer, changing the name it types from Tuttle to Buttle. Cut to Sam Lowery, a clever but unambitious office worker living in a futuristic police state. To escape the banality of his existence, Sam dreams of being a winged hero, flying through a fantasy world, rescuing a beautiful maiden from monstrous tormentors. While visiting Buttle's widow following his death under police interrogation, Sam glimpses a woman, Jill, uncannily resembling the girl of his dreams. Accepting promotion in order to track her down, Sam discovers Jill's attempts to highlight Buttle's wrongful arrest have identified her as a terror suspect, and he determines to save her from the authorities. As his obsession takes over, Sam's life gradually unravels in a trail of loose ends, misguided heroics, and unfiled paperwork, until he too feels the full brutality of the state.

Critique

A Kafkaesque nightmare vision of the future and the present, *Brazil* is Terry Gilliam's visually spectacular, darkly comic interpretation of

Production Designer:
Norman Garwood

Composer:
Michael Karmen

Editor:
Julian Doyle

Duration:
132 minutes

Genre:
Science Fiction

Cast:
Robert De Niro
Katherine Helmond
Ian Holm
Jonathan Pryce

Year:
1985

Nineteen Eighty-Four. Released just after the iconic date, Gilliam translates the practices of Orwell's totalitarian regime according to the rhetoric of Thatcher's Britain: to ensure taxpayers receive value for money, terror suspects are billed for their interrogation; torturers refer to their victims as customers; government representatives spout clichéd cricket metaphors and back-to-basics rhetoric to justify state violence. More imaginative and insightful than the literal adaptation released a year earlier, *Brazil* is *Nineteen Eighty-Four* from a 1984 perspective. Moreover, the doublethink rebranding of prisoner torture as 'information retrieval' is chillingly contemporary.

Brazil takes its technological and aesthetic inspiration from the past and consequently retains a timeless quality. The film's pervasive machinery has an archaic retro design. Computers are valve driven, with typewriter keyboards and giant magnifying glasses to enlarge their unembellished text screens. Operating systems are a mass of wires and cables. Ducts intrude from every ceiling, and office communication is via pneumatic tubes. At the same time, *Brazil* anticipates many contemporary developments. Smart cars, faddish over-engineered restaurant food, even illegal movie downloads are all anticipated in this dystopian tale.

More than a design choice, *Brazil*'s unwieldy technology underlines the film's theme: systems, mechanical or otherwise, are unreliable. Departments intended to work together fail to communicate, or harbour counterproductive grudges. Sam's (Jonathan Pryce) clockwork apartment, designed to streamline his morning routine, fails the basic task of waking him for work. And the entire narrative is set in motion by a literal bug in the system.

Technology fails, but more dangerous is the refusal to acknowledge the possibility of their failure, and the pleasure individuals take in using the system to pursue petty vendettas or to deny responsibility for their actions. Indeed, the people who staff the systems of *Brazil* are themselves breaking down. A heating engineer convulses at the mention of a 27B/6. Sam's boss is consumed by office paranoia and insecurities. Jack, Sam's old school friend, a sinister against-type performance by fellow Python Michael Palin, is a slick government torturer whose mental disintegration becomes terrifyingly visible with each successive scene. And Sam himself is a neurotic whose dreams translate the banality, and the horror, of his daily life into more manageable monsters which can be fought and vanquished. As the boundary between these two worlds becomes increasingly strained, the full extent of Sam's psychosis becomes apparent.

Brazil is also about the bittersweet promise that imagination offers for escape. The film takes its title from a 1930s' song, 'Aquarela do Brazil' which floats through the score, and minds of the characters, like a nostalgic dream or hope for a brighter tomorrow. While Orwell saw political action as offering a challenge to totalitarianism, for Gilliam, the visionary film director, it is the ability to imagine ourselves somewhere else, either through daydreaming or old films or even insanity. Both writer and film-maker appear pessimistic that either strategy will succeed.

Ewan Kirkland

SOCIAL REALISM

Although social realism is one of the defining characteristics of British film culture, the term has always been of more use to critics and scholars than audiences and film-makers. Describing a type of film that avoids the fanciful or epic-historical in favour of stories rooted in everyday experience and recognizable locations, British social realism is not so much a genre or creative goal, but an impulse shaping a significant proportion of British cinema, albeit in varying ways and to differing purposes.

Whilst it is difficult, and somewhat reductive, to distil the essence of British social realist cinema into a set of core traits, one starting point for definition is its preoccupation with place. Not every film with a claim to realism is concerned with how individuals are shaped, or overwhelmed, by their environment, but this theme provides a connecting thread between otherwise-divergent films situated within the social realist tradition, from A Kind of Loving (John Schlesinger, 1962) and Bronco Bullfrog (Barney Platts-Mills, 1969) to Billy Elliot (Stephen Daldry, 2000). A preoccupation with dynamics of place and identity – whether in terms of class, gender, sexuality, age or race – goes some way to justifying the use of the phrase 'social realism' as shorthand for films that invite a socio-political reading (even if the film-makers protest against this). This sociological inclination may also explain the tendency for stories about children or young people on the threshold of adolescence or adulthood, struggling to find their place in a rigidly demarcated world.

While a commitment to some kind of authenticity is a constant, the supposed 'realism' of the British social realist film has been interpreted in quite different ways. In one sense, realism can be interpreted as a pledge to document a certain type of experience or location that has hitherto been absent or underrepresented on screen. Indeed, it is possible to construct a history of British social realism as a progressive move towards social inclusion. For example, films of the so-called British New Wave of the late 1950s and early 1960s such as Saturday Night and Sunday Morning (Karel Reisz, 1960) were groundbreaking for their depiction of northern, working-class characters. But the general emphasis in New Wave films on the perspective of young white men was challenged in later decades by films such as Pressure (Horace Ové, 1976) and Letter to Brezhnev (Chris Bernard, 1985) that focused attention on the experiences, for example, of women, homosexuals and ethnic groups.

From the mid 1990s onwards, a number of films, such as The Full Monty (Peter Cattaneo, 1997), Nil by Mouth (Gary Oldman, 1997) and Fish Tank (Andrea Arnold, 2009), responded to emerging definitions of (and sometimes animosity towards) 'underclass' cultures with stories about individuals and communities struggling to exist outside the mainstream economy. British social realist cinema has also gradually shaken off its association with the industrial north of England – the setting for most of the New Wave narratives – with films made across the British Isles, from the rural Cotswolds of Better Things (Duane Hopkins, 2008) to the South Wales community of A Way of Life (Amma Asante, 2004).

British social realism has also been defined in terms of style. The 'kitchen sink' dramas of the New Wave era were uniformly black and

Left: Saturday Night and Sunday Morning, Woodfall/ British Lion/The Kobal Collection.

white, featured young and untried actors who mostly used their own regional voice, were loosely structured, and established a topography of domestic, industrial and rural spaces. That sense of place is still recognizable in the work of some contemporary directors; for example, the escapist flight from the privations of the city to the freedoms of the countryside remains a stock trope of rite-of-passage films, such as Lynne Ramsay's *Ratcatcher* (1999), that are set in grim urban landscapes.

For some realist film-makers, the ambition has been naturalism, whether from performances, visual style or editing. Yet, other than through impressionistic judgements about authenticity, filmic naturalism can only really be assessed in relation to previous attempts at capturing a sense of the real. For example, in comparison with the New Wave films of barely a decade earlier, Ken Loach's *Kes* (1969) seems far more rooted in authentic experience, as a consequence of its leisurely plotting and use of non-professional actors often using thick regional dialect. A comparison between the stylistic approaches of Ken Loach and Mike Leigh, two directors commonly associated with British realist cinema, emphasizes how realism is in fact an umbrella term for some very different attitudes to naturalism. Both tend to adopt an unfussy visual style, but whereas Loach withholds some story information from his actors to encourage believable responses to the increasingly grim predicaments in which he places their characters, Leigh only employs improvisation at the writing stage, resulting in a tendency towards a more heightened acting style; broadly speaking, Loach strives for accurate representation of social problems and structures whilst Leigh has a greater interest in interpersonal relationships. Other 'social realist' film-makers, such as Terence Davies, Pawel Pawlikowski, Lynne Ramsey and Andrea Arnold have sometimes been described as poetic realists or proponents of a social art cinema. They have evolved distinctive visual styles that emphasize psychological states or evocations of memory over documentary-like depictions of recognizable environments.

Within scholarship on British social realist cinema, the near-consensus on the key films, personnel and periods has recently been challenged. The New Wave cycle released between 1957 and 1963 has been justifiably canonized as a significant moment in British film culture. New Wave films such as Jack Clayton's *Room at the Top* (1959), Karel Reisz's *Saturday Night and Sunday Morning* (1960), John Schlesinger's *A Kind of Loving* (1962) and *Billy Liar* (1963), Tony Richardson's *A Taste of Honey* (1961), and Lindsay Anderson's *This Sporting Life* (1963) are bound together through commonalities of theme and influence, most notably the 1930s' documentary movement, Italian neorealist cinema, the contemporaneous British Free Cinema documentary movement and concurrent literary and theatrical wave of 'Angry Young Men' writers who provided the source materials for many new wave films.

However, the stylistic and thematic coherence of the New Wave cycle has been queried, and attention drawn to how signifiers of realism were, then as now, dispersed across a broad range of films and genres, not just gritty kitchen sink films about northerners. The oft-held notion that British social realism entered a fallow patch in subsequent decades, perhaps only kept going by diehards such as Ken Loach, is to underestimate the importance of pioneering work of the 1970s such as *Pressure* and *Nighthawks* (Ron Peck, 1978), and the importance of television drama by directors such as Mike Leigh and Alan Clarke. Whilst the 1980s did witness a revival of socially- and politically-committed cinema, assisted by the patronage of Channel 4, the films made during this time by the likes of Alan Clarke, Mike Leigh, Stephen Frears and Terence Davies are quite distinct in style and attitude. For example, Frears' *My Beautiful Laundrette* (1985) and Mike Leigh's *High Hopes* (1988) were state-of-the-nation responses to Thatcherism, whilst others, such as Davies' *Distant Voices, Still Lives* (1988), pursued more timeless and auteurist agendas. Commentators of the late 1990s were quick to identify an apparent revival of 'Brit Grit' films that adapted some of the iconographic and thematic features of the New Wave cycle to the post-industrial era. In retrospect, this cycle of films about British men

struggling to find their identity and exert authority as either fathers or workers – which included 'feel good' films such as the internationally popular *The Full Monty*, as well as more ambivalent explorations of masculinity such as *Nil by Mouth* – proved to be relatively short lived. That said, the 'men in crisis' theme has since been pursued at length, most notably in the films of Nick Love and Shane Meadows.

A survey of more recent British cinema offers further evidence of the limitations of social realism as an exclusive critical and promotional category. Shane Meadows, with his films about youth and disenfranchisement in Nottingham, is frequently cited as a keeper of the social realist flame. Yet his work connects with a variety of genres, including the sports film (*TwentyFourSeven*, 1997), the western (*Once Upon a Time in the Midlands*, 2002) and the period and/or subculture film (*This is England*, 2006). This hybridizing tendency, albeit far from new, is arguably one of the defining features of contemporary British cinema. It is manifest in issue-led films aimed at a youth audience, such as *Bullet Boy* (Saul Dibb, 2004) and *Kidulthood* (Menhaj Huda, 2006), as well as horror films like *28 Days Later* (Danny Boyle, 2002) and *The Disappeared* (Johnny Kevorkian, 2008) that use settings and locations associated with 'realist' drama as backdrops for supernatural, fantastic or violent events. Such films seem to disrupt traditional polarizations of British cinema in terms of realism versus popular genre, art, heritage, drama or 'tinsel'. Social realism may not necessarily be a conscious aspiration for that many film-makers today, but it continues as a bass note sounding vigorously through British cinema and television in the twenty-first century.

James Leggott

Saturday Night and Sunday Morning

Studio/Distributor:
Woodfall/Bryanston Films

Director:
Karel Reisz

Producers:
Tony Richardson
Harry Saltzman

Screenwriter:
Alan Sillitoe

Cinematographer:
Freddie Francis

Production Designer:
Edward Marshall

Composer:
John Dankworth

Editor:
Seth Holt

Duration:
89 minutes

Genre:
Social Realism
Melodrama

Cast:
Shirley Anne Field
Albert Finney
Bryan Pringle
Rachel Roberts

Year:
1960

Synopsis

Arthur Seaton, a Nottingham factory worker, makes the most of his social life and vows not to be ground down like his parents' generation. He has been enjoying a reckless affair with Brenda, the wife of Jack, one of his colleagues, and narrowly escapes being caught on numerous occasions. When Brenda tells him that she is pregnant with his child, he asks his Aunt Ada to arrange an abortion, but this fails, and she later decides to keep the baby. When, at a visit to the fair, Arthur and Brenda are seen together by Jack, his soldier brother and their friends, the soldiers chase and attack him. At the same time, Arthur has been courting a younger woman, Doreen, and is now forced to choose between the women, and to contemplate his future.

Critique

Saturday Night and Sunday Morning is for many film critics the quintessential British New Wave film. It made a star out of a 24-year-old Albert Finney in the role of Arthur Seaton, a Nottingham factory worker railing against the establishment, the older generation, and all those standing in the way of a good time. Discussions of the film invariably place it at the heart of a cycle of gritty, realist films about northern anti-heroes with complex love lives. Although there are obvious stylistic and thematic connections with films such as *A Kind of Loving* (John Schlesinger, 1962), *Saturday Night and Sunday Morning* stands slightly apart from the New Wave canon in its nuanced representation of northern working class culture, as personified by the truculent yet charismatic Arthur.

The film's reputation as an influential work of British social realism, together with the enduring fame of Albert Finney's oft-cited voice-overs ('Don't let the bastards grind you down'), has to some degree obscured its success as a tightly-constructed, visually-arresting and sensitively-cast dramatic piece. The screenwriter Alan Sillitoe whittled away the more discursive elements of his 1958 novel to produce a script that economically sketches the parameters of Arthur's family, work and social lives without ever seeming schematic. For example, Sillitoe skilfully weaves together contrasting sequences of Arthur's simultaneous courtship of the middle-aged Brenda and the aspirational young Doreen in a way that explains the respective attractions of both women for Arthur, but also encapsulates his ambivalence towards a changing working-class culture of upward mobility.

Saturday Night and Sunday Morning contains some imagery that would quickly become clichés of northern realism, such as shots of canals and sloping terraced houses. But accounts of the film often overlook how subtle changes of tone and characterization are conveyed through a constantly-changing visual palette, courtesy of Freddie Francis' work as director of photography; take, for example, the noir-ish lighting around the furtive, post-coital Arthur

and Doreen outside the pub, or the way that pub interiors can be raucous, youthful or gloomily oppressive, depending on Arthur's mood at the time. Further texture comes via the supporting cast; Shirley Ann Field and Rachel Roberts, as Doreen and Brenda, bring very different yet complementary types of glamour to their potentially thankless roles, but there are other strong turns here, such as Norman Rossington as Arthur's placid foil, and the musical hall comedienne Hylda Baker as a sympathetic but steely matriarch.

Inevitably, though, the film belongs squarely to Arthur Seaton. Some critics have made a case for his sexism, citing his aggressive treatment of Ma Bull (Edna Morris). Others have seen him as a defender of traditional working-class culture against tides of consumerism. There is also debate over whether the ending represents a troublemaker finally growing up, or a force of nature tragically ground down by domesticity. The film does not insult the audience with any definitive answer, instead giving the last word to Arthur himself: 'Whatever people say I am, that is what I'm not.'

James Leggott

A Taste of Honey

Studio/Distributor:
Woodfall/Bryanston

Director:
Tony Richardson

Producer:
Tony Richardson

Screenwriters:
Shelagh Delaney
Tony Richardson

Cinematographer:
Walter Lassally

Production Designer:
Ralph Brinton

Composer:
John Addison

Editor:
Antony Gibbs

Duration:
100 minutes

Synopsis

Jo, a teenager, moves with her mother to a slum area of Salford. Walking along the canals, she meets Jimmy, a black man who works as a ship's cook, and after a few dates they spend the night together before he sets sail again. Meanwhile, Jo's mother is courting a new lover, Peter, who does not get on with Jo. A family visit to Blackpool creates furthers tensions as Jo's mother announces her marriage and her intention to move away. Having left school, Jo rents a derelict flat and takes a job in a shoe shop, where she meets Geoffrey, who moves in with her. She soon has to deal with the consequences of her brief romance with Jimmy, which ultimately leads to changing relationships with Geoffrey, her mother, her environment and her own body.

Critique

A Taste of Honey, directed by Tony Richardson, is usually placed in the British New Wave cycle of the late 1950s and early 1960s. Yet its story about Jo (Rita Tushingham), a teenage lone mother, makes it markedly different from those films, which focus almost exclusively on male experience and have sometimes been criticized for their 'masculinist' attitude. Based on a play by the Salford-born Shelagh Delaney, still a teenager herself at the time of its 1958 première, A Taste of Honey depicts a world where maternal bonds are the most significant, and it is men who are 'Othered'. Jo is ungainly, dreamy and not without wit ('my usual self is a very unusual self!'). When she is abandoned by her black lover (Paul Danquah) and her mother (Dora Bryan), left alone and heavily pregnant, she creates a home of her own with her homosexual friend

Genre:

Social Realism
Melodrama

Cast:

Dora Bryan
Murray Melvin
Robert Stephens
Rita Tushingham

Year:

1961

Geoffrey (Murray Melvin), another outsider cut loose from family and conventional society. It is hard to escape the symbolism of one of the film's final sequences depicting children setting fire to an effigy of Guy Fawkes just after Jo and her mother are reunited.

The Salford canals, broodingly shot by Walter Lassally, provide an evocative backdrop for Jo's bumpy path to adulthood. The film begins with Jo and her mother taking one of their regular flights from a landlord, their bus ride portering them beyond the grand civic buildings and statues of the city towards the run-down slums on the periphery. Richardson frequently contrasts this fascinatingly squalid landscape – populated almost entirely, it would seem, by children chanting nursery rhymes – with the tacky, ersatz spaces of adult leisure and courtship frequented by Jo's mother and her boyfriend. In a similar fashion to Lindsay Anderson's O Dreamland (1953), the film reveals some unfortunate snobbery in its assessment of popular culture as fundamentally vulgar.

A Taste of Honey betrays its theatrical origins in a script that strikes a sardonic note throughout, particularly in the tart exchanges between Jo and her exasperating mother. There is also a literary quality to its recurrent light-related symbolism. Yet the lingering impressions of the film derive not from the occasionally arch dialogue, but from the striking framing of characters against arches, canals, sloping streets and hills, as well as from Tushingham's extraordinarily guile-free performance. The tone darkens considerably as the film progresses: Jo's disgust at her physical condition, and the possibility of bearing a 'half-wit' child, is echoed in her growing repugnance for the filthy canals that were once her playground. These harrowing scenes move the film into a very different emotional and visual territory from other realist films of the era. In some respects they point towards a kind of poetic realism that would take at least two more decades to properly flourish in British cinema via film-makers such as Terence Davies and Lynne Ramsay.

James Leggott

Kes

Studio/Distributor:

Woodfall
Kestrel/United Artists

Director:

Ken Loach

Producer:

Tony Garnett

Synopsis

Billy Casper, a teenager in a northern mining village, is about to leave school. He is unsure of his future profession but determined not to become a miner like his brother Jud. He gets up early to deliver a paper round, endures a range of humiliations at school, then takes a solitary afternoon walk in a rural area. During one walk, Billy becomes fascinated by a kestrel hawk in flight, and seeks out information about how to train it. He adopts the bird, looks after it in his coal shed, and takes it on training flights. Although school teachers and fellow pupils pick on Billy, a sympathetic teacher takes an interest in the bird and comes to see Billy train it. However, Billy's new hobby brings him into conflict with his brother.

Screenwriters:
Tony Garnett
Barry Hines
Kenneth Loach

Cinematographer:
Chris Menges

Production Designer:
William McCrow

Composer:
John Cameron

Editor:
Roy Watts

Duration:
110 minutes

Genre:
Social Realism

Cast:
David Bradley
Freddie Fletcher
Brian Glover
Lynne Perrie

Year:
1969

Critique

Ken Loach's *Kes* has been canonized, parodied, and even loosely remade (it was an inspiration for Stephen Daldry's 2000 film *Billy Elliot*), making it easy to forget the impact of its naturalism upon British audiences when it was released in 1969. Although by no means the first film to capture aspects of working-class experience rarely seen on screen, *Kes* has an air of authenticity that continues to impress viewers and influence generations of film-makers.

A major contribution to the 'realism' of *Kes* is the casting of (mostly) non-professional actors, some of whom use a thick York-shire dialect that can be baffling to non-natives – and possibly to censors too, given that there are more four-letter words here than might be expected from one of the truly great British films about childhood. Viewers with first-hand experience of the British education system still marvel at the veracity of its lengthy school sequences, such as the excruciating sports lesson where a teacher (Brian Glover), with delusions of footballing talent, bullies his charges around the pitch, or the hilarious scene where a line-up of wrong-doers can barely disguise their sniggers when being dressed down by their pompous head-teacher (Bob Bowes). But even for those who did not happen to attend an English comprehensive school in the 1960s, *Kes* still manages to capture the broad spec-trum of childhood experiences, from the tedium of the classroom and the delights of back-chat and banter, to the unfairness and humiliation of bullying at the hands of family, school friends and teachers.

In the central role of Billy Casper, a gangly boy on the threshold of adulthood, David Bradley gives a touching and seemingly-unaf-fected performance of loneliness and distraction. Determined not to follow his brother down the mines, Billy's adoption and training of the kestrel hawk brings brief solace from the benign neglect of his family and his isolation at school. The gloomy message of Barry Hines' screenplay – adapted from his own novel and co-written with Loach and producer Tony Garnett – about the cruel, imagina-tion-crushing inevitability of a life of manual labour, is also visually conveyed. Billy's playground, loomed over by the mine head, offers striking vistas that combine the pastoral with the bleakly industrial in a manner that evokes the inevitable end of childhood.

Kes remains one of Loach's most popular and well-known films, and it demonstrates many of the formal techniques and thematic obsessions of his later films, such as *Riff Raff* (1991), which are very often about social and political injustices, and filmed in an unfussy, slightly dispassionate style. Judged within the context of Loach's experimentations with drama-documentary form, *Kes* is not without flaw. The club sequences involving Billy's brother (Freddie Fletcher) and mother (Lynne Perrie) are notably stilted, and Loach himself has acknowledged the one-dimensional characterization of Jud as a nar-cissistic bully. Yet in some respects, these imperfections only add to the film's charm and, in balancing the artful with the slightly rough-hewn, they produce a work of great humanity and enduring power.

James Leggott

Pressure

Studio/Distributor:
BFI

Director:
Horace Ové

Producer:
Robert Buckler

Screenwriters:
Samuel Selvon
Horace Ové

Cinematographer:
Mike Davis

Synopsis

British-born Tony lives in Ladbroke Grove, London, with his immigrant parents from Trinidad and his brother Colin, who is involved with the Black Power movement. Tony leaves school but is unable to find work appropriate to his qualifications. Increasingly frustrated, Tony spends time with black friends and is drawn to his brother's political meetings. When a meeting is violently disrupted by the police on the pretext of a drug bust, Colin and Tony are arrested, and their family home is searched and upturned. This brings to a head an argument between Tony and his parents about their conformity and lack of understanding of the problems faced by his generation. Tony gets involved with the militant group campaigning against the police, but he disagrees with some of their more radical anti-white sentiments, arguing instead for a universal fight against discrimination and enslavement.

Pressure, BFI/The Kobal Collection.

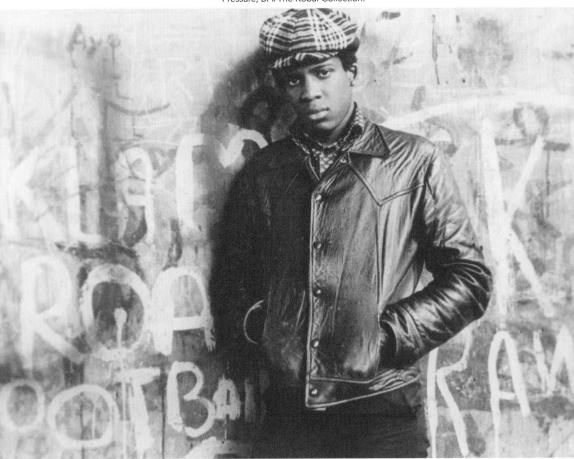

Editor:

Alan J Cumner-Pryce

Duration:

120 minutes

Genre:

Social Realism

Cast:

Oscar James
Lucita Lijertwood
Herbert Norville
Sheila Scott-Wilkinson

Year:

1975

Critique

Horace Ové's *Pressure*, often unfairly sidelined in accounts of British realist cinema, has more verve than its basic summary might suggest. *Pressure* describes the gradual politicization of a British-born son of West Indian immigrants. Tony (Herbert Norville) initially distances himself from his older brother's militancy, his parents' passivity, and the fatalism and petty criminality of some his streetwise friends. But his mounting frustration at not finding work, together with his exposure to institutional racism at the hands of employers and the police, pushes him inexorably towards the Black Power movement. However, Tony's conflicting allegiances and eventual assertion of his heritage are conveyed as much through signifiers of cultural identity, such as language, dress, music and food, as through the mechanics of the narrative. At the beginning, Tony is chided by his brother (Oscar James) for his preference for fish and chips over avocado, and mocked by his friends for confusing patties with pâté, but, after a humiliating encounter with the police, he sits down with his brother to eat a West Indian dish. Ové adds another layer of cultural richness through his careful use of music. Tony, an apparent fan of Gary Glitter, is exposed throughout the film to reggae, the pop music of a 'white' club, the roots music of a 'black' club, and the gospel choir at his mother's church, all contributing to a nuanced narrative of its own about integration and segregation.

For all its qualities as a document of black British experience, *Pressure* invites criticism for its schematic approach to plot and characterization. Yet *Pressure* can be easily situated within a tradition of British social realism that prioritizes performance and authenticity over style. In particular, some of the Ladbroke Grove sequences involving Tony and his pals have an unforced naturalism, with Herbert Norville's sympathetically-gauche and well-spoken character making a suitably awkward fit with his patois-speaking acquaintances (all played by non-professional actors). Now and again, there is an exterior scene that runs slightly longer than might be expected, allowing Ové to capture an everyday vignette of London life. In comparison, a sequence showing Tony confronting his family about their servility seems overly-written and more consciously performed.

Ové and his co-writer Samuel Selvon save their most formally radical move to the very end, in effect offering two conclusions. In a stylized dream sequence, Tony bloodily slaughters a bed-ridden pig in a stately home, to the sound of tribal drumming. But the film closes with the more mundane image of browbeaten protestors, including Tony, trudging through the drizzle with placards outside the police station where their friends have been brutalized. The viewer is left to speculate what will become of Tony, and what this protest might lead to.

James Leggot

Letter to Brezhnev

Studio/Distributor:
Yeardream
Film4
Palace Pictures

Director:
Chris Bernard

Producer:
Janet Goddard

Screenwriter:
Frank Clarke

Cinematographer:
Bruce McGowan

Production Designers:
Lez Brotherston
Nick Englefield
Jonathan Swain

Composer:
Alan Gill

Editor:
Lesley Walker

Duration:
97 minutes

Genre:
Social Realism
Melodrama

Cast:
Margi Clarke
Peter Firth
Alfred Molina
Alexandra Pigg

Year:
1985

Synopsis

Elaine and Teresa reject their local social club, preferring the thrill of an illicit night in Liverpool's bars and clubs, where they meet Peter and 'Igor', two Russian sailors on shore for one night only. Despite the brevity of their encounter Elaine and Peter fall in love only to be torn apart the following day. As they bid farewell, the lovelorn couple vow to find a way to be together once more. Peter returns to his ship and leaves Elaine behind. Despite the negativity of family, friends and officials, Elaine remains determined to escape, believing that life in the Soviet Union may actually be better than life in Liverpool. She tries to follow her heart, with a little help from Russian President Brezhnev.

Critique

Letter to Brezhnev is a social realist fairy tale romance of love, escape and destiny set against the depressive and impoverished Merseyside of the eighties. In many ways the film is symptomatic of a number of Channel 4 Film social realist productions of the mid-eighties alongside *Rita, Sue and Bob Too!* (Alan Clarke, 1986) and *Sammy and Rosie Get Laid* (Stephen Frears, 1987). *Letter to Brezhnev* is a typically low-budget production characterized by a reliance on a televisual rather than cinematic aesthetics, emphasized through settings including pubs, clubs, chip shops and street corners. The opening shots from the Mersey river give way to sweeping aerial shots of an urban landscape shrouded in grey mist, conveying the sense of stasis and entrapment from which Teresa and Elaine seek escape. While the film is, in many ways, a romantic fairy tale of fateful (and possibly fated) love, it is firmly located in a tradition of British social realist cinema that focuses on working-class characters, experience and culture. In so doing the film does not shy away from issues of domestic politics and the debilitating consequences of unemployment but engages with them with a dexterous comic touch.

Narrative momentum is carried by the charismatic coupling of Teresa (Margi Clarke) and Elaine (Alexandra Pigg) and this has led to it being positioned in the longer tradition of British 'women's film'. They make an unlikely couple; Teresa's sexual assertiveness provides a compelling foil to Elaine's rather more reserved, romantic idealism.

Through these characters the film explores the disparity between their desires and the realities of their lives. The two women represent hugely-contrasting models of femininity: Teresa's streetwise, earthy humour and overt sexuality construct her as something of an unruly woman, whereas Elaine is the self proclaimed 'straight girl from Kirby'. While Elaine seems to be the more conventional of the two she is the one who escapes with the promise of realizing her dreams.

In many ways Elaine typifies a form of femininity commonly found in the popular photo-stories of 1970s' and 1980s' British girls

magazines such as *Jackie* and *Blue Jeans*, but the film also allows her moments of feistiness which give her character an endearing frankness and sharp political awareness. For instance, during an argument about her impending migration to the Soviet Union, Elaine tells her mother to 'go and knit yourself an iron curtain!' Elaine's quiet refusal to accept the fate that others desired for her further adds to her appeal; the institutional authority of the Russian-speaking bureaucrat does not intimidate her and she holds her own in an encounter with a journalist seeking out a salacious story. Although Elaine's wilfulness is scorned by many, the film's tragic irony is that it is the rambunctious, assured Teresa, for all her verve and seeming spontaneity, who is left behind, trapped by her own psyche as much as by her social position and circumstances.

Sarah Godfrey

Rita, Sue and Bob Too!

Studio/Distributor:
Channel 4
Umbrella
British Screen/Film4

Director:
Alan Clarke

Producer:
Sandy Lieberson

Screenwriter:
Andrea Dunbar

Cinematographer:
Ivan Strasburg

Production Designer:
Len Huntingford

Composer:
Michael Kamen

Editor:
Stephen Singleton

Duration:
93 minutes

Genre:
Comedy/Social Realism

Synopsis

Rita and Sue, teenagers from a tough Bradford council estate, babysit for Bob and Michelle, who live in the more affluent suburbs. After driving them home over the moors one night, Bob seduces them and then has sex with both. Rita continues to meet Bob, on one occasion sneaking out of school to have sex with him in a show home on a newly-built housing development. Michelle has suspicions about her husband when she finds condoms in his trouser pocket. A neighbour, Mavis, reports seeing Rita, Sue and Bob at a club, so Michelle confronts the girls outside their houses on the estate, before leaving Bob. Sue starts going out with Aslam, who is jealous of her relationship with Rita and Bob. The situation between Bob, Rita and Sue becomes increasingly complicated. New commitments and suspicions arise, casting doubt on any reconciliation between the three.

Critique

This gritty comedy about a pair of Bradford teenagers and their three-way sexual relationship with a married man has a secure place within the canon of British social realist cinema. The screenplay was written by the Bradford-born Andrea Dunbar, who shot to fame aged 15 with *The Arbor*, her play about the Brafferton Arbor area of Bradford's notorious Buttershaw Estate, in which a local schoolgirl becomes pregnant by her Pakistani boyfriend. Dunbar's adaptation of another of her plays, *Rita* has a place within British social realist cinema for its authentic portrait of class divide in Thatcher's Britain and its groundbreakingly-frank, non-judgemental depiction of teenage sexuality.

 Rita has a contentious place within the oeuvre of its director Alan Clarke. During the 1970s and 1980s, Clarke made a series of highly-regarded television films, often on the theme of male violence, and some of the work he produced in the years before

Cast:

George Costigan
Siobhan Finneran
Michelle Holmes
Willie Ross

Year:

1986

his early death in 1990, such as the short film *Elephant* (1989), is notable for a radical experimentation with narrative form. *Rita* tends to be regarded as a more mainstream, and hence slighter, film, with the director's authorial stamp confined to his use of long-take tracking shots following Rita (Siobhan Finneran) and Sue (Michelle Holmes) as they stride confidently through their estate, their school and – in one amusing deviation – the cobbled streets of genteel Haworth, home of the Brontë sisters.

The film's relationship to the realist tradition is complicated. A quick summary of the plot suggests, not entirely fairly, a film about the sexual exploitation of teenagers, and a bleak state-of-the-nation film about an area blighted by alcoholism, unemployment and racial tension. Although its gaze is unflinching, *Rita* has a buoyant quality that matches the youthful guile of its two lead

Rita, Sue and Bob Too!, Film 4/Umbrella/British Screen/The Kobal Collection.

characters. They stand in direct contrast to the film's male charac-
ters, notably Bob (George Costigan) and Aslam (Kulvinder Ghir),
who are immature, needy and redundant, and to the coarse self-
importance of the socially-ambitious Michelle (Lesley Sharp). In one
of his most committed and memorable performances, Willie Ross
plays Sue's permanently inebriated father as a grotesque parody of
emasculation and physical decline.

A giddy, carnivalesque musical score – which includes, appropri-
ately, 'House of Fun' by Madness – emphasizes the film's height-
ened realism. One highlight is the club scene performance by
Black Lace, a tasteless 1980s' novelty band, that inspires the cast
to conga suggestively to a song about 'having a gang bang'. Such
scenes push the film towards the realm of the sex comedy, one of
British cinema's least respected genres, but its satirical, ambiva-
lent take on northern working-class culture points towards the
comic social realism that would be exploited in later years by Paul
Abbott's Channel 4 television series *Shameless* (various directors,
2004–)

For all *Rita*'s popularity, a dark shadow is cast across it by the
tragically early deaths of both its director and writer. Clarke died
of cancer in 1990 aged 54, and Dunbar died the same year at the
age of just 29, after collapsing in the pub featured in the open-
ing sequence of *Rita*. Dunbar's life on the Buttershaw Estate was
depicted in an avant-garde, community-based documentary in
2010, also entitled *The Arbor*. *Rita* grants its characters an upbeat
ending that was denied to those in the original play, the residents
of its increasingly-deprived council estate setting, or to Clarke and
Dunbar themselves.

James Leggott

Naked

Studio:
Channel 4
Umbrella
British Screen/Fine Line

Director:
Mike Leigh

Producer:
Simon Channing-Williams

Screenwriter:
Mike Leigh

Cinematographer:
Dick Pope

Synopsis

When a sexual encounter with a young woman in an alley turns
into an assault, Johnny, a drifter from Manchester, flees to London
and tracks down an ex-girlfriend, Louise. While crashing at her
house, Johnny seduces Louise's flatmate Sophie before leaving
both women and taking to the streets of nocturnal London. After a
series of philosophical and even confrontational encounters with a
motley array of individuals who are as desperate or disenfranchised
as himself, Johnny returns to Louise and Sophie only to discover
that their sinister yuppie landlord Jeremy has imposed his presence
on the women.

Critique

After the 'kitchen sink' dramas of *High Hopes* (1988) and *Life Is
Sweet* (1990), Mike Leigh's follow-up, *Naked*, is defiantly anti-com-
mercial and all the more daring and memorable for it. The opening
scene of rough sex that becomes abusive in a dark alley establishes

Production Designer:
Alison Chitty

Composer:
Andrew Dickson

Editor:
John Gregory

Duration:
131 minutes

Genre:
Social Realism

Cast:
Katrin Cartlidge
David Thewlis
Leslie Sharp
Peter Wight

Year:
1993

the desolate and brutal tone, augmented by Andrew Dickson's moody harp and cello score and Dick Pope's gritty cinematography. *Naked* is not an easy film, and watching some parts of it may feel like the proverbial slap in the face, but a slap that may shock the viewer into an alternate way of seeing things.

David Thewlis' performance as Johnny is a combination of eloquence, nihilism and menacing charisma. As an anti-hero, Johnny is repugnant but he is also capable of great wit and self-awareness. When Louise (Leslie Sharp) asks him, 'Why are you such a bastard?', Johnny replies, 'Monkey see, monkey do.' The audience may not condone Johnny's actions or beliefs, but he is reacting to what he sees as the state of the world: 'Humanity is just a cracked egg.' His machine-gun polemics and prophecies are ignored or dismissed by the people he encounters, except for Brian (Peter Wight), a security guard, who appears to be the only character to connect with Johnny on an intellectual level.

Johnny's character appears almost benign when juxtaposed with the misogynistic Jeremy (Greg Cruttwell) and Archie (Ewen Bremner), a belligerent homeless illiterate. Jeremy is representative of an upper class that is rich enough to get away with verbal and sexual sadism, whereas Johnny and Archie can only rail against society from within their economic and class confines. The treatment of the female characters in *Naked* is highly controversial and the film has been accused of misogyny. But it can be interpreted that such maltreatment is part of the depiction of an abusive and unequal society and that the men are judged for what they do. Subtle and genuine acting from Leslie Sharp, and the late Katrin Cartlidge as Sophie, ensure that the two female leads are more than mere passive victims.

Naked's strongest sequence is when Johnny spends a night on the streets of early 1990s' London that is coming down from the materialistic highs of late Thatcherism. Johnny's intense, philosophical dialogue with Brian, the 'insecurity' guard of an antiseptic modern office building, provides one of the most emotionally caustic and bleak scenes Leigh has filmed. Hopeful about his future, Brian tolerates Johnny's invective and advises him not to 'waste your life'. Flashes of black humour balance out the despair, such as when Johnny assists Archie in his search for his girlfriend 'Maggie', only for their reunion to erupt into a physically abusive argument.

Mike Leigh returned with the less controversial but equally unflinching social realism of *Secrets and Lies* (1996). Comparisons between *Naked* and *In the Company of Men* (Neil Labute, 1997) are invariable due to their common elements of amorality and misogyny, but in its uncompromising candour and examination of dysfunctional characters and relationships, *Naked* shares more with fellow British films *Nil By Mouth* (Gary Oldman, 1997) and *The War Zone* (Tim Roth, 1999).

Eeleen Lee

Billy Elliot

Studio/Distributor:

Tiger Aspect
Working Title
BBC Films/Universal Focus

Director:

Stephen Daldry

Producers:

Greg Brenman
Jonathan Finn

Screenwriter:

Lee Hall

Cinematographer:

Brian Tufano

Production Designer:

Maria Djurkovic

Composer:

Stephen Warbeck

Editor:

John Wilson

Duration:

110 minutes

Genre:

Social Realism

Cast:

Jamie Bell
Jamie Draven
Gary Lewis
Julie Walters

Year:

2000

Synopsis

Billy Elliot is an 11-year-old boy who lives in Durham with his father Jackie, older brother Tony and grandmother, his mother having passed away years before. Like many of the men in Durham, Jackie and Tony are coal miners on strike. But Billy has a passion for dancing and wants to attend ballet lessons, much to his father and brother's embarrassment and disapproval. Billy's dancing talent blossoms despite his family's objections and their poverty. Mrs Wilkinson, the local dance teacher, notices Billy's devotion to ballet and allows him to join her all-girl class. Eventually, Jackie and Tony support Billy's desire to become a ballet dancer when Mrs Wilkinson presents him with a life-changing opportunity to audition for the Royal Ballet School in London.

Critique

Central to *Billy Elliot*'s narrative is the exploration of masculinity in a northern England, working-class context set against the backdrop of the notorious 1980s' miners' strike. When Billy (Jamie Bell) has to attend an all-girl ballet class to realize his ambitions, he struggles against the expectations of his hyper-masculine father and brother. The safe, nurturing, feminine world of ballet shelters him from the difficulties of poverty and violence, and the film juxtaposes the beauty of classical music and ballet with the conflict between the male strikers and riot police. Through ballet, Billy glimpses the bourgeois worlds of his teacher Mrs. Wilkinson (Julie Walters) and the London ballet academy, where he feels so out of place that he hits a boy who shows him kindness. The scene at the ballet academy underscores Billy's position as a universal misfit: in Durham, his artistic sensibilities marginalize him, and in London, he is so out of his element in the opulent surroundings that he is nearly incapable of auditioning. During the audition, when asked when he became interested in ballet, he initially mumbles, 'dunno'. Although dancing is Billy's *raison d'être*, the reason for this is inexplicable; as his father Jackie (Gary Lewis) explains: 'The boy is always dancing, it is his nature, his essence.'

The film's gender politics colour the oedipal conflict between Jackie and Billy. Although Billy attempts to argue against his father, explaining that male ballet dancers are athletic, Jackie refuses to accept Billy for who he is: a dancer. In Billy's words: 'Just because I like ballet doesn't mean I'm a poof.' Or does it?—the film skirts around the issue of Billy's sexuality, which is sublimated into his one true love, ballet, as he rebuffs romantic advances from female and male classmates.

Billy Elliot also traces Jackie's emotional journey from denial to acceptance. Through Billy's determination and transformation, Jackie experiences a catharsis. He nearly destroys himself and all that he stands for by crossing the picket line to earn money for Billy's lessons. Yet in doing so, he openly breaks down.

Billy Elliott, Tiger Aspect Pics/The Kobal Collection/Giles Keyte.

Jackie's breakdown and journey to sensitivity as well as toler-ance makes *Billy Elliot* a male melodrama. Billy becomes Jackie's emotional surrogate, through whom Jackie lives vicariously. When Billy auditions for ballet school, Jackie radiates joy, pride and finds a possibility of redemption despite the bleak outlook for the strik-ing miners.

In *Billy Elliot*, dance transcends poverty, social discord, and darkness – of vision, of mindset and of the coal mine. Ballet itself seems to undergo a gender reversal: while at the start of the film, ballet was the realm of girls, by its closing sequence, ballet is masculine: the dancers are all male and the featured audience members appear almost entirely male as well, including Jackie, Tony (Jamie Draven), Billy's former schoolfriend Michael (Merryn Owen) and Michael's male companion. The homosocial company in which the film closes allows Jackie to accept his son for whom he has become: no longer a boy among girls, he is now a man among men.

Marcelline Block

The Duke of York's Cinema in Brighton.

FILM CULTURE FOCUS
BRITISH ARTHOUSE CINEMAS

Our greatest memories of films most likely involve being in a dark room, surrounded by strangers, staring at a big screen. Cinemas can hold a unique place in the imagination and in our collective memories as places to share emotions. While there are endless studies about the aesthetics, history and nature of film, little attention is paid to the spaces where it is experienced.

In terms of the history and evolution of the cinema sector, the commercialization of film evolved parallel to its evolution as an art form. Films (or rather a programme of shorts, news, animation, local scenes) were originally shown informally in tents, fairgrounds, end-of-pier attractions, 'penny gaffes' (where, for a penny, you could enjoy a picture show), public halls or churches. With the British Cinematograph Act of 1909, new regulations came into effect to improve safety; as film stock was highly flammable, the Act required the provision of a fire-resistant, purpose-built projection booth. This legislation encouraged the spread of purpose-built picture houses and sparked the rush of cinema building before WWI.

As audiences grew, so did the cinemas, with huge picture palaces being built in the years before WWII. The advent of sound only increased the audiences as cinema entered its Golden Age. A wide variety of films were shown, from home-grown British films to German expressionism, American gangster pictures and Fred Astaire musicals. Success was ensured through the vertical integration of production, distribution and exhibition of films by the major US studios that owned every element in the chain. Societal changes after the war meant audiences became more affluent and their leisure patterns evolved, with families spreading to the suburbs, buying cars and spending more time at home with their new modern appliances, including the television.

Simultaneously, new forms of cinema were emerging worldwide after the war: Italian neorealism, the French Nouvelle Vague, the New Hollywood, for example, experimented with new ways of making films. These films arrived in Britain at the same time as a new middle-class audience that wanted more than just generic American product emerged. Cinema began primarily as a working-class leisure pursuit; as the art form evolved the middle and upper classes embraced the medium, but demanded a more specialized product.

Film societies for a 'specialist product' existed since the 1920s, providing a small but steady stream of alternative cinema and, as audience tastes broadened, commercial cinemas began programming foreign and Art films. Festivals also emerged, with the Edinburgh Film Festival established in 1947 as a showcase for such films. Other important developments include the creation of the National Film Theatre (NFT) in London in 1952 and the London Film Festival in 1957. Regional branches of the NFT were established in the 1960s and film societies filled the exhibition gaps where local cinemas had closed.

These developments, then, are the foundations of what is now identified as 'arthouse' cinema. But what is an 'arthouse' film? The UK Film Council defines 'specialised' cinema as follows: 'it is quite broad and related to those films that do not sit easily within a mainstream and highly commercial genre' (UKFC). This includes foreign language films, documentaries and classics, films that lack a specific genre or 'hook', and films that possess a unique narrative or cinematic style. That definition covers everything from *Nosferatu* (Robert Weiner, 1922) to *Waltz With Bashir* (Ari Folman, 2008).

The emergence of the multiplex in the late 1980s re-energized a beleaguered film industry (in 1984 only 54 million Britons purchased cinema tickets), but also consolidated both the arthouse sector and the Hollywood model in Britain. In 2010, the mainstream exhibition sector experienced record audience levels due to the spread of multiplexes and new 3D technology, with films like *Avatar* (James Cameron, 2009) and *Mamma Mia!* (Phyllida Lloyd, 2008) attracting audiences that had stayed away from cinemas for years. Yet the arthouse sector represents just 7 per cent of all tickets sold, struggles to compete with the commercial multiplexes and receives very little public support; foreign language

films accounted for just 3.5 per cent of the box-office in 2008 (*UKFC Statistical Yearbook*). The majority (69 per cent) of specialized and arthouse films are shown in single-screen, independently-owned cinemas. Without them, arthouse film would have no outlet and the sector would shrink even further, cementing the dominance of the Hollywood film culture.

Britain has always attempted to preserve its national cinema industry through legislation, state funding and tax subsidies. The Cinematograph Films Act of 1927 was the first of a series of protectionist policies brought in up until the Thatcher Government in the 1980s, when policy moved towards 'pro-market' incentives such as tax relief for producers (Dickinson and Street 1985). In 2000, New Labour established the UKFC to 'stimulate a competitive, successful and vibrant British film industry and culture, and to promote the widest possible enjoyment and understanding of cinema throughout the nations and regions of the UK' (UKFC website). But in 2011 the UKFC was closed down as part of the 'austerity cuts' imposed by the Tory and Liberal Democrat coalition government. While arguments about the types of films state funding should support have consistently raged between film-makers and policymakers, the issue of supporting the exhibition sector has been tellingly absent from public debate.

While lack of funding and harsh competition are negatively affecting cinemas, digital technology is revolutionizing the film industry on a global scale. From production to projection, film equipment, delivery platforms and formats are constantly changing and the industry is in the process of completely altering its cost models and business practices. In 2006 the UKFC created the Digital Screen Network, which installed publicly-funded digital projectors in 240 British cinemas in exchange for a commitment to show more specialized cinema. Yet multiplexes received over half of the projectors and used them to show 3D Hollywood films, knowing that the threat of removal of equipment was unlikely to occur. This move accelerated the digital switch in Britain, but also left in its wake a gap of about 300 cinemas with no equipment and no capital to invest in it either, threatening their very existence. As of 2008, 73 per cent of British screens are in big chain multiplexes (*UKFC Statistical Yearbook 2008*) and 235 of Britain's 772 cinemas are digitalized (Cinema Exhibitors Association).

Changing viewing patterns, evolving technology, seismic cultural shifts and audience fragmentation are also eroding the monopoly cinemas once had on the exhibition of film. These changes are more complex for independent and arthouse cinemas, and small circuits dedicated to non-mainstream programming. While piracy is the biggest concern for big cinema chains (and the main driver behind 3D, which cannot yet be pirated), this is one area in which the arthouse sector has a distinct advantage over its competitors: by focusing on atmosphere, service, quality and comfort, the arthouse industry can establish a strong market presence. The arthouse cinema customer is less likely to illegally download a film, and more likely to value the social experience of cinemagoing.

What is more, the viewing habits of multiplex cinemas' target audience of 15–24-year-olds are radically changing: this group is more likely to download films for free or choose alternative forms of entertainment. Nonetheless, the major studios and big commercial chains continue to spend all their energies pursuing this demographic. And if global market forces are left to unravel, the potential is for an even more consolidated exhibition sector with further American corporate infiltration of all facets of the industry. This could mean the disappearance of smaller, independently-owned and arthouse cinemas, and it spells trouble for arthouse, independent, British-made, foreign language, documentary and other films.

One of the great success stories of the British arthouse scene has been the Picturehouse cinema chain. With 19 cinemas across Britain, Picturehouse cinemas have managed to create a completely commercial space for arthouse cinemas with little or no public money. Their strategy involves opening in university cities, often in historic buildings that

have been remodelled to fit extra screens and café/bar space, programming a very wide variety of films and adopting keen marketing strategies.

What are the benefits of a vigorous specialized arthouse film sector and a network of venues across Britain? The answer is long and complex but can summarized as follows: arthouse cinemas create spaces for culture, entertainment and creativity; stimulate local economies; inspire local film-makers; and create great opportunities for young people and other vulnerable members of society. An arthouse cinema can be a focal point for a community, providing a platform for debates, social interaction and increased regeneration in deprived areas. Some questions for the future, particularly in the new climate of shrinking public funding and consolidation of the commercial sector: does the public have a responsibility to protect the specialized exhibition sector in the face of market failure? If so, what can the Government do to stimulate and shield the arthouse and independent cinema business from global market forces?

Jon Barrenechea

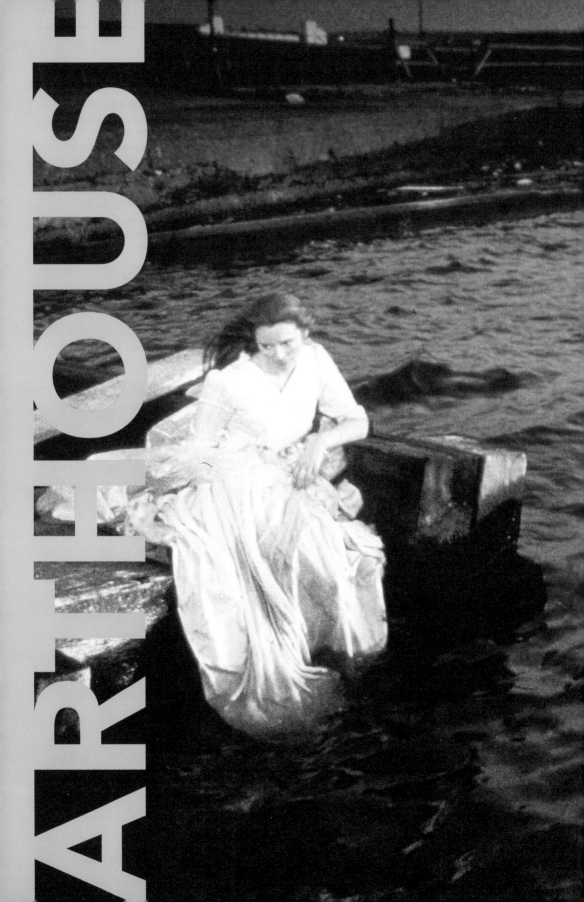

The term 'art cinema' is difficult to define. While it is commonly used to describe any high-minded, serious film set apart from Hollywood-style entertainment, critics have attempted more nuanced definitions. For example, David Bordwell has argued that 'art cinema' is a specific trend in post-war European film typified by movements such as Italian neorealism, the French Nouvelle Vague and New German cinema (Bordwell 2002). Exponents of such movements rejected (to varying degrees) the linear, neatly resolved stories and goal-orientated protagonists of classical narrative cinema (typified by Hollywood) in favour of more complex structures, unresolved endings and ambiguously motivated characters. Furthermore, Bordwell sees self-reflexivity as well as the technical and thematic signatures of auteur film-makers as commonplace in such 'art' films. Steve Neale has argued that 'art cinema' represents an institution within European film culture that has its own systems of funding, production and distribution designed to counter Hollywood dominance. Moreover, he argues that post-war European art cinema has it roots in the interwar period, when film-makers began to align themselves with modernist movements in painting, theatre and literature such as German Expressionism, French Impressionism, Dada and Surrealism (Neale 2002).

In Britain, art cinema, both as an aesthetic form and as an institution, is somewhat harder to locate. Indeed, some British critics have claimed that there has been no real art cinema tradition in their country (see Hill 2000). For example, in the late 1920s and 1930s, when European directors began to engage with modernism and to explore film's artistic possibilities, British cinema's equivalent, the British Documentary Movement, was conversely concerned with exploring film's didactic possibilities and was committed to a realist aesthetic.

The British Documentary Movement, which thrived, in various guises, from the late 1920s until after WWII, perhaps represents Britain's most lasting contribution to world cinema. Its figurehead, the director and producer John Grierson, thought that cinema should be factual and useful. The films Grierson oversaw engaged directly with social problems and often employed non-professional actors, and he is rightly seen as the father of the British Social Realist tradition. While Grierson is also criticized in some corners for his aesthetic conservatism (i.e. Aitkin 1990: 60–62), it is too simplistic to suggest that the British Documentary Movement's commitment to realism came entirely at the expense of experimentation. While he was not always comfortable with their work, Grierson did invite known innovators into his fold, including Alberto Cavalcanti and the pioneering animators Len Lye and Norman McLaren, who provided a direct link with the avant-garde. The experimental and realist facets of the movement come together most effectively in works such as Basil Wright and Henry Watt's *Night Mail* (1936) and Humphrey Jennings' seminal wartime documentary *Listen to Britain* (1942). The former begins as a realist documentary, but its climax rhythmically combines images of a mail train with a poetic voiceover by WH Auden and music by Benjamin Britten, whereas

Jennings' film eschews narration in favour of a 20-minute collage of image, sound and music.

While the influence of the British Documentary Movement can certainly be felt on European post-war developments such as Italian neorealism, as continental art cinema began to move towards realism, Britain ironically rejected it. Between 1945 and 1950, British film-makers including Cavalcanti, Carol Reed, Thorold Dickinson, David Lean and Laurence Olivier produced works that were expressionist or highly Romantic in their sensibilities and often anti-realist. Although they were often underappreciated at the time, the most important British film-makers of this period were unquestionably Michael Powell and Emeric Pressburger. Despite their strong commercial sense, Powell and Pressburger were tireless innovators who viewed cinema as a total art form. The influence of their work has been pervasive, both internationally and in British cinema itself, with Ken Russell going as far as to call their masterpiece, *The Red Shoes* (1948), Britain's first art film (Russell 1993: 34)

Always moving against the tide, British art cinema returned towards realism just as European directors began to reconnect with modernism. In the early-to-mid-1950s young British directors such as Lindsay Anderson, Karel Reisz and Tony Richardson began making short documentaries under the banner of 'Free Cinema', which marked a return to the aesthetics of the British Documentary Movement and Jennings' work in particular. By the end of the decade, spurred on by the success of Jack Clayton's *Room at the Top* (1959) and by the writings of the 'Angry Young Men', the Free Cinema alumni graduated to feature films and morphed into the British New Wave. The films that followed, including Richardson's *Look Back in Anger* (1959) and Reisz's *Saturday Night and Sunday Morning* (1960), amongst others, have been both praised as British cinema's equivalents to the Nouvelle Vague and decried as pale imitations of the same. Peter Wollen, for example, sees the French movement as representing auteur-led, modernist cinema while the British New Wave, despite its use of some modish filmic techniques, remained a writer's cinema with a commitment to realism.

While it is not uncommon to believe that the only true British art films of the 1960s were directed by expatriates such as Michelangelo Antonioni, Roman Polanski and the blacklisted American, Joseph Losey, Britain did produce notable film-makers whose work should be viewed squarely within the European art film tradition. For example, Peter Watkins and Ken Russell made some of the most aesthetically- and politically-radical British films of the time, albeit for the BBC; Clayton's *The Pumpkin Eater* (1964) bears comparison to Antonioni; Richard Lester's *How I Won the War* (1967) and Anderson's *O, Lucky Man!* (1973) are as radical in their use of Brechtian devices as any film by Jean-Luc Godard; and Nic Roeg and Donald Cammell's *Performance* (1970) brilliantly combined elements of European art cinema and the American Underground with the Hollywood gangster film.

If the mid-1970s were something of a low-point for British art cinema, with directors either overlooked or increasingly reliant on American money, that decade also produced several talented directors working on the margins of the industry. The BFI funded *The Bill Douglas Trilogy* (1973–1978), experimental works by Peter Greenaway, and Chris Petit's cult British road movie *Radio On* (1979). Derek Jarman, previously a painter and set designer, made three important independent features: the homoerotic *Sebastiane* (1976); the punk-inspired *Jubilee* (1977); and an avant-garde adaptation of Shakespeare's *The Tempest* (1979). Although very different in style, form and content, these films indicated that, given the proper support, Britain could indeed produce an art cinema of its own.

Some commentators and practitioners have complained that there was never quite enough support (i.e. Jarman 1984: 234); others have argued that it came at the expense of more important work in television and experimental film (i.e. Caughie 2000: 198). Bodies such as the BFI and later Channel 4 (founded in 1982) and British Screen (often in collaboration with European funding bodies) did attempt to foster a British art cinema

in the European tradition, which, for a short while, following the collapse of mainstream companies such as Goldcrest, became an important part of British film culture.

Indeed, the 1980s can be viewed as the golden age of British art cinema, so much so that Wollen has dubbed it the 'last New Wave' (Wollen 2006). Low-budget, director-led films such as Greenaway's *The Draughtsman's Contract* (1982) – the first BFI/Channel 4 co-production – were commercially and critically successful, and the decade saw important features from Terence Davies, Sally Potter, Ken McMullen and Isaac Julien, as well as a resurgence in the careers of Jarman, Mike Leigh and Ken Loach. Like all European movements, 1980s British art cinema is less a coherent movement than an eclectic group of individuals with disparate styles and agendas whose combined talents nonetheless made for an incredibly rich film culture

By 1993, however, spurred on by the runaway success of *Four Weddings and a Funeral*, British cinema began trying to compete with Hollywood again. Left with even less financial and institutional support, British art cinema was further pushed to the margins and subsequent hopes for a revival have been quickly dashed. Undeniably-talented directors who emerged in the 1990s such as Patrick Keiller, Andrew Kotting, and the Brothers Quay have been unable to sustain careers as feature film-makers. Even well-established names like Greenaway struggled to find funding and concentrated on work in other arts and media. More recent developments give cause for concern: the New Labour government's decision in 2000 to dissolve the BFI Production Board and British Screen into the UKFC, and the appointment of the notoriously anti-intellectual, Hollywood-based Alan Parker as its head, indicated an official attempt to pursue the American market. But the closure in 2011 of the UKFC by the Tory and Liberal Democrat coalition government is an altogether grimmer prospect. While some recent debuts, such as Steve McQueen's *Hunger* (2008) have shown that the potential for innovative British art cinema is still there, others, such as Sam Taylor-Wood's *Nowhere Boy* (2009) are more anonymous and conventional. It remains to be seen what the full impact of digital production and distribution on British art cinema will be in the next decades to come.

Brian Hoyle

If...

Studio/Distributor:
Memorial/Paramount

Director:
Lindsay Anderson

Producers:
Lindsay Anderson
Michael Medwin

Screenwriters:
John Howlett
David Sherwin

Production Designer:
Joceyln Herbert

Cinematographer:
Miroslav Ondricek

Composer:
Marc Wilkinson

Editor:
David Gladwell

Duration:
107 minutes

Genre:
Art

Cast:
Malcolm McDowell
Christine Noonan
Richard Warwick
David Wood

Year:
1968

Synopsis

If... pulls back the curtain on the British public school in the late 1960s. Following the daily lives of the first-years right up to the school Whips, it picks apart the traditions, friendships, fights, punishments and rituals of this very British institution. Three rebellious boys, headed up by Mick Travis, drink, mock and push against the system that is trying to form them. But the school and the institution will not accept such insolence; there are clashes with the Whips and punishments to try to bring them back in line. Stumbling across a stash of guns and grenades, the boys take to the roof of the school to strike back.

Critique

An uprising is in full flow. A student stands astride a school rooftop, grasping a machine gun. This is a striking image – all the more so because it happened during France's 1968 student riots which started two months before *If...* went into production. That a similar scene plays out underlines the deftness of Anderson's success in capturing and pre-empting the unrest of the time. Very much a *Clockwork Orange* proto-Droog, Malcolm McDowell's Travis' ruthless retort to this crushing institution is perhaps nothing more than a surreal 'if...', but it caught the rebellious mood of the late 1960s. Its counter-cultural message captured young people's mood for change as well as deepening criticisms of the class system, of British institutions, and of authority around the world.

Ostensibly charting the goings-on at a public school, the film unsettlingly shifts in tone and from colour to black and white to suggest some deeper change is emerging. Anderson admitted that budgetary restraints meant he had to shoot one scene in black and white, and he was so pleased with the result he decided to use it again. But, collectively, these shifts in colour heighten the film's increasingly surreal touches and its historical and cultural symbolism.

If... is an important film and something of a sacred cow, satirizing stuffy traditions and skewering the class system, all the while pushing the boundaries of what cinema can achieve. While its themes and messages remain relevant, the problems of class and the stifling nature of tradition now seem somewhat more oblique and diffuse, which makes it interesting as a snapshot of a cultural moment. Its depictions of daily school life remain contemporary; Anderson did not want to recreate the upper-class public schools of *Tom Brown's School Days*; he wanted the film to have, in his words, 'larger implications than the surface realities might suggest'. *If...* is a bold and striking attempt to mix social realism and rebellion against the conservatism of the day.

Adam Richmond

A Clockwork Orange

Studio/Distributor:
Warner Bros/Columbia-Warner

Director:
Stanley Kubrick

Producer:
Stanley Kubrick

Screenwriter:
Stanley Kubrick

Cinematographer:
John Alcott

Production Designers:
John Barry

Composer:
Walter Carlos

Editor:
Bill Butler

Duration:
131 minutes

Genre:
Art

Cast:
Malcolm McDowell
Patrick Magee
James Marcus
Warren Clarke

Year:
1971

Synopsis

Alex DeLarge spends his nights in the company of his 'Droogs' – a gang of juvenile delinquents who 'entertain' themselves with terrifying acts of 'ultra-violence': they attack an elderly tramp, beat and maim a writer, rape a woman and attempt to burgle a home containing an extravagant collection of erotic art. When the last of these 'entertainments' goes horribly wrong, Alex murders his victim just as the police arrive. He is sentenced to fourteen years' imprisonment, but volunteers for a treatment programme to secure an early release. Alex's treatment is a form of aversion therapy: pumped full of drugs, which cause feelings of panic and nausea, he is straitjacketed, strapped into a cinema seat and forced to watch extremely violent films. Upon his release, Alex discovers, at the hands of his former friends and victims, what it is like to become a victim of such brutality.

Critique

Stanley Kubrick's film-making is renowned for bleakness of emotional content and the corresponding clinical detachment of technique. This can be seen, for example, in the disturbing humour of *Lolita* (1961), the stark cynicism of *Dr Strangelove* (1963), the cosmic perspective of *2001: A Space Odyssey* (1968), the numbing horror of *The Shining* (1980), the casual brutality of *Full Metal Jacket* (1987) and the existential banality of *Eyes Wide Shut* (1999). *A Clockwork Orange* epitomizes and examines this perspective, and might be considered the most typical and reflective of Kubrick's films. From Alex's (Malcolm McDowell) empty-eyed stare into the camera in the opening scenes, through Kubrick's repeated use of static long-shots (which keep camera movement and reverse shots to a minimum, thereby maintaining emotional distance), to the austere surrealism of its production design, the visual style of the film signifies moral disconnectedness in the dysfunctional society it portrays and fixates upon moral alienation. When Alex rapes a woman in front of her husband, he sings Gene Kelly's 'Singin' in the Rain' – a grotesque counterpointing of action and music that recalls Kubrick's use of Vera Lynn's 'We'll Meet Again' as the bombs started to fall at the end of *Dr Strangelove*, and anticipates the blackly comic use of 'Stuck in the Middle with You' in the torture scene in Quentin Tarantino's *Reservoir Dogs* (1992).

This rupture between aesthetic and moral contexts that is central to Kubrick's film – perhaps to all his films – comes to haunt Alex DeLarge. The vicious hooligan is a devotee of the works of Beethoven, yet the aversion therapy designed to cure him of violence inadvertently fosters in his unconscious mind an incongruous and nauseating association between Beethoven's Ninth Symphony and Hitler's concentration camps. Such music was actually played over the tannoys in the Nazi death camps, and Kubrick's film reminds the audience that aesthetic and moral values do not always correspond. Similarly, an erotic sculpture becomes an implement for murder; Alex

A Clockwork Orange, Warner Bros/The Kobal Collection.

interprets the Bible as a collection of lascivious and gory vignettes; and cinema becomes both a cause of the violence of an anarchic underclass and a tool for the violence of an oppressive state.

A Clockwork Orange is Kubrick's re-imagining of Anthony Burgess' 1962 novel of the same name. The novel's warning against the moral estrangement of contemporary culture is transformed in Kubrick's adaptation into an icon of that estrangement. The film has even been linked with a number of so-called copycat crimes, most notoriously in 1972 when a schoolboy murdered a tramp and when rapists reportedly sang 'Singin' in the Rain' as they attacked a woman. These crimes and the resulting media furore testify to the enduring and disturbing relevance of the film's central message, its urgent anxiety over the hypocrisy of a society and a cinema which, in condemning the moral and emotional emptiness of its subjects, at the same time exploits and exhibits that very emptiness. Kubrick's work has been criticized for its moral and emotional detachment, but in *A Clockwork Orange* that detachment is the film's very subject, and therefore the key to its insight.

Alec Charles

Nighthawks

Studio/Distributor:

Four Corners
Nashburgh/Cinegate

Director:

Ron Peck

Producers:

Paul Hallam
Rob Peck

Screenwriters:

Paul Hallam
Ron Peck

Cinematographer:

Johanna Davis

Production Designers:

Back Streets
Jan Sendor

Composer:

David Graham Ellis

Editors:

Mary Pat Leece
Richard Taylor

Duration:

113 minutes

Genre:

Art/Social Realism

Cast:

Maureen Dolan
Rachel Nicholas James
Ken Robertson
Tony Westrope

Year:

1978

Synopsis

Jim is an exemplary geography teacher at a London secondary school whose sexual preference is an open secret to most except his parents and his pupils. Outside the classroom, Jim photographs a grim and distressed London, whilst at night he cruises gay clubs looking for 'Mr Right'. He begins a friendship with Judy, the new supply teacher, who is intrigued by his seemingly free and independent lifestyle. Successions of men come into Jim's life for a time and then disappear or simply fade away. The only stability he has is his work and friendship with Judy, and his impatience and desperation become increasingly apparent. When a confrontation with students causes Jim to make a big decision, it does not have the liberating impact he anticipated.

Critique

Nighthawks was Britain's first explicitly gay film that chronicled life for a single gay man in London at that time. Not only an important film in terms of its style and content, it is an authentic picture of London before Thatcherism, and of the gay scene before HIV/AIDS and after Stonewall. Previously, gay characters' sexuality was the origin of a problem, as in *Victim* (Basil Dearden, 1961), or treated as a peripheral matter, as in Tony Richardson's *A Taste of Honey* (1961) or Robert Aldrich's *The Killing of Sister George* (1968). *Nighthawks* made a clean break from previously camp representations of gay men on film. Though controversial upon its release, for its frank nudity and use of actual locations frequented by gay men, the film opened at the 1978 Edinburgh Film Festival and had some commercial success.

Paul Hallam and Ron Peck's grainy realism offers a fly-on-the-wall perspective of Jim's (Ken Robertson) life that can feel at times like an all-too-intimate intrusion. The lingering nature of some scenes, the abrupt ending of others, and the use of extraordinarily long takes and close-ups either alienate or enthral. A five-minute, slow, camera tracking shot from a club dance floor to Jim's hungry eyes show what it is like to cruise and be cruised. Peck has said that the real-time duration of some scenes bestowed a tension that both the actor and audience had to move through until the very end.

Robertson leads a mixed cast of actors and non-actors (including the director-artist Derek Jarman) such that some of the performances are amateurish whilst others capture the awkwardness of one-night stands and rendezvous. The inquisitive Judy (Rachel Nicholas James) is a stand-in for the straight 1970s' viewer as she interviews Jim about what life is like for a gay man, asking: 'What do you do in these bars? What are they like?'

The film's pacing and shifting between Jim's cramped flat, cruising spaces, conversations with Judy and the morning after the most recent conquest underscore the cyclical, mundane nature of his life. But how different is Jim's life from his straight colleague's life or even the viewer's? Work, socialize, try to find someone to be happy with, repeat. It is on this point that *Nighthawks* succeeds

supremely. The film's leisurely pacing works toward a crucial scene with Jim's students, and its aftermath that upends expectations for the film's climax. Narrative pleasure in the resolution is withheld from the audience and pleasures of transformation and resolution are withheld from Jim, as the film situates him almost in the place where he started. Though not a polished film, *Nighthawks* is a demystifying time-capsule that says much about the life of gay men in 1970s' London. It is also a testament to the vibrancy and do-it-yourself nature of independent film-making during the era.

Deirdre Devers

Radio On

Studio/Distributor:

BFI
Road Movies Filmproduktion
GmbH/Unifilms

Director:

Christopher Petit

Producer:

Keith Griffiths

Screenwriter:

Christopher Petit

Cinematographer:

Martin Schäfer

Production Designer:

Susannah Buxton

Editor:

Anthony Sloman

Duration:

104 minutes

Genre:

Art

Cast:

David Beames
Andrew Byatt
Lisa Kreuzer
Sandy Ratcliff

Year:

1979

Synopsis

Bristol, the late seventies. The German version of David Bowie's 'Heroes' plays on on a radio by a bath in which a man lies dead. Next morning in London, his brother Robert, a somewhat anomic factory DJ in the midst of a break-up with his girlfriend, is told the news by phone. Robert leaves London by motorway but travels to Bristol by country roads, meeting an army deserter from Northern Ireland and, near the site of the singer's death on the A4, a young man obsessed with Eddie Cochran. In Bristol, Robert finds his brother's girlfriend; neither was aware the other existed.

Robert falls in with two German women, one of whom, an English-speaker, is looking for her absconding husband and daughter. Suspecting his brother was involved in an illegal pornography ring, Robert helps her – though the search, like their brief encounter, is inconclusive. He spends another night in his brother's flat before drifting out into the city. After some drinks he drives to a quarry, gets stuck, and leaves his car there with Kraftwerk's 'Ohm Sweet Ohm' playing on the tape deck. Later he catches a train, destination unknown.

Critique

Ever since its première at the 1979 Edinburgh Film Festival, *Radio On* has been treated as a one-off, a 'film without a cinema' existing outside what its tyro writer–director Chris Petit saw as the prevailing social realist tradition of British cinema, 'strangled by class'. While it shuns character, narrative, and politics as normally construed, Petit's film establishes a relationship with the 'Angry Young Man' cycle begun two decades prior by the very strength of these negations. Like Lindsay Anderson's *O Lucky Man!* (1973) it is a road movie, but one systematically denuded of social commentary.

Not that the distance between Anderson's cohort and the generation of young German directors Petit looked up to should be overstated. Discussing *Radio On*, Petit has often quoted a famous line from his mentor Wim Wenders's film *Kings of the Road* (1976):

'The Americans have colonised our subconscious.' Jimmy Porter, the original Angry Young Man protagonist of John Osborne's 1956 play *Look Back In Anger*, similarly wondered if 'perhaps all our children will be Americans.' Addressing different concerns from different angles, Petit's film is as much a 'state of the nation' film as anything in Anderson's oeuvre.

Petit's successors at *Time Out*, where he had been film editor, wrote at the time that his debut 'represents that turning point away from the hopes of the '60s', a mood established by its protagonist's withdrawal (he is the anti-Jimmy Porter, a DJ where Jimmy was a jazzman); by its extraordinary soundtrack; and above all by its textural attentiveness to interiors and landscapes, urban, rural, and coastal. *Radio On* is a prime example of what Manny Farber in a *Film Comment* essay called 'the Seventies dispersed movie' (1977: 47), a phenomenon straddling the Atlantic that eschewed the 'big statement' for 'lower-case observations'. The opening sequence, likely inspired by Antonioni's road movie *The Passenger* (1975), explores the inside of a flat in a single snaking shot, seemingly indifferent to the dead man in the bathroom. The film reaches an early epiphany with a sequence that evokes novelist JG Ballard's early 1970s' trilogy of *Crash*, *Concrete Island* and *High Rise*, both in its imagery – Robert driving over the Westway, tower blocks glinting in the winter sun, and by its soundtrack – David Bowie's 'Always Crashing in the Same Car'.

While there is no plot to speak of, no great transformation, Petit loosens up a little as Robert heads west. For a film that begins with a suicide, contains prominent references to the Northern Irish Troubles, and is suffused with melancholy, there is a kind of humour to *Radio On* that is often missed by latter-day admirers, who have tended to want it to do exactly what Petit did not – make a big statement on the Thatcher era, dawning just when it was shot. It is the narrowness of Robert's failure to make connections that makes the film interesting and, in its way, hopeful.

Henry K Miller

The Draughtsman's Contract

Studio/Distributor:
BFI, Channel 4/BFI

Director:
Peter Greenaway

Synopsis

It is 1694 and Mrs Herbert, the wife of a wealthy landowner, has commissioned Mr Neville, a talented but arrogant draughtsman with social aspirations, to draw twelve elevations of her husband's country estate to mark his birthday. Neville is initially reluctant but agrees when an unusual deal, the contract of the title, is struck. In it, Mrs Herbert agrees to have sexual relations with Mr Neville each day in return for the drawings. But Mr Herbert, believed to be away on business, is found dead in the moat. Mrs Herbert's daughter, Mrs Talmann, who has a loveless and childless marriage to an impotent German aristocrat, draws up a similar contract with Mr Neville in the hope of conceiving a son to inherit her mother's

Producers:

David Payne

Peter Sainsbury

Screenwriter:

Peter Greenaway

Cinematographer:

Curtis Clark

Production Designer:

Bob Ringwood

Composer:

Michael Nyman

Editor:

John Wilson

Duration:

104 minutes

estate. Mr Neville soon begins to wonder if he has unwittingly recorded evidence of the murder in his drawings.

Critique

The Draughtsman's Contract is one of the most auspicious and distinctive feature debuts in British film, and a key work in the establishment of an auteur-led British art cinema in the 1980s. It was the first co-production between the BFI and the then newly-founded Channel 4, who would continue to co-fund important low-budget British films for the remainder of the decade. It was also a genuine sleeper. The enigmatic narrative, country-house setting, elaborate costume design, the late seventeenth-century decoration, arcane dialogue, and Michael Nyman's Purcell-inspired score all combined to capture the popular imagination of the time.

The film, which marked Greenaway's first engagement with anything resembling a conventional narrative, and his first significant use of professional actors, at first seemed rather incongruous with his previous work. Greenaway, who trained as a painter and film

The Draughtsman's Contract, BFI/United Artists/The Kobal Collection.

Genre:

Art

Cast:

Neil Cunningham
Anthony Higgins
Anne Louise Lambert
Janet Suzman

Year:

1982

editor, had established a modest reputation for a series of highly idiosyncratic and increasingly ambitious experimental films made in the late 1970s, such as structural film parody *Vertical Features Remake* (1978) and epic mock-documentary *The Falls* (1980). However, many of the attributes that made these early films so distinctive, such as the erudite, if rather pedantic wordplay, constant allusions to other works of art, and the deadpan black humour, were in fact carried over into this feature film.

Greenaway's conception of *The Draughtsman's Contract* was at first rather more experimental. His initial cut ran close to four hours and featured parallel narratives involving the household servants and a human statue. However, the producer, Peter Sainsbury, encouraged him to remove over half of this material and produce a comparatively straightforward, more commercially-viable film. While many of Greenaway's subsequent features conform to this two-hour model and have a classical three-act structure, a more eccentric organizing principle, such as the alphabet in *A Zed and Two Noughts* (1985) and sequential numbers in *Drowning by Numbers* (1988), often betrays his roots in the avant-garde.

While many of the recurring concerns of Greenway's work are present in *The Draughtsman's Contract*, including the self-reflexive equation of painting with cinema, and intertextual references to other films (including *Blow Up*, Michelangelo Antonioni, 1966, and *Last Year at Marienbad*, Alain Resnais, 1961), Greenaway's style is not yet fully formed. Whereas the films from *A Zed and Two Noughts* onwards were shot in 35mm and combine elaborate tracking shots with meticulous lighting reminiscent of the Dutch Masters, *The Draughtsman's Contract* was shot on 16mm, with the camera often locked off using predominantly available light. Nevertheless, it is visually striking in a way that belies its humble £200,000 budget.

Although the film was generally a commercial and critical success, it was far from universally liked. Many film-makers working at the more avant-garde end of British cinema reacted harshly against the film's excess of narrative and overtly literary qualities, criticizing the BFI and Sainsbury's move towards more commercially-viable features. The mainstream, however, damned it as pretentious, too clever, and an example of 'the emperor's new clothes'. However, British cinema has always had an anti-intellectual bias and it should come as little surprise that Greenaway has always enjoyed a far greater reputation in Europe.

Brian Hoyle

The Gold Diggers

Studio/Distributor:
BFI/Channel 4

Director:
Sally Potter

Producers:
Nita Amy, Donna Grey

Screenwriters:
Lindsay Cooper
Rose English
Sally Potter

Cinematographer:
Babette Mangolte

Production Designer:
Rose English

Composer:
Lindsay Cooper

Editor:
Sally Potter

Duration:
86 minutes

Genre:
Art

Cast:
Julie Christie
David Gale
Colette Laffont
Jacky Lansly
Hilary Westlake

Year:
1983

Synopsis

The Gold Diggers is a challenging and existential inquiry whose spiralling narrative is partially set against the Icelandic tundra. Ruby and Celeste undertake the quest to solve a riddle that takes them on a metaphysical journey referencing the history of cinema that mocks and rejects female performers as well as spectators. Ruby and Celeste confront and resist the patriarchy which pervades each intersecting layer of the film: women are silenced, excluded, oppressed, traumatized, and victimized by the institutionalization of male power and, as a result, have internalized misogyny. Although Ruby and Celeste are hampered by male bosses, 'experts,' audience members, dance partners, and a silent mob of men following them, together, the female characters flee their oppressors, escaping via horseback to an awaiting boat being repaired by a female welder.

Critique

The Gold Diggers, Sally Potter's first 35mm feature film, explores 'the connections between gold, money and women…looking at childhood and memory and seeing the history of cinema itself as our collective memory of how we see ourselves and how we as women are seen' (Potter 1984; 2009, 9). In depicting women within the patriarchal world that oppresses, rejects and circulates women as objects whose worth is determined by their outward appearances, the film launches its female protagonists on a quest to resolve the riddle spoken at the outset of the film, first by Ruby (Julie Christie), then by Celeste (Colette Laffont):

'I am born in a beam of light/I move continuously yet I'm still/I'm larger than life/Yet do not breathe/Only in the darkness am I visible/You can see me but never touch me/I can speak to you but never hear you/You know me intimately, and I/know you not at all/We are strangers, and yet/You take me inside of you/What am I?'

Ruby and Celeste investigate how cinema and capitalism – systems of production that have systematically excluded women – have effaced women's histories/the history of women from the dominant patriarchal culture's narrative. In Celeste's words, 'I was born a genius. That is a fact. I knew what was what, right from the start. Then it was taken away. I am concerned with redressing the balance. Are you reconciled with your own history? Do you know what it is?' For Ruby: 'I remember very little. Because I've been kept in the dark. Those were the conditions. The necessary conditions for my existence' – as a woman and as a film icon, thus (re)incarnating, (re)appropriating and subverting Christie's image as 'the accepted representation of femininity in the cinema…glamour and blondness and beauty' (Potter 1984; 2009, 17). Ruby's traumatic working through and recovery of her repressed early memories – represented by her childhood self digging in the dirt – is collapsed with her onstage performance, allowing for her return to the maternal body and psyche.

The film explores female loss – of self, identity, history, memory, ability (Lansly's Tap Dancer forgets her well-rehearsed steps when objectified by the collective gaze of the male audience) – and the (im)possibility of recuperating what has been 'taken' from women: subjecthood, subjectivity, pleasure. In the opening song, 'Seeing Red', written and sung by Potter herself, male interruption of female *jouissance* is incessant and violent: 'Went to the pictures for a break/Thought I'd put my feet up…/But then, a man with a gun came in through the door,/And when he killed her, I couldn't take it anymore/Please, please, please give me back my pleasure'. '"Seeing Red" sets up the classical role of women in film and shows how inadequately it fulfils the needs of the female spectator… Potter…intends to provide…pleasure for the female spectator that does not involve the death of the woman (à la Hitchcock's *Psycho*, 1960) or her submission to the will of the hero or the demands of the narrative' (Fowler 2008: 47–48). Although *The Gold Diggers* was poorly received – labelled 'pure torture' when reviewed in *The New York Times* – it remains one of the most important documents of women's cinema, as it enacts 'a female gest which overcomes the history of men' (Deleuze 1989:196).

Marcelline Block

The Last of England

Studio/Distributor:
Anglo International
British Screen
Channel 4/Blue Dolphin

Director:
Derek Jarman

Producers:
Don Boyd
James Mackay

Screenwriter:
Derek Jarman

Cinematographers:
Cerith Wyn Evans
Richard Heslop
Christopher Hughes
Derek Jarman

Production Designer:
Christopher Hobbs

Synopsis

Not so much a story as a series of images; the director sits at his desk, writing and working on a collage using black tar and bullets. In a rubble-strewn wasteland, a young punk shoots up with heroin and tramples and defiles a reproduction of Caravaggio's painting *Profane Love*, while another throws rocks into a pool. Soldiers in balaclavas round up refugees at gunpoint and one rapes another man on the Union Jack. An androgynous figure dances. The Queen inspects her troops. A man and a woman get married. The man is captured and executed by the soldiers. The bride, mourning his death, tears at her wedding dress with a pair of shears and dances wildly around a fire. Refugees leave in an image that recalls Ford Madox Brown's painting, *The Last of England*. Intercut with these sequences are home movies of Jarman's childhood, in faded colour, shot by the director's father. Throughout, the actor Nigel Terry reads Jarman's poetic voiceover in an official-sounding BBC 'RP' accent.

Critique

Although Derek Jarman made some films, such as *The Tempest* (1979) and *Caravaggio* (1986), that are reasonably conventional in shape and form, several of his works blur the usually clear distinction between art cinema and the avant-garde. *The Last of England* is certainly one of these. For example, it was entirely shot on lightweight, hand-held Super8 cameras (later blown up to 35mm).

Composer:

Simon Fisher Turner

Editors:

Peter Cartwright
Angus Cook
John Maybury
Sally Yeadon

Duration:

87 minutes

Genre:

Art

Cast:

Spencer Leigh
Tilda Swinton
Nigel Terry

Year:

1987

The cheapness of this 'amateur' equipment meant that Jarman and his collaborators could afford to shoot a large amount of footage and work without the fully-developed script required by most producers.

Although it is loose in structure, there is some narrative shape, which began to develop as shooting and editing progressed, most notably, the shots of Jarman working at his desk imply that the film depicts his vision. This links *The Last of England* to the avant-garde tradition of the 'trauma film', typified by Maya Deren's *Meshes of the Afternoon* (1943) and Kenneth Anger's *Fireworks* (1947) in which the film-makers appear to dream the narrative. However, while these earlier films were shorts, Jarman's is feature length, again complicating the division between underground and more commercial modes of art cinema.

The film is also aesthetically distinctive. Jarman was liberated by the mobility and freedom the Super8 cameras offered after what he saw as the rigid formality of shooting *Caravaggio* entirely in 35mm. Visually, the two films are as different as day and night. *Caravaggio* is comprised almost entirely of carefully-lit static tableaux, whereas *The Last of England* is constantly moving. Furthermore, Jarman thought that the grainy image and diffused colour of Super8 footage blown up to 35mm had a uniquely 'painterly' quality.

The Last of England differed greatly from Jarman's previous Super8 feature, *The Angelic Conversation* (1985). Where the earlier film was lyrical and languidly paced, *The Last of England* is aggressive both in content and form. In the hiatus between *The Tempest* and *Caravaggio*, Jarman directed several music videos and this experience clearly influenced the film: the 'disco' sequence contains no less than 1600 cuts and this rapid editing, combined with the constant camera movement and changes of film speed can put the viewer on edge.

While the film's anger is partly directed at Thatcherism, the Falklands war and the Royal Wedding, it remains a personal rather than a political statement. Indeed, its bleak tone owes much to Jarman's discovery during post-production that he was HIV-positive. *The Last of England* is a key film in Jarman's career, and his subsequent works, though varied in form, often overtly engaged with the cause of gay rights. Despite its highly personal nature, the work has been influential: it helped establish the aesthetic of the modern music video and remains a central film in the development of New Queer Cinema, with directors including Gus Van Sant and Michael Almereyda noting their admiration of it.

Brian Hoyle

Distant Voices, Still Lives

Studio/Distributor:
BFI
Channel 4/BFI

Director:
Terence Davies

Producers:
Jennifer Howarth
Colin McCabe

Screenwriter:
Terence Davies

Cinematographers:
William Diver
Patrick Duval

Production Designer:
Miki Van Zwanenberg

Editor:
William Diver

Duration:
85 minutes

Genre:
Art

Cast:
Freda Dowie
Angela Walsh
Pete Postlethwaite
Dean Williams

Year:
1988

Synopsis

Two related stories combine to depict the lives of the Davies, a working-class Catholic family in Liverpool, from WWII to the mid-1950s. Three siblings, Eileen, Masie and Tony and their mother, suffer the violent abuse of the family patriarch, Tommy Davies, who casts a shadow over their lives even after his death. The characters re-enact key events in the family's life, including weddings, a christening and Tommy's funeral as well as their memories of domestic abuse as well as of happier times.

Critique

If the first two parts of Terence Davies early autobiographical trilogy – *Children* (1976) and *Madonna and Child* (1980) – are recognizably rooted in the social realist tradition and perhaps betray the influence of Bill Douglas (who briefly taught Davies at the national film school in the late 1970s), the final part, *Death and Transfiguration* (1983), revealed the emergence of an utterly distinctive voice. In that short film, Davies demonstrated great narrative economy, cutting between events in an entirely non-linear fashion and eliding many events or reducing them to snippets of sound heard in voice-over. This voice grew to maturity in *Distant Voices, Still Lives*, which must stand as one of the truly great films about memory. The work is fragmented and the structure, which according to Davies follows an 'emotional logic', can at first be difficult to follow. However, it is self-consciously designed to reflect the disjointed way in which people remember. Davies also described the film as a mosaic, a film made up of tiny fragments that do not reveal a complete picture until one stands back from it and looks at it as a whole.

As in *Death and Transfiguration*, the use of sound and music is particularly rigorous, and reveals Davies to be the most original of all modern British film-makers in this respect. The soundtrack combines fragments of conversation with resonant sounds such as the BBC radio shipping forecast, which opens the film like an incantation, and pre-existing music, most often popular songs of the time, which underscore the images. While many songs are heard non-diegetically, Davies also has his cast perform songs *a cappella*, both alone and in groups. Indeed, music is so prevalent in the film that one critic called the film 'the first social-realist musical'. However, whether he uses music ironically, as he does Eddie Calvert's recording of 'O Mein Papa', or with total sincerity, as in Maisie's rendition of 'My Yiddisher Mama', Davies always manages to sidestep sensationalism and empty nostalgia.

Visually, the film is also a notable achievement. In order to recreate the rather drab colours Davies' remembers from his childhood, he employed the bleach bypass process to the negative. This, coupled with a very controlled use of camera movement, gives the entire film the appearance of a series of slightly-faded photographs. Indeed, the film has been likened to

Distant Voices, Still Lives, BFI/Channel 4/ZDF/The Kobal Collection.

leafing through a family photo album, and the narrative concentrates on birthdays, christenings and holidays. It was criticized in some critical corners for getting stuck between British social realism and European art cinema and not being sufficiently one or the other. Many critics, however, view it as a seminal British film that successfully reconciles these two strands of film-making: the former in its subject matter and milieu, the latter in its modernist structure.

Although the film is described as autobiographical, Davies in fact writes himself and several other brothers and sisters out of the film to concentrate on the collective memories of his mother and three eldest siblings. His follow-up, *The Long Day Closes* (1992) focused more directly on his own childhood and features an even more fractured and impressionistic narrative than its predecessor, and an equally more rigorous use of music and sounds, often taken from Davies' favourite childhood films.

Brian Hoyle

DOCUMENTARY

British documentary properly began with Scottish film-maker John Grierson and his 1929 film *Drifters*. Although documentary (or 'actuality') films were made from the very inception of moving pictures, prior to Grierson they tended to be either very short non-narrative films about nature, science and ordinary life or playful sequences of trick photography showing what the new medium could do with 'reality'. Grierson not only coined the term 'documentary' in a review of Robert Flaherty's 1926 film *Moana*, saying 'it has documentary value', but his film *Drifters* was the first British feature-length narrative 'documentary'.

In 1930 Grierson joined the Empire Marketing Board – a governmental agency to promote trade and British culture – and moved away from directing. He became the administrator, producer, recruiter, publicist and philosopher of the British documentary movement, and his influence lasted for many years. Grierson's views on the responsibilities of documentary to inform and educate coincided with, and bear many similarities to, those of John Reith, the first Director General of the BBC; in his 'manifesto' for documentary, Grierson wrote: 'I look on the cinema as a pulpit, and use it as a propagandist' (Grierson 1933: 119).

In 1933, the Empire Marketing Board became the General Post Office (GPO) Film Unit. Grierson left in 1937, but the GPO Film Unit, under Alberto Cavalcanti, went on to make many important films on many aspects of British cultural and social life, including *Song of Ceylon* (Basil Wright, 1935), *Housing Problems* (Edgar Anstey, Arthur Elton, Ruby Grierson and John Taylor, 1935), *Night Mail* (Basil Wright and Harry Watt, 1936), *Coal Face* (Alberto Cavalcanti, 1936) and *Spare Time* (Humphrey Jennings, 1939).

With the onset of WWII, the GPO Film Unit became the Crown Film Unit under the control of the Ministry of Information. It was charged with making propaganda films to aid the war effort, including the feature-length, dramatized documentary *Target For Tonight* (Harry Watt, 1941). In his 1942 film *Listen To Britain*, Humphrey Jennings introduced experimental narrative techniques, such as a non-linear structure, montage sequences and complex sound mixes, to create a poetic evocation of the country at war. In the aftermath of the war, the Crown Film Unit concerned itself with preparing Britain for peace and reconstruction, as well as articulating a continuing need to provide social cohesion and common values.

In 1956, a group of young film-makers, critics and technicians – principally, Karel Reisz, Lindsay Anderson, John Fletcher and Tony Richardson – founded the British Free Cinema movement. They derived their name from a series of programmes at the National Film Theatre where Reisz was an event programmer. These budding film-makers, struggling to get their films shown in the commercial circuits, decided to use the series to publicize themselves. They gave themselves the name 'Free Cinema' to indicate that, in contrast to the previous 30 years of state-sponsored documentary film production, these films were produced outside the usual constraints of government funding and control and were therefore free to be radical, personal and adventurous. However, they also shared a lot of common values and beliefs concerning the documentary

Left: *Touching The Void*, Film 4/Pathé/The Kobal Collection.

and took for inspiration more the lyricism, cultural focus and style of Jennings' project of 'an anthropology of our own people' rather than Grierson's observational purity. The approach was summed up in the Free Cinema Manifesto as 'conscious informality' in which 'no film can be too personal', and where they affirmed their 'belief in freedom, the importance of people and the significance of the everyday'.

Of course, the appearance of Free Cinema coincided with similar developments else-where – Direct Cinema in America, Cinema Vérité in France (which differed in its ideas as to how far it was possible to be purely objective), and the emergence of the French New Wave. The development of technology in the post-war period was a significant factor in the subjects of these films as well as the look of them. Faster film stock meant that shoot-ing at night-time and with better quality was possible; more flexible and sophisticated sound equipment and lighter cameras meant that shooting on location captured the real-ity as it happened. Karel Reisz's *We Are The Lambeth Boys* (1959), about a south London Youth Club, was the first documentary to have synchronized sound outside of the studio setting. The subjects of these films tended to be on aspects of British working-class life or on the beginnings of 'youth culture' – *Moma Don't Allow* (Tony Richardson, 1956), about a north London jazz club; *Everyday Except Christmas* (Lindsay Anderson, 1957), a portrait of twelve hours in the life of Covent Garden vegetable market; and *The Saturday Men* (John Fletcher, 1962), about West Bromwich Albion football club. British Free Cinema – with its assertion that 'an attitude means a style, a style means an attitude' – disbanded in 1959 as many of its key practitioners went on to make the social realist feature films in the decade of the 'Angry Young Man'.

For a variety of reasons, many of the most important contributions to documentary since the sixties have occurred within the television industry or have been enabled by it through funding arrangements. Developments in technology, changes in the funding of documentary projects, as well as other social factors such as the introduction of domes-tic television, have always played a significant yet often unrecognized part in the ways in which documentary in any particular country has evolved. Whilst in America, the new technologies and new attitudes which constituted Direct Cinema – what one would call 'observational' or, more loosely, 'fly-on-the-wall' – enjoyed a healthy cinema existence; in Britain this 'movement' existed almost exclusively within the television industry. This was in part because these extended, ambitious documentaries with enormous shooting ratios could only exist as part of a television schedule – Michael Apted's *Up* series (1964–), for example, follows the life stories of its participants in films produced every seven years of their lives. Equally, Paul Watson's *The Family* (1974), which also ushered in the term 'docusoap', Roger Graef's *Police* (1982) and Molly Dineen's portrait of Spice Girl Geri Halliwell in *Geri* (1999) are also significant in continuing to use the form to study our-selves and the institutions that constitute our social fabric. Similarly, the relentless political and investigative work of John Pilger (*Year Zero: The Silent Death of Cambodia*, 1979) and Philip Donnellan's impressionistic essay portraits of marginalized aspects of British society (*The Colony,*1964, about the West Indian immigrant experience; *The Irishmen*, 1965, about Irish construction workers and *Where Do We Go From Here?*, 1969, about the often-shameful treatment of traditional travelling communities) continued to develop the form and use it educate and inform. The polemical, personal and provocative work of Adam Curtis, such as *The Power of Nightmares* (2004) or *All Watched Over By Machines of Loving Grace* (2011), are other examples of the ways in which television has provided an environment and catalyst for the development of the genre.

This period was also notable for the production of documentaries brought about by the establishment of film and video collectives. These collectives – Black Audio Film Collec-tive, Amber Films, Cinema Action, Sheffield Film Co-Op amongst a great many others – produced documentary films in a variety of styles on issues that continue to articulate immediate political issues – gender, race, class and regional identity. Similarly, since Peter

Watkins' films of the mid-sixties – *Culloden* (1964) and *The War Game* (1966) – offered radical news ways of representing 'truth' and 'reality', the 'drama-documentary' has become a significant if contentious addition or contribution to the genre. Whilst many television and film dramas (*Hill Street Blues*,1981; *Blair Witch Project*, 1999, for example), were using documentary 'signatures' – wobbly hand-held shots, jump-editing and grainy footage to suggest 'reality' – the drama-documentary used drama and fiction techniques tell a story which, they would argue, could not be told in any other way. The most significant and powerful of these would include *Hillsborough* (Charles McDougall and Jimmy McGovern, 1996), *Touching The Void* (Kevin MacDonald, 2003), *The Government Inspector* (Peter Kosminsky, 2005) and the more recent work of Nick Broomfield.

It is clear that the documentary is an evolving and adaptable form, which might be described as one long experiment in capturing or portraying reality and truth for a variety of purposes. Recent examples of the form – *Bodysong* (Simon Pummell, 2003), *Erasing David* (David Bond, 2009), *Content* (Chris Petit, 2010) – suggest ways in which it might develop further to utilize both old new ideas of narrative and truth whilst experimenting with the potentials of new technologies of production and consumption.

Alan Clarke

Drifters

Studio/Distributor:

Empire Marketing Board
New Era/British International

Director:

John Grierson

Producer:

John Grierson

Cinematographer:

Basil Emmott

Editor:

John Grierson

Duration:

49 minutes

Genre:

Documentary

Year:

1929

Synopsis

A crew of herring fishermen leave their village and set sail for the North Sea fishing grounds. Fishermen prepare the nets, carry out maintenance work and get some much-needed sleep. The following day, in the midst of a storm, the men heroically fight the weather and haul in the catch. They sail back to the village and unload the fish, which is then sorted, gutted and made ready for sale at home. A boat leaves the harbour with the freshly prepared catch heading for markets elsewhere.

Critique

Drifters was the first British narrative documentary film ever made, and the only substantial film John Grierson himself ever directed. It is important to remember that the film was made only twelve years after the Russian Revolution and eleven years after the end of WWI. Despite its narrative simplicity – fishermen go to work, catch fish and come home – *Drifters* is a complex film in terms of its political, cultural and aesthetic significance.

Both the American prospector and film-maker, Robert Flaherty – the 'father' of documentary cinema – and Sergei Eisenstein, the Soviet film-maker and theoretician of 'montage' editing, heavily influenced Grierson. *Drifters* was released only seven years after the very first narrative documentary, Flaherty's *Nanook of the North* (1922), and was premiered at a private viewing in London alongside Eisenstein's *The Battleship Potemkin* (1925), which itself was banned from general release in Britain until 1954. These two films provide social and cultural frameworks not only for Grierson's sole directorial credit but also for his influence on, and vision for, the British documentary movement.

Grierson believed passionately in the social function of documentary cinema to solve problems, promote social cohesion and educate the people of an advanced industrial society. Although there is some evidence to suggest that he cynically chose the herring-fishing industry as the subject of his film because of an important government official's interest in that particular industry – thereby securing government funding for documentary film production – *Drifters* is a profound, important and very serious film.

From Flaherty, Grierson took the idea of people struggling in hostile environments to survive and to maintain traditional ways of life. From Eisenstein he took the idea of 'montage' – the assembling of shot sequences to produce compressed and intense narrative and intellectual experiences – along with Eisenstein's portrayals of heroic, if ordinary, people. Whilst *Drifters* clearly contains these elements, it is different from both of them; it is a particularly British film produced through the lens of Grierson's own beliefs and experiences.

The herring fishing industry, according to an introductory title card, was once 'an idyll of brown sails and village harbours, its story is now an epic of steel and steam'. Here, Grierson is clearly

encouraging the audience to see these ordinary working lives as a traditional way of life threatened by a new age of international commerce and industrial modernity. Whilst the film emphasizes, even celebrates, the machinery of the trawler's engine, and the heroic collective efforts of the crew in bringing home the catch in the face of hostile weather, the final sequence of fish being prepared for markets both at home and abroad is clearly intended to provide an important reminder of the contexts of these lives, as well as an indication of the nature of a changing industry.

Alan Clarke

Night Mail

Studio/Distributor:
GPO Film Unit
Associated British Film
Distributors

Directors:
Harry Watt
Basil Wright

Producers:
John Grierson (uncredited)
Harry Watt
Basil Wright

Screenwriters:
Basil Wright
WH Auden (verse)

Cinematographers:
Jonah Jones
HE 'Chick' Fowle

Composer:
Benjamin Britten

Editors:
Alberto Cavalcanti
RQ McNaughton
Basil Wright

Duration:
23 minutes

Genre:
Documentary

Synopsis

The 8.30pm 'travelling post office' leaves Euston station for Aberdeen. By the use of trackside nets, packages are picked up and dropped off without the train having to stop. At Crewe, the hub of the Midlands rail network, the train deposits and takes on hundreds of mailbags from all over England and Wales, and crew and engine are changed over. The delay of a connecting train almost disrupts the schedule. As the journey continues through the industrial north, the men working on board sort the mail and organize the drops and pickups. As the train passes into Scotland, the soundtrack gives way to verse by WH Auden, accompanied by music by Benjamin Britten.

Critique

Best described as a group effort on the part of John Grierson's GPO Film Unit – its credits are a matter of contention – *Night Mail* debuted as part of the opening festivities of the Cambridge Arts Theatre, built by John Maynard Keynes, on 4 February 1936. In the subsequent issue of TS Eliot's *Criterion*, the critic Desmond Hawkins wrote that 'with the development of the "documentary" the highbrows have begun an attempt to organise an independent cinema in which "policy" is not hostile to the director's purpose'. *Night Mail*, then, is closely bound up with the question not only of the British intelligentsia's recognition of cinema as an art form, but also of its direct involvement therein, almost unthinkable just a decade before. Critic and poet William Empson, a friend of the documentarists Basil Wright and Humphrey Jennings, classified the British documentary as 'Covert Pastoral', '"about" but not "by" or "for"'.

 Night Mail had to fulfil a bureaucratic commission, and contains a certain amount of educational or, as it were, 'documentary' material, particularly in its narration. Yet the film exceeded its remit, becoming a poetic meditation on the collective life of the nation – even before WH Auden and Benjamin Britten conjure up, as Ernest Lindgren (1948: 151) put it, 'one of those moments of departure from photographic truth' towards the journey's end. Early scenes

Night Mail, GPO Film Unit/The Kobal Collection.

Cast:
Workers of the Travelling Post
Office and LMS Railway

Year:
1936

establish the intricate human organization that makes possible the overnight postal service, brought to a head during the suspenseful changeover sequence at Crewe. Respectful of the mail and railway workers' labours, *Night Mail* pays tribute to the working class – not often the subject of cinematic representation at the time – more generally. There is a lump-in-the-throat bit of narration as the train passes by 'the mines of Wigan…the steelworks of Warrington… and the machine shops of Preston.'

'None will hear the postman's knock without a quickening of the heart / For who can bear to feel himself forgotten?' So ends Auden's verse, and the film, with a universalizing flourish. Yet, despite these affinities, all are not equal. While the night mail – and society at large – operates as a collective enterprise, it is not run as one. By providing a harmonious picture of British society in the mid-1930s, *Night Mail* could be seen as an exercise in mystification. Auden, just two weeks after the film's première, asked 'whether an artist can ever deal more than superficially with characters outside his own class, and most British documentary directors are upper middle'. But Empson had gone a troubling stop further, doubting if it were ever possible for the artist to be 'at one with any public'.

Henry K Miller

A Diary for Timothy

Studio/Distributor:
Crown Film Unit/Ministry of Information

Director:
Humphrey Jennings

Producer:
Basil Wright

Screenwriter:
EM Forster

Cinematographer:
Fred Gammage

Composer:
Richard Addinsell

Editor:
Alan Osbiston

Duration:
40 minutes

Genre:
Documentary

Cast:
John Gielgud
Dame Myra Hess
Michael Redgrave

Year:
1945

Synopsis

A fictional baby, Timothy James Jenkins, is born on the 3 September 1944. A diary of his life surveys Britain as it nears the end of WWII, showing the devastation the war has brought but also the social, cultural and personal recovery under way. The diary introduces symbolic characters – including Peter, an injured spitfire pilot, Goronwy, a Welsh miner and Alan a farmer – as well as symbolic events – Myra Hess performing a Beethoven sonata, John Gielgud performing *Hamlet*, celebrations on the eve of 1945, the clearance of landmines from beaches, the search for bodies in bombed buildings and a radio broadcast announcing the Russian Offensive. The images are guided by a voice-over written by EM Forster and narrated by Michael Redgrave.

Critique

Produced under the auspices of the Crown Film Unit (previously The GPO Film Unit and before that The Empire Marketing Board), *A Diary for Timothy* is a sophisticated, experimental and highly manipulative piece of wartime propaganda – although this was a label Jennings himself disputed. The film uses a narrative 'device' of a diary for an imaginary baby to encourage and strengthen national unity, common heritage and common values as the country moved towards the end of the war and into peacetime. In a sense, baby Timothy represents the hopes, fears and potentials of Britain's future.

Jennings used a similar strategy in an earlier film, *Fires Were Started* (1943), which portrayed the work of the Auxiliary Fire Service during the London Blitz through the eyes of a fictional new recruit. The effect of this radical and, strictly speaking, non-realistic technique is to encourage in the viewer a connection with the subject on an emotional and personal level rather than an objective or informational one. Jennings had little time for the idea of 'pure realism' or objective documentary as practised under Grierson. He was quite dismissive of the self-imposed limitations and lack of ambition he believed characterized state-sponsored British documentary at that time. Perhaps this is not surprising: Jennings had ambitions, both personal and artistic, that led to repeated clashes with orthodoxy. He read English at Cambridge University where he had been involved in both a magazine devoted to experimental literature and in avant-garde theatre set design. He had also been part of the organizing committee for the 1936 International Surrealist Exhibition and was an accomplished Surrealist painter himself. He also set up the 'Mass Observation' project with the sociologist Tom Harrison, with its stated aim to provide 'an anthropology of our own people', a 'science of ourselves'.

A Diary for Timothy brings together Jennings' ideas about art, documentary, culture, heritage and Britain. It is a lyrical, poetic and impressionistic film that uses intricate patterns of sights and sounds, multiple narratives and montage to evoke ideas of peace

and reconstruction as well as war. In the context of the development of British documentary, it is difficult to over-state how revolutionary and transformative *A Diary for Timothy* was. Whilst elsewhere in Europe documentary had embraced the formal experimentation of the Modernist movements (particularly Dziga Vertov's 1929 *Man With A Movie Camera*), British documentary, as initiated under Grierson, was founded on the principles of 'pure documentary', 'social realism' and 'objectivity'. The idea that documentary could depend on 'showing' and not 'telling', and could appeal to emotion and not reason, employ fictional devices and characters, be poetic, lyrical and impressionistic suggested exciting and radical future developments of the documentary form, its uses and its subjects.

Alan Clarke

We Are The Lambeth Boys

Studio/Distributor:
Graphic/J Arthur Rank
Director:
Karel Reisz
Producer:
Leon Clore
Cinematographer:
Walter Lassally
Composer:
John Dankworth
Editor:
John Fletcher
Duration:
52 minutes
Genre:
Documentary
Cast:
Members of Alford House Youth Club in Kennington
Year:
1959

Synopsis

A youth club convenes every evening in a London school and a succession of scenes depict different individuals reacting to different types of activity, such as dancing, gossiping, playing sport, and discussing the hot topics of the day. These glimpses create a portrait of the working-class teenager in the 1950s as they experience the transition from school to working lives.

Critique

We Are The Lambeth Boys is deceptively contemporary, foregrounding the docu-soap with its cast of characters, fixed location, passages of entertaining observation and guiding voice-over commentary. One can image how this film might have been made under John Grierson's control, with pre-scripted exchanges, or through Jennings' self-consciously painterly framing. *We Are The Lambeth Boys* cuts through the dense apparatus of earlier British documentary to deliver a modernist promise: technology can show what life is really like. Its feeling of contemporaneity is both significant and misleading. Its significance lies in the successful use of the newly-emerging image and sound-capture technologies of the time, namely 16mm film and quarter-inch tape. The commentary may seem stilted at times, however the crystal audio clarity and intimacy of the group discussions laid the foundations for the *vérité* style of documentary still produced for television today.

However, easy comparisons with observation-lite contemporary documentary mask much of the film's true significance. Its aesthetic context lies not only in the emergence of lighter and more flexible recording technology, but also in its identity as exemplar of the 'Free Cinema' movement which sought to uncover the areas of national life left untouched by the British film industry. *Lambeth Boys* contains many key tropes of both the Free Cinema movement and the later British New Wave. Director Karel Reisz, along

We Are The Lambeth Boys, Graphic Film/The Kobal Collection.

with Tony Richardson and Lindsay Anderson, was a central figure of both Free Cinema and the British New Wave. *Lambeth Boys'* jazz-based soundtrack by Johnny Dankworth is redolent of the soundtracks for British social realist classics such as *Look Back in Anger* and *The Loneliness of the Long Distance Runner* (Tony Richardson, 1959; 1962). The lives and topics under examination are indubitably social realist; the class system, the education system, the grind of daily urban work routines, the promise and frustration of youth.

However, when compared to other Free Cinema examples, *Lambeth Boys* exhibits less of a cutting social edge than its peers. A cricket match scene between working class and public school boys, whilst comparable with the cross country race in *The Loneliness of the Long Distance Runner*, has more than a touch of the St Trinian's about it. The scenes in which school hymn singing is inter-cut with images of workplace boredom lack the anger of similar use of hymnal in *If...* (Lindsay Anderson, 1968). The muted close, whilst suggesting that the teenagers' futures may not be as promising

as they hope, exudes a conformist calm that is a corrective to the teddyboy 'youth' stereotype of the time. *Lambeth Boys* chooses reportage over the social comment of Anderson's *O Dreamland* (1956), or the visual expressionism of *Refuge England* (Robert Vas, 1959) and, in so doing, provides a bridge between the public aims of Griersonian documentary, and the dominant voice of British television documentary for decades to come.

Dafydd Sills-Jones

The War Game

Studio/Distributor:
BBC

Director:
Peter Watkins

Producer:
Peter Watkins

Screenwriter:
Peter Watkins

Cinematographers:
Peter Bartlett
Peter Suschitzky

Production Designers:
Tony Cornell
Anne Davey

Editor:
Michael Bradsell

Duration:
48 minutes

Genre:
Documentary

Cast:
Michael Aspel
Peter Graham
Kathy Staff
Peter Watkins

Year:
1966

Synopsis

Following an invasion of South Vietnam by China, confrontation has moved to the then-divided Germany and spiralled out of control. The two world superpowers – America and the Soviet Union – engage in a limited nuclear war. Britain's preparations for the attack (based on actual government documents) mean the forced evacuation of civilians, attempted fortifications of homes and stockpiling food and other necessities. A Soviet missile, aimed at Heathrow airport, misses its target and lands in Rochester, Kent. After the blast and ensuing fire-storm, the devastation caused by radiation sickness, blindness, trauma and burns becomes horribly apparent: corpses are burnt in mass graves, there are food riots and looters are executed by firing squads. Society and its laws disintegrate.

Critique

One of the most controversial films ever made, and banned by the BBC for 20 years, *The War Game* nonetheless won the 1966 Oscar for Best Documentary Feature. The most surprising part of this is that the 'events' depicted never took place, and consequently the label 'documentary' is contentious, to say the least.

The War Game belongs to the category of 'drama-documentary' in which some or all of the events shown are based on fact or reality which has been recorded and verified in some way; the 'look' is of a documentary with voice-overs, hand-held cameras, address to camera, absence of soundtrack music and so on but, most importantly, the events are dramatized or reconstructed. If the purpose of documentary is to convey or investigate some aspect of reality – itself a problematic idea – drama-documentary exists to tell the same story in a different way. It is often more accessible and entertaining, but also more emotional and manipulative. Drama-documentary film-makers might argue that they are deploying alternative means of accessing the truth, and that there is simply no other way to tell that truth. Of course, this raises the important issue of trust between film-maker and audience.

Before *The War Game*, the idea of reconstructing past events in documentary was already well-established, although the practice caused consternation among some documentary purists. And Watkins' earlier film, *Culloden* (1964), a reconstruction of the infamous

1746 battle between Scottish and English armies, was shot in the style of a documentary or news event. However, the reconstruction of possible future events was another matter entirely.

When John Grierson described documentary as 'the creative treatment of actuality', he could not have foreseen a film such as *The War Game*. Yet the 'actuality' of the film is meticulously based on fact and reality. Watkins spent months researching scientific reports on the known and projected effects of nuclear attack, government briefings, and emergency services' planning assessments for social breakdown, including the role of the army in controlling civil unrest and in dealing with mass fatalities. Non-professional actors were used to give an added sense of reality and, while their dialogue was improvised, it was based on recorded eye–witness testimonies, including that of children, to the fire-bombing of Dresden and the nuclear attacks on Hiroshima and Nagasaki.

The War Game was produced at the height of Cold War nuclear paranoia, five years after the erection of the Berlin Wall and three years after the Cuban Missile Crisis. The BBC planned to broadcast the film on the twentieth anniversary of the Hiroshima bombing, but cancelled their schedule. They subsequently banned the film until 1985, when it only had a limited cinema release. Following the banning which, according to Watkins, was the result of governmental political pressure on the BBC, he left Britain and has never returned. Because the BBC still owns the rights to the film, Watkins has never made any money from it. He continued to make drama-documentaries on political subjects, such as *La Commune (Paris, 1871)* (1999) a six-hour film about the revolutionary Paris Commune.

Alan Clarke

Handsworth Songs

Studio/Distributor:
Black Audio Film Collective
The Other Cinema

Director:
John Akomfrah

Producer:
Lina Gopaul

Screenplay:
Black Audio Film Collective

Cinematographer:
Sebastian Shah

Synopsis

The events and background of the riots that occurred in the Handsworth area of Birmingham in 1985 are explored through a complex and fluid montage of archived news footage and home movie footage of the riots themselves. Other, more disparate sources, such as 1940s' newsreels and several (often simultaneous) layers of music and sound effects convey the psycho-historical terrain of the riots, and the complex history of race and society in Britain.

Critique

Handsworth Songs was made for Channel 4's *Britain: the Lie of the Land* documentary series and broadcast during the channel's *Eleventh Hour* slot that showcased experimental moving image work between 1982 and 1990. The film represents both a high point in Channel 4's commitment to documentary and narrative innovation and to challenging the implicit bias of existing media

Editors:

Anna Liebschner
Brand Thumin
Hugh Williams

Duration:

61 minutes

Genre:

Documentary

Year:

1986

structures. The film was critically acclaimed and won many awards, including the Grierson Award for best documentary. Its director, John Akomfrah, became a flag bearer for Black British film culture with later films such as *Testament* (1988), *Who Needs A Heart?* (1991), *Seven Songs for Malcolm X* (1993) and, more recently, *Mnemosyne* (2010).

The central question posed by *Handsworth Songs* is voiced early on in the film by a figure speaking within a fragment of news footage: 'Why did the riots occur in 1985?' This is just the first in a series of questions the film explores as it seeks to penetrate the corporate news industry's mediation and representation of the disturbances. As another voice within the documentary puts it: 'There are no stories in the riots, only the ghosts of stories.' By representing the cultural contexts and histories at stake in the Birmingham conflict, *Handsworth Songs* attempts to give voice to those ghosts, and to counter narrow journalistic narratives of the riots.

The film does this in several ways but, overall, it does it by challenging the norms of documentary and news discourse. There is no one, single, commanding voice-over: several commentaries are interweaved, some ironically taken from mainstream media, some from poetic sources and 'amateur' reportage, all using different levels of coherence and irony. Different locations and sources are intercut to create meanings of razor-sharp irony, such as the cutting from an entirely white press corps to CCTV cameras, implying a similarity of function.

A key sequence opens the second half of the film, in which a television discussion-panel programme is filmed. This sequence reveals the constructedness, and exclusivity, of the contemporary mass media narratives surrounding the riots. While this device is a staple of documentary, used in such divergent films as DA Pennebaker's *Primary* (1960) and Michael Moore's *Fahrenheit 9/11* (2004), the use of the recorded sound from the programme gallery and various cinematographers lends this passage its observational and revelatory power. This is no metaphor for Noam Chomsky's news filters; this is footage of the news filters at work.

What prevents *Handsworth Songs* from being a merely satirical observation on the mass media's mendacity is surely its soundtrack. Experimentally electronic, it represents the film's most jarring break with orthodox documentary realism, severing the sync between audio track and video track and opening up possibilities for images and sounds to be read against each other. Those readings are often radical and against prevailing media representations, as in the sequence where the hymn 'Jerusalem' is looped, cut, and sampled, with segments alternating between traditionally 'white' choral and brass band versions to reggae versions. This is a re-appropriation of white British cultural icons, but it simultaneously underlines Britain's multiplicity of cultural identities. This is not simply polemic (including the Reggae version of 'Jerusalem' would have achieved that) but is an attempt to challenge prejudice by uncovering and asserting alternative versions of British social history.

Handsworth Songs is still stunningly contemporary in relevance. It expands the representation and discussion of the 1985 riots from

merely 'racial', to discussions of the predicament of immigrant labour in a ruthless global capitalist system that extends back to the days of Empire and slavery, through Windrush, the Toxteth and Brixton race riots and towards the riots that spread across London, Birmingham, Liverpool and Manchester in August 2011.

Dafydd Sills-Jones

London Orbital

Studio/Distributor:
Illuminations
Film4/Channel 4

Directors:
Chris Petit
Iain Sinclair

Producer:
Keith Griffiths

Screenwriters:
Chris Petit
Iain Sinclair

Cinematographers:
Chris Petit
Iain Sinclair

Composer:
William Sinclair

Editor:
Emma Matthews

Duration:
77 minutes

Genre:
Documentary

Cast:
JG Ballard

Year:
2002

Synopsis

Stretching 117 miles, the M25 motorway that encircles Greater London is one of the world's longest orbital roads. Part-polemic, part-essay and part-autobiography, this 'portrait' of the M25 comprises a series of meditations on modern life, memory, time and space as well as a chronicle of a journey. Diverse visual sources, including 'found' images, camcorder footage through a car windscreen, CCTV footage, home movies and split-screen images, merge with a sound collage of telephone conversations, interviews, and an electronic ambient soundtrack mixed over the narration. As he orbits Britain's capital city, the film-maker meets various characters crucial to his understanding of the M25 and its political, psychic and cultural significance, amongst them the artist Rachel Lichtenstein, the film-maker John Sergeant and the novelist JG Ballard; the 'ghosts' of both HG Wells and Bram Stoker are also present.

Critique

Although film-maker Chris Petit and author Iain Sinclair are both credited as writer and director of London Orbital, the film is based on a walk around the M25 that Sinclair undertook in 2002 with KLF founder and artist Bill Drummond, and on the subsequent book of that journey. However, this is much more than simply a film version of either the walk or the book – not least because Petit decided, appropriately enough, to drive around the M25 instead of walking. On one level, London Orbital is literally a 'road movie' – a movie about a road, and on another level it is film about differences – differences between walking and driving, between literature and film, and between videotape and digital filming. Yet the film is also an existential essay and a mosaic of impressions, facts, stories, conspiracies and hidden histories.

While London Orbital is very much a collaboration between Petit and Drummond, who have worked together before on a number of experimental documentary films, and who each claim to have 'curated' their own parts of the film. London Orbital drifts through 'locations whose only ambition is to appear in scene-of-crime photographs', taking in the Bluewater Retail Centre ('Terminal 5 without the airstrip'), the Jewish Cemetery at Waltham Forrest, landfill sites and science parks and encountering marginal characters associated with the road including artists, philosophers, Essex gangsters and drug dealers.

Yet it is perhaps more of an expression of Sinclair's ongoing interests and obsessions. Sinclair is preoccupied with the arcane, obscure, forgotten and occult – both in the literal sense of 'hidden', but also in the suggestion of other realities at work – aspects of the built environment, which have become associated with the 'psycho-geography' movement. Devised in 1955 by the Situationist artist and film-maker Guy Debord, psycho-geography is 'the study of the precise laws and specific effects of the geographical environment, consciously organised or not, on the emotions and behaviour of individuals.' Much of London Orbital – most obviously the walk that inspired it – reworks the psychogeographical practice of the derivé or 'drift' – a purposefully-arbitrary walk taken to sense the unconscious life of the built environment and its influence on people. The practice has recently been revived by psycho-ramblers including the author Will Self and cartoonist Ralph Steadman, and London Orbital is an important text in contemporary psycho-geographical culture.

In that sense, London Orbital partially invites one to understand the M25 as an occult circle around the metropolis that is somehow necessitated by the presence of Carfax Abbey, where Bram Stoker placed Count Dracula's London home (actually in Purfleet), as 'negative space', 'dead time' and as 'no longer a road but a doorway to another dimension'. It is a road that goes precisely nowhere: 'a failed bypass in any surgical sense'. However, the road is also an anti-manifesto for modern life and a towering presence over the film, as is the novelist JG Ballard with his neo-Futurist fascination with cars, speed and concrete and his assertion that 'the future will be boring'.

Furthermore, the metaphor of the road gives Petit and Sinclair a device to discuss the nature of documentary itself, as well as the processes of digital filming and editing. London Orbital is certainly a visionary – even hallucinatory – portrait of a physical, human-made environment but it is also a record of an experience. Despite existing at the fringes of the documentary genre and implicitly challenging some of its fundamental ideas – objectivity, the nature of reality and whether or not it is possible to 'capture' it – London Orbital offers radical new possibilities of subject, substance, technique and technology.

Alan Clarke

Touching the Void

Studio/Distributor:
Film4/Pathé

Synopsis

Two expert climbers, Joe Simpson and Simon Yates, attempt the virgin peak of Siula Grande in the Peruvian Andes, and encounter life-threatening conditions on the descent. After an accident, Joe is left hanging over a snow-encrusted precipice, held in place by a connecting rope around his partner, Simon. With the cliff giving way underneath him, and with no hope of saving Joe, Simon is left

Director:
Kevin McDonald

Producer:
John Smithson

Writer:
Joe Simpson

Cinematographers:
Mike Eley
Keith Partridge

Production Designer:
Patrick Bill

Composer:
Alex Heffes

Editor:
Justine Wright

Duration:
106 minutes

Genre:
Documentary

Cast:
Nicholas Aaron
Brendan Mackey
Joe Simpson
Simon Yates.

Year:
2003

with a terrible choice: sacrifice his friend to save himself, or sacrifice himself and perish together.

Critique

Touching the Void is the documentary version of Joe Simpson's best-selling book of the same name, in which the story of a mountain climbing expedition gone wrong becomes the basis for a meditation on bravery and mortality. The film is a rare foray into theatrical distribution by the British television documentary production company, Darlow Smithson. In an early incarnation the story was envisaged as a thriller vehicle for Tom Cruise, but was taken up by Film4 and Darlow Smithson as a documentary project. It was then planned as one episode in a television series of what its producers called 'modern escape stories', inspired by Frank Marshall's *Alive* (1993), and drawing on the genre of emergency service drama-documentaries such as *999* (BBC, 1992–2003). The film's televisual origin is clear, as are the attempts to transform it into a sensory and cinematic film.

On one hand, *Touching* has what one might expect from a television documentary; talking-head interviews, wedded to reconstruction. Joe Simpson is a talented storyteller – as evidenced by his book and his status as a professional after-dinner speaker – yet the documentarian's skill emerges in the genuine emotional responses elicited from the film's slightly more phlegmatic contributors, Simon Yates and Richard Hawking. The film's documentary credentials are furthered by the visceral realism achieved in the reconstructions due to the unusually atrocious filming conditions encountered in the Alps.

There are obvious attempts to 'cinematize' the documentary – it is carpeted with music, and represents the antithesis of the traditional television documentary in not containing any observational material, nor adhering to a stylistically-austere mode of drama-documentary expression. The choice of director is a clear signal towards cinematic ambition, as Kevin McDonald was previously best known for his Oscar-winning cinematic documentary *One Day In September* (1999), about the Munich Olympics of 1972. McDonald stated that the film was an attempt to show 'something that had never been shown before' and that he wanted to break through the audiences' modern comfort zones and risk-aversion to present a story of real victory over adversity that cuts against the grain of the comfortable pleasures offered by television documentaries. The look of *Touching* takes full advantage of the vast cinematic canvas, and is able to place tiny, but discernible human figures in the sublime nature of ice-bound mountain landscapes. The reconstruction is more ambitious than in televisual documentary; by employing stuntmen, McDonald could show Joe and Simon on the vast canvas of Siula Grande, and not just rely on close-ups of actors in the Alps. In addition, the interviews are conducted using Errol Morris' 'interrotron' technology – a special auto-cue system that allows interviewees to speak directly to camera without losing eye contact with the interviewer, used extensively

in Morris' Oscar-winning cinematic documentary *The Fog Of War* (2003).

Despite its aspiration to cinematic scale, *Touching* is a very personal kind of epic and remains largely a drama-documentary manifestation of 'first-person media'. The interrotron and emotive interviews at its heart reflect the preoccupation in contemporary documentary with the subjective and personal, at the expense of discussion of the political and social.

Dafydd Sills-Jones

The Arbor

Studio/Distributor:
Artangel/Verve

Director:
Clio Barnard

Producer:
Tracy O'Riordan

Cinematographer:
Ole Bratt Birkeland

Production Designer:
Matthew Button

Composer:
Harry Escott
Molly Nyman

Editors:
Nick Fenton
Daniel Goddard

Cast:
Christine Bottomley
George Costigan
Monica Dolan
Manjinder Virk

Duration:
94 minutes

Genre:
Documentary

Year:
2010

Synopsis

Playwright Andrea Dunbar died tragically at the age of 29 when her daughter Lorraine was just ten years old. Andrea's raw and uncompromising plays such as *The Arbor* and *Rita, Sue and Bob Too!* were based on her experiences of growing up in Brafferton Arbor on the Buttershaw Estate, an area in Bradford notorious for poverty, crime and drugs. Barnard returns to Brafferton Arbor to catch up with Andrea's daughter. Lorraine, who is mixed-race, lost control of her life though abuse, depression, alcohol, drugs, prostitution, crime and estrangement from her family. Now aged 29 and at the end of a long prison sentence, she has converted to Islam and changed her name to Samaya Rafiq. She is re-introduced to her mother's plays and private letters to try to understand how, like Andrea, she spiralled out of control. The rest of this troubled family paint an uncomfortable portrait of mother and daughter as equally-troubled women.

Critique

As much a deconstruction of the notion of documentary as a tragic portrait of playwright Andrea Dunbar, her daughter, their family and friends, *The Arbor* is a remarkable and inventive work from artist and film-maker Clio Barnard. Barnard's approach is unique: she conducted interviews with Andrea and Samaya's friends and family, then had actors lip-synch to the recordings; she also staged key scenes of Andrea's plays out in the open on the Buttershaw Estate and simultaneously shows the audience of local people. Showing that the line between perception and reality is continually blurred is a variation on techniques of verbatim theatre and community film-making. This might initially seem gimmicky, but they give the film a vitality and energy often lacking in the constraints of more orthodox documentaries. The actors excel, especially given the requirement for them to stick to the nuances demanded by the interviews. Manjinder Virk is a revelation as Samaya, embodying touching innocence alongside fierce anger about the rejection, exploitation and racism she experienced as 'Andrea Dunbar's daughter'. And there is some canny casting, including a cameo by George Costigan who starred as Bob in Alan Clarke's film version of *Rita, Sue and Bob Too!*

Much of the film works simply because of the heartbreaking and disturbing stories of Andrea, Samaya and their family. Their tragedies seem unending, with Samaya's descent into drugs and abuse being particularly harrowing, yet there is also an indomitable spirit that provides some hope amongst all the bleakness. The interviewees hold differing views on Andrea's work and life – some feeling hard done by, others fiercely proud and protective – which shows how the family and community are still shaken that their personal lives were laid open for the world to see. Andrea's authenticity gave a painful but refreshingly-honest voice to a northern working class silenced by Thatcher's Britain, and she became an unlikely hero of the British cultural elite during the 1980s. Yet archive interviews with Andrea's parents show just how uneasy local people were with her success. Samaya's story ultimately uncovers the anger she felt about her mother's work, especially Andrea's own play *The Arbor* about a teenager trying to cope with being pregnant with a mixed-race baby in a racist community.

Certainly, Barnard's arresting take on documentary informs the film's examination of the discord between fiction and reality. *The Arbor* alludes to many questions: were Andrea's plays true representations of the Buttershaw Estate? Just whose portrait of Andrea or Samaya comes closest to the real women? As in life, these questions are never truly answered. On one level, *The Arbor* is a tragic record of one of Britain's most important playwrights. On another, it is an example of how – even when something makes a virtue of its honesty – truth is always elusive.

Laurence Boyce

Since its earliest appearance in the 1890s in films including *Scotch Reel*, *The Highland Fling*, and *Highland Reel*, Scotland has played three distinct but overlapping roles in world cinema: it has served as a source of inspiration, as a location and as a film industry in its own right. Though these roles might be seen as historically consecutive, their coexistence lies at the heart of contemporary Scottish cinema.

Scotland has inspired film-makers from London and Hollywood long before it could tell its own cinematic tales. Vitagraph, Pathé, Gaumont, Edison Co and others were drawn to Scotland's misty glens and craggy mountains to mine its abundant heritage for historical and literary adaptations. Pragmatically, however, early film-makers constructed mountain, moor and castle in the studios of London, Paris and Los Angeles to conjure up tragic King Macbeth or Sir Walter Scott's romantic hero Lochinvar. Over the first half of the twentieth century the lives of Scotland's historical figures were frequently celebrated. The life of Mary, Queen of Scots was filmed six times, from Albert Capellani in 1910 to John Ford in 1936, and other figures including Bonnie Prince Charlie, Robert Burns and David Livingstone, whose African exploits had been portrayed four times by 1939, proved popular. Literary Scottish figures such as Sir Walter Scott's Rob Roy also proved popular; Alan Breck, the redoubtable Jacobite hero of Scott's novel *Kidnapped*, for example, appeared in multiple incarnations, as did JM Barrie's *The Little Minister*.

From the 1930s onwards Scotland became a popular location for visiting film-makers, while domestic production nurtured an embryonic film-making infrastructure. By the 1930s, leading film-makers had begun to explore Scotland's potential for more contemporary stories. Michael Powell and Emeric Pressburger filmed Scotland several times – exploring industrial strife on the River Clyde in *Red Ensign* (1934) as well as the evacuation of St. Kilda in *Edge Of The World* (1937), espionage in *The Spy In Black* (1939) and highland romance in *I Know Where I'm Going* (1945). Alfred Hitchcock explored a shadowier Scotland in his adaptation of John Buchan's spy thriller, *The 39 Steps* (1935).

After WWII, a less romanticized view of Scotland emerged in adaptations of plays by Robert McLeish's *The Gorbals Story* (1950) and James Bridie's *You're Only Young Twice* (1952). Throughout the post-war era, Scottish novels also proved fruitful, with screen adaptations of books such as Eric Linklater's *Laxdale Hall*, Compton MacKenzie's *Whisky Galore!* and *Rockets Galore!*, James Kenaway's *Tunes of Glory*, and, of course, Muriel Spark's *The Prime Of Miss Jean Brodie*. The 'misty glen' did reappear in Vincente Minnelli's 1954 reworking of the Broadway musical *Brigadoon*, though the maverick Peter Watkins' 1964 version of the tragedy of Culloden put the event in a new light.

In *The Ghost Goes West* (1936) Rene Clair had deployed one of the most enduring tropes of Scottish cinema – the rich outsider, typically American, attempting to settle in or buy a piece of the land. Variations on this theme include *Trouble In The Glen* (Herbert Wilcox, 1954), *The Maggie* (Alexander Mackendirck, 1954), *Let's Be Happy* (Henry Levin, 1957) and *Local Hero* (Bill Forsyth, 1983). More recent international film visitors include France's Bertrand Tavernier

(*Deathwatch*, 1979), Denmark's Lars Von Trier (*Breaking The Waves*, 1996), India's Karan Johar (*Kuch, Kuch, Hota, Hai*, 1998) and Englishman Ken Loach's 'Scottish quartet' of *Carla's Song* (1996), *My Name Is Joe* (1998), *Sweet Sixteen* (2002) and *Ae Fond Kiss* (2004). Such visiting film-makers have made good use of Scottish material and talent and have expanded cinematic representations of Scotland. However, their very success helps to obscure the underlying fragility of Scotland's indigenous industry.

Scotland has aspired to its own national cinema with a regular output of films sustained by, though not limited to, Scottish roots. Indigenous Scottish film-making was given its first significant boost in the 1930s by 'father of the documentary' John Grierson and 'Films of Scotland'. Leading the way with his own *Drifters* (1929), Grierson encouraged his acolytes throughout the 1930s to pursue Scottish stories and settings. They responded enthusiastically with films like Basil Wright's *O'er Hill And Dale* (1930) and Scotsman Harry Watt's poetic masterpiece *Night Mail* (1936) and dramatic film, *North Sea* (1938). Originally conceived as a temporary project to provide films for Glasgow's Great Exhibition of 1938, 'Films of Scotland' survived the outbreak of war in 1939 to become a Government information tool. Its war-time morale boosters and post-war paeans to modernity – the coming of hydro-electricity in the Highlands (*Rivers at Work*, Lew Davidson, 1958) or New Towns for slum-dwellers (*Cumbernauld: Town For Tomorrow*, Robin Crichton, 1970) – left an important legacy for film-makers who became the vanguard of a movement to build a 'real' Scottish film industry. Their aspirations were driven by frustration at the limits of sponsored documentaries, even if one – Hilary Harris' *Seawards the Great Ships*, 1961 – had won Scotland its first Oscar (albeit directed by an American). In 1976 they began a campaign to secure public finance for features, encouraged by growing nationalist feeling that led to the country's first (if unsuccessful) devolution referendum in 1979.

Meanwhile, the first three major voices of contemporary Scottish cinema had found their own way to be heard. Supported by the BFI in London, Bill Douglas had already, in *My Childhood* (1972) and *My Ain Folk* (1973), powerfully evoked his emotionally-repressed 1940s childhood in the coal mining community of Newcraighall near Edinburgh. *My Way Home*, the final part of this mesmerizing trilogy, was completed in 1978.

In 1979, Bill Forsyth began his first feature film, *That Sinking Feeling*, using little more than his savings and the support of film-maker friends. That film deftly satirizes 1970s' deindustrialization, while *Gregory's Girl*, his 1980 classic, sympathetically sent up the Scottish adolescent male. In 1983 Forsyth made perhaps his finest film, *Local Hero*, produced by David Puttnam and featuring Burt Lancaster as a Texan oil millionaire – another visitor charmed by a Highland coastal paradise where, once again, the vices of modern capitalism are trumped by the virtues of fidelity to land and community. Another voice of 1979 was John MacKenzie's, following up his 1975 cinematic television play *Just Another Saturday* with *Just a Boy's Game* and a feature-length adaptation of killer-turned-artist Jimmy Boyle's autobiography, *A Sense Of Freedom*. Forsyth's sardonic humour was echoed in writer-turned-director Charlie Gormley's *Living Apart Together* (1983) and *Heavenly Pursuits* (1985).

By the early 1990s, Gilles Mackinnon made his feature debut *Small Faces* (1996), an energetic portrayal of Glasgow's gang culture and the possibility of escaping it through art, and he seemed the remaining Scot with an international career in prospect. Caton-Jones returned briefly to Scotland for the United Artists-backed 1995 version of *Rob Roy*, developed by local producer Peter Broughan from expatriate Scot Alan Sharpe's screenplay. 1995 also saw *Shallow Grave*, the debut feature of English theatre-director Danny Boyle, Glasgow-born producer Andrew MacDonald (grandson of Emeric Pressburger) and Scottish screenwriter John Hodge. Taking over £5m at the British Box-office on a budget of £1m, *Shallow Grave*'s success fuelled optimism about the nascent Scottish film industry which the trio's second film, the infamous *Trainspotting* (1996), did nothing to dispel. An iconic film of modern Scotland, *Trainspotting* propelled Boyle, MacGregor, Hodge and

its two Scottish stars, Ewan MacGregor and Ewen Bremner, to international fame. But it could do little to bolster the Scottish industry since its profits largely accrued elsewhere. The later 1990s saw more sustained production, with notable films including John Madden's tale of Queen Victoria's secret love in *Mrs Brown* (1997), Gilles Mackinnon's version of Pat Barker's WWI novel *Regeneration* (1997) and the debuts of Paul McQuigan (*Acid House Trilogy*, 1999) Peter Mullan (*Orphans*, 1999), and Lynne Ramsay (*Ratcatcher*, 1999). With Glaswegian screenwriter Paul Laverty, Ken Loach made ther first two of his Scottish-quintet of social realist films, *Carla's Song* (1997) and *My Name Is Joe* (1998).

Assisted by Scottish Screen, a new agency established in 1997, and by £3m annually of Lottery Funds, the first decade of the twenty-first century saw output double to six features a year. Following her Cannes prize-winning short, *Small Deaths* (1996), Lynne Ramsay made the critically-acclaimed *Ratcatcher* (1999), a coming-of-age story set against 1970s' industrial unrest in Glasgow. Her second feature adapted Alan Warner's blackly-comic cult novel *Morven Callar* (2002) and Ramsay ended the decade working in America, shooting her BBC Films-backed adaptation of Lionel Shriver's novel *We Need To Talk About Kevin* (2010). The films of David MacKenzie have also had success, and Kenny Glenaan (*Yasmin*, 2004; *Summer*, 2008) seems poised to follow. MacKenzie debuted in 2002 with a low-budget road movie *Last Great Wilderness*, but came to wider attention in 2003 with *Young Adam*, a sensuous adaptation of Alexander Trocchi's 1950s' novel, starring Ewan McGregor and Tilda Swinton. Modest US success helped secure Paramount's backing to adapt Patrick McGrath's novel *Asylum*, earning MacKenzie a Silver Bear in Berlin.

As Scotland opened its first Parliament in 300 years, actor Peter Mullan's directorial debut *Orphans* (1999) attracted critical praise and his first Venice prize. His second feature, *The Magdalene Sisters* (2002), is a harrowing account of institutionalized abuse in Ireland's Catholic Church 'asylums' for 'fallen' women. Though set in Ireland, it was largely filmed in Scotland. It succeeded critically, winning a Golden Lion in Venice and becoming one of Scottish Screen's most commercially successful investments. *Neds* (2010) – which stands for Non-educated Delinquents – saw Mullan revisit the same 1970s-era Glasgow as Ramsay's *Ratcatcher* to examine the same youth gang-culture as MacKinnon's *Small Faces*.

Entering its second century, Scottish Cinema continues to wrestle with what it means to be part of, yet still distinct from, Britain. Enmeshed in a complex political and cultural dynamic, Scotland remains a 'stateless-nation' that shares much in common with its southern neighbour, England, whilst retaining its cultural uniqueness.

Robin MacPherson

Whisky Galore!

Studio/Distributor:
Ealing Studios
General Film Distributors

Director:
Alexander Mackendrick

Producer:
Michael Balcon

Screenwriter:
Compton MacKenzie

Cinematographer:
Gerald Gibbs

Production Designer:
Jim Morahan

Composer:
Ernest Irving

Editor:
Joseph Sterling

Duration:
82 minutes

Genre:
Comedy

Cast:
Jean Cadell
Gordon Jackson
Basil Radford
Bruce Seton

Year:
1949

Synopsis

During WWII, the isolated Scottish island of Todday has a severe drought of whisky. When a ship carrying 50,000 cases of whisky runs aground off the coast of Todday, the hard-drinking islanders seize the opportunity to replenish their stocks. However, they are unbendingly Sabbatical and cannot relieve the ship of its booty because it is a Sunday. This gives the pompous and over-officious English Home Guard captain Paul Wagget time to attempt to protect the cargo. With the tacit assistance of Wagget's second-in-command, Sgt Odd, an Englishman who hopes to marry an islander, the residents raid the ship. They then devise increasingly absurd attempts try to conceal the stolen whisky from Wagget as well as the Customs and Excise officials he eventually assists. The main stash is stored in a local cave but when Wagget seems sure to discover it, the islanders must race to stop him.

Critique

One of the most acclaimed of the classic Ealing comedies, *Whisky Galore!*, for all its rambunctious and ultimately inconsequential comedy, is symptomatic of a desire to create something deeper than entertainment: the film captures, and is fuelled by, anxieties about the erosion of Celtic culture and the threat of encroaching cultural Englishness.

Until the catastrophic whisky drought, the war does not seem to directly trouble Todday; it brings no invasions or air raids. It does, though, bring an extension of English influences, signified by Captain Wagget (Basil Radford), who, once the whisky arrives, becomes the unspoken enemy of almost every islander. Wagget, which is to say Englishness, is shown as unfeeling and out of touch with the beauty of life. Although Wagget has the law behind him, and perhaps represents Todday's future, he lacks sufficient compassion to understand the importance of ending the whisky drought when the opportunity arises (on any day except Sunday). Even Sgt Odd (Bruce Seton), a far more palatable Englishman who is essentially on the islanders' side, cannot adequately understand them. When he attempts to propose to his beloved Peggy (Joan Greenwood), she looks away and says, 'It is a shame you haven't the Gaelic.' It is as if, for the islanders, the English have an irreparable deficiency of the soul.

Whisky Galore! has been enormously influential – most obviously on the films of Bill Forsyth. But for all its anti-English sentiments, it has left its mark on many subsequent British comedies about a small community or faction who are politically constrained and denied the progress that is cultivated in the rest of the nation – such as the post-Thatcherite suppression of northern working class men in *The Full Monty* (Peter Cattaneo, 1997), for example. The film's greatest influence, though, may be on television: the seminal and much-loved sitcom *Dad's Army* (various, 1968–1977), is undeniably indebted to *Whisky Galore!* Captain Wagget, for example, a preposterously self-important prig who bullyingly oversees a comically inept and ill-equipped Home Guard Unit, was

clearly one inspiration for Arthur Lowe's iconic Captain Mainwaring in *Dad's Army*. The classic scene in which Waggart oversees the installation of a single road block on the road that encircles the island – which typifies the film's keen awareness of the absurdity of English bureaucracy as well as its uproarious silliness – could have appeared in almost any episode of *Dad's Army*.

While the epilogue to *Whisky Galore!*, which was essentially forced upon it by the standards of contemporary censors, does somewhat diminish the film, *Whisky Galore!* is still a delightful comedy. It was Alexander Mackendrick's directorial debut and the first great film he made before going on to craft classics like *The Ladykillers* (1955), *The Man in the White Suit* (1951) and, in America, *Sweet Smell of Success* (1957). *Whisky Galore!* is equal to all of them.

Scott Jordan Harris

The Bill Douglas Trilogy

Studio/Distributor:
BFI/Films Inc

Director:
Bill Douglas

Screenwriter:
Bill Douglas

My Childhood

Producer:
Geoffrey Evans

Cinematographer:
Mick Campbell

Editor:
Brand Thumin

Duration:
46 minutes

Genre:
Art/Social Realism

Cast:
Stephen Archibald
Hughie Restorick
Jean Taylor Smith

Year:
1972

Synopsis

The three films of the Bill Douglas Trilogy: *My Childhood* (1972), *My Ain Folk* (1973) and *My Way Home* (1978) chronologically chart the life of Jamie, Douglas' surrogate, from his childhood in a poor Scottish mining village at the end of WWII to the time of his national service in North Africa in the mid-1950s. The first part begins in the final months of the war and sees Jamie living with his half brother, Tommy, and his maternal grandmother. Jamie's father lives close by but takes no interest in his son's life. The second part is set one year later and begins with the death of the boys' grandmother. Tommy is placed in an orphanage and Jamie goes to live with his father, his unstable paternal grandmother and ailing grandfather. In the final part, Jamie, who is now in his teens, runs away from home before being called up for national service. He ends the film in Egypt serving in the RAF. There he meets Robert, an educated young man who becomes his close friend and begins to nurture Jamie's ambition to become an artist.

Critique

Despite having completed only a handful of films before his premature death in 1991 aged 57, Bill Douglas has gained a reputation as one of the great post-war British film-makers. His poetic-realist style (and his slender oeuvre) has drawn comparisons with luminaries such as Jean Vigo and Humphrey Jennings, his austere imagery and camerawork have recalled Robert Bresson and Carl Dreyer, and his editing has been likened to that of Soviet Montage theorists such as Alexander Dovzhenko. Lofty though these comparisons may seem, Douglas' autobiographical trilogy can stand up to them.

The first part, *My Childhood*, was made for a mere £3500, which was provided by the BFI. Mamoun Hassan, then head of the BFI Production Board, agreed to support the film after reading the script and screening Douglas' student short film *Come Dancing*

My Ain Folk

Producer:
Nick Nascht

Cinematographer:
Gale Tattersall

Editor:
Brand Thumin

Duration:
55 minutes

Genre:
Art/Social Realism

Cast:
Stephen Archibald
Helena Gloag
Hughie Restorick

Year:
1973

My Way Home

Producers:
Richard Craven
Judy Cottan

Cinematographer:
Ray Orton

Production Designers:
Olivier Bouchier
Elsie Restorick

Editor:
Mick Audsley

Duration:
71 minutes

Genre:
Art/Social Realism

Cast:
Stephen Archibald
Joseph Blatchley
Paul Kermack
Hughie Restorick

Year:
1978

(1970). Although Hassan stipulated that the film be shot in colour (and 16mm), Douglas insisted that the film be printed in black and white. Douglas proved somewhat difficult to work with and the film was not initially a success in its native Scotland, yet it won enough attention and awards (including a Silver Lion at Venice) to merit Hassan funding the follow-up, *My Ain Folk*. This second film is the most severe, elliptical and difficult of the three and may be the masterpiece of the series. It memorably begins with a few seconds from *Lassie Come Home* (Fred M Wilcox, 1943) in glorious Technicolor before cutting to a monochrome reaction shot of Tommy (Stephen Archibald) watching the film. Douglas waited to film the third part, *My Way Home*, until Archibald was old enough to play the part of a soldier. This final film was the longest and most expensive (£35,000) and also the most self-conscious of the three. Even if Jamie's decision to become an artist and 'maybe a film director' seems a little too sudden, *My Way Home* is nevertheless a fine and fittingly-uplifting coda to the often bleak series.

Stylistically, despite some refinements, the three films are cohesive: each combines common tropes of British social realism, including naturalist performances from non-professional actors and location filming, with elements more resonant of certain European art films, including the elliptical structure, long passages of silence, minimal dialogue and shots that are sustained long after their narrative function is served. Douglas' direction is notably rigorous throughout, with the camera only moving when necessary. Also, diegetic music is used sparingly and there is no non-diegetic music in any of the films; Douglas instead allows natural, ambient sounds, such as the mineshaft elevator in *My Ain Folk*, to take their place. As a result the overall effect of the films has frequently, and rightly, been described as 'poetic'.

Partly because of his reputation as a difficult and uncompromising figure, Douglas found it almost impossible to find support for subsequent projects. He completed only one other film, *Comrades* (1986), an ambitious, if flawed, three-hour film about the Tolpuddle Martyrs, and left behind two unfilmed scripts, one based on the life of the photographer Edward Muybridge, the other an adaptation of Hogg's *Confessions of a Justified Sinner*. Nonetheless, Douglas' films are justly regarded as classics, and have had a notable influence on many directors, from the early work of Terence Davies to fellow Scottish film-makers such as Peter Mullan and Lynne Ramsey.

Brian Hoyle

Gregory's Girl

Studio/Distributor:
Lake/ITC

Director:
Bill Forsyth

Screenwriter:
Bill Forsyth

Producers:
Davina Belling and Clive Parsons

Cinematographer:
Michael Coulter

Synopsis

Scottish schoolboy Gregory loses his place as the football team's star player because he cannot maintain focus. Dorothy, a skilled and attractive player, with whom he develops an intense but one-sided fascination, replaces him. Quickly, Gregory discovers that he is not the only one, as many of his friends and classmates share the same feelings. When his best friend Steve refuses to help him win Dorothy's favour, Gregory turns to his 10-year-old sister Madeleine for surprisingly wise advice. He finally finds the courage to ask Dorothy out on a date, but when he arrives, one of her friends is there instead and tells him she could not make it. After spending time with Dorothy's friends, being passed from one girl to another, Gregory ends up with Susan, and must decide who he is in love with after all.

Gregory's Girl, ITV Global/The Kobal Collection.

Production Designer:
Adrienne Atkinson

Composer:
Colin Tully

Editor:
John Gow

Duration:
87 minutes

Genre:
Comedy

Cast:
Jake D'Arcy
Clare Grogan
Dee Hepburn
John Gordon Sinclair

Year:
1980

Critique

The best films about teenagers are the ones that convey the delicate balance between the responsibilities and ambitions of adulthood, and the naïveté and daydreaming of childhood. Bill Forsyth's characters, regardless of their age, seem to strive for that strange position of being caught between where they are and where they want to be, so it is only natural that he created one of the best portrayals of adolescence yet committed to celluloid.

The way John Gordon Sinclair plays Gregory is something of a blueprint for British teen comedy: he is all lanky limbs, bad jokes, awkward yet charming smiles, and constantly on the verge of breaking into nervous giggles. Gregory is confused by his feelings about losing his position as star player, and not only being replaced, but replaced by a girl he has a powerful crush on. As in most comedies about dopey teenagers, he spends the entire film unsuccessfully trying to convince a gorgeous, athletic, cultured girl (Dee Hepburn as Dorothy) that he is not the gangly goof he appears to be while another, much nicer, girl (Clare Grogan as Susan) waits unnoticed in the wings.

While Forsyth fills the screen with the bland landscape of the Scottish town of Cumbernauld he romanticizes it through the matter-of-fact way his characters interact with it. The film is a time capsule of not only a place but also of a specific time – looking back from a contemporary vantage point, the follies, fears, and failed come-ons of these teens seem even sweeter thanks to the abundance of outdated styles. Teenage love trouble is universal, but the way *Gregory's Girl* is so rooted to 1980s' Cumbernauld tells contemporary love-struck teens that things were always like this, no matter where or when – even their parents had the same problems, and looked and felt just as ridiculous.

Thus, while *Gregory's Girl* is steeped in Scottishness, its relevance is far from restricted to Scotland. What makes Forsyth one of Scotland's foremost directors is his way of holding up his homeland as emblematic of stories and problems faced everywhere. Rather than making his quirky characters objects of mockery, his comedy is warm, empathetic and grounded in an almost un-cinematic naturalness.

Patrick Tobin

Trainspotting

Studio/Distributor:
Channel 4
Figment/Polygram

Director:
Danny Boyle

Synopsis

Mark Renton and his friends Spud and Sick Boy are heroin addicts living in a deprived area of Edinburgh. They try to justify their drug taking and criminality as an alternative to the mediocrity of a conformist lifestyle motivated by career, possessions and family. On a whim Renton decides to quit heroin, but after a hellish detox he struggles to readjust to a 'clean' lifestyle. After a series of misadventures with his friends and a disastrous liaison with a girl called

Screenwriters:
John Hodge
Irvine Welsh (novel)

Producer:
Andrew Macdonald

Cinematographer:
Brian Tufano

Production Designer:
Kave Quinn

Editor:
Masahiro Hirakubo

Duration:
94 minutes

Genre:
Comedy

Cast:
Robert Carlyle
Kelly Macdonald
Ewan McGregor
Jonny Lee Miller
Peter Mullan

Year:
1996

Diane, he becomes bored and starts using heroin again. When a botched robbery and a brush with the law sees him forced into another detox, Renton decides to leave Edinburgh for a new life in London. However, his old friends, including a violent criminal called Begbie, track him down and draw him back into drugs and crime, culminating in a dangerous big-money drug deal they hope will make them all rich.

Critique

Director Danny Boyle's 1994 debut *Shallow Grave* injected some much-needed energy, edginess and youth appeal into a British film industry, which at that point consisted of heritage films and Richard Curtis comedies. His second film, *Trainspotting*, adapted from Irvine Welsh's blackly-comic novel of Edinburgh heroin addicts, established Boyle as one of the most significant British film-makers of his generation.

 Trainspotting stars Ewan McGregor as Renton, a man with a 'sincere and truthful junk habit', whose ambiguous attempts to quit heroin are repeatedly thwarted by fellow addicts and his own disaffection with 'normal' life. The film focuses on the juncture between these two worlds and Renton's position within them: 'Choose Life. Choose a job. Choose a career. Choose a family. Choose a fucking big television' sneers Renton's voice-over in an opening rant about the aspirations that consumer society encourages him to have. Renton will not conform: 'I chose not to choose life. I chose somethin' else…' *Trainspotting* adroitly tackles the controversial idea that drug addiction is a 'choice'. It shows Renton, Spud (Ewan Bremner) and Sick Boy (Johnny Lee Miller) as both willing users and nihilistic victims of their bleak social situation.

 Boyle does not spare the audience the brutal reality of heroin addiction, reflected in the addict's squalid squats and deathly physical appearances. One especially disturbing scene shows the tragic death of an addict's neglected baby, including a sustained close-up on the poor, lifeless infant. Through the character of Tommy (Kevin McKidd) in particular, the film shows heroin's rapidly-destructive impact. Tommy is a physically fit, good-natured lad whose break-up with Lizzie, his long-term girlfriend, (which is Renton's fault) leads him to search for something to numb his emotional pain. Tommy begs Renton to let him try heroin as he's heard it is 'better than sex', but develops full-blown AIDS because of his addiction. Boyle does not depict drug addiction in an uncomplicated way, however, showing the technique of heroin injection and references to the immense pleasure the drug can bring, as well as deploying an exhilarating and emotive soundtrack including Iggy Pop's 'Lust for Life', Lou Reed's 'Perfect Day' and Underworld's 'Born Slippy'.

 Despite the subject matter and disgustingly grimy *mise-en-scène*, *Trainspotting* is often brilliantly surreal and blackly comic. Its treatment of estranged youth, immorality, drugs and violence recalls Stanley Kubrick's *A Clockwork Orange* (1971). Boyle's direction is endlessly imaginative and belies the film's low budget. The language is inventive and uncompromising, with dialogue often

closely adapted from the heavy Edinburgh dialect in Welsh's novel. McGregor is perfect as Renton and, accompanied by Bremner, Lee Miller, McKidd and Macdonald, realizes the tragi-comic substance of John Hodge's screenplay. Actor-director Peter Mullan gives a poignant performance as Swanney the dealer. Robert Carlyle, however, can claim the film's standout performance as Begbie – a volatile Scottish 'hard man' archetype who threatens and intimidates even his closest friends. As Tommy says, 'Begbie's fucking psycho, man. But he's a mate, so what can you do?'

Robert Beames

Ratcatcher

Studio/Distributor:
BBC, Pathé
Holy Cow/Pathé

Director:
Lynne Ramsay

Producer:
Gavin Emerson

Screenwriter:
Lynne Ramsay

Cinematographer:
Allwin H Kuchler

Production Designer:
Jane Morton

Composer:
Rachel Portman

Editor:
Lucia Zuchetti

Duration:
94 minutes

Genre:
Drama/Social Realism

Cast:
William Eadie
Tommy Flanagan
Mandy Matthews
Michelle Stewart

Year:
1999

Synopsis

In Glasgow, in the early 1970s, adolescent James accidentally drowns his friend Ryan in the canal behind their council housing estate. Never confessing his secret, James drifts into a haze. While his most intimate contact with his parents consists of picking at the holes in their socks while they sleep, James begins a friendship with Margaret Anne, a damaged and timid teenage girl. There is an ongoing dustman's strike and the local kids spend their days rooting through mountains of rubbish on the deprived estate and ambling along the trash-filled canal. James ambivalently watches as boys abuse Margaret Anne and intimidate Kenny, a boy with learning difficulties who loves animals. Escaping by bus, James spends one happy afternoon playing in an unfinished housing development outside the city and running through the golden fields nearby. But after a revealing conversation with Kenny, James is forced to confront his past.

Critique

Lynne Ramsay's *Ratcatcher* is a moody, evocative film less concerned with plotting than with capturing atmosphere and character. As James (William Eadie) moves through his disjointed, impoverished world, each scenario flows loosely into the next, connected only by the setting and lead character. James' limited understanding of the world creates an amorphous, constantly evolving narrative – he is disconnected from his peers and family, leaving the audience with only a vague understanding of one character's relationship to another. He makes his most significant connection with Margaret Anne (Leanne Mullen), and their scenes together find James at his happiest.

In the opening scene, a boy named Ryan Quinn (Thomas McTaggart) wraps himself up in curtains, trapping himself within and creating a makeshift, and foreboding, death shroud. The camera then follows Ryan down to the canal where he and James begin to scuffle in the water. When James accidentally drowns Ryan, there is a significant narrative disconnect in that Ryan appeared to be the lead but the guilty party has now become the protagonist. With

this deliberate misdirection, Ramsay has unsettled the audience by creating a suspicion about James that carries through the film.

From the outset, Ramsay introduces two recurring motifs: submersion and rubbish. At various points, characters are shown submerged in water, lowering themselves into bathtubs and playing in or falling into the filthy canal. Water offers comfort and solace to James and Margaret Anne when they share a playful bath together, but also threatens to carry the children to their deaths. The rubbish motif is significant. Not only does it historically situate the film in the 1970s' social crisis of extreme poverty, governmental neglect, power shortages and workers' strikes, it also serves as an analogy to the children who roam the streets and canals – like the rubbish that sits uncollected, they have been abandoned.

In both *Ratcatcher* and her later film *Morvern Callar* (2002), Ramsay is committed to creating haunting, indelible images. Though both films contain upsetting scenes, she is less concerned with judging her characters than with creating an authentic scenario and setting. With its focus on poverty and need, *Ratcatcher* may appear to be part of the didactical social realism school, but Ramsay is more concerned with showing than telling. Her quest for truthfulness might be mistaken for amorality, but Ramsay's films are intensely humanist and deeply sympathetic.

Randall Yelverton

WALES

Wales has a long film-making tradition, reaching back to the 1890s. The first film shot in Wales, featuring a royal visit to Cardiff, was made in 1896 by the American Birt Acres. The first Welsh-based film-maker was the flamboyant entrepreneur, Rhyl's Arthur Cheetham (1864–1936). Between 1898 and 1908 he documented local events in north and mid-Wales, creating silent shorts such as *Slateloading onto Ships at Porthmadog* (1898), *Ladies Boating at Aberystwyth Bay* (1898), *Royal Visit to Conway* (1899) and *Buffalo Bill and May Day Procession, Rhyl* (1903). The key creative figure in these early days in Welsh cinema was the travelling showman William Haggar (1851–1925), who made around thirty fiction films, such as *A Desperate Poaching Affray* (1903) and *Life of Charles Peace* (1905), which spanned an impressive range of genres and were distributed around the world by Gaumont and Urban.

Between 1910 and 1912 Wales itself was at the peak of industrial prosperity, but extant films from the period bear no trace of its political struggles, social tensions or the iconic industrial mining, milling or farming landscapes. Filming forays into Wales sprang from recognition of the country's photogenic locations, but it was rural Wales that proved popular with visiting film companies such as Edison and British and Colonial. Hollywood discovered Wales as early as 1913, when Sir Walter Scott's novel *Ivanhoe* was adapted for Carl Laemmle's pioneering Independent Moving Pictures Company (IMP), a forerunner of Universal. Ivanhoe was shot in Welsh locations, including Chepstow Castle and the surrounding countryside, which doubled for the locations in Scott's novel. Many of the films from this era are lost, including *A Welsh Singer* (1915), adapted from the novel by Allen Raine, starring Florence Turner, the famous 'Vitagraph Girl'.

It was left to London's Strand Company to depict the plight of the industrial working class in Wales. Communist Ralph Bond's agit-prop documentary *Today We Live* (1937) attempted to show the plight of the unemployed and the dignity of the proletarian working class, and included sequences shot in the Rhondda Valley. In the same year, Douglas Alexander's *Eastern Valley* (1937) was shot in Gwent. In 1935, *Y Chwarelwr*, the first ever Welsh language talkie, was shot by Ifan ab Owen Edwards in the slate quarry areas of Blaenau Ffestiniog. After the outbreak of WWII, the village of Cwmgiedd was used as the location for Humphrey Jennings' propaganda film *Silent Village* (1943). Designed as a tribute to the mining community of Lidice, Czechoslovakia, Jennings recreated the atrocities that happened there but transported them to South Wales, drawing analogies with the oppression of the Welsh language by Anglicization.

The Citadel (1938), one of three features made by MGM in Britain just before WWII, was set partly in a South Wales mining community but did not fully express the original novel's political message. Like many other films during the 1930s and 1940s, *The Citadel* was made by outsiders and cast Wales as an exotic other, filtering working-class life through the lens of Hollywood or the major British studios. Pen Tennyson's film *The Proud Valley* (1940) was largely made at Ealing Studios, with pit exterior scenes shot in Staffordshire collieries after South Wales mine owners refused the crew permission to film

Left: *Hedd Wyn*, Pendefig Ty Cefin/S4C/The Kobal Collection.

there. The adaptation of Emlyn Williams' stage play *The Corn is Green* (1945), with Bette Davis as Williams' schoolmistress/mentor, was entirely shot in America with virtually an all American cast.

The most influential of these American films was *How Green Was My Valley* (1941), which is best seen as a reflection of John Ford's predilection for mythology rather than a true reflection of Welsh life. Winning five Academy Awards, and shot on a back lot in Malibu, its cast included only one Welshman, apart from the ubiquitous Welsh choir members. *How Green Was My Valley* exported a powerfully mythic version of Wales that has proved difficult to dislodge. On the other hand, Jill Craigie's brave *Blue Scar* (1949) criticized the National Coal Board, but its message was diluted somewhat due to the fact that half its funding came from the Board itself. In 1951, Paul Dickson made *David* as the Welsh contribution for the Festival of Britain, skilfully blending amateur and professional actors.

Between 1950 and 1970 the lack of funding and infrastructure to promote indigenous productions meant that, too often, the representation of the nation was at the mercy of preconceptions and prejudices of visitors content to trade in lazy stereotypes. But the 1970s saw many promising developments. 1971 saw the establishment of the Welsh Film Board, set up exclusively to produce and tour Welsh language films. Financial problems severely hindered the Board's ambitions, but they managed to produce four features, a number of shorts and films for children. Chapter Arts Centre's Film Workshop became a breeding ground for talent, with members such as Chris Monger and Steve Gough going on to make notable features. At the same time, Karl Francis' graphic, raw and sometimes controversial images in films, including *Above Us the Earth* (1976), *Giro City* (1982), *Ms Rhymney Valley* (1985) and *Milwr Bychan/Boy Soldier* (1986), shattered any romantic allusions about life in the post-industrial South Wales valleys.

The launch of S4C, the Welsh-language fourth channel, in November 1982 spawned an embryonic film industry. Initially, the channel looked to costume drama and mythology for inspiration, but had two surprise hits when Milwr Bychan and Stephen Bayly's comedy *Rhosyn a Rhith/Coming Up Roses*, both initially shot on 16mm, made history as the first Welsh-language films to gain London West End cinema release, in subtitled versions. This success led to S4C committing to producing Welsh language features, and the subsequent emergence of talented directors such as Stephen Bayly, Endaf Emlyn, Marc Evans and Sion Humphreys. These directors delivered notable films, but distribution issues meant that, despite being garlanded with film festival awards, they were hardly seen in Britain. The most prominent example is *Hedd Wyn* (1992), the first Welsh film to be nominated in the Foreign Language Category at the Academy Awards, as well as winning a Royal Television Society Best Drama award. It nonetheless failed to attract a British distributor.

Since the early nineties a wider and more accurate representation of contemporary Wales is notable, particularly since 1997, where films appear to reflect Wales' gradual journey towards devolution with confident and varied versions of Wales. *House of America* (1997) and *Twin Town* (1997) both play on Welsh icons and raise interesting questions about Wales. *Little White Lies* (2006) and *A Way of Life* (2004) both address ideas of multiculturalism from a solidly Welsh perspective. The establishment of Film Agency Wales in 2006 has sought to strengthen the fragility of the infrastructure, and has invested in a number of films, including Richard Ayoade's coming of age comedy *Submarine* (2011) and Marc Evans' *Patagonia* (2011). Both these films reflect the tensions and challenges while wrestling with the concept of a Welsh cinema. *Submarine*, executively produced by actor Ben Stiller, in its insightful exploration of a teenage boy, follows in the Anglo-American mould of coming-of-age films and was selected to be shown at Sundance. *Patagonia*, a bilingual Welsh/Spanish film, co-funded by S4C and Film Agency Wales, puts Welsh alongside the global language of Spanish in an essentially low-budget film with cinematic

ambition. Wales is essentially a part of Britain, but has voted to increase its devolved powers; as part of Britain it is part of a predominantly Anglophone island, but its bilingual nature means that is has much in common with Europe and other sub-state nations. Wales is a small nation that continually grapples with these tensions. It is no surprise that its films continue to do so as well.

Kate Woodward

David

Studio/Distributor:
BFI/Regent

Director:
Paul Dickson

Producer:
James Carr

Screenwriter:
Paul Dickson

Cinematographer:
Ronnie Anscombe

Composer:
Grace Williams

Editor:
Kit Wood

Duration:
38 minutes

Genre:
Drama-documentary

Cast:
John Davies
DR Griffiths
Sam Jones
Rachel Thomas

Year:
1951

Synopsis

In the small Welsh town of Ammanford, Ifor Morgan reflects on his childhood and recalls the story of the popular and respected school caretaker, Dafydd Rhys. When his only son, Gwilym, dies of TB, Dafydd fundamentally changes. He spends hours distilling his memories of his son into a poem, which Ifor and his father persuade him to enter in the Crown competition in the National Eisteddfod. On a walk with Ifor, Dafydd narrates his life story, recalling life in the pit, marriage and the birth of his son. Being in hospital after a mining accident gave Dafydd a chance to compose poetry, the door-to-door sales of which enabled Gomer Roberts, a young local, to take up a college place. Gomer, now a minister and eminent historian, returns to attend a school prize-giving, and tells those present that were it not for Dafydd Rhys he would never have been able to attend college.

Critique

Paul Dickson's drama-documentary *David* was the Welsh selection for the 1951 Festival of Britain screenings in London. At its heart is DR (David Rees) Griffiths, a caretaker, ex-miner and respected poet, also known by his bardic name, Amanwy. Griffiths was also the brother of Jim Griffiths, the former South Wales Miners Federation President who later became the first Secretary of State for Wales (1964–5). Largely autobiographical, DR Griffiths, in his sixties, plays himself, under the name 'Dafydd Rhys'.

The Welsh Committee for the 1951 Festival of Britain decided to commission 'a two reel black-and-white film on the subject of "the Spirit of Wales"'. Despite the centrality of Dafydd Rhys to the film, he is a vehicle to convey the Welsh Everyman, and the town of Ammanford functions as a microcosm of the whole of Wales. Aneirin Talfan Davies, charged with developing the script, surely had films such as *How Green was My Valley* (John Ford, 1941) and *The Proud Valley* (Pen Tennyson, 1940) at the forefront of his mind when he insisted that *David* would avoid the caricatures of Welsh peasants that prevailed in preceding years. The film opens in a manner similar to John Ford's deeply-romantic portrait of a Welsh valley. Ivor intones: 'My name is Ifor Morgan and I've come home. There at my feet is the town where I was born' as he looks back on his childhood and his friendship with the old man Dafydd Rhys. As in many other films filmed or set in Wales, such as *Y Chwarelwr/The Quarryman* (Ifan Ab Owen Edwards, 1935) *Noson Lawen/A Fruitful Harvest* (Marc Lloyd, 1949) and *How Green Was My Valley*, education is of the utmost importance, being a means of escaping the hardship of life underground in the mines and a key to a better world.

Despite the Committee's insistence that the film should avoid sentiment, *David* is a deeply sentimental film. Episodes of DR Griffiths' life are selected, sometimes distorted, and infused with fiction and imagination to show a selective version of the miner's life and present a 'respectable' image of Wales. As in many films

made by visitors to Wales, the miner is a hero, and much of the injustice and hardship of the lives of the miners are glossed over to show the Welsh working class 'at their best'.

Reception of *David* in Wales was largely positive, with a *South Wales Evening Post* columnist declaring that 'most films about Wales have sent the sensitive Welshman into the nearest public house or into the cinema on tiptoe, where he has viewed the screen through his fingers'. But on this occasion it was felt that every Welsh person could revel in Dickson's accomplishment. Others felt that by wallowing in self pity and sentimentality the film sustained the traditions of Hollywood and British studio films. For some, *David* is a masterpiece in miniature; the fact that it has a Welsh story and local actors at its heart does not prevent it from recycling the same myths and romance in honour of the heroic miner.

Kate Woodward

Hedd Wyn

Studio/Distributor:
Pendefig Ty Cefn
S4C/Northern Arts
Entertainment

Director:
Paul Turner

Producer:
Shân Davies

Screenwriters:
Alan Llwyd
Paul Turner

Cinematographer:
Ray Orton

Production Designers:
Martin Morley
Jane Roberts

Composer:
John ER Hardy

Editor:
Chris Lawrence

Duration:
123 minutes

Genre:
Drama/Biopic

Synopsis

Young poet Ellis Evans, known by his *nom de plume*, Hedd Wyn, is brought up on the family farm, Yr Ysgwrn, near Trawsfynydd. At 14, Evans leaves school and three years later is conscripted into the Army to serve in France. While in the army, he writes the poem 'Yr Arwr' (The Hero), which he submits for the Chair competition in the National Eisteddfod. One month later, on the first day of the Battle of Passchendaele, he is mortally wounded. A letter arrives at the farm house informing his family that he had won the competition. Evans is awarded the Chair posthumously at the Eisteddfod in Birkenhead in 1917, and is known as Bardd y Gadair Ddu (The Poet of the Black Chair).

Critique

Hedd Wyn made history as the first Welsh language film ever to be nominated for an Oscar in the Best Foreign Language Film category. The Welsh Fourth Channel, S4C, has been accused of turning too often to the past for inspiration for its films since its inception in 1982. Far from dramatizing a familiar myth or legend, *Hedd Wyn* utilized the little-known story of WWI poet Ellis Evans (Huw Garmon).

Ellis lies mortally injured at Passchendaele, and the film depicts the events running through his consciousness as life slowly leaves his body. In life, Evans spoke openly about his inability to understand the war and his friends' involvement with it. Far from being a remote event, he experiences the effects of the war on his rural community in north Wales where the army trained on the mountains of Snowdonia, shattering its idyllic silence.

Ellis' attitude to the war is evoked through a series of juxtapositions: Wales and England, the Welsh and English languages, war and peace, family and the military, the farm and the battlefield. In

Cast:

Huw Garmon
Judith Humphreys
Nia Dryhurst
Sue Roderick

Year:

1992

one scene, for example, as English soldiers loudly sing a warmon-gering song in the pub, Ellis stands and sings the romantic song 'Myfanwy'; language, pacifism and romance are unified in one song against the soldiers' macho aggression.

Ray Orton's cinematography and Chris Lawrence's editing are exceptional. Some of the film's most memorable scenes in the trenches evoke the chaos, brutality and rawness of war. In one superbly-crafted sequence, the camera lingers on the eyes of the young men before they climb out of the trench to go over the top.

Director Paul Turner successfully balances the private and public Ellis, and three convincing love affairs lend the main character an air of notoriety and poetic romanticism. Turner also gives the poems a central role as a key device to understanding the man. Ellis' muse is symbolized by Arianrhod, the Celtic goddess of the moon, who appears as a veiled woman (although not always con-vincingly). Elegantly scripted by Alan Llwyd, himself a chaired and crowned poet, this film truly celebrates a great Welsh poet.

Hedd Wyn gave Welsh cinema new ambition, as S4C slowly real-ized that a truly memorable story, ably told, can transcend linguistic borders. The film's success led S4C to invest further in film including *Solomon a Gaenor* (Paul Morrison, 1999) – a Romeo and Juliet tale dealing with racism in the south Wales valleys during the 1910s – also achieving a Best Foreign Language Film Oscar nomination in 2000.

Kate Woodward

House of America

Studio/Distributor:

September Films
Egmond/First Independent Films

Director:

Marc Evans

Producers:

Sheryl Crown
Hans de Weers

Screenwriter:

Ed Thomas

Cinematographer:

Pierre Aïm

Synopsis

Sid, Gwenny and Boyo live with their elderly mother in a deprived post-industrial area of South West Wales. Their father left home when they were small children, apparently having gone to chase his dream in America: the lands of dreams. Consequently, Sid is obsessed with American culture, dreaming constantly of joining his father. The news that an American company is starting an open cast mine in the area offers a glimmer of hope. But their mother is so against the idea that she sabotages Sid's motorbike and the brothers arrive too late to secure a job. The lack of employment in the area means that the young characters turn increasingly to alco-hol, drugs and Americana, with Sid and Gwenny finding dangerous solace in the work of Jack Kerouac. While Sid and Gwenny's grip on reality gradually loosens, and their mother's mental state slowly collapses, Boyo is left to deal with the tragic consequences.

Critique

Marc Evans' *House of America*, adapted from Ed Thomas' stage play, explores the trauma of rapid de-industrialzation in South Wales and the search for a modern national cultural identity, by focusing on one dysfunctional family. It also acknowledges, and attempts to break away from, the dominant depictions of Wales on

Production Designers:
Edward Thomas
Mark Tildesley

Composer:
John Cale

Editor:
Michiel Reichwein

Duration:
93 minutes

Genre:
Drama

Cast:
Steven Mackintosh
Lisa Palfrey
Sian Phillips
Matthew Rhys

Year:
1997

screen. 'Mam' (Sian Phillips) is an extreme and polarized contrast to the traditional 'Welsh Mam' in mining films of the 1940s and 1950s. She is a fragile and confused figure, increasingly alienated from reality. Mam and her three children are irrevocably bound together in an unyielding knot, and their life is a self-suffocating existence.

In *How Green Was My Valley* (John Ford, 1941), America is the land of promise and opportunity for the Welsh; in *House of America*'s 'bypassed town in a bypassed country' the relationship between the two places is far more problematic. The American Dream and post-industrial Wales are persistently juxtaposed, highlighting twin forces in contemporary Wales: increasing devolution on the one hand, and rapid globalization on the other. America is a threatening symbol, both mentally and physically, with Michigan Mining offering much-needed employment but digging dangerously close to the family's home. Long wide roads, Zippos and Marlboros are ubiquitous motifs in the film, and the Michigan Mining Company emblem towers over the valley like the famous Hollywood sign.

House of America offers a darker picture of Wales than previously seen on film. South Wales offers nothing for the three youngsters. It is a society empty of spiritual or social empathy, without a strong family unit or a close-knit community. Sid and Gwenny immerse themselves in American fantasies; they create a hybrid myth that their dead Welsh father is living on a ranch in America. While Gwenny addresses her letters, 'Clem Lewis, Dodge City, America', drowning slowly in the dream, Sid resentfully turns his anger on his homeland and refuses to believe that anything of quality has ever come out of Wales. In their desire to sterilize their reality, Sid and Gwenny embrace 'Yankage', and die a cultural death by borrowing second-hand myths from another culture. The seeming futility of Sid and Gwenny's existence, and their inability to change their situation, results in extreme, dangerous behaviour. Wales is transformed for them, having replaced the chapel and faith with clubs, drugs and disturbing sexual experimentation.

When the Lewis boys receive a brutal and bloody beating from the workers of Michigan Mining, it is a physical expression of the psychological attack they suffer as a result of the American company's domination of the region. While Sid deals with his social impotence by enveloping himself in the mythology of Jack Kerouac, Boyo tries to salvage an existence within the local community. But as a disabled rugby player, the perversion of a traditional male stereotype, he is also socially impotent. The baby his sister Gwenny carries, the product of incestuous sex with her brother Sid, symbolizes the future of his decaying community.

By focusing on one dysfunctional family, Evans demonstrates the need for Wales to reinvent its own contemporary mythology, rather than a recycling of myths and stories from other cultures. This need is emphasized when Sid asks: 'Where are our heroes, where are our kings? One answer Boyo, we haven't got any.' *House of America*, released in the year of the referendum on devolution in 1997, is a passionate and powerful depiction of not only the need but also the necessity for nations to dream and create their own heroes.

Kate Woodward

N.IRELAND

Commenting on British national cinema, Sarah Street has pointed out that 'the question of national cinema is complex and contentious' (1997: 1). This is particularly true of Northern Irish cinema. To date, critical appraisal has tended to view the cinema of Northern Ireland as part of the Irish national cinema. But this is mis-representative in that it ignores the region's unique cultural and political position – its shared Irish and British heritage.

While cinema-going in Northern Ireland, as in much of Britain, has been a popular pastime, John Hill argues that 'Northern Ireland itself, for a variety of economic, political and geographical reasons, did not develop as a significant centre for film production. As a result, most standard histories of British cinema ignore Northern Ireland altogether, while most studies of Irish cinema concentrate overwhelmingly on developments on the rest of the island' (Hill, 2006: 2.) While there have been several significant instances of film-making within the region, the earliest examples being a series of films shot in the Belfast area by the Lumière company in 1897, and some Northern Irish films have enjoyed considerable box-office success, it was only with the inauguration of the Northern Ireland Film Council (now Northern Ireland Screen) in 1988 that the beginnings of a regional film industry of sorts emerged.

Can Northern Ireland be said to have a cinema in its own right? And if so, is it truly representative of its people? The elephant in the room is the 'Irish Nationalist' and/or 'Republican' themes that have dominated film-making in and about Northern Ireland. Politically, Northern Ireland has been a complex and sensitive area since the partition of Ireland in 1922 – an event parodied in the film adaptation of Spike Milligan's novel *Puckoon* (Terence Ryan, 2002), co-funded by the NIFC. Whilst the region now exists as part of the United Kingdom, a percentage of its population (in particular 'Nationalists' and 'Republicans') consider it to be an indistinguishable part of Ireland. Culturally, the region takes its influences from both Britain and Ireland, yet within the contexts of cinema the presence of a 'Protestant' culture (pigeon-holed as either 'Unionist' or 'Loyalist') has been largely neglected, or else grossly misrepresented. The few films that have emerged from and about Northern Ireland have focused primarily on the 'Troubles' with a particular concentration on 'Nationalist' and 'Republican' themes or narratives which are clearly sympathetic to the Republican movement.

For example, the protagonists in both *Odd Man Out* (Carol Reed, 1947) and *The Gentle Gunman* (Basil Dearden, 1952), played by James Mason and Dirk Bogarde respectively, are IRA activists shot by the RUC (the then Northern Irish police force, which was generally viewed as a Protestant/British organization) while committing violent acts, and are forced to go on the run to survive. Despite being produced by British studios, the glamorization of the Republican movement is the central focus of these films.

Casting matinée idols such as Mason and Bogarde in the role of the anti-hero can be viewed as an obvious attempt to lure audiences. This romanticizing of the Republican 'struggle' by casting Hollywood stars as terrorists appears to have served as something of a blueprint for future films regarding Northern Ireland and the

Troubles. The most imprudent and quixotic example of this is the casting of heart-throb Brad Pitt as IRA man Rory Devaney in the political thriller *The Devil's Own* (Alan Pakula, 1997).

With a lucrative overseas market for films about the Irish struggle for independence, it should be of little surprise that Republicanism has been a dominant presence in films made in and about Northern Ireland. More surprising, however, is the fact that not only Irish but also British producers (and others) have taken this approach, and in the process have skewed the portrayal of the political situation in the region and that of its population.

Despite a substantial part of the region's population declaring themselves 'British' with allegiances to British politics and culture, this has not been transferred onto the cinema screen. According to the 2001 census, 13% of the Northern Irish population are Protestant, and 43.76% Catholic (www.nisranew.nisra.gov.uk); a 2008 survey by the Economic and Social Research Council found that of the Northern Ireland population, 37% saw themselves as British, 26% Irish, and 29% Northern Irish (www.ark.ac.uk). This suggests not only that the British population is larger than the Irish population in the region but also that nearly a third of the population recognize their unique nationality. Considering the existing gamut of films that have been made in and about Northern Ireland to date, it is incontestable that there has been a scarcity of Unionist/Loyalist representation in stark contrast to the ubiquitous presence of Nationalism/Republicanism.

The onset of the Troubles in 1969 has further cemented the dominance of Irish Republican imagery in Northern Irish cinema, with films produced in and about the region ubiquitously focusing on IRA bombers, and the brutality of the British forces in films such as *The Crying Game* (Neil Jordan, 1992) and *The Boxer* (Jim Sheridan, 1997). Films such as *The Devil's Own* (Alan Pakula, 1997) and *Titanic Town* (Roger Michell, 2000) are typical of Troubles films set in Northern Ireland, with only minimal filming actually conducted in the region – *The Devil's Own* actually has none.

In the wake of the 1997 Good Friday Agreement and the perceived success of the Northern Irish Peace Process, the possibility of an alternative cinema that does not depend on trauma narratives has emerged. Yet this cinema remains fraught with cultural discrepancies and lacks a depiction of the 'Loyalist' or 'Unionist' contingent in anything other than a supporting role or as an oppressive stereotype. Despite a universal story-line of miscreant youth and sexual awakening, *Cherrybomb* (Lisa Barros D'Sa and Glenn Leyburn, 2009) retains a deep sub-textual 'Nationalist' coding (through subtleties like character names) which is perhaps unclear to those outside the region.

John Simpson's crime thriller *Freeze Frame* (2004) is one of several films that have emerged in the last decade which make use of Northern Irish writers, directors, crews, and locations, but do not directly depict the region itself. Instead, a non-descript Belfast is redressed for an unspecified English setting, presenting a complex essay on issues of surveillance and police corruption. The film is, arguably, representing British aspects of the country's culture and yet feels it has to distance itself from them. Yet it is near impossible to read any Northern Irish film dealing with representations of the police and security forces without thinking about the British presence in the province and the old Royal Ulster Constabulary (RUC). Conversely, Mark Hammond's film *Johnny Was* (2006) uses identifiable Belfast locations to represent Brixton in a bizarre film about Irish Republicans on the run in London. The film is explicitly Irish in its concerns, and yet is needlessly dressed with such 'Britishness'.

Within genre pieces it seems there is some hope for an emergent regional cinema which is concerned with something other than Northern Ireland's troubles which has dominated it for so long. A string of horror films including *Wilderness* (Michael J Bassett, 2006), *Shrooms* (Paddy Breathnach, 2007), *Puffball* (Nic Roeg, 2007) and *Wake Wood* (David Keating, 2010) avoid all mention of the political situation, but also present them-

selves as co-productions with filming split between both parts of the island, 'north' and 'south', and respective funding bodies Northern Ireland Screen and the Irish Film Board. *City of Ember* (Gil Kenan, 2008) used the new Paint Studios space at the former Harland and Wolff shipyard. It is an American-financed big-budget film (with little evidence of onscreen Northern Irish talent) co-produced by Tom Hanks and starring Bill Murray and Tim Robbins. Despite Murray's involvement, this science fiction narrative was disappointing at the box-office and met with poor critical reviews. Whilst offering an alternative to Troubles pictures the film arguably failed because it was deprived of the very things that would have set it aside – the Irish/Northern Irish element.

Whilst an indigenous film industry is possible, the content of recent films still tends to focus on the Troubles – what the Northern Irish playwright Darragh Carville refers to as 'Balaclava Dramas', such as Steve McQueen's *Hunger* (2008), Kari Skogland's *Fifty Dead Men Walking* (2008), Oliver Herschiegle's *Five Minutes of Heaven* (2009), etc. (See McDonald 2009). This prompts the question: is the cinema of Northern Ireland a National Cinema? The collective Northern Irish identity has so far been lost in the translation to screen. In the absence of a sustained body of films produced in the region, by an indigenous cast and crew, and funded by bodies within the region, one cannot yet point towards an identifiably Northern Irish national cinema. Northern Irish cinema in the twenty-first century will be vying for an identity it can claim for itself.

Robert JE Simpson and Chris Legge

Odd Man Out

Studio/Distributor:
Two Cities/General Film
Distributors

Director:
Carol Reed

Producers:
Carol Reed
Phil C Samuel

Screenwriters:
FL Green
RC Sherriff

Cinematographer:
Robert Krasker

Production Designer:
Ralph W Brinton

Editor:
Fergus McDonell

Composer:
William Alwyn

Duration:
116 minutes

Cast:
Cyril Cusack
FJ McCormick
James Mason
Robert Newton

Genre:
Crime drama

Year:
1947

Synopsis

In an unidentified Northern Irish town, a Republican cell is plotting a bank robbery to replenish the organization's dwindling funds. An alarm is triggered during the robbery and, in the struggle to escape, the group's leader Johnny McQueen accidentally shoots a man dead. Abandoned by his friends, the wounded McQueen darts through the back streets of the city in a frantic attempt to reach the docks and get a safe passage out of the country. Increasingly delirious, McQueen is plagued by increasingly surreal visions and faces a moral struggle as the British police draw ever closer.

Critique

Since its release in 1947, *Odd Man Out* has become the template for Northern Irish, Troubles films, in much the same way as *The Quiet Man* (John Ford, 1951) has become for films about Ireland. *Odd Man Out*'s central focus on a group of Republican terrorists, the sympathy portrayed for the 'cause' amongst the working-class inhabitants of Northern Ireland, and the oppressive, cold face of the British in the form of the police, resonate through cinema in the region.

Remarkably, whilst criticism of the film points to a Belfast setting, and the Republican organization being the IRA, neither are mentioned by name in the film. Carol Reed's crew shot some material on location in Belfast, but the bulk of the filming took place on sets built at Denham Studios in England. The iconographic skyline is undeniably Belfast (the Albert Clock is ubiquitous, and a replica of the city's distinctive Crown Bar are crucial to the plot), but this is a skewed vision of the city, in keeping with the chiaroscuro lighting and high dramatic tension dictated by the script and by Reed's directorial style. It is an English studio masquerading as somewhere resembling Belfast. Like Northern Ireland itself (and by extension Northern Irish cinema), this is a film struggling internally with its identity. Essentially it is a British film but one which shows an appreciation of the political divide in the country, with some balance towards both 'sides' of the about Northern Irish Troubles.

In casting matinée idol James Mason as the protagonist (Johnny McQueen), this cinematic portrayal of the Republican gains an air of romantic idealism – a clear marketing strategy that sparked a trend in casting attractive Hollywood actors as IRA members, most notably homaged fifty years later with the casting of Brad Pitt in *The Devil's Own* (Alan Pakula, 1997). *Odd Man Out* is peopled with curious national identities: William Hartnell's barman is undeniably English but shows a peculiar respect (or fear) for the ailing terrorist – an ambiguity not normally afforded the portrayal of British characters in cinema from/about the region; Eddie Byrne's dual role of policeman and skipper raises peculiar possibilities of him being an undercover policeman, enforcer and protector, Republican and Unionist, British and Irish.

Whilst pre-dating the recognized Troubles by some twenty years, this is very much a Troubles film. Complete with terrorists, acts of

violence, and the eternal struggle between the Irish nationals (the underdogs) and the British 'oppressors'. Ultimately, *Odd Man Out* is a morality tale which suggests that, regardless of the ideology, terrorist allegiance is a doomed position. Whilst their presence is tolerated (either through fear or sympathy), at every step along the way the members of the cell find themselves being expelled from sanctuary – that of the boarding house, the pub, the squat and even the church. McQueen is gunned down not merely because he is a Republican, but because he himself killed a man in cold blood.

Robert JE Simpson

Hunger

Studio/Distributor:
Blast, Film4/Icon

Director:
Steve McQueen

Producers:
Robin Gutch
Laura Hastings-Smith

Screenwriters:
Steve McQueen
Enda Walsh

Cinematographer:
Sean Bobbitt

Production Designer:
Tom McCullagh

Editor:
Joe Walker

Composer:
David Holmes
Leo Abrahams

Duration:
96 minutes

Cast:
Liam Cunningham
Michael Fassbender
Stuart Graham
Brian Milligan

Genre:

Synopsis

Davey Gillen is an IRA volunteer sentenced to six years in Northern Ireland's notorious Maze Prison. Frequently subjected to brutal attacks by British prison officers, Gillen, along with fellow Republican inmates, take part in the infamous Blanket and No-Wash protests to remonstrate against their mistreatment and the British government's refusal to grant them the status of political prisoners. As the protests fail and the beatings worsen, IRA Officer Commanding Bobby Sands leads a new hunger strike, refusing to eat until the British government acknowledges the IRA as a legitimate political organization.

Not everyone is convinced by the strike, however – least of all Father Dominic Moran who questions Sands' motives and the effectiveness of the strike. As conversation between Sands and Father Moran intensifies it becomes apparent that, if anything, the priest's visit has made Sands more determined. News of Sands' strike reaches the attention of the international media and, as his fragile condition slowly deteriorates Sands' emaciated body eventually succumbs to his self-imposed torture.

Critique

Hunger, the feature film debut by British Turner Prize winning artist-turned-film-maker, Steve McQueen, depicts the 1981 hunger strike, staged by Republican prisoners in Northern Ireland's infamous Maze Prison (also known as Long Kesh) in a bid to regain political prisoner status. The Troubles have been the predominant focus of many films to come out of Northern Ireland. Few, though, have been as provocative or as compelling as *Hunger*. Indeed, the film won numerous awards, including the prestigious Camera d'Or at Cannes in 2008.

McQueen resists conventions commonly associated with docu-drama and approaches his subject in a more austere, yet beautifully haunting way. The film unfolds in three distinct acts, each different in mood and method of inquiry. The first follows a troubled prison officer (Stuart Graham) in his daily routine: bathing his bruised knuckles, changing into neatly pressed clothes, eating breakfast and checking for bombs under his car before leaving for work.

Drama

Year:
2008

After this unnerving scene the rest of the film is set almost entirely within the claustrophobic confines of the Maze prison H-blocks.

In this hellish environment McQueen evokes the nauseous reality of the 'dirty protests', in which prisoners took to flooding corridors with urine and smearing faeces on walls. One can almost smell the heavy stench of excreta, rotting food and unwashed bodies. Equally disconcerting are the brutal beatings, the demoralizing cavity searches, force-feeding and forced baths. If there is any sense of reprieve in this sickening atmosphere it is the otherwise stomach-turning images of flies, rotting food, infested with maggots, or a disgusting yet, strange to say, aesthetically-compelling motif of a spiral created from shit.

Whereas the first act is nearly silent, the second is talk. *Hunger*'s centrepiece is a master class in acting in the second act between Michael Fassbender's Sands and Liam Cunningham's tough-talking Father Dominic Moran, in which the moral and political ramifications of Sands' proposed actions are heavily discussed. McQueen sets most of this as a 17-minute-long, static shot of the two men facing each other across a table, smoking. From his point of no return, the film observes the Sands' painful demise and physical deterioration. Fassbender's performance is ferociously convincing, as is his emaciated appearance, so much so, that it is almost unbearable to watch. As in the first act, the dialogue is minimal, the camera pervasive.

Despite its controversial subject matter, *Hunger* is not a political film. Rather, it is something much starker, more visceral. Although McQueen's sympathies clearly lie with the prisoners, his preoccupations are more existential than political. There is evident concern for human cost on both sides of the political divide, not only in the violence directed towards the prisoners, but in showing a riot guard breaking down in tears and the brutal execution of a prison officer in front of his elderly mother. Ultimately, McQueen focuses on the human cost of the strike rather than its political impact.

Chris Legge

Cherrybomb

Studio/Distributor:
Generator
Green Park/Universal

Directors:
Lisa Barros D'Sa
Glenn Leyburn

Producers:
Simon Bosanquet
Michael Casey

Synopsis

With their exams over, best friends Malachy and Luke are ready to enjoy what could be their last summer together when a mysterious blonde girl arrives on the scene. Michelle has moved back to Belfast from London to live with her father, and Malachy and Luke are both instantly smitten. But the object of their desires is actually the wayward daughter of Malachy's boss at the local leisure centre. Michelle plays a ruthless game of cat and mouse as the two boys battle for her affections, testing the limits of their friendship to see how far they will go. What was meant to be an idyllic summer, before the boys go their separate ways, quickly turns into a hedonistic turmoil of binge drink, drugs, sex and joyriding that has potentially dire consequences.

Mark Huffam
Brian Kirk

Screenwriter:
Daragh Carville

Cinematographer:
Damien Elliott

Production Design:
David Craig

Editor:
Nick Emerson

Composers:
David Holmes
Stephen Hilton

Duration:
86 minutes

Cast:
Rupert Grint
James Nesbitt
Kimberley Nixon
Robert Sheehan

Genre:
Drama

Year:
2009

Critique

Cherrybomb is a coming-of-age drama set against the backdrop of contemporary, Troubles-free Belfast. The film is the joint debut feature of Belfast-based, award winning shorts directors Glenn Leyburn (a native of Northern Ireland) and Lisa Barros D'Sa, and features a score by acclaimed Belfast-based Hollywood composer and Steven Soderbergh-collaborator, David Holmes.

While the idea behind *Cherrybomb* is generic – plots involving teen love triangles, binge drinking, and experiments with drugs and sex are plentiful – the teen film is a new genre trend in films made in and about Northern Ireland over the last decade. For many years the region was only known in cinema through its association with the Troubles. This has continued with the recent success of film and TV dramas such as *Fifty Dead Men Walking*, *Hunger* and *Five Minutes of Heaven*. More recently, however, the trend has shifted from 'gritty' thrillers to relatively-low-budget features about Northern Ireland or using it as a back-lot. In a further bid to boost the region's fledgling film industry and establish box-office potential, recent productions bring in big-name actors from outside Northern Ireland, such as Heather Graham, Gillian Anderson, Tim Robbins, Donald Sutherland, Bill Murray, Ben Kingsley, Michael Fassbender and Rupert Grint.

Most of *Cherrybomb*'s initial attraction must be attributed to Grint's involvement and ardent fan base – the film was without a distributor until fans of the Harry Potter star started an online petition. Despite an admirable attempt at the local accent, it is impossible to see Grint as anything other than Ron Weasley, albeit a Northern Irish one who takes drugs, drinks, joyrides and tries to pull girls. Indeed, much of the hype surrounding the film was concerned with Grint being in a sex scene. No doubt this was an attempt to give the film an 'edgier' appeal, however it was likely lost on contemporary youth – certainly on viewers of the controversial Channel 4 teen series *Skins*.

Despite being a commercial disappointment and receiving lukewarm critical reviews, *Cherrybomb* is still an interesting film that eschews the conventions commonly associated with films to come out of Northern Ireland. There are no references to the 'Troubles legacy', and the focus is almost entirely on universal issues of teenage rebellion and adolescent angst. Whilst it would be wrong to repress Northern Ireland's troubled past and pretend it never existed, there is room for other stories to be made in Northern Ireland and *Cherrybomb* is proof of this. However, *Cherrybomb*'s narrative does retain a stark violence that triggers more subtle associations, with scenes of domestic abuse, illicit drug trade, near-tribal paint throwing, explosions (in the form of fireworks) and a brutal beating.

Remarkably for a film from Northern Ireland, *Cherrybomb*'s three 'adolescent' leads are not from the region. Nonetheless, much of the film's production was indigenous: it was written by Daragh Carville – writer of the critically acclaimed *Middleton* – shot entirely on location in Northern Ireland, and as produced in association with Northern Ireland Screen and with the participation of the Irish Film Board.

Chris Legge and Robert JE Simpson

RECOMME READING

Aitken, Ian (1992) *Film and Reform: John Grierson and the Documentary Film Movement*. London: Routledge.

Aldgate, Anthony & Richards, Jeffrey (2009) *Best of British: Cinema and Society from 1930 to the Present* (2nd edition). London: IB Tauris.

Alexander, K (2000) 'Black British Cinema in the 90s: Going Going Gone' in R Murphy (ed) *British Cinema of the 90s*, London: BFI, pp. 109–14.

Ashby, Justine & Higson, Andrew (eds) (2000) *British Cinema: Past and Present*. London: Routledge.

Bailey, C (1992) 'What the Story Is: An Interview with Srinivas Krishna', *CineAction*, 28: 38–47.

Barnes, Alan & Hearn, Marcus (eds) (2007) *The Hammer Story: The Authorised History of Hammer Films*. London: Titan Books.

Barnes, John (1998) *The Beginnings of the Cinema in England 1894–1901, Vol.1: 1894–1896* (Second edition) Exeter: University of Exeter Press.

Barr, Charles (1977) *Ealing Studios*. London: Studio Vista.

Barry, Iris (1926) *Let's Go the Pictures*. London: Chatto and Windus.

Bell, Melanie (2009) *Femininity in the Frame: Women and 1950s British Popular Cinema*. London: IB Tauris.

Bell, Melanie & Williams, Melanie (eds) (2009) *British Women's Cinema*. London: Routledge.

Berry, David (1996) *Wales and Cinema*. Cardiff: University of Wales Press.

Blandford, Steve (2007) *Film, Drama and the Break-Up of Britain*. Bristol and Chicago: Intellect.

Boot, Andy (1996) *Fragments of Fear: An Illustrated History of British Horror Films*. London: Creation Books.

Bordwell, David (2002) 'The Art Cinema as a Mode of Film Practise' in Catherine Fowler, (ed) *The European Cinema Reader*, London: Routledge, pp. 94–102.

Bourne, Stephen (2001) *Black in the British Frame: The Black Experience in British Film and Television* (2nd edition). London: Continuum.

Bright, Morris (2007) *Pinewood Studios, 70 Years of Fabulous Film-making*. London: Carroll and Brown Publishers Ltd.

Brown, Allan (2000) *Inside The Wicker Man: The Morbid Ingenuities*. London: Sidgwick & Jackson.

Brownlow, Kevin (1997) *David Lean: A Biography*. London: Faber and Faber.

Brunsdon, Charlotte (2007) *London in Cinema: The Cinematic City Since 1945*. London: BFI.

Bryce, Allan (2000) *Amicus: The Studio That Dripped Blood*. Plymouth: Stray Cat Publishing.

Burrows, Jon (2003) *Legitimate Cinema: Theatre Stars in Silent British Films, 1908–1918*. Exeter: University of Exeter Press.

Catterall, Ali & Wells, Simon (2002) *Your Face Here: British Cult Movies Since the Sixties*. London: Fourth Estate.

Caughie, John (2000) *Television Drama: Realism, Modernism and British Culture*. London: Clarendon Press.

Chandler, Raymond (1979), 'The Simple Art of Murder' in *The Second Chandler Omnibus*, London: Book Club Associates, pp. 3–15.

Chapman, James (1998) *The British at War: Cinema, State and Propaganda 1939–1945*. London: IB Tauris.

Charlesworth, Michael (2011) *Derek Jarman (Critical Lives)*. London: Reaktion Books.

Chibnall, Steve & McFarlane, Brian (2009) *The British 'B' Film*. London: BFI.

Chibnall, Steve & McFarlane, Brian (2006) *Quota Quickies: The Birth of the British 'B' Film*. London: BFI.

Chibnall, Steve & Murphy, Robert (eds) (1999) *British Crime Cinema*. London: Routledge.

Chibnall, Steve & Petley, Julian (2001) *British Horror Cinema*. London: Routledge.

Claydon, E Anna (2009) 'British-South Asian Cinema and Identity II: 'When did Mr Collins become the "Ugly American"? Representing America in the films of Gurinder Chadha', *South Asian Cultural Studies*, 2: 2, pp. 27–58.

Claydon, E Anna (2008) 'British South-Asian Cinema and Identity I: 'Nostalgia in the Post-National: Contemporary British Cinema and the South-Asian Diaspora', *South Asian Cultural Studies*, 2: 1, pp. 26–38.

Claydon, E Anna (2005) *The Representation of Masculinity in British Cinema of the 1960s:* Lawrence of Arabia, The Loneliness of the Long Distance Runner *and* The Hill. Ceredigion: Edwin Mellen Press.

Cook, Pam (2005) *Screening the Past: Memory and Nostalgia in Cinema*, London: Routledge.

Cook, Pam (1997) *Gainsborough Pictures*. London: Cassell.

Cook, Pam (1996) *Fashioning the Nation: Costume and Identity in British Cinema*. London: BFI.

Cox, Alex (2003) 'A Call To Arms' Speech to the Independent Film Parliament, Cambridge.

Craig, Cairns (1991) 'Rooms without a View', *Sight and Sound*, 1:6.

Dave, Paul (2006) *Visions of England: Class and Culture in Contemporary Cinema*. Oxford: Berg Publishers.

Deleuze, Gilles (1989) *Cinema 2: The Time-Image*. Trans. Hugh Tomlinson & Robert Galeta. Minneapolis: University of Minnesota Press.

Dickinson, Margaret (ed.) (1999) *Rogue Reels: Oppositional Film in Britain 1945–90*. London: BFI.

Dickinson, Margaret & Street, Sarah (1985) *Cinema and State: Film Industry and the Government 1927–1984*. London: BFI.

Dickson, William Kennedy-Laurie & Dickson, Antonia (1895) *History of the Kinetograph, Kinetoscope and Kineto-Phonograph*. New York: Albert Bunn; rpt. 1970, Arno Press.

Docherty, David; Morrison, David, & Tracey, Michael (1987) *Last Picture Show?: Britain's Changing Film Audiences*. London: BFI.

Donnelly, KJ (2002) *Pop Music in British Cinema*. London: BFI.

Duguid, Mark (2006) 'Fantastic Life' BFI. http://www.bfi.org.uk/features/pilgrims/fantastic.html. Accessed 23 September 2011.

Durgnat, Raymond (2009) 'Some Lines of Inquiry into Post-war British Crimes' in Robert Murphy (ed) *The British Cinema Book*. London: BFI, pp. 247–58.

Dyer, Richard (2002) *The Culture of Queers*. London: Routledge.

Elseasser, T (1972/1987) 'Tales of Sound and Fury: Observations on the Family Melodrama' in C Gledhill (ed) *Home is Where the Heart is: Studies in Melodrama and the Woman's Film*. London: BFI, pp. 43–69.

Eshun, Kodwo & Sagar, Anjalika (eds) (2007) *The Ghosts of Songs: The Art of the Black Audio Film Collective*. Chicago: Chicago University Press.

Farber, M & Patterson, Patricia (1977) 'Beyond the New Wave: I. Kitchen Without Kitsch', *Film Comment*, Nov–Dec.

Fowler, Catherine (2008) *Sally Potter (Contemporary Film Directors)*. Champaign: University of Illinois Press.

Friedman, Lester D (ed) (2006) *Fires Were Started: British Cinema and Thatcherism* (2nd edition) London: Wallflower Press.

Geraghty, Christine (2000) *British Cinema in the Fifties: Gender, Genre and the 'New Look'*. London: Routledge.

Gledhill, Christine (2007) 'Reframing Women in 1920s British Cinema: the Case of Violet Hopson and Dinah Shurey', *Journal of British Cinema and Television*, 4.1: pp. 1–17.

Gledhill, Christine (2003) *Reframing British Cinema 1918–1928: Between Restraint and Passion*. London: BFI.

Gledhill, Christine & Swanson, Gillian (eds) (1996) *Nationalising Femininity: Culture, Sexuality and British Cinema in the WWII*. Manchester: Manchester University Press.

Gray, Frank. (1998) 'Robert Paul in 1896: Innovation, Success and Wonder' in Claire Dupré de la Tour, André Gaudreault & Roberta Pearson (eds) *Cinema at the Turn of the Century*. Quebec: Éditions Nota bene, 1998), pp. 325–33.

Gray, Frank (1996) *The Hove Pioneers and the Arrival of Cinema*. Brighton: University of Brighton.

Gray, Frank; Medhurst, Andy; Chibnall, Steve & Coleby, Nicola (eds) (2002) *Kiss and Kill: Film Visions of Brighton*. Brighton: Royal Pavilion, Libraries and Museums, Brighton.

Grierson, John (1933) 'Propaganda: a problem for Educational theorists'. In: *Sight and Sound*, 2:8, pp. 119–21.

Griffiths, Robin (ed) (2006) *British Queer Cinema*. London: Routledge.

Gunning, T (1995) 'Crazy Machines in the Garden of Forking Paths: Mischief Gags and the Origins of American Film Comedy' in K Brunovska Karnick & H Jenkins (eds) *Classical Hollywood Comedy*, London: Routledge, pp. 87–105.

Hammond, Michael & Williams, Melanie (2011) *British Silent Cinema and WWI*. London: Palgrave Macmillan.

Hanson, Stuart (2007) *From Silent Screen to Multi-screen: A History of Cinema Exhibition in Britain Since 1896*. Manchester: University of Manchester Press.

Harper, Sue (2000) *Women in British Cinema: Mad, Bad and Dangerous to Know*. London: Continuum.

Hayward, Anthony (2004) *Which Side Are You On? Ken Loach and His Films*. London: Bloomsbury Publishing.

Hendricks, Gordon (1966) *The Kinetoscope: America's First Commercially Successful Motion Picture Exhibitor*. New York: The Beginnings of the American Film.

Hepworth, Cecil (1897) *Animated Photography. The ABC of the Cinematograph* (London: Hazell, Watson & Viney.

Higson, A (2000), 'The Instability of the National' in Justine Ashby & Andrew Higson (eds) *British Cinema: Past and Present*. London: Routledge, pp. 35–49.

Higson, Andrew (2011) *British Silent Cinema*. Exeter: University of Exeter Press.

Higson, Andrew (2010) *Film England: Culturally English Film-making Since the 1990s*. London: IB Tauris.

Higson, Andrew (2006 [1993]) 'Re-presenting the National Past: Nostalgia and Pastiche in the Heritage Film' in Lester Friedman (ed) *Fires Were Started: British Cinema and Thatcherism* (2nd edition), London: Wallflower, pp. 91–109.

Higson, Andrew (2003) *English Heritage, English Cinema: Costume Drama Since 1980*. Oxford: Oxford University Press.

Higson, Andrew (1997) *Waving the Flag: Constructing a National Cinema in Britain*. Oxford: Clarendon Press.

Higson, Andrew (ed.) (1996) *Dissolving Views: Key Writings on British Cinema*. London: Cassell.

Higson, Andrew (1995) *Waving the Flag: Constructing a National Cinema in Britain*. Oxford: Clarendon Press.

Hill, John (2000) 'The Rise and Fall of British Art Cinema: A Short History of the 1980s and 1990s', *Aura* 6:3, pp. 18–32.

Hill, John (2006) *Cinema and Northern Ireland: Film, Culture and Politics*. London: BFI.

Hill, J (2004) 'UK Film Policy, Cultural Capital and Social Exclusion', *Cultural Trends*, 13: 2, pp. 29–40.

Hill, John (1999) *British Cinema in the 1980s: Issues and Themes*. Oxford: Oxford University Press.

Hill, John (1986) *Sex, Class and Realism: British Cinema 1956-1963*. London: BFI.

Hogan, Patrick Holm (2008) *Understanding Indian Cinema*. Austin: Texas University Press.

Holmes, Su (2005) *British TV and Film Culture of the 1950s: Coming to a TV Near You*. Bristol and Chicago: Intellect.

Hopwood, Henry (1899) *Living Pictures: Their History and Photo-Production and Practical Working*. London: The Optician and Photographic Trades Review.

Hunter, IQ (ed) (1999) *British Science Fiction Cinema*. London: Routledge.

Hunter, Jack (ed) (1996) *House of Horror: The Complete Hammer Films Story*. London: Creation Books.

Jarman, Derek (1984) *Dancing Ledge*. London: Quartet Books.

Johnson, William (1980) '*Peeping Tom*: a Second Look'. *Film Quarterly*, 33:3, pp. 2–10.

King, Geoff (2002), *Film Comedy*. London: Wallflower.

Landy, Marcia (1991), *British Genres: Cinema and Society 1930–1960*. Princeton: Princeton University Press.

Lant, Antonia (1991) *Blackout: Reinventing Women for Wartime British Cinema*. Princeton: Princeton University Press.

Lay, Samantha (2002) *British Social Realism: From Documentary to Brit-Grit*. London: Wallflower Press.

Leggott, James (2008) *Contemporary British Cinema: From Heritage to Horror*. London: Wallflower Press.

Lindgren, Ernest (1948) *The Art of the Film*, London: George Allen and Unwin.

Lowenstein, Adam (2000) '"Under-the-Skin Horrors": Social Realism and Classlessness in *Peeping Tom* and the British New Wave' in Justine Ashby & Andrew Higson (eds) *British Cinema Past and Present*, London: Routledge, pp 221–32.

McDonald, Henry (2009), 'Writer wants an end to "balaclava drama": Darragh Carville calls for post-Troubles work about the new Northern Ireland', *The Observer*, 26 April.

McFarlane, Brian (2008) *The Encyclopaedia of British Film* (3rd edition). London: Methuen Publishing Ltd.

Mackenzie, SP (2006) *British War Films, 1939–1945: The Cinema and the Services*. London: Continuum.

Malik, S (1996) 'Beyond "The Cinema of Duty"? The Pleasures of Hybridity: Black British Cinema of the 80s and 90s' in Andrew Higson (ed) *Dissolving Views: Key Writings of British Cinema*, London: Cassell, pp. 202–15.

Martin-Jones, David (2010) *Scotland: Global Cinema: Genres, Modes and Identities*. Edinburgh: Edinburgh University Press.

Meadows, Shane (2007) 'Under My Skin', *The Guardian* (Film section), 21 April.

Medhurst, Andy (2007) *A National Joke: Popular Comedy and English Cultural Identities*. London: Routledge.

Miskell, Peter M (2006) *A Social History of the Cinema in Wales, 1918–1951: Pulpits, Coalpits and Fleapits*. Cardiff: University of Wales Press.

Mitchell, Neil (ed) (2011) *World Film Locations: London*. Bristol and Chicago: Intellect.

Monk, Claire & Sargeant, Amy (eds.) (2002) *British Historical Cinema*, London: Routledge.

Moor, Andrew (2005) *Powell and Pressburger: A Cinema of Magical Spaces*. London: IB Tauris.

Morris, Nathalie (2008), 'The Early Career of Alma Reville' in Richard Allen & Sid Gottlieb (eds), *The Hitchcock Annual Anthology*, London: Wallflower Press, pp 41–65.

Murphy, Robert (1989) *Realism and Tinsel: Cinema and Society in Britain 1939–1949*. London: Routledge.

Murphy, Robert (ed) (2009) *The British Cinema Book* (3rd Edition). London: Palgrave MacMillan/BFI.

Murphy, Robert (ed) (2000) *British Cinema of the 90s*. London: BFI.

Murphy, Robert (1992) *Sixties British Cinema*. London: BFI.

Neale, Steve (2002) 'The Art Cinema as Institution' in Catherine Fowler (ed) *The European Cinema Reader*. London: Routledge, pp. 103–20.

Newland, Paul (ed.) (2010) *Don't Look Now: British Cinema in the 1970s*, Bristol and Chicago: Intellect.

Norman, Barry (1998) *100 Best Films of the Century*, Revised Edition, London: Orion Publishing.

Nowell-Smith, G (1987) 'Minnelli and Melodrama' in C Gledhill, (ed) *Home is Where the Heart is: Studies in Melodrama and the Woman's Film*. London: BFI, pp. 70–74.

Petrie, Duncan (2000) *Screening Scotland*. London: BFI.

Phillips Ray (1977) *Edison's Kinetoscope and its Films: A History to 1896*. Trowbridge: Flicks Books.

Pidduck, Julianne (2004) *Contemporary Costume Film: Space, Place and the Past*. London: BFI.

Pines, J (1997) 'Black Cinema and Black Representation' in R Murphy (ed) *The British Cinema Book*. London: BFI, pp. 207–17.

Pirie, David (2009) *A New Heritage of Horror: The English Gothic Cinema* (updated edition). London: IB Tauris.

Potter, Sally (1984) 'British Independents: *The Gold Diggers*: An In-Depth Interview with Pam Cook, London, February, 1984', reprinted 2009 in *The Gold Diggers* DVD booklet, London: BFI, pp. 9–27.

Powell, Michael (1986) *A Life in Movies: An Autobiography*. London: Heinemann.

Richards, Jeffrey (2009) *The Age of the Dream Palace: Cinema and Society in 1930s Britain*. London: IB Tauris.

Rose, James (2009) *Beyond Hammer: British Horror Cinema Since 1970*. Leighton Buzzard: Auteur.

Ross, Robert (2008) *The Carry On Story: 50th Anniversary Edition*. Richmond: Reynolds and Hearn Ltd.

Rotha, Paul (1930) *The Film Till Now*. London: Jonathan Cape.

Russell, Ken (1993) *Fire Over England*. London: Random House.

Russell, Patrick & Taylor, James (eds) (2010) *Shadows of Progress: Documentary Film in Post-war Britain*. London: BFI.

Ryall, T (1997) 'A British Studio System: The Associated British Picture Corporation and the Gaumont-British Picture Corporation in the 1930s' in R Murphy (ed) *The British Cinema Book*. London: BFI, pp. 27–36.

Sargeant, Amy (2005) *British Cinema: A Critical History*. London: BFI.

Schmuel, Corinne (2010) 'Erasing David: An Interview with Melinda McDougall', Bird's Eye View, www.birds-eye-view.co.uk/news/2010/05/04/erasing-david-an-interview-with-melinda-mcdougall/. Accessed 11 May 2010.

Shail, Robert (ed) (2008) *Seventies British Cinema*. London: BFI.

Shail, Robert (2007) *British Film Directors: A Critical Guide*. Edinburgh: Edinburgh University Press.

Smith, Justin (2010) *Withnail and Us: Cult Films and Film Cults in British Cinema*. London: IB Tauris.

Spicer, Andrew (2001) *Typical Men: The Representation of Masculinity in Popular British Cinema*. London: IB Tauris.

Steele, D (2004) 'Developing the Evidence Base for UK Film Strategy', *Cultural Trends*, Vol.13:4.

Street, Sarah (2008) *British National Cinema* (2nd Edition). London: Routledge.

Street, Sarah (2000) *British Cinema in Documents*. London: Routledge.

Street, Sarah (1997) *British National Cinema*. London: Routledge.

Street, Sarah & Dickinson, Margaret (1985) *Cinema and State: the Film Industry and the British Government, 1927–84*. London: BFI.

Street, Sarah & Fitzsimmons, Linda (eds) (2000) *Moving Performance: British Stage and Screen, 1890s–1920s*. London: Flicks Books.

Sutton, David R (2000) *A Chorus of Raspberries: British Film Comedy, 1929–1939*.

Exeter: University of Exeter Press.

Swann, Paul (1989) *The British Documentary Film Movement 1926–1946*. Cambridge: Cambridge University Press.

Sweet, Matthew (2006) *Shepperton Babylon: The Lost Worlds of British Cinema*. London: Faber and Faber.

Threadgall, Derek (1994) *Shepperton Studios*. London: BFI.

Tynan, Kenneth (1965) 'Identikit Girl on the Make', *The Observer*, 19 September: p 24.

Vincendeau, Ginette (2001) (ed) *Film/Literature/Heritage: a Sight and Sound Reader*. London: BFI.

Voigts-Virchow, Eckart (ed) (2004) *Janespotting and Beyond: British Heritage Retrovisions Since the Mid-1990s*. Tubingen: Gunter Narr Verlag Tubingen.

Walker, Alexander (2004) *Icons in the Fire: The Rise and Fall of Practically Everyone in the British Film Industry 1984–2000*. London: Orion.

Walker, Alexander (1985) *National Heroes: British Cinema in the Seventies and Eighties*. London: Harrap.

Walker, Alexander (1974) *Hollywood, England: The British Film Industry in the Sixties*. London: Joseph.

Watson, Garry (2004) *The Cinema of Mike Leigh: A Sense of the Real*. London: Wallflower Press.

Wollen, Tana (1991). 'Over Our Shoulders: Nostalgic Screen Fictions for the 1980s' in John Corner & Sylvia Harvey (eds) *Enterprise and Heritage: Crosscurrents of National Culture*, London: Routledge, pp. 45–75.

Wollen, Peter (2006) 'The Last New Wave: Modernism in the British Films of the Thatcher Era' in Lester Friedman (ed) *Fires Were Started: British Cinema and Thatcherism*. London: Wallflower, pp. 35–51.

Wood, Robin (1986), *Hollywood from Vietnam to Reagan*. New York: Columbia University Press.

Industry Reports Cited:

Cinema Exhibitors Association *(2007) Annual Report*.

Department for Culture Media and Sport (2008) *Creative Britain*.

Silver, J & Alpert, F (Sep-Oct 2003) *Digital Dawn: Business Horizons*.

Silver, J & McDonnel, J (2007) *Are Movie Theatres Doomed? Business Horizons*.

UK Film Council (2009) *Stories We Tell Ourselves: the Cultural Impact of UK Film, 1946–2006*.

UK Film Council (2008) *Statistical Handbook*.

UK Film Council (2007) *Crossing Boundaries*.

UK Film Council (2005) *Impact of Local Cinemas*.

UK Film Council (2002) *UKFC Specialised Distribution and Exhibition Strategy*.

BRITISH CINEMA ONLINE

Bill Douglas Centre
www.billdouglas.org
The Bill Douglas Centre at the University of Exeter has a vast collection of material relating to the history of film and visual media.

British Academy of Film and Television Arts
www.bafta.org
The British Academy of Film and Television Arts, with archives, awards information and what's on links.

British Board of Film Classification
www.bbfc.co.uk
The British Board of Film Classification is the regulator of the moving image (especially film, video/DVD and video games), and also a service provider for new and developing media.

British Film Institute
www.bfi.org.uk
The British Film Institute has vast national film archives with online research tools, databases and cinema listings, including the BFI Southbank film theatre and the *Sight and Sound* film magazine.

British Women's Film
www.birds-eye-view.co.uk
Birds Eye View celebrates and supports international women film-makers. It started as the British women's film festival but is now extending its activities.

British Film Locations
www.reelstreets.com
British film locations, including contemporary photographs of locations.

British Horror Films
www.britishhorrorfilms.co.uk
Website devoted solely to British horror films.

British Pathé
www.britishpathe.com
World news, entertainment and video film archive covering the period
1896–1976.

Britmovie
www.britmovie.co.uk
Films, actors, directors and studios from all eras of British cinema.

The Cinema Museum
www.cinemamuseum.org.uk
The Cinema Museum, based in London, has a vast collection of equipment,
props and memorabilia from the 1890s to the present as well as temporary exhi-
bitions and screenings.

Carry On *films*
www.carryon.org.uk
Everything related to the *Carry On* series.

Creative Scotland
www.creativescotland.com/arts-screen-and-creative-industries/screen
Film production in Scotland, including investment, education and showcasing of
emerging talent.

Directors UK
www.directors.uk.com
The voice of British film and television directors established to improve the rec-
ognition, status, pay and creative conditions for British-based directors.

Documentary Film-makers Group
www.thedfg.org
The Documentary Film-makers Group works to promote documentary film-
making talent and innovation in Britain. Supported by The Grierson Trust as part
of the Sheffield Doc/Fest.

East Anglian Film Archives
www.eafa.org.uk
The East Anglian Film Archives, covering Bedfordshire, Cambridgeshire, Essex,
Hertfordshire, Norfolk and Suffolk.

Ealing Studios
www.ealingstudios.co.uk
The world's oldest working film studio, detailing its history and current productions.

Film Directing4Women
www.filmdirecting4women.co.uk
Support, training and showcase opportunities for aspiring female film-makers in Britain.

Film Education
www.filmeducation.org
A charity supported by the British film industry to promote and support the use of film within the curriculum.

Film London
www.filmlondon.org.uk
London film and media agency dealing with funding, talent, business, training and the London Screen Archives.

Hammer Films
www.hammerfilms.com
Online site for the famous studio, detailing its history and current productions.

Journal of British Cinema and Television
www.euppublishing.com/journal/jbctv
Edinburgh University Press's *Journal of British Cinema and Television.*

The Media Archive
www.macearchive.org
The Media Archive for Central England has a collection of film, videotape and digital moving images from the nineteenth-century to the present day.

The National Film and Television School
www.nftsfilm-tv.ac.uk
The National Film and Television School is the UK's national centre of excellence for postgraduate education.

The National Media Museum
www.nationalmediamuseum.org.uk
The National Media Museum in Bradford has an extensive collection of all aspects of film, television, photography and radio production in Britain.

National Screen and Sound Archives of Wales
www.archif.com
Welsh films, television programmes, videos, sound recordings and music, available in the Welsh and English languages.

Northern Ireland Screen
www.northernirelandscreen.co.uk
Film production in Northern Ireland, including investment, funding, education, archiving and exhibition.

The Northern Region Film and Television Archive
www.nrfta.org.uk
The Northern Region Film and Television Archive at the University of Teesside.

The North West Film Archive
www.nwfa.mmu.ac.uk
The North West Film Archive preserves moving images made in, or about, Greater Manchester, Lancashire, Cheshire, Merseyside and Cumbria.

Pinewood
www.pinewoodgroup.com
The Pinewood Group's film studios, including Pinewood Studios, Shepperton Studios and Teddington Studios.

Scotland – Movie Location Guide
www.scotlandthemovie.com
Scottish film and TV locations arranged by region.

Scottish Screen Archive
www.ssa.nls.uk
Scottish Screen Archive, preserving over one hundred years of Scottish film and video.

Screen Archive South East
www.brighton.ac.uk/screenarchive
Screen Archive South East preserves all aspects of screen media, from the magic lantern to DVD, with films and research materials.

The South West Film and Television Archive
www.swfta.org.uk
The South West Film and Television Archive, from the 1880s to the present day.

Welsh film
www.filmagencywales.com
The national development agency for the Welsh film industry.

Wessex film and Sound Archive
www3.hants.gov.uk/wfsa.htm
Wessex Film and Sound Archive of Central Southern England, covering the nineteenth-century to the present day.

Women and Silent British Cinema
www.womenandsilentbritishcinema.wordpress.com
Collates and shares research undertaken on women in silent British cinema.

Yorkshire Film Archive
www.yorkshirefilmarchive.com
The Yorkshire Film Archive with over one hundred years of film and video.

Questions

1. Which British photographer is often cited as the 'father of cinema'?
2. Which British pioneer showed the first British Kinetoscope films, and when?
3. Where did George Albert Smith establish his 'film factory' in 1897?
4. In which year did Ealing Studios open for business?
5. What did the 1927 Cinematograph Films Act aim to do?
6. Which British studio did Warner Bros. purchase in 1931?
7. In which year was the Edinburgh Film Festival established?
8. When was The British Board of Film Censors created?
9. Which critic wrote in 1926, the 'one thing never to be lost sight of in considering the cinema is that it exists for the purpose of pleasing women'?
10. At which British studio were the *Harry Potter* films shot?
11. Which female producer began her long and successful career in the 1940s?
12. What was David Lean's first feature film?
13. What was the name of Powell and Pressburger's production company?
14. What was Shane Meadows' first film?
15. Which British studio became associated with melodrama in the 1940s?
16. Who directed the Oscar winning short film *Wasp*?
17. What was the name of the first feature-length film to be directed by a black British director, and who was that director?
18. Gurinder Chadha's *Bride and Prejudice* was a co-production between Britain and which other country?
19. Which film, directed by Tony Young, was the most high profile release for the Brighton Film Studios?
20. A Victorian-era poisoning case provided the inspiration for which Brighton-set film by Robert Hamer?
21. Which of his own films did Shane Meadows describe as a 'crock of shit'?
22. Which British studio is most readily associated with horror films?
23. 1969 saw the release of a popular adaptation of a DH Lawrence novel. What was it and who directed it?
24. Who suggested the British style of violence may be subtler than the direct Hollywood approach?
25. What is the name of the serial killer in Michael Powell's *Peeping Tom*, and who played him?
26. Basil Dearden directed Dirk Bogarde in which ground-breaking crime drama of 1961?

27. Which leading female star of the 1920s was most associated with the character 'Squibs'?
28. In 1954, who appeared in drag as Miss Fritton in *The Belles of St. Trinian's*?
29. When did the term 'heritage film' emerge in British cinema?
30. Which production company was responsible for the resurgence of quality British heritage cinema in the 1980s?
31. Which heritage film helped establish Working Title as a powerful British player?
32. In which two films can the origins of British horror cinema be found?
33. What was Britain's first feature-length horror film?
34. Which two small British production companies released a number of horror films during the period of Hammer Studios' dominance of the genre?
35. The late 1950s and early 1960s saw the release of a number of films bracketed under which catch all title?
36. Which state-of-the-nation film did Stephen Frears direct in 1985?
37. Which film did Ken Russell christen Britain's first art film?
38. Which trilogy of short films was funded by the British Film Institute between 1972 and 1978?
39. Which film gave noted Cinematographer and director Chris Menges his first credit?
40. Where and when did Chris Petit's *Radio On* have its première?
41. Which film-maker coined the term 'documentary'?
42. When the GPO Film Unit became the Crown Film Unit, who assumed control?
43. Karel Reisz, Tony Richardson, John Fletcher and Lindsay Anderson were the principal founders of which movement?
44. Which drama-documentary did the BBC ban for twenty years?
45. Which actors took the lead roles in *Odd Man Out* and *The Gentle Gunman* respectively?
46. Which film about the Troubles in Northern Ireland was filmed entirely outside of the country?
47. Which historical figure was portrayed in six films between 1910 and 1936?
48. Burt Lancaster appeared as a Texan oil millionaire in which 1983 film set in Scotland?
49. Which travelling showman was the key creative figure in the early days of Welsh cinema?
50. What was the first Welsh film to be nominated in the Foreign Language Category at the Academy Awards, and it what year was it nominated?

Answers

1. Eadweard Muybridge. 2. Robert Paul, 1894. 3. Hove. 4. 1902. 5. Protect the British film industry and encourage domestic production. 6. Teddington Studios, 7. 1947, 8. 1912, 9. Iris Barry, 10. Leavesden. 11. Betty Box. 12. *In Which We Serve* (1942), 13. The Archers, 14. *Smalltime* (1996). 15. Gainsborough. 16. Andrea Arnold. 17. *Pressure*, by Horace Ové. 18. India. 19. *Penny Points to Paradise*. 20. *Pink String and Sealing Wax*. 21. *Once Upon a Time in the Midlands*. 22. Hammer Studios. 23. *Women in Love*, by Ken Russell. 24. Raymond Durgnat, 25. Mark Lewis and Carl Boehm. 26. *Victim*. 27. Betty Balfour. 28. Alistair Sim. 29. The early 1990s. 30. Merchant Ivory. 31. *Elizabeth*. 32. *Photographing a Ghost* and *The Haunted Curiosity Shop*. 33. *The Wraith of the Tomb*. 34. Amicus and Tigon. 35. The British New Wave. 36. *My Beautiful Laundrette*. 37. *The Red Shoes*. 38. The Bill Douglas Trilogy. 39. *Kes* (1969). 40. The Edinburgh Film Festival in 1979. 41. John Grierson. 42. The Ministry of Information. 43. The Free Cinema Movement. 44. *The War Game*. 45. James Mason and Dirk Bogarde. 46. *The Devil's Own*. 47. Mary Queen of Scots. 48. *Local Hero*. 49. William Haggar. 50. *Hedd Wyn*, 1992.

Nannette Aldred is Senior Lecturer in Continuing Education: Visual Culture at the University of Sussex and is actively involved with regional cultural organizations. She has published work on Michael Powell, Hein Heckroth and The Archers, *Performance* and the *Summer of Love*. She is also the author of a short history of the ICA and of Herbert Read.

Jon Barrenechea is General Manager of the Duke of York's Picturehouse in Brighton, Britain's oldest cinema, and Business Development Manager at the Stratford Picturehouse in London. He is co-author of *The Duke's at 100* and *The Ultimate Film and Television Brainbuster Quiz Book*. He blogs about the film industry at splendorcinema.blogspot.com and is co-host of the Splendor Cinema Podcast, a film review and discussion show.

Robert Beames is a journalist. He has contributed to Intellect's *Directory of World Cinema: American Independent* (volume 2) and *World Film Locations: London*, as well as reviews for *The Sunday Telegraph*. He has appeared on BBC Radio Sussex and guest-presented Picturehouse Cinemas' online show, 'Flick's Flicks'. He has interviewed Darren Aronofsky, Samuel Maoz and Oliver Stone, and blogs at: beamesonfilm.blogspot.com.

Emma Bell is Senior Lecturer in Film and Screen Studies at the University of Brighton. She has published work on aesthetics and morality, the ethics of representation, artists' film-making, continental philosophy, critical theory, and gender and popular culture. She is currently researching scientific showmanship in early visual culture.

Adam Bingham completed a PhD at the University of Sheffield and teaches film studies at Edge Hill University in Lancashire, UK. He regularly contributes to the journals *CineAction*, *Cineaste*, *Senses of Cinema* and *Asian Cinema Journal*, and edited Intellect's *World Cinema Directory: East Europe*.

Marcelline Block is Lecturer in History at Princeton. She edited *Situating the Feminist Gaze and Spectatorship in Postwar Cinema*, *World Film Locations: Paris*, and has published work about Maurice Pialat in *Excavatio*; a chapter about Robert Bresson in *Vendetta: Essays on Honour and Revenge;* and contributed to several editions of Intellect's *Directory of World Cinema* and *World Film Locations* series.

Laurence Boyce is an award-winning film journalist based in Britain and Estonia who writes for publications including *Screen International*, *International Film Guide*, *Moviescope*, *Little White Lies* and *The Baltic Times*. He was programmer and moderator for the Leeds International Film Festival, director of GLIMMER: the Hull International Short Film Festival and is currently working for the Black Nights Film Festival in Tallinn. He is a member of Fipresci (The International

Federation of Film Critics) and the British Academy of Film and Television Arts (BAFTA).

Alec Charles is Principal Lecturer in Media at the University of Bedfordshire. He has worked as a journalist in Eastern Europe and as a documentary programme-maker for BBC Radio. He is editor of *Media in the Enlarged Europe* and co-editor of *The End of Journalism*. His recent publications include articles in *Science Fiction Studies* and *Science Fiction Film and Television*, and chapters on *Doctor Who*, Tod Browning and Edgar G Ulmer.

E Anna Claydon lectures at the University of Leicester. She has published work on British South-Asian cinema, masculinity in British cinema, film music in British film, representations of the mind, disability in film, landscape and cityscape. She has completed a book on imagination and memory in film and is currently working on masculinity and television crime drama and the representation of the British rural landscape.

Deirdre Devers is a digital strategist and academic with an interest in screen cultures (e.g. online multiplayer gaming, cinema outside the multiplex), interactive entertainment and celebrity studies. She enjoys using film as a vehicle to spur young people's creativity whilst helping them to engage with film history, storytelling and technology.

Martin Fradley has taught at the universities of Aberdeen, East Anglia, Keele and Manchester. He has published work in collections including *Falling in Love Again: Romantic Comedy in Contemporary Cinema*, *American Horror Film: The Genre at the Turn of the Millennium* and *Fifty Contemporary Film Directors*. He is a regular contributor to *Film Quarterly* and has written for *Screen*, *Film Criticism* and *Canadian Journal of Film Studies* and is co-editor of a collection of essays on Shane Meadows.

David Forrest is a Tutor and Research Associate at the University of Sheffield. He has published articles on the British New Wave, Shane Meadows, Contemporary British Realism and British Television Drama.

Adrian Garvey teaches film at Birkbeck, University of London. He is the author of 'Pre-Sold to Millions: British Sitcom Films of the 1970s in *Don't Look Now: British Cinema in the 1970s* and 'The Boy Friend: Ken Russell's "Anti-Musical"' in *Culture and Society in 1970s Britain: The Lost Decade*.

Sarah Godfrey is Associate Tutor at the University of East Anglia and City College, Norwich. Her publications include work on gender, race and class in British and American film and television. She is currently working on a number of projects about British film-makers Shane Meadows and Nick Love. She is also a community film-maker.

Frank Gray runs the Screen Archive South East and is Senior Lecturer in Screen Studies at the University of Brighton.

Scott Jordan Harris writes for *The Spectator* and edits its arts blog. He is also editor of *The Big Picture* magazine and several of Intellect's *World Film Locations* books. Roger Ebert lists @ScottFilmCritic among his top 50 'movie people' to

follow on Twitter and featured Scott in his article 'The Golden Age of Movie Critics'; runninginheels.co.uk included Scott's blog, A Petrified Fountain, in its selection of the twelve 'best movie blogs'.

Stephen Harper is Senior Lecturer in Media Studies at the University of Portsmouth. His main research interest is in radical media criticism and his publications include *Madness, Power and the Media* and *Beyond the Left: The Communist Critique of the Media*. He has also written about horror film and is co-editor of *Constructing the Wicker Man* and *The Quest for the Wicker Man: Historical, Folklore and Pagan Perspectives*.

Brian Hoyle is lecturer in English Literature and Film Studies at the University of Dundee. He has published work on Ken Russell, Derek Jarman, Sally Potter, Isaac Julien, Orson Welles, Joseph H Lewis and Bela Tarr. He is currently co-editing an edition of the Oscholars on Oscar Wilde and film and completing a monograph on John Boorman.

Michael King is from Liverpool, Merseyside. He is a graduate of the University of Brighton Film and Screen Studies degree and is embarking on a career in teaching. This is his first publication.

Ewan Kirkland is Senior Lecturer in Film and Screen Studies at the University of Brighton. His research interests include children's culture, science fiction film and television, and the critical analysis of videogames. In 2007 Ewan organized the first academic conference on the reimagined Battlestar Galactica, and in 2010 co-organized a conference on memory in new fantasy cultures. He has contributed to a range of journals, including *Animation*, *Convergence* and *Screen*, and publications on subjects including horror videogames, star studies, new media technologies, zombies, evil, and vampires. His work include studies of *Dora the Explorer*, *Silent Hill*, *Starbuck*, Disney cinema, *Hook*, *Twilight*, *Dexter* and *The Powerpuff Girls*.

Eeleen Lee studied English Literature at the University of York and Royal Holloway College, University of London. Her short fiction is published by Monsoon Books, and in 2009 she was shortlisted for the Malaysian MPH Alliance Bank National Short Story Award. Her reviews are included in *Directory of World Cinema: American Independent* as well as The Portal – an online review of short-form science fiction, fantasy, and horror: sffportal.net.

Chris Legge is a PhD candidate at the University of Ulster Coleraine. He is currently researching the emergence and development of the cinema industry in the north of Ireland and Northern Ireland 1895–1925, concentrating on the greater Belfast area. He has worked in a number of different roles within the cinema industry in Northern Ireland and is a former cinema projectionist.

James Leggott lectures on film and television at Northumbria University. He is the author of *Contemporary British Cinema: From Heritage to Horror* and has written on various aspects of British film and television culture, including social realist film-making, television comedy, reality television, and the work of the Amber Collective.

Robin MacPherson is Professor of Screen Media at Edinburgh Napier University,

Director of Screen Academy Scotland – a Skillset Film and Media Academy, and Director of ENGAGE – an EU MEDIA programme supported collaboration with the Irish, Estonian and Finnish national film schools. Formerly a documentary film and television producer with British and Scottish BAFTA nominations, Robin joined Edinburgh Napier from Scottish Screen where he was head of development. In 2010 the Scottish Government appointed him to the Board of Creative Scotland.

Henry K Miller is researching a PhD thesis at Birkbeck College, London on the origins of film culture in Britain. He has contributed to *Film Comment, Sight and Sound, Cinema Scope* and *Time Out*, occasionally blogs for *The Guardian*, and wrote a foreword to the second edition of Raymond Durgnat's *A Long Hard Look at Psycho*. He has taught at Anglia Ruskin University.

Neil Mitchell is a freelance film critic, writer and editor based in Brighton, East Sussex. He edited the London edition of Intellect's *World Film Locations* and contributes to various editions of their *Directory of World Cinema*, as well as *The Big Picture*, RogueCinema.com and *Electric Sheep*. He blogs at: nrmthefourth-wall.blogspot.com and tweets on @nrm1972.

Nathalie Morris is Curator of Special Collections at the BFI. She has completed a thesis on the critical history of the British studio, Stoll, and published on various aspects of silent cinema including the early career of Alma Reville and the British 'woman's' film in the 1920s. She co-created the website Women and British Cinema and is a member of the Women's Film History Network (Britain and Ireland).

Adam Richmond is a London-based journalist and author. He is a regular contributor to the free magazine *The Other Side* and blogs about film for their website.

James Rose has published work in a range of national and international journals and edited collections, predominantly on contemporary Gothic, Horror and Science Fiction cinema and television. He is the author of *Beyond Hammer: British Horror Cinema since 1970* and *Studying The Devil's Backbone*, and blogs at: jamesrose-writer.blogspot.com.

Dafydd Sills-Jones is a lecturer in media production at Aberystwyth University. He was previously a researcher, producer and director in broadcast and online media. He specializes in the history and theory of documentary film, and the study of media production.

Robert JE Simpson is a PhD candidate at Trinity College Dublin, researching the early history of the British Hammer Films group, focusing on Exclusive Films. He has written for many publications including *Film Ireland* and an edited collection on Stanley Kubrick. He is the editor of *Diabolique* magazine, and an archival consultant to Hammer Films. He can be found at www.avalard.co.uk.

Lindsay Steenberg is a lecturer in Film Studies at Oxford Brookes University. She has published work on the wuxia genre, war and art cinema, Guillermo del Toro, and crime film and television. She is completing a monograph entitled *Forensic*

Science in Contemporary American Popular Culture.

Patrick Tobin studied visual art in America before receiving an MLitt in Film Journalism from the University of Glasgow in 2010. He currently resides in Boston, Massachusetts.

Belén Vidal is Lecturer in Film Studies at King's College London. She has published on the period film in *Screen* and *Journal of European Studies.* She is the co-editor of *Cinema at the Periphery* and the author of *Heritage Film: Nation, Genre and Representation.*

Melanie Williams is Lecturer in Film Studies at the University of East Anglia. She has published work on British cinema in *Screen, Sight and Sound, Cinema Journal, Feminist Media Studies,* and several edited collections. She is co-editor of *British Women's Cinema* and author of *Prisoners of Gender: Women in the Films of J Lee Thompson.*

Kate Woodward is Lecturer in Film Studies at Aberystwyth University. She has published work on both Welsh- and English-language films from Wales and is currently preparing a volume on the history and films of the Welsh Film Board. She is a member of the Arts Council of Wales and Management Board of Cyfrwng, and has served as a member of the BBC Broadcasting Council of Wales.

Randall Yelverton is Assistant Director of the Washington District Library and an advocate for libraries, and is based in Peoria, Illinois. He is also the film critic for LakeExpo.com and blogs about film and libraries at: randallyelverton.com.

FILMOGRAPHY